art-SITES
SAN FRANCISCO

also available

art-SITES BRITAIN & IRELAND

art-SITES FRANCE

art-SITES LONDON

art-SITES NORTHERN ITALY

art-SITES PARIS

art-SITES SPAIN

art-SITES
SAN FRANCISCO

The Indispensable Guide to Contemporary
Art–Architecture–Design

Second Edition

sidra stich

san francisco

art-SITES SAN FRANCISCO
first published—2003
second edition—2007

Published by
art-SITES Press, 894 Waller Street, San Francisco, CA 94117
www.art-sites.com

Book production by
Pete Masterson, Aeonix Publishing Group, www.aeonix.com

Although the author and publisher have tried to make the information as accurate and current as possible, they accept no responsibility for any loss, injury, or inconvenience sustained by any party as a result of errors, omissions, or advice contained in this book.

ISBN-13: 978-1-931874-04-5
ISBN-10: 1-931874-04-2

cover image: de Young Museum, Herzog & de Meuron, architects: see p. 165

Printed in the United States of America

table of contents

We appreciate your help

If you found errors regarding information about a site we discussed or know about sites we missed, please tell us.

art-SITES, 894 Waller Street, San Francisco, CA 94117
tel: 415-437-2456
fax: 415-701-0633
www.art-sites.com
info@art-sites.com

Preface

This is a revised and expanded edition of *art-SITES SAN FRANCISCO*. Like other books in the *art-SITES* series, it identifies and discusses the best places to see innovative, intriguing, topnotch creativity from the current era. Museums, galleries, exhibition spaces, film centers, architecture, public art, design showrooms, parks, gardens, bookstores, and even some sites associated with the Bay Area's famed wineries and gourmet food culture are included.

art-SITES SAN FRANCISCO provides background, analytic and practical information that orients you to a place or project, both in your advance-planning phase and during actual visits. Along with context-based data, like the naming of sample exhibitions and gallery artists, spicy bits of history and critical evaluations help you make choices among the multitude of possibilities. Detail maps keyed by number to each site also eliminate hassles in finding your way, and illustrations give a glimpse of what to expect. Since the book is organized geographically, you can easily take walking tours of neighborhoods or excursions outside the city.

Each *art-SITES* book is a rich compendium of information on what's happening in a particular location. If you're already familiar with the more famous museums and tourist monuments, these handbooks will help you discover hidden treasures and off-the-beaten-track places. They are invaluable resources, whether you have only a few hours or several weeks at your disposal, whether you're an arts professional or a neophyte art lover.

art-SITES: The Indispensable Guides to Contemporary Art—Architecture—Design

ABOUT THE AUTHORS

SIDRA STICH is an art historian, museum curator, and avid art traveler. She received a master's degree in visual studies from Harvard University and a doctorate in art history from the University of California, Berkeley. In addition to organizing a comprehensive *Yves Klein* retrospective and such other exhibitions as *Anxious Visions: Surrealist Art*, *Made in USA*, and *Rosemarie Trockel*, which were all accompanied by major catalogues, she has taught and lectured widely. She also serves as the executive director of the Lucelia Artist Award program at the Smithsonian American Art Museum.

JORDAN ESSOE is an artist and critic who writes for *Artweek* and *SF Gate*. For the 2007 revised edition, he assisted in the research and writing of text entries.

THANKS

art-SITES thanks the many people who have shared their experiences and provided information and photographs for this book. The project could not have been done without the talents, patience, and valued input of Pete Masterson, a real maestro in book design and production.

Introduction

Despite its reputation as a forward-thinking city that leads the way in sociopolitical reform and has a far-left cultural orientation, San Francisco has a conservative bent when it comes to the visual arts. To be sure, vanguard activity has risen to the forefront from time to time, and the city can pridefully claim its share of significant art institutions, world-class buildings, and movers and shakers. But these exist within a pervasive don't-rock-the-boat mentality. Rather than forge new territory and encourage experimentation, the art and architecture scene in the Bay Area tends to follow, supporting safe, sure creativity, even if it tends toward mediocrity or retrograde expression. If it were not for defiant individuals who refuse to partake in the status quo and continuously inject new energy into the community, San Francisco would indeed be a capital of provincialism. Fortunately, pockets of edgy innovation keep arising, reasserting the city's viability as a notable center of contemporary art.

The odd mix of conservatism and radicalism has colored the past and still affects the scope and character of current developments. It is obvious in the choice of museum and gallery exhibitions, the artists represented in museum collections and public art, and the architecture that shapes the region. If you are looking for high-caliber contemporary creativity, you will surely find it, but it may well be submerged within a glut of humdrum work or situated far afield from expected settings.

The major event that put San Francisco on the international art map occurred in 1995 when the San Francisco Museum of Modern Art moved from the Civic Center, where it occupied the upper floors of the Veterans Building, to a signature building designed by the renowned Swiss architect Mario Botta in a prime downtown location. Finally, the museum had a proper home and took its place as the centerpiece of an arts district. The move also brought forth a more dynamic exhibition program and spurred an incredible enrichment of the permanent collection.

Most recently, the city again experienced a major elevation of its arts profile with the opening of the de Young Museum, celebrated for its design by Herzog & de Meuron. The new Federal Building by Thom Mayne and the Contemporary Jewish Museum by Daniel Libeskind are other architectural landmarks that have significantly changed San Francisco's image.

During the past decade, the city's art scene has also profited from the creation of the Yerba Buena Center for the Arts, the expansion of the Legion of Honor, the development of a San Francisco campus for the California College of the Arts— replete with a new exhibition and public events program—and the expansion of the Asian Art Museum, which relocated to a dedicated space downtown. A spate of new galleries and an upsurge in attention to national artists have also strengthened the scope of activity. Not to be overlooked is the significant role played by alternative spaces, such as Camerawork, Galería de la Raza, New Langton Arts, and Southern Exposure. Since the 1970s, these valued enterprises have been presenting exhibitions that showcase the work of emerging artists who bring critical ideas and issues to the forefront. Complementing these veteran organizations, is the stream of new community-oriented project spaces and artist-run galleries that have taken root in the Mission district and in downtown Oakland.

The past decade has also witnessed expansion of arts institutions in the greater Bay Area. These include the Cantor Arts Center at Stanford University, the establishment of preeminent residency programs at the Headlands Center for the Arts in Marin and at Montalvo in

Saratoga, and new exhibition spaces in San Jose, Napa, and Sonoma. Along with the new, such stalwart institutions as the Berkeley Art Museum continue to add spice to the regional scene.

An overview of the local art scene would hardly be complete without recognition of the film dimension. Independent film and video have long enjoyed the support of the Pacific Film Archive in Berkeley, Bay Area Video Coalition, and San Francisco Cinematheque. In addition, repertory movie theaters (Castro, Roxie, Rafael) and major film festivals have been extraordinary resources for viewing classics, rare gems, documentaries, and new releases. Adding icing to the cake are the major studio facilities (Pixar, Lucasfilm/George Lucas, and American Zoetrope/Francis Ford Coppola) that have located their headquarters in the Bay Area.

Though San Francisco is a cosmopolitan city with a European flair and great ethnic and social diversity, it is also a city in which nature gives culture a run for its money. You cannot help but be enamored by the landscape and vistas that greet your eyes at every turn. Historic neighborhoods (Chinatown, North Beach) and vintage Victorian architecture also contribute to the city's distinctive charm. Respecting the environment and conserving venerated traditions while recognizing difference and embracing the new is an ongoing challenge in the Bay Area. It not only affects architectural and urban-planning decisions, but also shapes the very fiber of the art that is created and shown here.

ART

When America rose to prominence in the avant-garde art world after World War II, Abstract Expressionism gained a foothold in the Bay Area via the presence of Mark Rothko and Clyfford Still as visiting faculty at the San Francisco Art Institute. Some local abstract artists and the Bay Area Figurative School—characterized by colorful, impasto painting with figures embedded in bold brushwork—attained broad recognition. At the helm were Elmer Bischoff, Richard Diebenkorn, Frank Lobdell, Nathan Oliveira, and David Park.

The next generation, inspired by Beat culture and loosely allied with the Beat poets (who were centered around North Beach), developed diverse styles and subject matter. A figurative impulse was sustained in the work of Joan Brown and Manuel Neri; abstraction dominated in the paintings of Jay De Feo; and assemblage became the mode of choice for Bruce Conner and Jess. During the 1960s, artists also turned to popular culture, creating lush paintings like those of Wayne Thiebaud, or photorealist compositions, like those of Robert Bechtle. Upbeat humor and funky aesthetics also came to the fore in the mixed-media objects of Roy De Forest, Robert Hudson, and William T. Wiley, and ceramics moved beyond the craft tradition in sculptures by Robert Arneson, Stephen De Staebler, Ron Nagle, and Peter Voulkos.

Though San Francisco was a focal point of counterculture revolutions within the sociopolitical and music spheres during the 1960s (the summer of love, the hippie scene in Haight Ashbury, free-speech events on the Berkeley campus of the University of California, Grateful Dead, Janis Joplin, Santana), the prevailing energies did not manifest themselves in art—at least not immediately or directly. Outside the sanctums of museums and galleries, however, graphic art was transformed by psychedelic design—especially in the posters used to promote performances at The Fillmore—and comic-strip content and style were radicalized by R. Crumb. As a sidebar to Bay Area art history, it is interesting to note that Jennifer Bartlett, Mark di Suvero, Robert Morris, Elizabeth Murray, Bruce Nauman, and Richard Serra all went

to college in the Bay Area during the 1960s but then escaped to New York, where they made their names as major artists.

During recent decades, no single style, medium, or approach has dominated the San Francisco art scene. Conceptual art has held sway in the work of Nayland Blake, Terry Fox, David Ireland, and Tom Marioni; new ideas in environmental art have been pursued by Doug Hollis; expressive statements have appeared in installation projects by Mildred Howard and Paul Kos; innovative technology has marked the videos of Jim Campbell, Lynn Hershman, and Alan Rath; and artists like Kathy Acker, Karen Finley, Guillermo Gomez-Pena, and Survival Research Lab (SRL) have asserted San Francisco's leadership in the burgeoning field of performance art. In addition, the legacy of California's great photographers (Ansel Adams, Imogen Cunningham, Dorothea Lange, Edward Weston) remains strong, evidenced in the work of Linda Connor, Doug Hall, Richard Misrach, Larry Sultan, and Catherine Wagner, as well as in the primacy of attention paid to the medium by local museums and galleries.

Within the realm of painting, an image orientation with a diaristic, ethnic, political, or poetic base has prevailed, exemplified in the work of Squeak Carnwath, Enrique Chagoya, Rupert Garcia, Hung Liu, and Deborah Oropallo. Most recently, the mural tradition, urban-vernacular stylizations, and socially engaged imagery have emerged as the fodder for paintings, installations, and drawings by an emerging generation of hotshots who have attracted international attention. Foremost among them are Chris Johanson, Margaret Kilgallen, Barry McGee, Keegan McHargue.

ARCHITECTURE

The signature element of San Francisco architecture is the bay window, and though it is ubiquitous, its varied manifestations in old and new buildings, residential and high-rise structures never cease to amaze. The best way to see a sampling—or to view the city's famed Victorians, or to experience its hills and breathtaking vistas—is to walk around a given neighborhood. (Be sure to wear sturdy shoes with nonslip soles, and do not ignore the alleys and stepped pathways, since they sometimes contain unexpected treasures.)

Though San Francisco missed the skyscraper boom of the early 20th century, high-rises with boxy profiles drastically altered the topography and caused the destruction of older buildings during the 1960s and 1970s. Public outcry against the Manhattanization of the skyline was vehement. Ultimately, it resulted in the enactment of a Downtown Plan (1985) that put limits on height and instituted strict design controls. Preservation ensued, but it also had a deleterious effect on the construction of innovative architecture: not only were traditional buildings protected, but new structures had to conform with past conventions. As John King, the architecture critic of the city's main newspaper, has observed: "By expecting the worst from anything new, this otherwise vibrant city has settled for an architecture of least resistance—sheepish-looking buildings designed to avoid controversy. They're so careful to fit in, few stand out. San Francisco is missing exhilaration in its architecture."

Despite the constraints, some striking contemporary designs by internationally renowned architects have been (and are being) added to the inventory of city buildings. Among them are the Asian Art Museum (Gae Aulenti), California Academy of Sciences (Renzo Piano), Contemporary Jewish Museum (Daniel Libeskind), de Young Museum (Herzog & de Meuron), Federal Building (Thom Mayne), Main Library (James Ingo Freed), San Francisco Museum of Modern Art (Mario Botta), Yerba Buena Center for the Arts (Fumihiko Maki), and Yerba Buena Theater (James Stewart Polshek).

Major redevelopment of downtrodden areas is also contributing to the dramatic transformation of neighborhoods and historic reconfiguration of the city as a whole. The reinvention of the Yerba Buena district, which began in the 1970s, gave new life to acreage in the midst of the urban core while also sparking renewal of the broader South of Market zone. Similarly, the construction of AT&T Park (2000, formerly named Pac Bell Park) became the catalyst for sweeping rehabilitation of an industrial wasteland in the China Basin area, and the new campus of the University of California, San Francisco in Mission Bay (begun in 2003) is situated to become the nucleus of expansive growth.

Intertwined with major development efforts, new zoning laws applicable to loft dwellings and high-rises (1988) and the dot-com boom of the late 1990s created a burst of housing and office construction. Largely centered in the South of Market, Potrero Hill, and Mission districts, this activity has encompassed the renovation of old factories and warehouses as well as the creation of new live/work lofts. Among the new structures are some intriguing designs by acclaimed San Francisco–based architects: David Baker, Mark Cavagnero, Jim Jennings, Stanley Saitowitz, and Daniel Solomon.

Within the broader Bay Area, distinctive exemplars of contemporary architecture are also invigorating the urban and rural landscapes. Of note are designs by such architects as Fernau & Hartman, Norman Foster, Michael Graves, Mark Horton, Frank Israel, Richard Meier, Charles Moore, Antoine Predock, and Kevin Roche.

DESIGN

Public access to top-of-the-line designer furnishings and accessories has recently expanded with the establishment of showrooms and boutiques that are not exclusively the province of professionals. When leading international companies—Alessi, Artemide, Kartell, Vitra—opened flagship stores in San Francisco (2002–03), the city became a veritable design center. In addition, Limn has promoted high-end designer creations in its grandiose showroom, and various other enterprises—Arkitektura-in-Situ, Atys, Design Within Reach, Friend, Propeller, Zinc Details—have enhanced the offerings.

FESTIVALS AND FAIRS

Throughout the year, a broad spectrum of arts (or artsy) festivals and street fairs take place in the major exhibition halls and in local neighborhoods around the city. Most have a specific theme or ethnic, sexual, or sociopolitical orientation or are focused on a particular genre of art-making, among them crafts, books, rock music, jazz, women, gay pride, '60s psychedelic nostalgia, or Hispanic, Asian, or Italian culture. For specifics on these, check current listings in the mass media. The following festivals and events are expressly devoted to contemporary art.

First Thursdays. Though this is not technically a festival, every month on the first Thursday, from 5:30–7:30, the area around Union Square has a festive air as artists and art-world patrons scurry about from gallery to gallery attending the opening receptions of new exhibitions. It is an upbeat social occasion, self-tailored to encompass a run-through of lots of shows or a concentration on a few. You do not need a special invitation; the gallery openings are freely accessible to the public, and wine is even served at most locations.

First Fridays. Formalized in January 2006 under the name "Oakland Art Murmur," this monthly event (7–10 pm) is a communal opening of the art galleries in downtown Oakland. With its youthful, block-party ambience, this lively gathering is an East Bay showcase for

emerging artists. Street performances, art installations, music, political activism, and other activities sometimes add to the festivities. (www.oaklandartmurmur.com)

Open Studios. Since 1975, artists have been opening their studios to the public for a citywide event held during the four weekends in October. (Each weekend focuses on a different geographic area.) Artists of every stripe are included, and the span of creativity extends from traditional crafts to high-tech designs and everything in between. Since the event is totally unedited and uncurated, there is no telling what you will encounter. You not only get to see artwork, but also to meet artists and get a glimpse of their work spaces and production processes. In order to avoid overload (there are more than eight hundred participants), you can devise a personalized tour plan based on a preview at the Open Studios exhibition at SomArts, 934 Brannan Street (415-861-9838), where one work by each artist is displayed. Check the local media or www.artspan.org for details and neighborhood studio maps.

ZeroOne San Jose. Inaugurated in August 2006 and planned as a biennial, this ambitious art festival focuses on technology-inspired new media and its place within digital culture. It comprises a sprawling assortment of exhibitions, performances, screenings, and workshops held throughout the San Jose area at various locations. (408-916-1010; fax 516-8994; www.01sj.org; info@zero1.org)

San Francisco International Film Festival. Held annually in April, this is the oldest film festival in the United States. It showcases independent and commercial American and foreign films, screening a full program over the course of two weeks at several venues in the Bay Area. Adding to the excitement are the awards ceremonies and presence of celebrity guests. Recent honorees have included Joan Allen, Robert Altman, Cyd Charisse, Milos Forman, Paul Haggis, Ed Harris, Werner Herzog, Dustin Hoffman. In addition to the festival, the San Francisco Film Society organizes other film events throughout the year. Highlights include New Italian Cinema at the Kabuki Theater each November; and "Film in the Fog" presentations in the Presidio in September–October. (415-561-5000; fax 561-5099; www.sffs.org; info@sffs.org)

Film Arts Festival of Independent Cinema. The focus here is on Bay Area filmmakers, and the festival includes screenings and panel discussions of premieres and rarely seen documentaries and feature films. With San Francisco's strong track record as a feeding ground for emerging film talent, you are likely to preview innovative, edgy work by tomorrow's leading names at this event. It takes place in November at various theaters in the city. (415-552-8760; fax 552-0882; www.filmarts.org; info@filmarts.org)

San Francisco International Lesbian and Gay Film Festival. Founded in 1976, this festival has become the world's showcase for lesbian, gay, bisexual, and transgendered cinema. For eleven days each June, a panoply of films are shown, usually to packed houses, at the Castro and other theaters. (415-703-8650; fax 861-1404; www.frameline.org; info@frameline.org)

San Francisco International Asian American Film Festival. Focusing on independent cinema that relates to the Asian American experience, this festival was created in 1982 and showcases films and videos created in dozens of countries around the world. Spanning eleven days in the second half of March and incorporating screening venues in San Francisco, Berkeley, and San Jose, it is the single largest event of its kind in North America. (415-863-0814; fax 863-7428; www.asianamericanmedia.org; festival@asianamericanmedia.org)

San Francisco Jewish Film Festival. Occurring sequentially during July–August in San Francisco, Berkeley, Menlo Park, and San Rafael, this festival has developed a vast audience. Its films explore the relationships between Jews and other groups and how Jews express their national and cultural identities. (415-621-0556; fax 621-0568; www.sfjff.org; jewishfilm@sfjff.org)

San Francisco Black Film Festival. Celebrating African America cinema and the African cultural diaspora, this festival presents screenings, with a strong emphasis on independent films, and accompanies them with panels and workshops. Begun in 1998, it takes place in mid-June at various theaters in the city. (415-771-9271; fax 775-1332; www.sfbff.org; info@sfbff.org)

PERFORMANCES

With the upsurge of crossover activity in the arts, in which visual artists collaborate with musicians, dancers, filmmakers, and playwrights, some extraordinary artwork is visible outside the expected art venues. For example, *Philip on Film*, at Davies Symphony Hall (fall 2002), was a superb program featuring innovative short films created by artists and filmmakers—including Atom Egoyan, Peter Greenaway, Shirin Neshat, and Michal Rovner—who developed their vision in response to the music of Philip Glass. Such events are organized by San Francisco Performances (415-398-6449; fax 398-6439; www.performances.org; info@performances.org) and several other independent presenters and held at public halls around the city. Check the local media for announcements and details.

Yerba Buena Center for the Arts Theater (see p. 31) and Cal Performances at the University of California, Berkeley (see p. 202) are the two main venues for presentations by performance artists or productions involving collaborations with contemporary artists. Local dance companies, who perform in other spaces, are also worth noting. The Margaret Jenkins Dance Company, for example, has been wowing audiences around the world with high-energy creations, which have included the outstanding performance art of Rinde Eckert or imaginative scenic designs by Terry Allen, Barbara Kasten, and Bruce Nauman.

CURRENT EXHIBITIONS AND EVENTS

Gallery Guide—West Coast (a small booklet published monthly) and *San Francisco Bay Area Gallery Guide* (a bimonthly brochure) provide listings of current exhibitions in galleries and museums. Though neither is comprehensive (galleries must pay to be included), they offer basic coverage of the Bay Area. Both are available for free in art galleries and exhibition spaces. A more complete calendar of exhibitions—as well as listings for art, theater, music, dance, literary, and festival events and a few feature articles—is found in *San Francisco Arts Monthly* (www.sfarts.org), a broadsheet, which is distributed free in bookstores, museums, and hotels. For reviews and commentaries, check out *Artweek*, a monthly publication covering the West Coast ($5), or the online zines *Stretcher* (www.stretcher.org) and *San Francisco Arts Online* (www.sfarts.org), which focus on the San Francisco art scene. Other internet sources for Bay Area art coverage include the Artsync calendar (www.artscync.com), and the Fecal Face blog (www.fecalface.com).

In addition to the aforementioned, art listings and reviews in local newspapers are a prime source of information about what is currently going on in the Bay Area. Since most of these publications duplicate their in-print copy on their websites, the Internet is also

useful. Comprehensive gallery and museum listings appear in the "Calendar" section of the *San Francisco Chronicle*'s Sunday edition (www.sfgate.com). The *Bay Guardian* (www. sfbg.com), *SF Weekly* (www.sfweekly.com), and *East Bay Express* (www.eastbayexpress. com) are weekly alternative papers—available for free in street newsracks, bookstores, and cafés—that similarly have extensive art listings as well as reviews and commentaries.

Practicalities

Information provided in *art-SITES SAN FRANCISCO* is as up-to-date as possible, but changes are inevitable. Galleries, in particular (like restaurants) appear, disappear, and change addresses with great frequency. Despite our best efforts, you may find that some sites may no longer exist, or that hours, contact information, admission prices, gallery rosters, and addresses differ from those indicated. We apologize for the inconvenience and hope you will inform us of changes so we can make corrections and update the next edition.

ADMISSION FEES

Unless otherwise noted, there is no cost to visit the venues discussed in this book. Where relevant, admission fees are given in two or three levels. The first is for general adult admission, and the second and third are reduced rates for seniors, students, or other special categories.

HOLIDAY CLOSINGS

Most galleries, museums, and other arts venues are closed on New Year's Day, Independence Day (July 4), Thanksgiving, and Christmas. Many also close on such national holidays as Martin Luther King Jr.'s Birthday (third Monday in January), President's Day (third Monday in February), Memorial Day (last Monday in May), and Labor Day (first Monday in September).

GETTING AROUND

The public transportation system in San Francisco is adequate within the center of the city, but sparse and requiring transfers between lines when you move to surrounding neighborhoods and the outskirts. A similar situation exists in other Bay Area cities (Berkeley, Oakland, Palo Alto, Santa Cruz, San Jose). Bus or train travel to rural areas adjacent to the urban hubs or to nearby regions like Napa and Sonoma is very limited and time-consuming, or nonexistent. Should you plan to tour regional destinations, you may want to rent a car.

BART (Bay Area Rapid Transit, 510-464-6000, www.bart.gov), a regional network of four interconnected high-speed rail lines serving San Francisco, Millbrae (San Francisco Airport), and the East Bay, is a speedy, efficient system. However, it is mainly a commuter system, with only six stations in the downtown area. In contrast, Muni (415-673-6864, www.sfmuni.com), San Francisco's municipal railway system, operates streetcars (Muni Metro), buses (diesel coaches and electric trolleys), and cable cars throughout the city. The F-Market line is of particular note since the streetcars on this route are all vintage with international pedigrees. Among them are *Car 130*, a blue and yellow vehicle from the San Francisco World's Fair of 1915; *Desire*, a dark hunter green and burgundy car from New Orleans, 1924; *Blackpool*, a cream-colored, open-air boat-car from England, 1934; and the 1954 *Red Baron* from Hamburg, Germany.

Transportation to and within the areas surrounding San Francisco is provided by: Sam-Trans—San Mateo County in the South Bay (800-660-4287, www.samtrans.com); CalTrain—Peninsula and San Jose (800-660-4287); AC Transit—Alameda and Contra Costa Counties in the East Bay (510-839-2931, www.actransit.org); and Golden Gate Transit—Marin and Sonoma Counties in the North Bay (415-923-2000, www.goldengatetransit.org).

Within this book, the nearest BART station is noted as a suggested means of transportation to the art sites in San Francisco. If BART doesn't serve the location, the best Muni or bus route is named. For regional sites, bus or train transportation is indicated, except where the only means is by car, and then road directions are provided.

TELEPHONE

You do not have to dial the area code (the three-digit prefix, such as "415" in San Francisco) when calling to a number with the same code. For calls outside a given area code, dial 1 and the full ten-digit number.

Directory

Urban Planning

Parks, Gardens, Plazas

Design

Bookstores

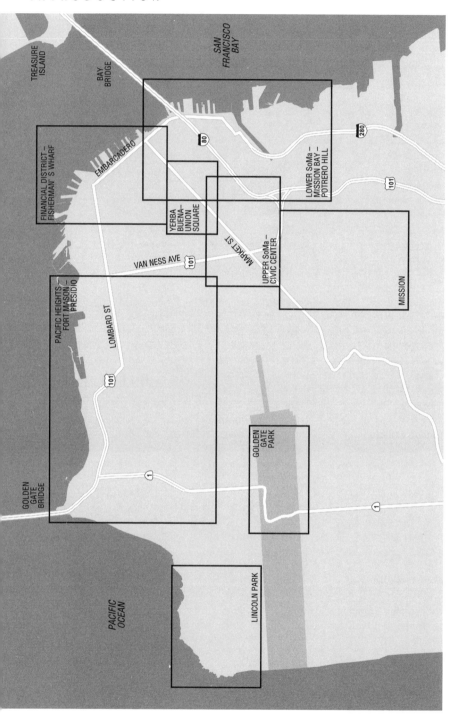

San Francisco

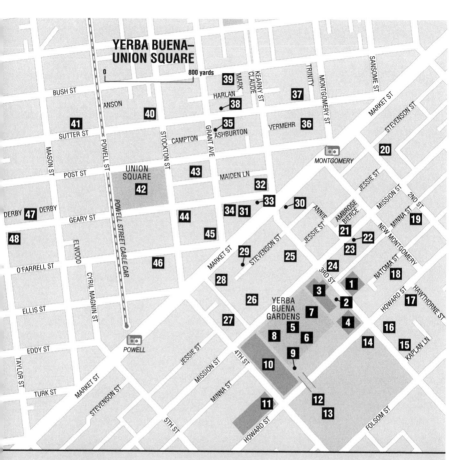

YERBA BUENA–UNION SQUARE

1. SFMOMA
2. J. Roloff, *Deep Gradient*
3. YBCA Gallery
4. YBCA Theater
5. Yerba Buena Gardens
6. M.L. King Jr. Memorial
7. R. Goto, *Cho-en*
8. Smith & Luna, *Reflection*
9. T. Allen, *Shaking Man*
10. Metreon
11. Diller + Scofidio, *Facsimile*
12. C. MacMurtie, *Urge*
13. Zeum and Rooftop
14. K. Haring, *3 Dancing Figures*
15. D. Shuler, *Spider Pelt*
16. S. De Staebler, *Man with Flame*
 J. Dine, *Venus with Rope*
17. Crown Point Press
18. Aurobura Press
19. 111 Minna Gallery
20. S. LeWitt, *Wall Drawings*
21. Lisa Dent Gallery
22. Cartoon Art Museum
 Foto-Grafix Books
23. Catherine Clark Gallery
 SF Camerawork
 Patricia Sweetow Gallery
24. MoAD
25. Argent Hotel courtyard
26. Contemporary Jewish Museum
27. Museum of Craft & Folk Art
28. Four Seasons Hotel
29. M. Howard, *Antique Keys*
30. Modernism Inc.
31. S. De Staebler, *Angel*
32. Gallery Paule Anglim
33. 871 Fine Arts
 Stephen Wirtz Gallery
 Fraenkel Gallery
 Jack Fischer Gallery
 Toomey-Tourell Fine Art
 Scott Nichols Gallery
 Haines Gallery
 Robert Koch Gallery
 Gregory Lind Gallery
 Brian Gross Fine Art
34. Rena Bransten Gallery
 Heather Marx Gallery
35. John Berggruen Gallery
36. Crocker Galleria
37. Hallidie Building
 AIA SF Gallery
38. Hackett-Freedman Gallery
39. Hotel des Arts
40. Alessi
41. SF Museum of Craft & Design
42. Union Square
 R.M. Fischer, *Colonnade*
43. V.C. Morris/Xanadu Gallery
44. Neiman Marcus
45. Emporio Armani
46. C. Sproat, *Spine*
47. Diva Hotel
48. Clift Hotel

Yerba Buena–Union Square

Yerba Buena Redevelopment

Named for the earliest settlement in San Francisco, the Yerba Buena redevelopment area encompasses a nine-block (87-acre) zone south of Market Street and midway between the financial district and Civic Center. Despite its central location, the area was largely forsaken after the earthquake and fire of 1906 and remained a derelict working-class neighborhood until the city decided to reclaim it in the 1960s. Years of legal battles ensued, ultimately resulting in scaled-down proposals that embraced open space and mixed-use development with a human dimension. In addition to the Moscone Center, the convention facility that is a centerpiece of the project, Yerba Buena is home to an appealing and very popular urban park, a range of cultural and entertainment facilities, residential housing, hotels, office structures, and retail businesses.

A major factor in the success of this urban development project was the 1976 voter mandate that designated the convention center as an underground facility. Moscone South (the first building in the complex), designed by **HELLMUTH, OBATA & KASSABAUM** and opened in 1981, and the adjacent Esplanade Ballroom (1991) and Moscone North (1992) by **GENSLER** are all huge structures, but they do not dominate the skyline and their subterranean design has enabled green space in the midst of the downtown cityscape.

Although some aspects of the grand scheme have yet to be implemented and construction is still ongoing within the area, revitalization is apparent on all fronts. The district is now a thriving tourist destination as well as a magnet for city residents drawn by its broad spectrum of activities.

1 San Francisco Museum of Modern Art

architect: **MARIO BOTTA**, 1995
151 3rd St, 94103
415-357-4000 f: 357-4037
www.sfmoma.org
Sept–May: Mon–Tues, Fri–Sun, 11–6; Thurs, 11–9
June–Aug: Mon–Tues, Fri–Sun, 10–6; Thurs, 10–9
admission: $12.50/8/7; free first Tues; half-price Thurs, 6–9
BART: Montgomery
Located between Mission and Howard Sts, across from Yerba Buena Gardens.

If you want to taste the classics of modern art and be captivated by creations of recent generations, this is the place. The museum has upgraded its collection by leaps and bounds and become part of the international circuit of blockbuster exhibitions since moving into its new building. With a schedule showcasing painting, sculpture, installation, photography, architecture, design, and new media, SFMOMA covers the span of contemporary activity, highlighting some superstars and calling attention to emerging hotshots. What was once a very provincial institution, albeit the third oldest museum of modern art in the United States, is now a respectable and respected center of art activity.

Without question, Mario Botta's building served as a forceful catalyst in changing the direction of SFMOMA and bringing about its rise to prominence. The fortress-like structure, patterned in cinnamon-colored brick accentuated with zebra-striped stone, has become a San Francisco landmark. Within the city's landscape, the black-and-white cylindrical skylight is as recognizable as the Transamerica Pyramid.

Grandiosity is conveyed by the building's rigorously symmetrical order and pure geo-

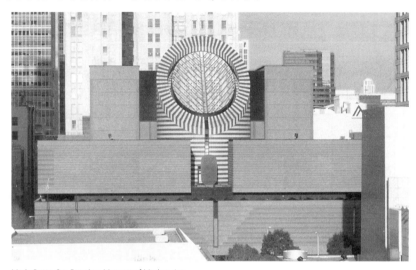

Mario Botta, San Francisco Museum of Modern Art

metric volumes. The monumental aura has been compared to that of a cathedral, hence recalling the oft-repeated idea that museums are the cathedrals of the modern era. And as in a cathedral, the majestic vision elicited by the exterior is reinforced by the soaring space of the interior. A central atrium with glistening black marble floor, walls sheathed in pale birchwood, a grand altar-like stairway broken by stacked trays of balconies, and a 100-foot-high glass-ceilinged tower crossed by a dramatic steel bridge on the top level elicits awe. The meticulous craftsmanship and refinement of the surface textures and design details heighten this sensation, imbuing the pathways into the galleries with a reverential tone.

A pleasant café, auditorium, and the **MuseumStore**—a well-stocked gift and book shop—surround the atrium on the ground floor. Two monumental murals (*Wall Drawing #935* and *#936*, 2000) by the esteemed artist **SOL LEWITT** enliven the entry space, even as they give evidence of the conceptual strain of avant-garde contemporary art—a focal aspect of the museum's program. Collection galleries for painting and sculpture, organized in a chronological

schema, occupy the main area of the second floor. The display begins with some superb fauvist paintings, including Henri Matisse's *Woman with the Hat* (1905). Although coverage of the early modern period is hardly encyclopedic, exemplary works by various leading and secondary artists offer an interesting overview. Some highlights are signature cubist compositions by Georges Braque (*Violin and Fruit Dish*, 1910) and Pablo Picasso (*Female Torso*,1908); classics of American modernism by Joseph Stella (*Bridge*, 1936) and Georgia O'Keeffe (*Black Place I*, 1944); Latino paintings by Frida Kahlo (*Frieda and Diego Rivera*, 1931) and Diego Rivera (*The Flower Carrier*, 1935); a wide range of works by Paul Klee; Mondrian's iconic *Composition No. III, White-Yellow*; *Two Spheres within a Sphere* (1931) and other historic works by Alexander Calder; *Fountain* (1917/64), the renowned Dada object by Marcel Duchamp; and surrealist gems by Max Ernst (*The Numerous Family*, 1929), Salvador Dalí (*Unsatisfied Desires*, 1928), Joan Miró (*Dark Brown and White Oval*, 1926), and René Magritte (*Personal Values*, 1952).

The collection galleries also encompass a strong representation of mid-century

American art by Robert Arneson, Richard Artschwager, John Baldessari, Louise Bourgeois, Willem de Kooning, Richard Diebenkorn, Jim Dine, Philip Guston, Eva Hesse, Jasper Johns, Donald Judd, Franz Kline, Roy Lichtenstein, Brice Marden, Gordon Matta-Clark, Bruce Nauman, Barnett Newman, Claes Oldenburg, Jackson Pollock, Mark Rothko, Richard Serra, Robert Smithson, Frank Stella, Wayne Thiebaud, and Andy Warhol. Interspersed among these are key objects by Europeans such as Joseph Beuys, Richard Deacon, Katharina Fritsch, Rebecca Horn, Anselm Kiefer, Yves Klein, Richard Long, Sigmar Polke, and Gerhard Richter. In addition, a sampling of the museum's in-depth holdings of Ellsworth Kelly, Sol LeWitt, Robert Rauschenberg, Robert Ryman, and Clyfford Still are included in the display.

Brice Marden, *Cold Mountain 6 (Bridge)*, 1989–91; SFMOMA

SFMOMA possesses a rich selection of work from the most recent decades, showcased in several rooms on the second floor and in a more comprehensive spread on the fifth floor. The collection represents cutting-edge work by influential artists not otherwise seen in the Bay Area. The list includes Matthew Barney, Chuck Close, Olafur Eliasson, Robert Gober, David Hammons, Mona Hatoum, Jenny Holzer, Toba Khedoori, Jeff Koons, Cady Noland, Chris Ofili, Jorge Pardo, Elizabeth Peyton, Matthew Ritchie, Cindy Sherman, Thomas Struth, Sarah Sze, Luc Tuymans, Kara Walker, Rachel Whiteread, Christopher Wool, and Andrea Zittel.

The architecture and design galleries, also located on the second floor, present special exhibitions and displays of objects from the permanent collection. Focus is on historical modern and contemporary creativity in the realm of buildings, interiors, landscapes, furniture, industrial and handmade products, and graphic design. Though the program is international in scope, particular attention is paid to West Coast and Pacific Rim projects and artists. Sample exhibitions: *2 x 4*, *Yves Béhar Fuseproject*, *John Dickinson*, *Todd Eberle*, *Alexander Girard*, *Glamour—*

Fashion/Industrial Design/Architecture, *Lindy Roy*, *Xefirotarch*.

Even if you are not interested in spending time in the Koret Education Center, which occupies the whole back section of the second floor, you might consider walking through the area to see the interior renovation by **TANNER LEDDY MAYTUM STACY** (2002). Comprising classrooms, a lecture hall, and an interactive learning lounge with audiovisual and data-resource systems, the center offers a range of programs and facilities for children and adults.

The mainstay of the third-floor galleries is photography. Holdings from the museum's extensive photography collection occupy one wing, and a special exhibition, usually a one-person show of a major figure, takes place in the adjacent sequence of galleries. The collection display suffers greatly from not having enough space to give more than a very abbreviated sense of the historical, technical, thematic, and conceptual richness of photography. Nevertheless, just getting a taste of superb exemplars of the medium is exhilarating. In contrast, monographic exhibits provide in-depth investigations often concentrating on a particular theme or series. Sample exhibitions: *1906 Earthquake*, *Robert Adams*, *Contemporary Photography and the Archive*, *Richard Long*, *Mexico as*

Philip Guston, Untitled (Head), 1980; SFMOMA

Muse—*Tina Modotti and Edward Weston, Martin Munkacsi, John Szarkowski, Taking Place, Shomei Tomatsu, Henry Wessel.*

Galleries devoted to media arts, located on the fourth floor, invariably showcase of-the-moment, innovative creativity by some of the most adventurous artists of international renown. SFMOMA has been at the forefront in embracing this realm of contemporary art, which includes film, video, sound, digital and other time-based compositions, and multimedia installations. Sample exhibitions: *Fikret Atay, Jeremy Blake, Mary Lucier, Gordon Matta-Clark, Steve McQueen, Reprocessing Information, Pipilotti Rist, Peter Sarkisian, Jane & Louise Wilson.* In addition to the gallery presentations, the media arts program periodically features film screenings and performances in the auditorium.

The blockbuster special exhibitions, located in the spacious galleries on the fourth floor, are often the most popular attraction in the museum. (Occasionally, special exhibitions are also on the fifth floor.) Generally these are megaretrospectives of internationally renowned artists. Since they tend to be intense explorations comprising numerous examples and covering a broad span of work, be prepared to spend a fair amount of time or, better yet, plan several visits. Typically these shows are accompanied by catalogues, free brochures, lectures, and other related programs. Sample exhibitions: *Matthew Barney, Romare Bearden, Robert Bechtle, Chuck Close, Joseph Cornell, Olafur Eliasson, Anselm Kiefer, Roy Lichtenstein, Brice Marden, Matisse—The Painter as Sculptor, Picasso and American Art, Kiki Smith, Frank Stella, Jeff Wall.*

In addition to the grand-scale special exhibitions, a small gallery at the back of the fifth floor presents small shows of new work by mid-career or emerging artists. Sample exhibitions: *Phil Collins, Tim Gardner, Marcelino Gonçalves, Rachel Harrison, Evan Holloway, Marilyn Minter, Dave Muller, Wangechi Mutu, Zak Smith.*

The museum's exhibition space will be expanding to include a rooftop sculpture garden, located above the parking garage and linked to the fifth floor galleries. In 2006, the architects **JENSEN & MACY** were commissioned for this project. In addition to

displaying large-scale objects in an outdoor setting, the new space contains a glass-walled, indoor component designed with reference to the famous Barcelona Pavilion of Mies van der Rohe.

2 John Roloff

Deep Gradient/Suspect Terrain, 1993
BART: Montgomery
Located behind the Yerba Buena Center for the Arts, on the path connecting SFMOMA with Yerba Buena Gardens.

This tall ship-like sculpture of steel and glass, positioned at a steep angle jutting into the pavement, is the work of the John Roloff, a San Francisco-based environmental artist. Sealed within the form are deposits of sedimentary materials dredged from the ocean floor off the California coast. Incidental plant growth resulting from the seeds encased naturally in the sediment is nurtured by a misting system activated several times a day.

Roloff's greenhouse environment not only relates to the sedimentary character of the coastal topography, known as "suspect terrain," but his descending ship is a metaphor for the long, slow process of deposition and accretion. In addition, the work is shaped by an awareness that the surface of the Yerba Buena landscape makes no reference to the cavernous convention center below. The ship conceptually plunges into or rises out of this abyss.

3 Yerba Buena Center for the Arts

architect: **FUMIHIKO MAKI**, 1993
701 Mission St, 94103
415-978-2700 f: 978-9635
www.ybca.org
info@ybca.org
Tues–Sun, 12–5; Thurs, 12–8
admission: $6/4; free first Tues
BART: Montgomery

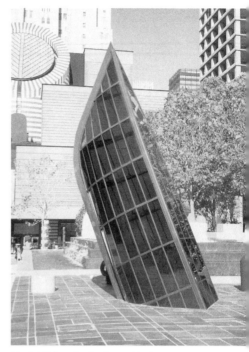

John Roloff, *Deep Gradient/Suspect Terrain*

Located in the northeast corner of Yerba Buena Gardens at the intersection of 3rd and Mission Sts.

The Yerba Buena Center for the Arts includes two buildings: this one, which is mainly used for exhibitions and activities related to the visual arts, and a second structure containing a theater (see below).

Clad in corrugated aluminum and housing open warehouse-like spaces, this structure exemplifies the merger of minimalist, Asian, and industrial aesthetics—a trademark of its Pritzker Prize-winning architect, Fumihiko Maki. A double-height glass-fronted lobby opens the building to the neighboring garden, while simultaneously bathing the entrance hall with natural light. Lying behind the lobby are two main galleries, an outdoor amphitheater, and a flexible hall (Forum) used for special events and performances. The upper level contains an additional gallery, balcony display area, and a screening room. Unex-

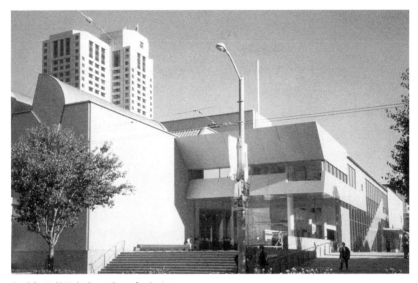

Fumihiko Maki, Yerba Buena Center for the Arts

pected connections link the disparate parts of the interior, enabling an open flow of circulation throughout. Although the diversely scaled spaces exude a functional simplicity, humanizing and irrational features—like the tiny Japanese-style courtyard with bamboo, rocks, and a reflecting pool in middle of the building or the eccentrically shaped window cut into the balcony wall overlooking the

Doug Aitkin, *New Opposition II*, 2001; YBCA

lobby—disrupt the impression of stark, spare modernity.

With its large, flexible exhibition spaces, YBCA offers an ideal setting for contemporary art. Indeed, the center offers a program brimming over with exuberant, youthful expression. Sprawling multimedia assemblages, graffiti-ridden and raw-formed installations often shaped by urban-street references and sociopolitical issues are a mainstay in nearly all the exhibitions. Underrecognized and emerging artists are also favored and work shaped by multicultural trends is strongly represented. Many exhibitions veer outside the art realm into the quotidian landscape of popular culture (skateboarding, zines, hip hop). *Bay Area Now*, a biennial survey, offers a challenging overview of work by young, local artists. Sample exhibitions: *Black Panther Rank and File*, *Cosmic Wonders*, *Wang Du*, *Mexican Street Graphics*, *Cornelia Parker*, *Peer Pleasure*, *William Pope L.*, Erwin Wurm.

In addition to showing videos associated with exhibitions, the upstairs media room presents screenings from the San Francisco Cinematheque, hosts film festivals (Human Rights Watch, Jewish, Madcat), and offers

special film programs in partnership with other institutions (Museum of the African Diaspora, Mexican Museum, Goethe Institut, Bay Area Video Coalition, Film Arts Foundation).

4 Yerba Buena Center for the Arts Theater

architect: **JAMES STEWART POLSHEK**, 1994
700 Howard St, 94103
415-978-2787 f: 978-5210
www.yerbabuenaarts.org
BART: Montgomery
Located in the southeast corner of Yerba Buena Gardens at the intersection of 3rd and Howard Sts.

In contrast to the monolithic bulk of most theater buildings, James Stewart Polshek designed an extroverted structure in which differentiated volumes, colored in a white-black-gray spectrum, are expressions of internal uses. The whole is a masterful collage of cubic shapes ornamented with finely modulated surface details: the fly loft, a slightly angled box, is clad in a grid of aluminum panels; the auditorium is a solid cube sheathed in dark ceramic tiles; the lobby is encased in glass with a projecting red awning; and internal staircases are revealed by glass-brick walls.

While the exterior is dynamic without being flamboyant, the interior is lively and functionally efficient. Foyers, which connect the front and back entrances and open onto the theater, are simple, high-ceilinged spaces with exuberantly colored walls, and the auditorium itself is a skeletal, high-tech design seating 755 in an intimate ambience with excellent sight lines throughout.

With its program of dance, music, theater, multimedia performance, and lectures, the YBCA Theater has become one of the leading Bay Area venues for live arts events. The contemporary avant-garde is well represented by such attractions as David Dorfman, Joe Goode, Margaret Jenkins, Sankai Juku, TchéTché, Yin Mei.

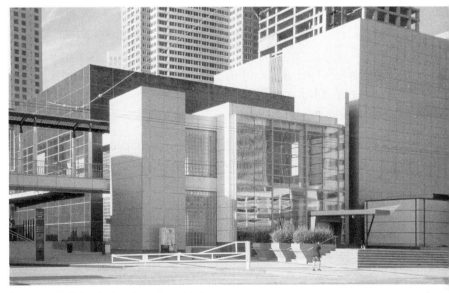

James Stewart Polshek, Yerba Buena Center for the Arts Theater

5 Yerba Buena Gardens

architect: **ROMALDO GIURGOLA**, 1992
between Mission and Howard, 3rd and 4th
Sts, 94105
BART: Montgomery, Powell

This handsome 5.5-acre esplanade built atop the Moscone Center is one of the best things to have happened to San Francisco in recent decades. It is an open green space that truly accommodates people and community activities in the midst of the city. Grassy lawns, trees, flowers, benches, checker and chess tables, meandering paths, and skyline views of downtown make this urban oasis visitor friendly and inviting. Especially at noontime, when scheduled and ad hoc music events, performances, and poetry readings take place, the gardens provide a welcome respite from the workaday world.

Shaped as an oval bowl, with hilly contours sculpted out of great blocks of polyurethane and sod-coated polystyrene, the center meadow is overlooked by a pair of cafés linked by a covered walkway, terraces, and a pool flowing into a waterfall. Not only does the upper level create a backdrop for the gardens, but it also disguises the entrance to Moscone North and blocks contact with the traffic along Howard St.

6 Houston Conwill, Estrella Majozo, Joseph De Pace

Revelations, 1993
BART: Montgomery, Powell
Located at the south end of the lower level of Yerba Buena Gardens.

Flanked by a pleated granite wall with silver tracery in a cloudlike pattern (designed by **LIN UTZON**), the memorial to Martin Luther King Jr. features a grotto situated beneath a 22-foot-high, 50-foot-long waterfall. A dramatic path leading under the water passes in front of two photographs and twelve glass panels inscribed with quotations from the slain civil rights leader written in English as well as the languages of San Francisco's sister cities.

The memorial was a collaborative project involving the sculptor Houston Conwill, architect Joseph De Pace, and poet Estrella Majozo.

7 Reiko Goto

Cho-en (Butterfly Garden), 1993
BART: Montgomery
Located on the east side of the Yerba Buena esplanade.

Embracing the aesthetics of a Japanese garden, with an encircling path and stones set among grasses and low plantings, Reiko Goto has created a serene habitat for butterflies native to San Francisco. Granite benches enclose a small area where plaques with encyclopedia-like texts and images describe the various species that may be visible in the setting.

8 Jaune Quick-to-See Smith and James Luna

Oché Wat Té Ou—Reflection, 1993
BART: Powell
Located on the west side of the Yerba Buena esplanade.

This tribute to the native Ohlone Indians, the first inhabitants of the Yerba Buena neighborhood, is a ceremonial or meditation circle. Shaped as a crescent surrounded by rocks and framed on one side by a wooden wall patterned with Ohlone basket designs, the setting is intended by the artists to serve as a performance area for poetry, storytelling, and other events in the oral tradition.

9 Terry Allen

Shaking Man, 1993
BART: Powell
Located along the walkway leading to the upper terrace in the southwest corner of Yerba Buena Gardens.

Frenzied motion and ribald humor characterize this life-size bronze by Terry Allen, the maverick musician and artist from Lubbock, Texas. The figure, a business executive who totes a briefcase, extends three outstretched hands, stands on five sidestepping legs, and smiles with a high-wattage grin. His effusive and nerve-racked greeting is not unlike the behavior seen in the nearby convention center, hotels, and corporate office buildings.

10 Metreon

architects: **SIMON MARTIN-VEGUE WIN-KELSTEIN MORIS, GARY E. HANDEL**, 1999
101 4th St, 94103
BART: Powell

Located on the west edge of Yerba Buena Gardens, occupying the entire frontage along 4th St between Mission and Howard Sts.

With its glass facade opening onto Yerba Buena Gardens and its public terrace with sweeping skyline vistas, the block-long Metreon building was designed to be an integral part of the esplanade. It also was intended as a digital-age playground, a razzmatazz retail and entertainment complex geared to kids, computer-game fanatics, high-tech gurus, movie lovers (it includes a 15-screen cineplex and 600-seat IMAX theater), fast-food addicts, and fantasy or impulse shoppers.

Architecturally, the building has two distinct orientations. The garden side—shaped to follow the oval of the esplanade, with numerous entry points and a glass curtain wall—has a decidedly open, inviting character. A nice interface between outdoor and indoor spaces prevails on all levels In contrast, the street side—a vast windowless facade clad in metal and articulated by five screen-like color panels—emphatically relates to the urban setting.

Although the corner tower, marquee, and neon delineations on the building's surface animate the Mission-4th St intersection, the boxy design of the structure gives little indication of the atmosphere inside. The minute you cross the threshold, you enter a realm of visual overload, in which crisscrossing

Jaune Quick-to-See Smith and James Luna, *Oché Wat Té Ou—Reflection*, 1993

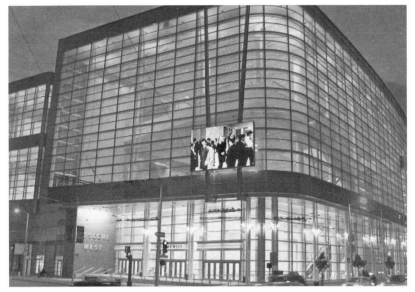

Diller + Scofidio, *Facsimile*, 2003

escalators, a grand staircase, kiosks, open food courts, videos, box-office queues, and a panoply of signage and decorative displays bombard one another for attention within a soaring two-story space. You will probably get lost within the multileveled, crowded, noisy environment, but you will have a good time finding your way. What's more, you can easily escape to the unexpectedly serene and delightful setting of the fourth-floor terrace.

11 Diller + Scofidio

Facsimile, 2003
Moscone West, 800 Howard St, 94103
BART: Powell
Located at the corner of Howard and 4th Sts across from Metreon.

The acclaimed New York artist-architect team of Elizabeth Diller and Ricardo Scofidio has created a 16-by-25-foot, high-resolution LED video screen for the exterior of the west section of the Moscone Center. Suspended by a vertical steel armature that rides a track on the roof, the screen moves along the

4th and Howard Street facades displaying a mix of live footage captured from a camera pointed into the building's lobby, scans of the outside surroundings, and prerecorded imagery of fictional vignettes seen through the glass curtain walls of fictional office buildings. Private and public, real and virtual merge, raising awareness about practices of deception and voyeuristic viewing.

Due to technical problems, this extraordinary public artwork has been virtually nonfunctional since its installation. The city continues to seek solutions to make it operate continuously as planned.

12 Chico MacMurtie

Urge
Zeum, 221 4th St, 94103
BART: Montgomery, Powell
Located on the left side of the front courtyard of Zeum, just beyond the carousel at the corner of 4th and Howard Sts.

Chico MacMurtie, the artistic director of Amorphic Robot Works, is the creator of kinetic interactive works emphasizing the

primacy of movement. In this example, a mechanical man stands atop a large globe; if the mechanics are functioning, he sits down when you trigger the action by sitting on the center bench in front of the sculpture, and stands when you stand.

13 Zeum and Rooftop at Yerba Buena Gardens

architects: **ADELE NAUDÉ SANTOS; M. PAUL FRIEDBERG** (landscape), 1998
221 4th St, 94103
415-820-3320
www.zeum.org
info@zeum.org
Wed–Sun, 11–5; summer, Tues–Sun, 11–5
admission: $8/7/6
BART: Montgomery, Powell

The main entrance, at the corner of 4th and Howard Sts, can be accessed from the street level or by a bridge connected to Metreon and the esplanade of Yerba Buena Gardens.

Located over Moscone South, Zeum and the Rooftop form a sprawling cultural and recreational complex dedicated to kids aged 8 to 18. The children's center is a place for exploring technology as a creative tool in hands-on exhibits, an animation studio, a production lab, and a performing-arts theater. Complementing this, the expanse includes a five-acre park, ice-skating rink, bowling alley, outdoor amphitheater, and a 1906 carousel salvaged from Playland-at-the-Beach.

For the Zeum building, Adele Naudé Santos designed a whimsical fortress-like structure whose muted colors give a syncopated rhythm to the exterior. Flat concrete surfaces are enlivened by tiles, glass bricks, and corrugated metal, while varying roof heights, balconies, awnings, and a segmented composition keep the block-long mass from being monolithic or having a repetitive appearance. Curved volumes, like the inverted glass cone with a spiral ramp, further diversify the whole and establish a spatial flow reiterated in the circular plaza on the upper level.

Even if you are not a kid, it is worth taking a short detour to see the Zeum complex and walk around the delightfully landscaped Rooftop gardens and imaginatively designed multiactivity playground.

Adele Naudé Santos, Zeum

14 Keith Haring

Three Dancing Figures, 1989
southwest corner of 3rd and Howard Sts
BART: Montgomery

Enlivening the small plaza at the street intersection adjacent to Moscone South, this lively sculpture adds a light-hearted touch to the urban landscape. The pictographic figures—typical of Keith Haring's simplified, contour-based imagery brightly painted in the primary colors—reveal the confluence of cartoon, graffiti, and calligraphic modes that were adopted by the artist. Although actively involved in public and community art projects expressing child-like jubilance and humor, Haring often blatantly depicted sexuality and violence to call attention to social issues and urgent causes like AIDS.

15 Dustin Shuler

Spider Pelt, 1985
Moscone Parking Garage, 255 3rd St, 94103
BART: Powell
Located on the side wall facing Clementina St.

Look up to the top of the elevator tower on this exterior wall of the Moscone Parking Garage and you will see Dustin Shuler's witty image of a car. It does not look like a car, however, since it is a flattened, splayed-out image of a car's carapace—a 1971 red Fiat Spider. Pinned to the wall like an animal pelt, it assumes the image of a hunter's trophy. According to the artist, "As animals become more of an endangered species, the urban hunter will seek the automobile as his prey."

16 Stephen De Staebler

Man with Flame, 1986
mall alongside the Convention Plaza Office Building, 201 3rd St, 94103
BART: Montgomery
Located in the small, narrow plaza between the Convention Plaza Office Building and Moscone Parking Garage just south of Howard St.

Recognizable as a fractured human figure but resembling an ancient Egyptian statue in its upright, graceful stance, this torch-bearing bronze sculpture is imbued with a mythological presence. Fragile yet immutable, it conveys endurance and tenacity.

16 Jim Dine

Venus with Rope, 1986
mall alongside the Convention Plaza Office Building, 201 3rd St, 94103
BART: Montgomery

Instead of the smooth, seductive surface and graceful form of the Venus de Milo, one of the most familiar art icons symbolizing supreme beauty, Jim Dine presents a headless, rough-hewn figure with a rope tied around its lower torso. The image conjures the rescue of an ancient ideal demoted to a ruined state as well as the wryly humorous re-creation of a romanticized myth.

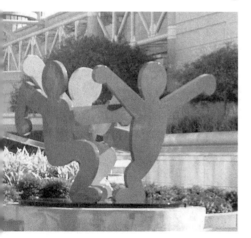

Keith Haring, *Three Dancing Figures*, 1989

17 Crown Point Press

20 Hawthorne St, 2nd flr, 94105
415-974-6273 f: 495-4220
www.crownpoint.com
gallery@crownpoint.com
Tues–Sat, 10–6
BART: Montgomery
Located in an old brick warehouse on Howard St, with a side entrance on Hawthorne St. (The ground floor in the back is occupied by the posh restaurant Hawthorne Lane.)

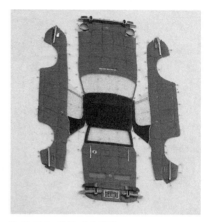

Dustin Shuler, *Spider Pelt*, 1985

Begun in 1962 as a print workshop in the basement of the Berkeley home of its founder and longtime director, Kathan Brown, Crown Point Press has emerged as a renowned international publisher, often lauded as "the most instrumental American printshop in the revival of etching as a medium of serious art." Testament to its leadership role and achievements are the exhibitions showcasing its history that have occurred at the Museum of Modern Art in New York and National Gallery of Art in Washington. Indeed, the boundless character of the press is evident in the range of artists who have worked there, beginning with Richard Diebenkorn and Wayne Thiebaud in 1965, followed by artists working in a minimalist or conceptual mode (Vito Acconci, Chris Burden, John Cage, Sol LeWitt, Brice Marden), and cutting-edge Europeans (Christian Boltanski, Daniel Buren, Anish Kapoor, Markus Raetz). As if this were not enough, from 1982 to 1993, Crown Point took artists to Japan and China to create woodcuts using traditional Asian techniques.

The gallery area, set behind an entry bookshop, is spacious, light, and airy. Exhibits present the latest print release or a thematic show revealing interesting relationships among various artworks in Crown Point's archive. Greatly enriching the print displays are works in other media by featured artists, as well as informative labels and excellent texts in *Overview*, the press's newsletter. The gallery even gives a view into the adjacent studios through glass walls. It is not unusual to catch a glimpse of an artist at work or the prints in production.

Artists: Vito Acconci, Anne Appleby, William Bailey, John Baldessari, Robert Barry, Iain Baxter, Robert Bechtle, Christian Boltanski, William Brice, Brad Brown, Christopher Brown, Günter Brus, Chris Burden, Daniel Buren, John Cage, Enrique Chagoya, Francesco Clemente, Chuck Close, Robert Colescott, Tony Cragg, Fredric Dalkey, Brad Davis, Elaine de Kooning, Richard Diebenkorn, Peter Doig, Rackstraw Downes, June Felter, Eric Fischl, Joel Fisher, Dan Flavin, Terry Fox, Helen Frankenthaler, Jane Freilicher, Hamish Fulton, Katsura Funakoshi, April Gornik, Hans Haacke, Mary Heilmann, Al Held, Tom Holland, Robert Hudson, Bryan Hunt, Shoichi Ida, Yvonne Jacquette, Joan Jonas, Anish Kapoor, Alex Katz, Per Kirkeby, Jannis Kounellis, Joyce Kozloff, Robert Kushner, Bertrand Lavier, Li Lin Lee, Sherrie Levine, Sol LeWitt, Markus Lupertz, Robert Mangold, Sylvia Plimack Mangold, Brice Marden, Tom Marioni, Julie Mehretu, Robert Moskowitz, Dorothy Napangardi, David Nash, Joan Nelson, Nathan Oliveira, Gay Outlaw, Laura Owens, Judy Pfaff, Janis Provisor, Markus Raetz, Rammellzee, Steve Reich, Laurie Reid, Tim Rollins + K.O.S., Ed Ruscha, David Salle, Italo Scanga, Sean Scully, Wilson Shieh, Jose

Richard Tuttle, *Costume C,* 2002; Crown Point Press

Maria Sicilia, Shahzia Sikander, Kiki Smith, Richard Smith, Susana Solano, Pat Steir, Gary Stephan, Wayne Thiebaud, David True, Richard Tuttle, William T. Wiley, Fred Wilson, Yutaka Yoshinaga.

18 Aurobora Press

147 Natoma St, 94105
415-546-7880 f: 546-7881
www.aurobora.com
monotype@aurobora.com
Mon–Sat, 11–5
BART: Montgomery
Located in the middle of the alley-like street behind SFMOMA.

Occupying an old fire station constructed from the bricks of buildings destroyed by the 1906 earthquake, Aurobora Press combines a large printshop with a small gallery. Its speciality is monotype prints created by emerging and established artists from the local and national scene. Artists are invited to collaborate with in-house printers and explore the printmaking process. The results tend to be conservative—finely executed abstract or figurative compositions displaying formalist proficiency.

Artists: Charles Arnoldi, Lynda Benglis, Ford Crull, Reed Danziger, Tony Delap, Stephen De Staebler, Guy Dill, Brad Durham, Mark Eanes, Pia Fries, Rupert Garcia, Fernando Garcia Correa, Flavio Garciandia, Joanne Greenbaum, Willy Heeks, Wade Hoefer, Frank Hyder, David Ireland, Roberto Juarez, Ken Kelly, Kurt Kemp, Wesley Kimler, Gary Komarin, Pat Lipsky, Ricardo Mazal, Frances McCormack, Todd McKie, Wes Mills, Natalia Nestrova, Bob Nugent, Sabrina Ott, Mark Perlman, Matt Phillips, Maria Porges, Jennifer Reeves, Gustavo Ramos Rivera, Andreas Reinhardt, Sam Richardson, Liz Rideal, Italo Scanga, Katherine Sherwood, Stuart Shils, Anne Siems, Hans Sieverding, Pia Stern, Fraser Taylor, Darren Waterston, Stephen Westfall, William T. Wiley, Anne Wilson, John Zurier.

19 111 Minna Gallery

111 Minna St, 94105
415-974-1719 f: 974-1753
www.111minnagallery.com
gallery@111minnagallery.com
gallery: Tues–Sat, 12–5
BART: Montgomery
Located at the corner of 2nd St.

Minna is a contemporary art salon, nightclub, microcinema, and bar. Deriving its name from the street on which it is situated and from the Japanese word for "everybody," the gallery at 111 Minna aims to "nurture and support a communal gathering of artists and collaboration between diverse art forms." Far from being as unctuous as this suggests, Minna is a lively, hip enterprise with broad appeal and an upbeat spirit.

The spare L-shaped setting includes two large rooms, each with a long bar, casual seating, open dance floors, and performance and exhibition areas. A giant fly sculpture by Pepe Ozan, which hangs from the ceiling, spearheads the provocational tone borne out

by the art displayed on the walls. Favoring figurative and narrative expression, often verging on kitsch, with inspiration from cult sources like *Juxtapoz* magazine, the gallery embraces a cartoon, iconoclastic, satiric, political-commentary, California-lifestyle, raw, sexual, illustrator, graffiti, urban-street, low-brow, L.A., lurid, consumerist, hip-hop, digital aesthetic and subject matter.

Thematic shows are particularly irreverent in a humorous sort of way. For example, *The Eames Project* (2002) and *My Adidas* (2002) entailed an odd mode of collaboration in which a select group of artists were asked to redesign the classic furniture of Charles and Ray Eames or embellish a pair of Adidas shoes. *Sci-fi Western* (2003) was an equally imaginative curatorial exercise comprising over 100 artists and a disparate assortment of work notable for its stylized, eccentric fusion of past and future, history and fantasy. Other exhibitions: *10 Years of Alarm Magazine*, *Brian Barneclo & Greg Galinsky*, *Cannonball Press*, *Kim Cogan*, *Coro & Nate Van Dyke*, *Micah LeBrun*, *Octonarius Lunius*, *Alexandre Orion*, *Worst Case Scenario*.

Gallery viewing is the focus during the day, and though DJ, performance, film, and club action are the headline activities at night, the art is still visible. On the last Monday of every month, Minna presents a film program of shorts, videos, and digital works by independent filmmakers from around the world. (*Independent Exposure*, organized by Microcinema International, $6.) "Video wallpaper" projections and a DJ or live music set the mood before the screenings and during intermissions.

20. Sol LeWitt

Wall Drawing #1027, Isometric Form, 2002
Wall Drawing #1028, Isometric Form, 2002
KPMG Building, 55 2nd St, 94105
415-543-6098
Mon–Fri, 9–5
Located between Stevenson and Jesse Sts.

Sol LeWitt, *Wall Drawing #1028, Isometric Form*, 2002

A product of the percent-for-art mandate, these two brightly colored murals were commissioned specifically for the lobby of this office building. They sit snugly in shallow coves on either side of the entry space facing each other. As with many of LeWitt's wall drawings featuring basic geometric forms, the compositions have an energetic, complex character enlivened by tension and playfulness. Here, the off-kilter placement, rich colors, and isometric structure add a dynamic pulse to the image of an X and square grid. The effect is related to, but quite different from LeWitt's color-band murals in the SFMOMA lobby (see p. 26).

21 Lisa Dent Gallery

660 Mission St, 4th flr, 94105
415-975-0860 f: 975-0890
www.lisadent.com
info@lisadent.com
Tues–Fri, 12–6
BART: Montgomery

Don't be put off by the rickety elevator, dark stairwell, and sloped wooden floors leading up to the Lisa Dent Gallery. Since opening in 2004, this well-regarded gallery has developed a finely-tuned program that enhances the San Francisco art scene. Its artists, though largely in the beginning stages of their careers, are practitioners of conceptual

Tim Sullivan, *At the Ocean Floor*, 2005; Lisa Dent Gallery

sophistication and technical mastery. Diverse styles, media, and conceptual approaches are in evidence, though the gallery tends to favor work addressing social and identity politics. Shows have included the sound environments of Kianga Ford, the videos and subtly manipulated photographs of Hank Willis Thomas, Basil Twist's puppets, the staged documentary photographs of

Thomas Chang, Maiko Sugano's design sculpture, Robin Ward's delicate paintings on paper, and the inflatable installations by Flo McGarrell.

Artists: Thomas Chang, Matthew Cusick, Ala Ebtekar, Kianga Ford, Sean Horchy, Marcia Kure, Candice Lin, Flo McGarrell, Shane Aslan Selzer, Maiko Sugano, Tim Sullivan, Robin Ward, Hank Willis Thomas, Basil Twist, Jeong-Im Yi.

22 Cartoon Art Museum

655 Mission St, 94105
415-227-8666
www.cartoonart.org
office@cartoonart.org
Tues–Sun, 11–5
admission: $6/4/2; first Tues, pay what you wish
BART: Montgomery
Located between 3rd and New Montgomery Sts.

A generous gift from *Peanuts* creator Charles M. Schulz in 1987 allowed the Cartoon Art Museum, operating as a "museum without walls" since 1984, to establish a permanent home in the Yerba Buena neighborhood. Fourteen years later, in 2001, the museum moved into its current location,

Patrick McDonnell, *Mooch* from *Mutts*; Cartoon Art Museum

where it displays temporary exhibitions and a comprehensive sampling of its permanent collection. The collection includes a vast assortment of original art from comic books, magazines, newspapers, and animated films; television programs and videos; computer animation; and paintings and sculptures depicting cartoon imagery.

Within the galleries, the collection is installed in sections titled "Animation," "Underground," "Magazine," "Editorial," "Comic Strip," and "Comic Book." Each includes a rich array of materials. For example, the history of animation is illuminated by production cels, storyboards, color concepts, background set-ups, model sheets, drawings, color keys, and a special Walt Disney component. Without prejudice, the collection documents both mainstream and alternative comics, popular commercial examples and quirky off-beat productions.

Particularly relevant to San Francisco is the "Underground Comics" (or "commix") display, with its subversive or X-rated content associated with the city's hippie scene of the late 1960s. Addressing heavy issues—war, religion, ecology, political and corporate corruption—such pioneering artists as R. Crumb, Victor Moscoso, and Gilbert Shelton, forged a distinctive path that still provokes attention today.

Temporary exhibitions range from monographic shows to thematic projects with spicy topics like *Hate Mail: Comic Strip Controversies* (2003), which dealt with the treatment of sex and sexuality, violence, racism, and class warfare in the work of various artists. Sample exhibitions: *Andrice Arp, Cartoon Tunes, Draw Me a Story, Edward Gorey, Dan Piraro, John Porcellino, She Draws Comics—Great Women Cartoonists, Jeff Smith, Queer Culture & the Comics*.

22 Foto-Grafix Books

655 Mission St, 94105
415-495-7242 f: 495-0579
www.foto-grafixbooks.com
foto_grafixbks@yahoo.com
Tues–Sun, 11–5:30
BART: Montgomery
Located in the lobby fronting the Cartoon Art Museum.

Having begun its life as a bookstore for the Ansel Adams Center, Foto-Grafix Books was subsequently embraced by the Cartoon Art Museum. The current shop is an amalgam of both with its own independent flair. It carries a broad selection of cartoon and photography books, postcards and posters, and publications related to fashion, graphics, animation, street art, and graffiti. In addition to the usual selection of glossy picture books, the selection includes a limited array of catalogues from photography exhibitions, small edition texts on emerging artists, and even some out-of-print photography monographs.

A monthly program, usually held on Thursday evenings, presents talks and book signings by photographers, cartoonists, writers, and critics.

23 Catharine Clark Gallery

657 Mission St, 94105
415-399-1439 f: 399-0675
www.cclarkgallery.com
morphos@cclarkgallery.com
Tues–Fri, 10:30–5:30; Sat, 11–5:30
BART: Montgomery
Entrance to the gallery is from either 657 Mission or 150 Minna St.

Exhibitions at Catherine Clark Gallery feature emerging and mid-career artists working in a variety of media with an adventurous mindset. Objects and installations are often feisty and provocative, allied with prevailing trends and indicative of international currents. Inspiration from the mass media,

Ed Osborn, *Flying Machine*, 2002; Catherine Clark Gallery

including comics and advertising, holds sway in much of the art shown here. Among the notable artists are Ed Osborn, who produces engaging sound and video projects; Nina Katchadourian, whose projects are shaped by cultural and personal identity markers; Ray Beldner, who uses dark humor to enliven his conceptual compositions; and Masami Teraoka, who merges traditional Japanese print erotica with contemporary themes.

Video is a seminal component of the gallery program and a regular schedule of video projects takes place in a dedicated space. The selections vary in subject matter and character from the absurd to the serious. Most all are well-worth viewing, so reserve a bit of extra time for this component of the gallery when you visit.

Artists: Chester Arnold, Ray Beldner, Sandow Birk, Timothy Cummings, Anthony Discenza, Christoph Draeger, Al Farrow, Ken Goldberg, Scott Greene, Julie Heffernan, Packard Jennings, Nina Katchadourian, Philip Knoll, leonardogillesfleur, Reuben Lorch-Miller, Ed Osborn, Aaron Plant, Walter Robinson, Travis Somerville, Inez Storer, Josephine Taylor, Masami Teraoka, Jil Weinstock, Yoram Wolberger.

23 SF Camerawork

657 Mission St, 2nd flr, 94105
415-512-2020 f: 512-7109
www.sfcamerawork.org
sfcamera@sfcamerawork.org
Tues–Sat, 12–5
admission: $5/2
BART: Montgomery

Walid Ra'ad, *Notebook Volume 38: Already Been in a Lake of Fire*, 1999–2002; SF Camerawork

Located between 3rd and New Montgomery Sts.

Founded in 1974 as an artists' organization, SF Camerawork has developed a multifaceted program to promote and support photography and related media—including video, film, and installation—by regional, national, and international artists. The organization inaugurated its current gallery in October 2006, following a period of relocations that disturbed its activity schedule but did not diminish its resolve. Indeed, it now has spacious exhibition rooms with flexible possibilities for displaying both traditional photography and innovative forms of camera-based work and alternative photographic technologies.

Exhibitions feature emerging and trend-setting artists, as well as themes that call attention to topical issues and ideas. For example, *Ghosts in the Machine* (2006) dealt with the role of the past that continues to haunt the present, and the construction of counter-histories. The subject was exemplified by Walid Ra'ad's digital photos and film footage taken from documentary materials related to the Lebanese wars, and Dinh Q. Lê's riveting wall installation mixing found photographs with Hollywood stills of images referencing the Vietnamese war.

Sample exhibitions: *Body—Building, Monument Recall, Not Given— Talking of and around Images of Arab Women, Pop_Recall, Traces of Life on the Thin Film of Longing*

In addition to its exhibition rooms, Camerawork also has an education center and reference library. Lecture events, workshops, and publications, especially

the journal *Camerawork*, are also notable components of the organization's program.

23 Patricia Sweetow Gallery

657 Mission St, 4th flr, 94105
415-788-5126 f: 788-5207
www.patriciasweetowgallery.com
info@patriciasweetowgallery.com
Tues–Fri, 11–5:30; Sat, 11–5
BART: Montgomery

Sweetow has introduced San Francisco to otherwise unfamiliar European artists (especially Germans) of an abstract, minimalist persuasion, while also presenting narrative and figurative work by American artists. The diversity encompasses the rectilinear, grayscale watercolors of Joachim Bandau, David Huffman's fantasy landscapes embedded with conflict-ridden scenarios, the glittery landscapes of Jamie Vasta, Rachel Lachowicz's composite objects crafted from cosmetic products, and the subtly modulated monochrome paintings of Peter Tollens.

Artists: Kim Anno, Joachim Bandau, Laurenz Berges, Jonathan Burstein, Peter Dreher,

David Huffman, *Basketball Pyramid*, 2006; Patricia Sweetow Gallery

Mark Emerson, Jeanne Finley/John H. Muse, Jane Harris, Bernhard Härtter, Frederick Hayes, David Huffman, Irmel Kamp, Rachel Lachowicz, Markus Linnenbrink, Renee Lotenero, Joseph Marioni, Cornelia Schulz, Weston Teruya, Michael Toenges, Peter Tollens, Jamie Vasta.

24 Museum of the African Diaspora

685 Mission St, 94105
415-358-7200 f: 358-7252
www.moadsf.org
Mon, Wed–Sat, 10–6; Sun, 12–5
admission: $10/5
BART: Montgomery
Located near 3rd St.

Opened in November 2005, this museum takes a pan-ethnic perspective aiming to connect all people through the cultures and histories of the African diaspora. More than focusing on the transatlantic slave trade, the museum espouses a view of the diaspora as being rooted in the original movement of Homo Sapiens from Ethiopia—the site of the first human remain findings—across the globe. It is an intriguing approach and MoAD's displays offer a sweeping, quirky mix of evidence to support it. The presenta-

Yinka Shonibare, *Scramble for Africa*, 2000; Museum of the African Diaspora

tion begins with an enormous, three-story photomosaic, visible on the street through the glass facade that borders the museum's grand staircase. The mural introduces the diaspora theme through the face of an African child whose image is a composite of 2700 portraits, all in sepia tone, of individuals from a multitude of places and histories.

After entering the museum's reception lobby and gift shop on the ground floor, you ascend to the exhibition galleries on the second and third floors—a modest parcel of space within the back side of the St. Regis Museum Tower. The second floor contains a handful of permanent displays, ranging from a dark room with oral narratives about slavery to a grouping of collage mannequins conveying African dress. Presentations are generally informative, though a slick, promotional aura tends to prevail.

The third level presents temporary art exhibitions. These are predominately thematic and mainly based on contemporary art. Despite interesting subjects, the shows suffer from an uneven selection of artwork and a weak development of ideas. The inclusion of outstanding works—like Yinka Shonibare's *Scramble for Africa* (2000) in the exhibition *Looking Both Ways: Art of the Contemporary African Diaspora*—add luster and make visits worthwhile.

Sample exhibitions: *Beaded Blessings*, *Dispersed*, *Linkages and Themes in the African Diaspora*, *Made in Africa*, *Qes Adamu Tesfaw*, *Tradional West African Textiles and the Art of Gee's Bend Quilts*, *Carrie Mae Weems*.

25 Argent Hotel, side courtyard

50 3rd St, 94103
415-974-6400
BART: Montgomery
Located between Market and Mission Sts. Direct access to the courtyard can be made from 3rd St on the left side of the hotel.

This pleasant little garden courtyard,

Daniel Libeskind, Contemporary Jewish Museum

which provides outdoor seating for the Jester Restaurant, includes a grassy area with sculptures by **DAVID NASH**—the esteemed British artist whose charred wood, multipartite work makes reference to life-cycle issues and the nature-culture dialogue—and **CHARLES GINNEVER**—an artist with Bay Area roots whose steel objects typify a type of mid-20th-century geometric abstraction.

Clustered on the ground, the nine slabs of wood comprising Nash's *Stream of Vessels* (1992) have an eery presence. Their long, narrow, and blackened forms with slit cavities resemble primitive canoes, the residues of a previous era or vanished civilization. The imagery evokes the rawness of nature even as it calls to mind thoughts about life and death, destruction and re-creation. In contrast, Ginnever's *Funambulists* (1989) has an upbeat expression. Planar elements, shaped into parallelogram and hexagram forms, give the illusion of depth and the sensation of buoyancy.

26 Contemporary Jewish Museum

architect: **DANIEL LIBESKIND**, 2008
222 Jessie St, 94103
www.jmsf.org
BART: Montgomery, Powell
Located at the rear of Jessie Sq across from Yerba Buena Gardens.

Since launching plans in 1996 to make its new home in a rehabilitated, expanded power substation built in 1907 by the distinguished architect Willis Polk, the Contemporary Jewish Museum has been plagued by administrative, financial, and conceptual problems. A striking design by Daniel Libeskind—famed for his Jewish Museum in Berlin and his winning submission for the World Trade Center reconstruction in New York—had to be reduced and modified, but the building finally entered the construction phase in July of 2006 and is scheduled to open its doors in 2008.

Libeskind's proposal calls for preserving the brick facade, towering skylights, historic crane, and catwalk of the landmark Polk

structure. An explosive, sharply angled, multilevel addition, clad in vibrant blue stainless-steel panels, will expand the museum's space and give it a signature image. The dramatic form of the addition has its source in the Hebrew letters of the word *l'chaim*, which means "to life." A soaring lobby energizes the interior, leading visitors to galleries, a theater, media lab, bookstore, and café.

By creating a dialogue between past and present, the design addresses the museum's mission of providing a contemporary perspective on Jewish art, history, ideas, and culture.

27 Museum of Craft and Folk Art

51 Yerba Buena Lane, 94103
415-227-4888 f: 227-4351
www.mocfa.org
Tues–Fri, 11–6; Sat–Sun, 11–5
admission: $5/4; free first Tues
BART: Montgomery, Powell
Located in the middle of the pedestrian passage on the west side of Jessie Sq.

After almost two decades at the Fort Mason Center, MOCFA relocated in 2005 to this extremely compact, but better situated space. The museum's approach is fairly traditional, emphasizing technique, functional forms, and conventional craft objects (baskets, vases, ceramics, quilts, jewelry, clothing, furniture). Nevertheless, you will find exhibitions and objects that break with existing boundaries and explore intriguing new directions. Sample exhibitions: *Art of Gaman, Folk Art for the Soul, Four Generations of African-American Quiltmakers, Tobi Kahn, Menagerie—Artists Look at Animals, Mithila Painting, Scandinavian Modernists and Their Influence on Contemporary California Design*.

Should you be on a shopping spree, you might enjoy perusing the museum store, which occupies extensive footage in the reception area. It showcases a large selection of contemporary and traditional works by international and California artists.

28 Four Seasons Hotel

757 Market St, 94103
415-633-3000 f: 633-3001
www.fourseasons.com
BART: Montgomery, Powell
Located between 3rd and 4th Sts.

This ultraluxury hotel doesn't just rely on its proximity to San Francisco museums and galleries to raise its profile. It has its

Sensuous Curve exhibition, Museum of Craft & Folk Art

own public art program with more than 90 paintings, sculptures, and works on paper by California artists showcased in its ground-floor and lobby spaces, restaurant, bar, and meeting rooms. The art is largely abstract or figurative, tasteful with nothing offensive or radical in its imagery or style. Since elegance oozes from the setting and furnishings, the art assumes a decorator aura, all the more so because ostentatious (and inappropriate) gold frames have been added to nearly all the wall objects.

Although there are no identifying labels, you can get a brochure with names and locations from the concierge or at the front desk. Among the artists represented are Lita Albuquerque, Anne Appleby, Robin Carnes, Guy Dill, Max Gimblett, Diane Andrews Hall, Wade Hoefer, David Ireland, Marc Katano, John Lewis, Nathan Oliveira, Deborah Oropallo, Raymond Saunders, Katherine Sherwood, David Simpson, Stephen Singer, Jennifer Starkweather, Kathryn Van Dyke, Darren Waterston, and Rex Yuasa.

Mildred Howard. *Antique Keys*, 2000

30 Modernism Inc.

685 Market St, 2nd flr, 94105
415-541-0461 f: 541-0425
www.modernisminc.com
danielle@modernisminc.com
Tues–Sat, 10–5:30
BART: Montgomery
Located in the grand Monadnock Building just off the corner of 3rd St across from the intersection with Geary St.

29 Mildred Howard

Antique Keys, 2000
Stevenson St
BART: Montgomery
Located in the alley-like section of Stevenson St off 3rd St.

Using two different templates as images, Mildred Howard has created a series of large-scale bronze keys and set them as upright posts along the sidewalk bordering the Stevenson Street entrance to the Four Seasons Hotel. As is her custom, this veteran Bay Area artist makes a common object resonate by developing its contextual association within a given setting. Here, the keys denote the hotel, even as they offer a bygone signifier that has progressively been replaced by electronic room cards.

Gottfried Helnwein, Untitled, 2005; Modernism Gallery

With flair and conviction, Modernism specializes in an unusual mix featuring historical Russian avant-garde art from 1910–30, French *affichiste* (torn poster) compositions from the mid-20th century, contemporary realist and abstract painting, comic-strip depictions, and conceptual performance art. The range is formidable, with exhibitions shifting from the racy pop images of Mel Ramos to the Hopperesque paintings of John Register, to the lacerated and layered collages of Jacques Villeglé, to the nightmarish and innocent portraits of Gottfried Helnwein, to the scientific projects of Jonathon Keats.

Although most of the gallery artists lie outside current cutting-edge developments and may not be household names, many enjoy cult followings based on the particularized, personal, and often provocative nature of their creativity. Modernism therefore offers a chance to broaden your awareness. Access to 20th-century European artists little known in the U.S. is itself worth a visit.

Artists: Charles Arnoldi, Edith Baumann, Glen Baxter, Jean-Charles Blais, Edward Blumenfeld, Alexander K. Bogomazov, Margaret Caldwell, Hugo Cloud, R. Crumb, John De Andrea, Sheldon Greenberg, Duncan Hannah, James Hayward, Gus Heinze, Gottfried Helnwein, Tony Hernandez, Bill Kane, Jerry Kearns, Jonathon Keats, George Koskas, Naomie Kremer, Le Corbusier, David Levinthal, Peter Lodato, John M. Miller, Patti Oleon, Valentin Popov, Mel Ramos, John Register, Curtis Ripley, Arsen Roje, Cesar Santander, Erik Saxon, David Simpson, Robert Stivers, Mark Stock, Sam Tchakalian, Konstantin Titov, David Trowbridge, Jacques Villeglé, Robert Yarber.

The gallery also runs **MODERNISM WEST**, a project space in the back of Foreign Cinema—one of the city's illustrious restaurants (see p. 121).

31 Stephen De Staebler

Angel, 1989
720 Market St, 94102
BART: Powell
Located just west of 3rd St.

Set high atop a tall bronze column in front of the slightly recessed, black marble facade of the entrance to a nondescript high-rise, this sculpture disappears into its surroundings. The placement of an angel image in a busy commercial and office neighborhood is also puzzling, although the figure is depicted with a corroded, gnawed surface that arouses symbolic meaning about the human condition. Such metaphoric readings are common in the work of De Staebler, a Berkeley-based artist who gained prominence during the 1970s for his ceramic sculptures often configured as towering columns of stacked, seemingly petrified chunks imbedded with anatomical fragments.

32 Gallery Paule Anglim

14 Geary St, 94108
415-433-2710 f: 433-1501
www.gallerypauleanglim.com
anglim@gallerypauleanglim.com.
Tues–Fri, 10–5:30; Sat, 10–5
BART: Montgomery
Located just off the corner of Market St, on the second floor of a two-story, brick-faced

Barry McGee, Untitled #17, 2002; Gallery Paule Anglim

modern building oddly squeezed between massive downtown structures. The entrance, an unobtrusive glass door opening onto a steep staircase, is easily missed.

Unexpectedly, the honky facade and bland entryway yields to a delightful, skylit space that adapts well to displaying all sorts of contemporary art. Comprised of a comfortably scaled main room and a small back room, the gallery is organized for the simultaneous presentation of a major and a small show.

This is a good place to see Bay Area art, since Anglim represents many key names from the mid- and late-20th-century generations as well as hot young and emerging artists from the local scene. If you are not familiar with the narrative-collage paintings of Jess, the archeological-like creations of David Ireland, the street-mural figurations of Barry McGee, or the dynamic space compositions of Shirley Shor, do not miss the opportunity to see their work here. The exhibition program also includes a smattering of shows by such star-studded national names as Louise Bourgeois and Tony Oursler.

Sample exhibitions: *Anne Appleby, Robert Bechtle, John Beech, Leo Bersamina, Nayland Blake, Deborah Butterfield, James Castle, Ann Chamberlain, James Drake, Ala Ebtekar, Keith Hale, David Hannah, David Ireland, Judith Linhares, Andrew Masullo, Tomas Nakada, Gay Outlaw, Richard Overstreet, Robert Pimple, Brett Reichman, Rigo, Clare Rojas, John Roloff, Shirley Shor, Jesse Simon, Dean Smith, John Zurier.*

49 Geary Street

Located just off Market Street, this building has become a gallery emporium for San Francisco. Its long, narrow corridors extending back from the lobby areas facing the elevators open onto large and small exhibition spaces. Both prime, established galleries and upstart newcomers share this address.

33 871 Fine Arts

49 Geary St, 2nd flr, 94108
415-543-5155 f: 398-9388
f871@earthlink.net
Tues–Sat, 10:30–5:30
BART: Montgomery

871 is both a gallery and a bookstore. The elongated front room serves as the main exhibition space, and a room packed with bookshelves lies behind. The latter may look like a private library, but do not hesitate to wander around, peruse the shelves, and ask questions. As one of the few places in the city specializing in art books, especially out-of-print or international publications and museum catalogues, this is a veritable treasure trove for bibliophiles or plain folk wanting good resources on individual artists or art movements.

Although the gallery's exhibition program doesn't deal with cutting-edge contemporary art per se, it offers a valuable, often offbeat perspective on issues and approaches that still hold sway. The focus is on the 1950s, 1960s, and 1970s (Fluxus, Pop Art, Abstract Expressionism, Bay Area Figurative School)—not the big objects, but such things as artists' books, ephemera, unusual collectibles, small works, and drawings. These intriguing items inevitably enhance appreciation and understanding of art world events

Wallace Berman, Untitled (posthumous fragment # 16), 1976; 871 Fine Art

and activities even as they reveal undercurrents about artistic concern and production. In addition, exhibitions often call attention to crosscurrents between art and literature.

Sample exhibitions: *Assemblage and Collage in California in the 1960s, Wallace Berman, Between Poetry and Painting II, Peter Downsbrough, June Felter and Susan Felter, Lynn Glaser, Geoff Hendricks, Lee Lozano, Emily McVarish, Performance Photographs from the 1970s.*

33 Catharine Clark Gallery

49 Geary St, 2nd flr, 94108
415-399-1439 f: 399-0675
www.cclarkgallery.com
morphos@cclarkgallery.com
Tues–Fri, 10:30–5:30; Sat, 11–5:30
BART: Montgomery
See pp. 41–42; new address as of May 2007.

33 Stephen Wirtz Gallery

49 Geary St, 3rd flr, 94108
415-433-6879 f: 433-1608
www.wirtzgallery.com
swg@wirtzgallery.com
Tues–Fri, 9:30–5:30; Sat, 10:30–5:30
BART: Montgomery

You probably won't see radical movers and shakers at the Stephen Wirtz Gallery, but you will find solid work endowed with technical expertise, creative craftsmanship, and a refined aesthetic. A formalist orientation, rooted in emphatic compositional rigor with a strong focus on material expression and mild conceptual underpinings, tends to predominate. Of note are the evocative paintings of Deborah Oropallo, with their carefully balanced repetitions of images, words, color zones, linear demarcations, and other surface elements, and the symbolically charged photographs of Larry Sultan that merge domestic settings in suburbia with nudes referencing pornographic films.

With its spacious rooms, the gallery can readily accommodate large-scale work and diverse modes. Usually an exhibit of photography or drawing occupies the side room off the entrance, while work by a different artist is installed in the large main space. Since many Bay Area artists shown at Wirtz are local favorites, this is another gallery to check out if you want to grasp the character of the San Francisco art scene.

Artists: Dave Anderson, Rick Arnitz, Lewis Baltz, Masahisa Fukase, Jim Goldberg, Todd Hido, Marc Katano, Michael Kenna, Deborah Oropallo, Ulrike Palmbach, Arnaldo Pomodoro, Lucy Puls, Laurie Reid, Raymond Saunders, Kathryn Spence, Doug & Mike Starn, Joseph Sterling, Larry Sultan, Katherine Van Dyke, Catherine Wagner, Masao Yamamoto, Jack Zajac, Heidi Zumbrun.

Deborah Oropallo, *Windows*, 2005; Stephen Wirtz Gallery

Richard Avedon, *Andy Warhol and Members of The Factory,* 1969; Fraenkel Gallery

33 Fraenkel Gallery

49 Geary St, 4th flr, 94108
415-981-2661 f: 981-4014
www.fraenkelgallery.com
mail@fraenkelgallery.com
Tues–Fri, 10:30–5:30; Sat, 11–5
BART: Montgomery

Founded in 1979 with early exhibitions of Carleton Watkins, Lee Friedlander, and NASA's lunar photographs, Fraenkel Gallery focused on photography long before it became fashionable and has become one of San Francisco's premier art sites. The continuous stream of high-caliber shows and publications together with the expertise of its directors have established the gallery's international renown and esteemed reputation. Museum-quality work is the norm, with vintage prints by historical figures alternating with groundbreaking contemporary productions that expand the boundaries of the medium. Exemplifying the latter are exhibitions such as *Warhol and Members of the Factory,* featuring giant-sized, multipanel portraits by Richard Avedon, and Adam Fuss's masterful photograms.

On occasion, the gallery develops projects that juxtapose photographs with paintings, sculptures, and drawings that stretch consideration of each medium. Such occurred in the spectacular *Not Exactly Photographs* (2003), with its riveting selection of objects by 31 artists, including Hans Bellmer, Joseph Cornell, Jay De Feo, Jasper Johns, Ellsworth Kelly, and Ad Reinhardt; and in the presentation (2000) that evocatively paired Rodney Graham's *Welsh Oaks* with Sol LeWitt's wall paintings. (If you peak into the office adjacent to the back gallery, you can see LeWitt's monumental composition depicting a multitoned cubic rectangle splayed on a turquoise ground.)

The aura of a classy enterprise is evident from the moment you walk into the gallery, with its attractive reception area on the right, catalogue display wall on the left, and polished wood floors. Though modest in size, the three exhibition rooms, designed by notable San Francisco architect **G. DAVID ROBINSON**, are well suited to viewing and displaying photography. Be sure to explore all the rooms, which angle off one another, so you are sure to see the full span of the featured show as well as selections from the gallery's inventory, located in the back space.

Artists: Robert Adams, Diane Arbus, Eugene Atget, Richard Avedon, Bernd and Hilla Becher, E. J. Bellocq, Harry Callahan, Susan Derges, Walker Evans, Robert Frank, Lee Friedlander, Adam Fuss, Nan Goldin, Katy Grannan, John Gutmann, Peter Hujar, Idris Khan, Helen Levitt, Sol LeWitt, Ralph Eugene Meatyard, Richard Misrach, Eadweard Muybridge, Nicholas Nixon, Paul Outerbridge, Irving Penn, August Sander, Hiroshi Sugimoto, Carleton E. Watkins, Edward Weston, Garry Winogrand.

33 Jack Fischer Gallery

49 Geary St, 4th flr, 94108
415-956-1178
www.jackfischergallery.com
info@jackfischergallery.com
Tues–Sat, 10:30–5:30
BART: Montgomery

Despite its tiny space, the Jack Fischer Gallery has established itself as a notable, unique presence since opening in May 2005. The gallery bills itself as specializing in "self-taught outsider contemporary visionary intuitive naive" art. Fischer has a sensitive eye

Andrew A. Reilly, Untitled (San Jose, Ca), 2005; Jack Fischer Gallery

for informal sensibilities and styles, showing the best of what these modes have to offer. Often blocky and fragmentary, saturated with primary colors and compositionally obsessed with the center of the image space, the resoundingly ritualistic quality of the works can be deeply seductive and moving. There is some sculpture and photography displayed, but the focus is mainly on painting and works on paper.

Artists: Deborah Barrett, Rob Chin, Bill Dane, Gus Fink, Sylvia Fragoso, Sam Gant, Willie Harris, Galvin Harrison, Alexandra Huber, John Hundt, Monica Johnson, L-15, Marjorie Lutter, David Martin, Karl Mullen, Marlon Mullen, Bernardo Roman Palau, Jonathan Parker, Gina Pearlin, Philadelphia Wireman, Ian Pyper, Kevin Randolph, Andrew Reilly, Douglas Sheran, Donald Walker, Billy White.

33 Patricia Sweetow Gallery

49 Geary St, 4th flr, 94108
415-788-5126 f: 788-5207
www.patriciasweetowgallery.com
Tues–Fri, 11–5:30; Sat, 11–5
BART: Montgomery

See pp. 43–44; new address as of March 2007

33 Toomey-Tourell Fine Art

49 Geary St, 4th flr, 94108
415-989-6444 f: 989-6644
www.toomey-tourell.com
admin@toomey-tourell.com
Tues–Fri, 11–5:30; Sat, 11–5
BART: Montgomery

A romantic, conservative strain of abstract, landscape, and figurative art is the dominant direction at Toomey-Tourell. A retro or derivative character prevails in most of the art, though occasional exhibitions give evidence of an edginess that transcends a decorative aesthetic. Of note are paintings by Heather

Wilcoxon, where childlike, cartoon imagery combines with anxiety-ridden expression.

Recent exhibitions have featured work by Clythie Alexander, Philip Willem Badenhorst, Claire Burbridge, Jerrold Burchman, Matthew Byloos, Xavier Damon, Monroe Hodder, Marilyn Levin, Jeffrey Long, Maria Park, Mark Perlman, Matthew Picton, Silvia Poloto, Nathaniel Price, Roland Reiss, Gregg Renfrow, Brian Rutenberg, Joan Tucker, Ray Turner, Stephanie Weber, Audrey Welch, Joni West, Heather Wilcoxon.

33 Scott Nichols Gallery

49 Geary St, 4th flr, 94108
415-788-4641 f: 555-1212
www.scottnicholsgallery.com
scott@scottnicholsgallery.com
Tues–Sat, 11–5
BART: Montgomery

This is another of the San Francisco galleries specializing in photography. Its concentration is on classic California artists (Adams, Bernhard, Cunningham, Weston)—pioneers from the early 20th century who created prints with fine clarity and striking imagery. In addition, the gallery exhibits vintage photographs by other historical figures and new work by emerging, mainly local artists. Of note are the stark culture-based depictions of Reid Yalom.

Artists whose work is available here include: Berenice Abbott, Ansel Adams, Kiichi Asano, Ruth Bernhard, Wynn Bullock, Henri Cartier-Bresson, Paul Caponigro, Imogen Cunningham, William Garnett, Johan Hagemeyer, Rolfe Horn, Andre Kertesz, Mona Kuhn, Dorothea Lange, Irving Penn, Michael Rauner, Pentti Sammallahti, George Tice, Brett Weston, Edward Weston.

Alan Rath, *Scopophiliac,* 2001; Haines Gallery

33 Haines Gallery

49 Geary St, 5th flr, 94108
415-397-8114 f: 397-8115
www.hainesgallery.com
info@hainesgallery.com
Tues–Fri, 10:30–5:30; Sat, 10:30–5
BART: Montgomery

Large, airy, suffused with natural light from above, this L-shaped space is a dazzling setting for the display of contemporary art. The gallery's roster features a fair number of sculptors and artists dealing with themes associated with nature. Land art, installation, and new-media work are strong components of the program. Highlights have included trailblazing objects by such renowned names as Andy Goldsworthy, David Nash, and Dennis Oppenheim. Photography, another concentration of the gallery, showcases both traditional and experimental manifestations of the medium as exemplified in works by Linda Connor, Binh Danh, David Maisel, Kokihiro Saito, and Joel Sternfeld.

Typically, an exhibit in the front space is complemented by a second show in the back area and a presentation of work by a young artist in a rear project space. A side office contains a prime installation work by Goldsworthy—a mud wall constructed of moist

Edward Burtynsky, *Rock of Ages #1, Active Section, E. L. Smith Quarry, Barre, Vermont,* 1991; Robert Koch Gallery

from the 1920s and 1930s, vintage prints from the launch years of the medium, and modernists from Eastern Europe are pockets of particular focus. More than showing big names, the gallery actively explores untrodden realms, discovering new artists and less-researched frontiers of the still emerging scope of photography.

Increasingly, the contemporary era has become a central part of the program. Work from this realm is not so much audacious experiments or cutting-edge conceptual projects, but rather highly sophisticated, technically and visually riveting prints. Among these are the metaphysical panoramic landscapes of David Parker, and the gnawingly disconcerting shipwrecks, industrial wastelands, and provocative depictions of Bangladesh and China by Edward Burtynsky. Brian Ulrich's large-scale images capturing the excesses and peculiarities of American consumer culture give evidence of another trend in photography from the current era. In addition to the main space, a small room in back displays selections from the gallery roster.

clay mixed with human hair and concerned with issues of nature and time. To view this, ask the receptionist at the front desk.

Artists: Brad Brown, Max Cole, Linda Connor, Rob Craigie, Binh Danh, Amy Ellingson, Kota Ezawa, Max Gimblett, Andy Goldsworthy, Mike Henderson, David Klamen, Patsy Krebs, David Maisel, David Nash, Dennis Oppenheim, Nigel Poor, Alan Rath, Yoshitomo Saito, Tokihiro Sato, David Simpson, Joel Sternfeld, Stephaine Syjuco, James Turrell, Darren Waterston.

33 Robert Koch Gallery

49 Geary St, 5th flr, 94108
415-421-0122 f: 421-6306
www.kochgallery.com
info@kochgallery.com
Tues–Sat, 10:30–5:30
BART: Montgomery

Established in 1979, the Robert Koch Gallery specializes in photography, covering the full span of its history from the 19th century to the present. Experimental work

Contemporary artists: Dick Arentz, Nathan Baker, Tom Baril, Debra Bloomfield, Ken Botto, Jeff Brouws, Edward Burtynsky, Debbie Fleming Caffery, Elliott Erwitt, Sally Gall, Lynn Geesaman, Lauren Greenfield, Lynn Hershman, Simen Johan, Josef Koudelka, Wayne Levin, Sally Mann, Duane Michals, Mario Cravo Neto, Bill Owens, David Parker, Nicholas Prior, Holly Roberts, Jan Saudek, Larry Schwarm, Mike Smith, Jock Sturges, Brian Ulrich, Jo Whaley, Michael Wolf.

Among the 19th- and 20th-century artists:

Ansel Adams, Eugene Atget, Bill Brandt, Henri Cartier-Bresson, Lewis Carroll, Imogen Cunningham, Edward Curtis, Frantisek Dritikol, Philippe Halsman, Yousuf Karsh, Eadweard Muybridge, Alexander Rodchenko, Josef Sudek, William Fox Talbot, Carleton Watkins, Clarence White.

33 Gregory Lind Gallery

49 Geary St, 5th flr, 94108
415-296-9661 f: 296-9662
www.gregorylindgallery.com
info@gregorylindgallery.com
Tues–Sat, 10:30–5:30
BART: Montgomery

Opened in 2002, Gregory Lind Gallery shows an easily accessible strain of contemporary art that largely traffics in upbeat, witty imagery or well-crafted abstraction. Highlights include Sarah Bostwick's poetic drawings cast and carved with nearly invisible images referencing architecture, Aaron Parazette's abstract paintings dynamically structured out of letters and words, and Amy Rathbone's delicate wall murals riven with congregate populations of tiny marks and repetitive images. Even given the gallery's small space, its exhibitions are engaging, revealing independent modes of creative exploration.

Artists: Sarah Bostwick, Chris Corales, Marti Cormand, Randy Dixon, Chris Duncan, Sharon Engelstein, Jim Gaylord, Christ Gentile, Jonathan Hammer, Seth Koen, Bob Matthews, Christian Maychack, Mark Mulroney, Asuka Ohsawa, Aaron Parazette, Mal Prest, Amy Rathbone, Duane Slick, Jovi Schnell, Tucker Schwarz, Barbara Takenaga, Dannielle Tegeder, Donald Traver, Sarah Walker, Will Yackulic, Frank Yamrus, Sofi Zezmer.

Aaron Parazette, *Grind*, 2006; Gregory Lind Gallery

33 Brian Gross Fine Art

49 Geary St, 5th flr, 94108
415-788-1050 f: 788-1059
www.briangrossfineart.com
gallery@briangrossfineart.com
Tues–Fri, 10:30–5:30, Sat, 11–5
BART: Montgomery

Founded in 1990, Brian Gross Fine Art specializes in abstract and reductive painting and multimedia creations, largely by California artists. Recognized talents who earned national reputations in the 1960s—Robert Arneson, Ed Moses—are shown here, and the orientation of others has a modernist aura even if it dates to the current period. The range includes atmospheric color field compositions with smooth or impasto brushwork, monochromes, grids, and patterned paintings.

Artists: Peter Alexander, Joe Amrhein, Robert Arneson, Jill Baroff, James Barsness, Karl Benjamin, Chad Buck, Marco Casentini, Roy De Forest, Lewis deSoto, Josh Dov, Donald Feasél, Linda Fleming, Teo González, Willy Heeks, Robert Jack, Dale Kistemaker, Gary Lang, Robin McDonnell, Ed Moses, Sono Osato, Richard Pousette-Dart, Meridel Rubenstein, Robert Sagerman, Phil Sims,

Vik Muniz, *Prometheo, after Titian*, 2006; Rena Bransten Gallery

since you will usually see edgy art grappling with provocative issues, compelling imagery, or atypical modes of expression. Exemplifying this are the enigmatic spatial plays in the photos of Uta Barth, the architectural images of Matthias Hoch with their eery starkness, and Vik Muniz's reconstructed images made from clouds, chocolate syrup, string, soil, and other rudimentary materials.

Artists: Yoshi Abe, Ann Agee, Ruth Asawa, John Bankston, Uta Barth, Rebeca Bollinger, Jim Christensen, Chris Finley, Viola Frey, Dennis Gallagher, Rupert Garcia, Doug Hall, Chris Hellman, Matthias Hoch, Candida Höfer, Eirik Johnson, Hung Liu, Chip Lord, Reagan Louie, Ari Marcopoulos, Peter Mitchell-Dayton, Martin Mull, Vik Muniz, Joseph Park, Ron Nagle, Paul Henry Ramirez, Jennie Smith, Jessica Snow, Henry Turmon, John Waters, Henry Wessel, Fred Wilson, Nicholas Woods, Sandra Wong.

Stephen Sollins, Nellie King Solomon, Amy Trachtenberg, Andrea Way, Patrick Wilson.

31 Rena Bransten Gallery

77 Geary St, 2nd flr, 94108
415-982-3292 f: 982-1807
www.renabranstengallery.com
info@renabranstengallery.com
Tues–Fri, 10:30–5:30; Sat, 11–5
BART: Montgomery
Located in the office building on the corner of Grant Av.

Although a long-standing San Francisco gallery, Rena Bransten has broadened and shifted its base from an early focus on local artists, many associated with funk art and ceramics, to a concentration on international artists and vanguard currents. Usually the gallery presents two exhibitions simultaneously in its spacious three-room layout. Group shows, which include artists not represented by the gallery, are also a significant part of the program. Even if you are not familiar with the names, a visit here is well worth the time,

34 Heather Marx Gallery

77 Geary, 2nd flr, 94108
415-627-9111 f: 627-9110
www.heathermarxgallery.com
hmg@heathermarxgallery.com
Tues–Fri, 10:30–5:30; Sat, 11–5
BART: Montgomery

Since opening in late 2001, Heather Marx has presented exhibitions of a young generation of artists mainly focused on abstraction or figurative work with a fantasy, indecorous, or retro character. The carnivalesque sculptures of David Hevel, the sci-fi landscapes of William Swanson, Libby Black's droll commentaries on high fashion, and James Gobel's dandyish portraits exemplify these modes.

Artists: Michael Arcega, Tim Bavington, Sharon Ben-Tal, Libby Black, Brigette Burns, Davis & Davis, Dana Dekalb, Jennifer Faist, Stephen Giannetti, Matt Gil, James Gobel, David Hevel, David Lyle, Lisea Lyons, Paul Mullins, Timothy Nolan, Paul Paiement, William Swanson, Gary Szymanski, Taravat

Talepasand, Sharon Weiner, Forrest Williams.

35 John Berggruen Gallery

228 Grant Av, 2nd–4th flrs, 94108
415-781-4629 f: 781-0126
www.berggruen.com
info@berggruen.com
Mon–Fri, 9:30–5:30; Sat, 10:30–5
BART: Montgomery
Located between Post and Sutter Sts.

Founded in 1970 and expanding ever since, this gallery is San Francisco's honcho, blue-chip establishment. It occupies three levels, with special exhibitions on the second and third levels and a selection of work by gallery artists on the fourth. Polished wood floors, white walls, natural light, and human proportions create a comfortable, spacious, upscale setting for viewing art.

Berggruen's roster includes a span of renowned local and national names from the mid-to-late-20th century with some classic modernists and a spectrum of contemporary figures adding spice to the mix. Among the highlights are exhibitions of museum-quality paintings by superstars like Willem de Kooning, Richard Diebenkorn, and Agnes Martin. Many shows are accompanied by illustrated catalogues.

Although there is a contemporary aspect to the gallery program, you won't find any of the raucous images, detritus-laden installations, or in-your-face erotica that has been the focus of art-world attention during recent years. Instead, the current era is represented by

James Gobel, *All We Have to Do Is Take These Lies and Make Them True (Double Portrait–Drew)*, 2006; Heather Marx Gallery

paintings, sculptures, drawings, and prints that are more subdued, often tempered by a formalist or process orientation.

Artists: Mark Adams, Donald Baechler, Stephen Balkenhol, David Bates, Robert Bechtle, Fletcher Benton, Tony Berlant, Elmer Bischoff, Christopher Brown, Alexander Calder, Squeak Carnwath, Enrique Martinez

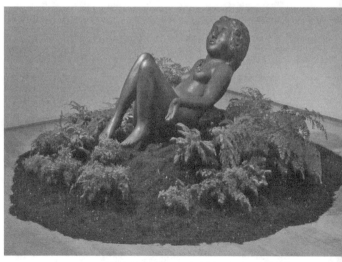

Kiki Smith, *Reclining Nude*, 2005; John Berggruen Gallery

Celaya, Bruce Cohen, Gregory Crewdson, Williams de Kooning, Mark di Suvero, Richard Diebenkorn, Jim Dine, Patrick Faulhaber, Barry Flanagan, Caio Fonseca, Helen Frankenthaler, Lucien Freud, Timothy Greenfield-Sanders, Isca Greenfield-Sanders, Michael Gregory, Diane Andrews Hall, Jane Hammond, Stephen Hannock, Tom Holland, Ellsworth Kelly, Robert Kelly, Clare Kirkconnell, Roy Lichtenstein, Robert Mangold, Brice Marden, Agnes Martin, Henri Matisse, Tom McKinley, Ricahrd McLean, Robert Motherwell, Claes Oldenburg, Nathan Oliveira, Tom Otterness, David Park, Maria Porges, Juan Carlos Quintana, Robert Rauschenberg, Linda Ridgway, Ed Ruscha, Juliao Sarmento, Sean Scully, Joel Shapiro, Judith Shea, Kiki Smith, Frank Stella, Wayne Thiebaud, Andy Warhol, William T. Wiley, Donald Roller Wilson, Paul Wonner.

36 Crocker Galleria

architect: **SKIDMORE, OWINGS & MERRILL**, 1983
50 Post St, 94104
415-393-1505
Mon–Fri, 10–6; Sat, 10–5
BART: Montgomery
Located at the corner of Montgomery St with entrances from Post and Sutter Sts.

This elegant shopping center recalls the Italian arcades with their long, open passageways and barrel-vaulted glass roofs. The idea here was to establish a link between the commercial zone around Union Square and the financial district on Montgomery Street, considered the "Wall Street of the West." The passage also connects the base of the historic bank building at 1 Montgomery with a new office tower fronting Kearny Street.

Comprising two levels of upscale boutiques, and a top level of eateries with tables and chairs scattered about the balconies, Galleria draws in both downtown office workers and shoppers. Plant and floral arrangements, seasonal displays, midday concerts, and other attractions in the ground-floor plaza

enhance the setting encouraging people not just to visit but to use it as a leisure destination. Should you really want to escape the hubbub of downtown activity, take the stairs from the upper level (or the elevator from the vestibule of 1 Montgomery) to the roof garden, where benches and tranquility offer a nice respite.

37 Hallidie Building

architect: **WILLIS POLK,** 1917
130 Sutter St, 94104
BART: Montgomery
Located between Kearny and Montgomery Sts.

The Hallidie Building holds an important place within the history of modern architecture as one of the first buildings to use a steel frame as the support mechanism for a transparent facade. As is evident from the subsequent proliferation of skyscrapers with glass curtain walls, these design and structural developments spurred a revolution, radically changing the appearance of the urban landscape.

Unlike later versions of the curtain wall, where the glass is an uninterrupted, austere plane, here thin mullions create a grid pattern across the surface, while tracery cornices of sheet metal (aged to look like wrought iron) and the corner projecting balconies of the fire escapes add a decorative character to the eight-story office block.

37 AIA SF—Center for Architecture & Design Gallery

130 Sutter St, 6th flr, 94104
415-362-7397 f: 362-4802
www.aiasf.org
info@aiasf.org
Mon–Fri, 9–5
BART: Montgomery
Located between Kearny and Montgomery Sts.
Having renovated its space and reoriented

its mission, the San Francisco chapter of the American Institute of Architects inaugurated a new gallery in September 2006. Still responsive to its professional membership, the gallery and related programs now aim to broaden the audience with particular outreach to the general public. Exhibitions feature photographs, drawings, plans, models, videos, design objects, books, and building materials related to architectural and environmental topics. The subjects vary widely and presentations include engaging text panels with documentary and explanatory information. The focus is on local and international, historical and contemporary work. Edgy creations are included in such shows as *The Other Pleasure*, which explored the relationship between pleasure and design from an interdisciplinary perspective, featuring such talents as David Adjaye, Shigeru Ban, pd design, Predock Frane, and Slade. Sample exhibitions: *Altered Practice*, *Going Green*, *Historical San Francisco—Then & Now*, *Informing the Future of Bay Area Architecture*, *The Other Pleasure*.

In addition to its exhibitions, AIA SF also presents a rich selection of lectures, tours, film screenings, and special events. One of the best offerings in the Bay Area is the lecture series sponsored jointly with SFMOMA. Speakers have included internationally renowned figures, such as Elizabeth Diller and Ricardo Scofidio, Steve Erhlich, Norman Foster, Zaha Hadid, Jacques Herzog and Pierre de Meuron, Stephen Holl, Thom Mayne, Bernard Tschumi, Tod Williams and Billie Tsien, as well as less familiar but equally riveting talents. (These lectures are held in the SFMOMA auditorium; admission $15/10.) *Architecture and the City*, the festival of activities held annually in September, is also a highlight of the AIA SF program.

38 Hackett-Freedman Gallery

250 Sutter St, 4th flr, 94108
415-362-7152 f: 362-7182
www.hackettfreedmangallery.com
hfg@hackettfreedmangallery.com
Tues–Fri, 10:30–5:30; Sat, 11–5
BART: Montgomery
Located in a slickly renovated building between Grant Av and Kearny St.

The main focus of Hackett-Freedman is traditional genres (figurative, landscape, still life, narrative, abstraction) in early- and mid-20th-century American art. A tame form of New York Modernism, exemplified by such artists as Milton Avery, Robert de Niro, and Marsden Hartley, is featured along with work by some key San Franciscans—Frank Lobdell, Manuel Neri, and David Park. Although the contemporary era isn't emphasized, on occasion the gallery presents a group show including works by such blue-chip artists as Willem de Kooning, Richard Diebenkorn, Jess, Joan Mitchell, Robert Motherwell, and Wayne Thiebaud.

Artists: Milton Avery, Robert de Niro Sr., Guy Diehl, Jeanne Duval, Ann Gale, Marsden Hartley, F. Scott Hess, Tom Lieber, David Ligare, Frank Lobdell, Ann Lofquist, Carlo Maria Mariani, Manuel Neri, Roland Petersen, Paul Resika, Jeffrey Ripple, Judith Rothschild, Richard Ryan, Robert Schwartz, Raimonds Staprans, Skip Steinworth, Terry St. John, Marc Trujillo, Esteban Vicente, Brian Wall, Amy Weiskopf.

39 Hotel des Arts

447 Bush St, 94108
415-956-3232 f: 956-0399
www.sfhoteldesarts.com
reservations@sfhoteldesarts.com
BART: Powell
Located between Grant and Kearny Sts.

Transformed from a former Victorian boardinghouse, this boutique hotel has

commissioned emerging artists to customize the guestrooms and lobby. Designs for the "painted rooms" range from zany installations to graffiti-inspired creations to abstract decoration. One of the most notable, room 307 by Anthony Skirvin, has been described as "the Unibomber's workshop." In it, the desk area is filled with a mass of clutter and personal effects, the main wall is covered with a monumental photo of a cabin in the woods, and the bathroom is papered with maps.

If your not a hotel guest, you can visit the lobby and get a glimpse of what lies beyond. Alternatively, you can view depictions and descriptions of each room on the hotel's website. Indeed, you can use the website to determine which artist's decor you prefer when making a reservation.

40 Alessi

architect: **ALESSANDRO MENDINI**, 2002
424 Sutter St, 94108
415-434-0403 f: 434-0503
Mon–Sat, 10–6; Sun, 11–5
www.alessi.com
BART: Powell, Montgomery
Located just off the corner of Stockton St.

Mario Botta, *Tua Jug*, 2000; Alessi

Alessi occupies a narrow, modest storefront but it is chockablock full of the treasures that have made the company a pioneer in affordable (and expensive) high-style housewares, kitchen and dining implements, and accessories. In addition to commissioning top contemporary architects and designers—Ron Arad, Mario Botta, Frank Gehry, Michael Graves, Marc Newsom, Aldo Rosso, Philippe Starck, Ettore Sottsass—to produce utilitarian objects, the Milanese firm reproduces classic designs from the Bauhaus archive. Some are sleek stainless-steel forms and others are whimsical, brightly colored plastic creations. All are well crafted, exemplars of superb refinement or clever innovations embracing a transformation of both functional and aesthetic aspects.

Like its products, the store itself, the first American flagship for Alessi, is chic and classy. Silver and aqua cabinets line the sides, the walls are colored blue and yellow, and the floor is a polished expanse of pink terrazzo. Electronically generated murals and orange tiles add pizzazz to the setting.

41 San Francisco Museum of Craft and Design

550 Sutter St, 94102
415-773-0303 f: 773-0306
www.sfmcd.org
info@sfmcd.org
Tues–Wed, Fri–Sat, 10–5; Thurs, 10–7; Sun, 12–5
admission: $3/2; free first Thurs, 5–7
BART: Powell
Located between Powell and Mason Sts.

The iron gate and garden of the chic entry here is a hold-over from the Elizabeth Arden Salon, which occupied the site in the 1950s–60s, but the interior has been totally revamped to fit current needs. The museum opened in 2004 with the mission of interpreting the role of craft and design in contemporary society. Presentations concentrate on materials you would expect

to see (textiles, glass, jewelry, ceramics), though unconventional objects—toys, wine labels, auto parts, home appliances—spice up the program. The offerings tend to have a decidedly populace orientation, but occasional exhibitions of renowned masters, like *Raymond Loewy* (2006), occur.

Sample exhibitions: *New Visions in Wedding Tradition*, *Playing Around—Toys Designed by Artists*, *Joyce J. Scott*, *Studio Furniture of Tasmania & America*, *Textile Art in the 21st Century*, *Tools as Art*.

Be sure to check out the museum shop, which contains unique items, including an array of products made from recycled materials.

42 Union Square

architects: **MICHAEL FOTHERINGHAM, APRIL PHILIPS**, 2002
BART: Powell, Montgomery

True to its conservative core, San Francisco opted for a traditional design after holding an open competition for a sweeping reconstruction of its main downtown plaza, the hub of the city's high-end shopping district. To be sure, the reconstituted Union Square is far more inviting than previously, since now there are lots of benches and other accommodations for people and events. Sadly, the opportunity to construct a dazzling, innovative urban plaza was lost in favor of a more conventional setting.

The design centers on a vast open space paved in green and tan granite. It comprises: four entryways at the corners bordered by palm trees; a café and half-price theater ticket pavilion; a large stage for performances; a terraced slope with tiers of grass, plantings, pathways, and concrete ledges; and an underground parking garage. The Dewey monument (1903) commemorating the victory at the Bay of Manila in the Spanish-American War remains from the old plaza as the centerpiece.

42 R.M. Fischer

Union Square Colonnade, 2003
Union Sq
BART: Powell, Montgomery

For the streetlight sculptures he created for the middle of Union Square, R.M. Fischer hybridized a reference to San Francisco's Victorian architectural heritage with sci-fi stylizations—a signature feature of his art. The oddity of the combination, plus the line-up of four dissimilar but related light posts, calls attention to the installation. Three of the sculptures combine historical design elements in the green-painted metal, polished stainless-steel globes, and clear spheres. The fourth features a large (five feet in diameter) brushed stainless-steel sphere, divided into two sections and lit from within. Together, the four parts, mounted on red granite columns, rise high in the air forming a prominent, glitzy border on the south side of the central plaza.

43 V.C. Morris Gift Shop (now Xanadu Gallery)

architect: **FRANK LLOYD WRIGHT**, 1949
140 Maiden Ln, 94108
415-392-9999 f: 984-5856
www.xanadugallery.com
info@xanadugallery.com
Mon–Sat, 10–6
BART: Montgomery

Even today, more than a half-century after its construction, this amazing little building stands out as a venerable avant-garde design. It was a rare remodeling project for the famed American architect Frank Lloyd Wright, and he took the opportunity to challenge radically the conventional big front window and open floor plan of the formulaic store. Instead he produced an unbroken brick facade with an arched tunnel entry and a spectacular interior featuring a spiral ramp and a skylight shielded by a futuristic, bulbous-form plastic. The ramp, which connects the ground and

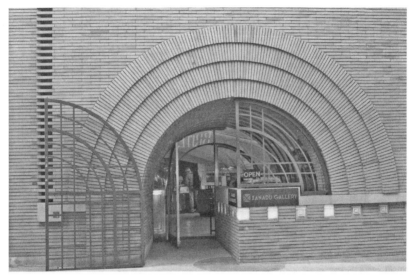

Frank Lloyd Wright, V.C. Morris Gift Shop

mezzanine levels, is a prototype of the design developed for the Guggenheim Museum in New York.

Beyond the captivating, visionary architecture, which utterly transforms a rectilinear shell into a sculptural, circular, ambulatory, luminous, flowing space, Wright also paid careful attention to refining details. The bricks, for example, are not just red blocks but terra-cotta-toned elongated bars. And though the brick from the facade continues on the left half of the entrance vault, the right half and door wall are glass, enabling a view inside and the influx of natural light. The tunnel entry, moreover, orchestrates a skillful interface between the flat exterior wall and the volumetric, curving interior space.

Originally commissioned for a boutique selling china, silver, and other exclusive home accessories, the store has functioned variously, with a succession of different occupants over its lifetime. The current owner restored the space to its original character in 1998, such that the curved wood cabinets, display tables, suspended acrylic planter, bottom-lit stands, ceiling panels, and yellow walls are now exactly as Wright intended.

44 Neiman Marcus

architect: **PHILIP JOHNSON**, 1982
150 Stockton St, 94108
Mon–Wed, Fri–Sat, 10–7; Thurs, 10–8; Sun, 12–6
BART: Montgomery, Powell
Located at Union Sq, on the corner of Geary St.

As part of a renovation and expansion project (2002), the cylindrical entrance of Philip Johnson's design was changed into a right-angled shape with a glass facade matching that of the new addition down Geary Street. The rest of the structure—a giant box clad in harlequin-patterned rose granite—was untouched, if not strengthened. It was the first of three buildings in San Francisco by the famed New York architect (see pp.129, 139 for the others). Unfortunately, none exemplify the innovative strength that established his reputation.

The severe, geometric minimalism of the exterior hardly prepares you for the decorative grandeur of the soaring, gilded atrium that greets you once you pass through the doors. Framed by enameled wrought-iron

balconies and topped by a stained-glass dome depicting a sailing ship and the motto "Fluctuat nec Merguitur" ("He floats but does not sink), this elliptical rotunda is a remnant and nostalgic reminder of the beloved 1909 City of Paris store that previously occupied the site. Incongruous as it is, the exuberant atrium sets the tone for the luxurious merchandise and high-style displays within Neiman Marcus's shopping emporium.

45 Emporio Armani

architect: **THANE ROBERTS**, 1992
1 Grant Av, 94108
415-677-9400 f: 398-0202
www.emporioarmani.com
Mon–Fri, 10–7; Sat, 10–6; Sun, 12–6
BART: Montgomery. Powell
Located at the corner of O'Farrell St across from the intersection with Market St.

Just as contemporary marketing has challenged the idea that an advertisement must overtly depict the product, Emporio Armani confounds the notion that a clothing store is simply a place to shop for clothes. Primary attention is instead focused on lifestyle and appearance—which, of course, embraces the look of a chicly clad person dressed in high-style, pseudo-casual Armani attire.

Lifestyle is emphatically signified by the store's centerpiece: an elegant, grandiose oval bar inviting social encounters, eating, drinking, and relaxation—in short, a fashionable environment for seeing and being seen. The bar itself is lush white marble and polished dark wood in an Art Deco style. In contrast, the overhead halogen lighting is pure industrial modern with its system of suspended steel beams and tension cables. Turning in the other

historical direction, the high coffered ceiling and imposing Corinthian columns reference a past architectural era and the original function of the building as a big city bank. This is also evident on the exterior, where the pitched roof, pediment, and mammoth Ionic columns call forth the image of a classical temple.

A café-restaurant set high across the back of the main room as an open balcony complements the bar, reasserting the aura of affluence, leisure, and chicness. To be sure, Armani clothes are also given primacy in the store, albeit placed off to the sides and on the lower level. Unlike the central zone, which is open and very public, the sales area is laid out as a sequence of intimate spaces lined with light-toned oak armoires of Shaker simplicity that double as room dividers and closet-like cases for displaying merchandise.

According to plan, Emporio Armani has become a popular, upscale destination for weary shoppers, business people, fashion mongers, happy-hour unwinders, and art collectors.

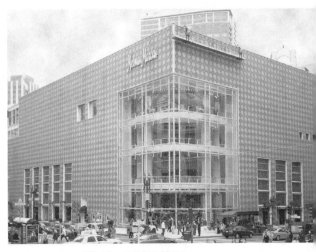

Philip Johnson, Neiman Marcus

Christopher Sproat, *Spine,* 1993

46 Christopher Sproat

Spine, 1993
Ellis-O'Farrell Parking Garage
123 O'Farrell St, 94102
BART: Montgomery
Located between Powell and Stockton Sts.

Creating functional public art that becomes an integral, enhancing part of busy, often mundane settings is a seminal aspect of projects by New York artist Christopher Sproat. Here his fluorescent and stainless-steel sculpture forms a linear spine from the entrance to the back of the parking garage. It also serves to illuminate a pedestrian walkway and staircase. Although the work may not advertise itself as "Art," it provides welcome enhancement to an otherwise bland environment.

47 Diva Hotel

architect: **T. OLLE LUNDBERG**, 1999
440 Geary St, 94102
415-885-0200 f: 346-6613
www.hoteldiva.com
BART: Powell
Located two blocks west of Union Sq between Mason and Taylor Sts.

Diva was among the first hotels to break away from the usual bland decor in favor of a boutique milieu with high style. In its first incarnation (1985), the hotel transformed the 1912 building into an ultra-chic, Art Deco palace. In 1999, a second redesign occurred, this time using an industrial aesthetic tempered by sensuality. You will see this immediately in the wavy glass wall on the entrance facade and in the small but sleek lobby with its striking reception desk made from a curving, black granite top and backlit, onyx-paneled base. Should you stay in one of the hotel rooms, you can expect thick cobalt-blue carpeting and accouterments like long, tubular bud vases of stainless-steel hanging on the walls, tall rolled-steel headboards, and lateral filing cabinets as dressers. Textured accents and artsy touches abound.

48 Clift Hotel

architect: **PHILIPPE STARCK**, 2002
495 Geary St, 94102
415-775-4700 f: 441-4621
www.clifthotel.com
clift@ianschragerhotels.com
BART: Powell
Located on the corner of Taylor St.

This may be a five-star luxury boutique hotel, but do not expect to see its name blazoned across the exterior. Indeed, there is no exterior signage identifying the Clift. As is instantly conveyed in the double-height arched entryway and the public areas within, however, understatement hardly characterizes the eccentrically charged design of the hotel's 2002 reincarnation.

Philippe Starck's over-the-top creativity is a fun-filled, eye-popping, mind-boggling experience that can be enjoyed even if you just stroll through the lobby, bar, and restaurant. Like other interiors Starck has created for hotelier Ian Schrager (initially famous for Studio 54, the hip New York nightclub that symbolized the excesses of the 1970s), this one has a theatrical lobby with zany furnishings and a surreal, fantasy ambience. Gone is the old-world elegance of the original Clift Hotel, built in 1913, and utterly abandoned is the idea that a classy interior be subdued and adhere to pragmatic or age-old conventions.

Rather than transform the space and structural character of the lobby, Starck has emphasized its high ceilings and cubic shape by cladding the walls in hand-painted pale gray plaster and covering the floor with limestone. These cool, severe surrounds are a perfect backdrop for the odd mix of disparately styled furnishings placed within. These include a bronze coffee table by **SALVADOR DALÍ**, which rests on a single, winding leg with a hand at one end and a tiny stiletto-clad foot at the other; an ostrich-skin-and-ox-horn couch by **MICHEL HAILLARD**; a sleek metal concierge desk by **JEAN NOUVEL**; a seven-foot-tall, Louis XV bronze chair upholstered in antique turquoise and gold French brocade by Starck; a witty black bowler chair with a green-apple cushion called *Magritta* by **SEBASTIAN MATTA**; a monumental bronze hearth with wave-like surfaces by **GÉRARD GAROUSTE**; *Darwish*, a bronze seating unit by **WILLIAM SAWAYA** comprising four chairs, each facing a different direction; *Egg*, a curvy armchair by **ARNE JACOBSEN**; a hand-carved dark mahogany, reception desk; and additional items, like the faux-fur blankets strewn across several couches.

Off to the right side of the lobby, a wood-paneled room serves as a more intimate alcove. Although checkers, chess, and mahjong boards are embedded in the tables

and old-fashioned club chairs are featured as seating, this is hardly a serious replication of the traditional hotel lounge. As suggested by the substitution of a grid arrangement of little square black-and-white photographs of plastic animals (by **JEAN-BAPTISTE MONDINO**) for the conventional wall display of genteel portraits, the setting is shaped by subversive humor.

From the lobby, you can walk back through a passageway to the famed Redwood Room—a cavernous, high-ceilinged bar created in 1933 and presumably paneled with wood from a single California tree. Though retaining the historic redwood and the original Art Deco fixtures, Starck has again radically altered the environment by punctuating the walls with faux Gustav Klimt paintings in light boxes. Moreover, the decor now features a long, narrow, underlit bar mirrored with Venetian-style cut glass, and a complementary back bar with a backlit lemon-toned vitrine for displaying liquor bottles. As in the lobby, eccentric furnishings abound. These include high-back, low-seat banquettes in red velvet; ostrich-skin stools; very long, narrow, and low steel-and-glass, underlit tables equipped with Starck's lustrous amphora stools. Although a monochromatic red color scheme permeates the whole, the wide range of materials, textures, and tones adds diversity even as it heightens the effect of sensuality. A high-end, Las Vegas-style aura of artificial glamour and excess prevails.

A similar spirit characterizes the design of Asia de Cuba, the restaurant located alongside the Redwood Room to the rear of the lobby. Here, too, red dominates, not from wood paneling but from walls draped in red velvet curtains. Spots of color-contrast occur in bright green Murano lamps shades, but the focal centerpiece is a large, X-shaped, illuminated communal table whose cut-glass, mirrored design repeats that of the bar.

UPPER SOMA–CIVIC CENTER

0 500 yards

1. Restaurant Lulu
2. Azie
3. Yerba Buena Lofts
4. Boyd Lighting
5. Hosfelt Gallery
6. Braunstein/Quay Gallery
7. Howard St. House
8. The Luggage Store
 Osgemeos, mural
9. M. Kilgallen, door painting
10. B. McGee, door painting
 Rigo, *Truth*
11. Federal Building
12. New Langton Arts
13. Arkitektura In-Situ
14. Rigo, *One Tree*
15. lofts, 1022 Natoma
 housing, 1028 Natoma
16. Linc Real Art
17. RNM
18. Friend
19. Propeller
20. lofts, 292 Ivy St
21. Citizen Cake
22. Bucheon Gallery
23. H. Moore, *Reclining Figure*
24. P. Voulkos, *Hiro II*
25. SF Arts Commission Gallery
26. L. deSoto, *Jury Assembly Room*
27. Warren–Johnson State Office
 Blgs.
28. Plaza, P. Burton Federal Blg.
29. Asian Art Museum
30. G. Rickey, *Double L*
31. Main Library

Upper SOMA–Civic Center

1 Restaurant Lulu

architect: **CASS CALDER SMITH**, 1993
816 Folsom St, 94107
415-495-5775 f: 495-7810
Sun–Thurs, 11:30–10:30; Fri–Sat, 11:30–11:30
BART: Powell
Located just off the corner of 4th St one block south of Yerba Buena Gardens.

San Francisco architect Cass Calder Smith dramatically transformed this 1910 warehouse into a convivial restaurant with a rustic flavor that rapidly emerged as one of the most popular havens within the SOMA district. A white stucco, slighted bowed exterior with freely placed windows of colored glass derives inspiration from Le Corbusier's Ronchamp, though the elliptical center and trapezoidal shape of the main dining room were based on Michelangelo's Piazza del Campidoglio in Rome. Architectural history notwithstanding, the cavernous interior, with its barrel-vaulted wooden roof, skylights, large brick oven, and colonnaded side areas, provides a plaza-like setting that balances a public arena with private zones.

Red tile floors, yellow walls, and an ultramarine bar add color details, and a commissioned painting by **RICHMOND BURTON** elevates the artistic quotient of the space without becoming background decoration. Indeed, the long, narrow shape of *Pieces of Om* (1996) accentuates the horizontal thrust of the overhang even as its swirling, curlicue rhythms in blue and white provide a lively, albeit meditative counterpoint.

Two event rooms situated on either side of the main area offer more intimate dining. The one on the right further elaborates the Mediterranean style of the restaurant by adorning its walls with an architectonic streetscape and the image of Le Corbusier's modular man.

2 Azie

architect: **CASS CALDER SMITH**, 1999
826 Folsom St, 94107
415-538-0918 f: 538-0916
Sun–Thurs, 5:30–10:30; Fri–Sat, 5:30–11:30
BART: Powell
Located next door to Restaurant Lulu.

Although designed by the same architect as Restaurant Lulu, Azie has a totally different mood and aesthetic. The bilevel design, intended to suggest a bustling Asian street, is spatially dramatic yet full of intimate, imaginative enclaves. A subdued, warm atmosphere prevails with crimson, mustard, and olive tones enriching the decor.

A central, red-columned pavilion anchors the double-height main area and is surrounded by a diversity of independent zones. Some are unenclosed with long, communal tables and others are delimited as private booths. The floor space is quite modest but a wall of mirrors makes the room appear larger and the multistoried arrangement cleverly increases the seating capacity without diminishing the openness. A central staircase bordered by steel bars further opens the

Richmond Burton, *Pieces of Om*, 1996; Restaurant Lulu

space by enabling vistas around the entire restaurant.

In addition to the restaurant, the property includes ten live/work lofts situated on the top level. The building's renovation is therefore part of SOMA's evolution into a chic residential neighborhood.

3 Yerba Buena Lofts

architect: **STANLEY SAITOWITZ**, 2001
855 Folsom St, 94107
BART: Powell
Located between 4th and 5th Sts.

As one of city's largest loft projects constructed since new zoning laws were passed in 1988, this 200-unit structure epitomizes the transformation of SOMA into a trendy residential area. And like much of the new housing, it merges contemporary industrial stylistics with references to San Francisco vernacular, especially the Victorian tradition of bay windows.

The building exemplifies the orientation of Stanley Saitowitz, an internationally acclaimed UC Berkeley professor and committed modernist whose ideas about no-frills,

Stanley Saitowitz, Yerba Buena Lofts

reductive design are strongly influenced by such masters as Le Corbusier and Louis Kahn. As is evident here, he favors an architecture of planar surfaces structured as repeating elements in a rhythmic composition of alternating patterns derived from plays of light and shadow, solid and void. Using cast-in-place concrete, steel, and translucent and clear glass, he has created a syncopated alignment of box-shaped glazed bays, inset balconies, and terrace extensions. Although the facade along Folsom is more regularized, the back, which opens onto Shipley Street, has a stepped structure in which the receding and projecting elements of the stacked units are more rigorously articulated.

4 Boyd Lighting

architect: **BRAYTON & HUGHES**, 1998
944 Folsom St, 94107
BART: Powell, Civic Center
Located between 5th and 6th Sts.

This boldly symmetrical facade, perforated by a grid of small blue-glass blocks and capped by a stepped roofline, is a breath of fresh air in a neighborhood of nondescript warehouses. A grouping of window panels stacked in the center over a pair of steel doors further defines the facade, even as it allows a view into the concrete factory shell reconstructed as a multilevel showroom and offices with an open cover of skylights.

As is fitting for a company whose business is lighting, the architectural design of this renovation is all about light.

5 Hosfelt Gallery

architect: **ANNE FOUGERON**, 1999
430 Clementina St, 94103
415-495-5454 f: 495-5455
www.hosfeltgallery.com
info@hosfeltgallery.com
Tues–Sat, 11–5:30
BART: Powell
Located just off the corner of 5th St.

Although this section of SOMA still shows the decayed, derelict character of the area as it was before the Yerba Buena revitalization, you immediately enter another world when you ascend the ramp leading up to the front doors of the Hosfelt and Braunstein/ Quay Galleries. The two galleries share the ground floor of a warehouse renovated in an award-winning minimalist design by San Francisco architect Anne Fougeron. Retaining the old concrete walls, she has created unadorned, raw spaces that are open and airy yet partitioned in accordance with functional needs. The vestibule, previously a loading dock, is especially impressive with its walls sheathed in sandblasted glass panels backlit by neon tubes—actually an artwork by **CORK MARCHESCHI**.

Brayton & Hughes, Boyd Lighting

The commanding space of the entryway recurs in the interior of Hosfelt Gallery. A vast, high-ceilinged central room is complemented by smaller rooms situated around the periphery and intended to accommodate video, installations, and works on paper. Indeed, the gallery showcases art in different media by emerging and mid-career artists from the local, national, and international scenes. Although their styles, subject matter, and approach is quite varied, the artists favored by Hosfelt tend to be very obsessive, creating work featuring intricate details, decorative patterns, repetitive phenomena, or mesmerizing techniques.

Typically two solo shows occur simultaneously, and occasionally there is a thematic group exhibit. If you are not familiar with the technologically inventive video creations of Jim Campbell or the dreamlike, dense paintings of domestic interiors and landscapes by Stefan Kürten, this is a good place to expand your horizons.

Artists: John Andrews, Richard Barnes, Nelleke Beltjens, Jim Campbell, Russell Crotty, Reed Danziger, Susan Marie Dopp, Jacob El Hanani, Anoka Faruqee, Nicole Phungrasamee Fein, Roland Flexner, Andrea Higgins, Timothy Horn, Joyce Hsu, Alfredo Jaar, Byron Kim, Naomie Kremer, Stefan Kürten, Jill Lear, Michael Light, Crystal Liu, José Antonio Suárez Londoño, Emil Lukas, Marco Maggi, Gerhard Mayer, Catherine McCarthy, Wes Mills, Dorothy Napangardi, John O'Reilly, Gay Outlaw, Liliana Porter, Lordy Rodriguez, Greg Rose, Gideon Rubin, Shahzia Sikander, Arngunner Yr.

Stefan Kürten, *Grey Days*, 2006; Hosfelt Gallery

Bean Finneran, *Rosy-Pink Dome, 4000 Curves*, 2006: Braunstein–Quay Gallery

5 Braunstein/Quay Gallery

430 Clementina St, 94103
415-278-9850 f: 278-9841
www.bquayartgallery.com
bquayg@pacbell.net
Tues–Sat, 11–5:30
BART: Powell

This is one of the stalwart San Francisco galleries, dating back to 1961. Its roots are strongly embedded in Bay Area art, especially crossover artists who work in clay, fiber, wood, and glass, blurring the line between craft and fine art. Historical names from the gallery's early years—John Altoon, Robert Brady, Richard Shaw, Nell Sinton, Peter Voulkos—share space with younger-generation artists who may not espouse the same ideas but evince a similar quirkiness in the use of materials and articulation of imagery. For example, the sculptures of Bean Finneran allude to tangled, piled, and amassed forms in nature, recreated from a profusion of individual clay elements brightly colored and shaped into discrete objects without using fixatives.

Artists: Jeff Adams, John Altoon, Jeremy Anderson, Kimberly Austin, Tom Bolles, Robert Brady, Helen Cohen, Paul DeMarinis, Christine Eudoxie, Bean Finneran, Patricia Tobacco Forrester, Robilee Frederick, Cynthia Ona Innis, Cork Marcheschi, Michael McConnell, Grace Munakata, Craig Nagasawa, Arthur Okamura, Aaron Petersen, Paul Pratchenko, Beverly Rayner, Kyle Reicher, Jane Rosen, David Ruddell, Ursula Schneider, Richard Shaw, Nell Sinton, Mary Snowden, Michael Stevens, Peter Voulkos, Susan York.

6 Rigo

Innercity—Home, 1994
241 6th St, 94107
BART: Powell, Civic Center
Located a block up from Folsom St and visible for a distance looking north.

Superbly placed high on the side of an apartment building just off the exit from I-280 on the way into downtown, this urban mural transforms the familiar highway shield to designate the nature of the locale rather than a roadway's number. Marking one's arrival into the center of San Francisco, the mural acts like a welcome mat with the term "home" set in apposition to the term "innercity." In this and other outdoor murals,

Rigo, *Innercity—Home*, 1994

Rigo adapts the language of traffic signs, "a good delivery system," to add life to bleak buildings, subvert commercial advertising, and call attention to what is lost in the process of urbanization.

Instead of his full name Ricardo Gouveia, the artist signs his work "Rigo," followed by the last two digits of the year in which the work was created.

7 Howard Street House

architect: **JIM JENNINGS**, 2002
967 Howard St, 94107
BART: Powell
Located between 5th and 6th Sts.

With its severe box shape, stark facade of rusted Cor-ten steel panels, some of which are perforated with small light holes, and giant inset—a square wall of translucent glass divided into quadrants—this building is a radical expression of industrial minimalism. It is also an object of wonderment. The exterior reveals nothing of the structure's use, least of all suggesting it is a chic residential dwelling. Even the entrance door is hidden, situated perpendicular to the facade at the corner of the inset section.

Behind the planar frontage, the interior is capped by a slightly barrel vaulted ceiling and connected to a large courtyard leading to a rear garage and guest house.

8 The Luggage Store

1007 Market St, 2nd flr, 94103
415-255-5971 f: 863-5509
www.luggagestoregallery.org
lazer@luggagestoregallery.org
Wed–Sat, 12–5
BART: Powell, Civic Center
Located near 6th St in the downtrodden Tenderloin area of Market St. The entrance, a nondescript service-type door opening onto a steep flight of stairs, is squeezed between two storefront shops.

Carrying on the grassroots, nothing-fancy

Amber Room exhibition, 2006; The Luggage Store

tradition of the original, community-based alternative venues, The Luggage Store occupies a rather dilapidated space but presents an energetic program of offbeat creations. Its multidisciplinary exhibits and activities feature emerging artists who work in the visual art, installation, performance, music, and spoken-word realms. Not limiting itself to the confines of the gallery, The Luggage Store also stages projects elsewhere in the neighborhood. Of particular note is its development of public murals and street festivals, which gave early support to such artists as Fred Hayes, Arnold Kemp, Margaret Kilgallen, Alicia McCarthy, Barry McGee, Rigo, and Philip Ross.

Although local artists are the mainstay of the exhibition program, recent years have seen an increasing number of presentations by artists from outside the Bay Area. For example, extraordinary shows featured

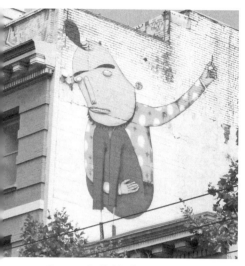

Osgemeos, Untitled (Pavil), 2003

Osgemeos, a pair of Brazilian twins renowned for their mural projects, and Tavares Strachan, a New York artist who creates ludicrous installations dealing with displacement, unattainable desires, and the transcendence of time and space.

Sample exhibitions: *The Amber Room*, *Explosive Compulsive*, Walter *Kitundu*, *Yoon Lee*, *Vulcan*, *Writing Letters*.

8 Osgemeos

Untitled (Pavil), 2003
1007 Market St, 94103
BART: Powell, Civic Center
Located on a rooftop wall, visible from across Market Street, this mural depicts a crouching figure who holds a small flame in his outstretching arm. It was created in tandem with the artists's exhibition at The Luggage Store. With its witty and wrenching demeanor, sad face, flattened body, and attenuated limbs, the image exemplifies the signature style of the street art that brought international attention to Osgemeos.

8 Margaret Kilgallen

Untitled, 1996
1007 Market St, 94103
BART: Powell, Civic Center
This strip of Market Street was so depressing that The Luggage Store aimed to upgrade the environment by arranging for artists to embellish the roll-down security doors of several storefront shops. Unfortunately, the transformative imagery is only visible at night and on Sundays when the businesses are closed.

On its own door, The Luggage Store has a delightful work by Margaret Kilgallen depicting a tree. Not only is a flourishing natural image egregiously paradoxical in this

Margaret Kilgallen, Untitled, 1996 (left); Barry McGee, Untitled, 1996 (right)

bleak urban setting, but its stylized, refined portrayal dramatically contrasts with the garish commercial signs in the area.

9 Barry McGee

Untitled
1009 Market St, 94103
BART: Powell, Civic Center

For the roll-down security door of New Step Fashion, the clothing shop next to The Luggage Store, McGee created a superb version of one of his classic mournful faces.

10 Rigo

Truth, 2002
26 7th St, 94103
BART: Civic Center

Located on the upper west wall of the Odd Fellows Building at the corner of 7th and Market Sts. For the best view of this work, cross Market St and stand at the far end of United Nations Plaza.

Using his trademark imagery of bold graphics borrowed from traffic signage, Rigo created a monumental mural with black-and-white diagonal stripes positioned in a chevron and overlaid with the word "TRUTH." The work is dedicated to Robert H. King, a member of the Black Panthers who was held in solitary confinement for 29 years in a Louisiana prison.

11 Federal Building

architect: **THOM MAYNE**, 2007
Mission and 7th Sts
BART: Civic Center

Designed by the Pritzker Prize architect Thom Mayne—a principal in the cutting-edge Los Angeles firm Morphosis—this building aroused controversy in its planning stages because it didn't conform with the Beaux-Arts-style courthouse across the street. Its eccentric appearance is still a subject of debate and consternation, even though the design has raised the city's profile in

Thom Mayne, Federal Building

international circles concerned with green construction practices. Not only does the project's unconventional architecture contrast with the usual conservative character of federal buildings, but, paradoxically, because it is a federal project it was not subject to the notoriously overbearing restraints typically imposed by the San Francisco Planning Commission.

Comprising a slender 18-story glass tower, four-story annex and large plaza, the design markedly contrasts with the bulky mass and full-block construction that have become the norm for office buildings. Moreover, such key features as the innovative skin of perforated metal panels that regulate the natural flow of light and heat, the cathedral-like entrance and streetside cafeteria, the three-story "skygarden"—a gathering space notched into the 11th–13th floors, the egalitarian lack of corner offices, and the skip-stop elevators that open on every third floor all give precedence to energy-efficient technologies and the enhancement of social and human dynamics in the work environment.

12 New Langton Arts

1246 Folsom St, 94103
415-626-5416
www.newlangtonarts.org
gallery@newlangtonarts.org
Tues–Sat, 12–6
BART: Civic Center
Located between 8th and 9th Sts.

As one of the original alternative spaces (it was founded in 1975), New Langton Arts was and has remained at the forefront of artist-run organizations that cultivate experimental and innovative artwork. Although the dominant focus is Bay Area art, compelling work from outside the region is often shown, usually in group exhibitions. The range of work varies widely though a common thread is a relatedness to contemporary cultural issues. You never know what you will find on display at New Langton Arts, but you can almost guarantee that it will be different, edgy, and usually against the grain. Sample exhibitions: *Elusive Materials*, *Five Habitats—Squatting at Langton*, *Nothing Stands Still*, *Textual Works*.

The facility itself is pretty bare-bones

Dawn Kasper, *Five Habitats* exhibition, 2006; New Langton Arts

Rigo, *One Tree*, 1995

and funky with the main gallery situated on the upper level, and a theater, which often doubles as a video and installation space, occupying the ground floor. In addition to exhibitions, Langton presents a full program of performance, lecture, music, literary, and interdisciplinary events. It also provides various support systems for artists.

13 Arkitektura In-Situ

architect: **BAUM THORNLEY**, 1999
560 9th St, 94103
415-565-7200 f: 565-7299
www.arkitekturainsitu.com
Mon–Sat, 10–6
bus: 19, 47
Located between Brannan and Bryant Sts.

Designed as a museum-like showroom for high-end European and American furniture, lighting, and accessories, Arkitektura In-Situ displays a vast array of objects, complementing them with silk-screened wall graphics and texts about the manufacturers and designers. The space itself—an immense, skylit, stripped-down warehouse with exposed wood and steel beams—is creatively partitioned into individual studios. Asserting a nuanced industrial flavor, the setting is as much a

focal point as are the exhibited items.

Although the furniture tends to be more refined and comfortable than daring, Arkitektura has work by most all the avant-garde leaders: Ron Arad, Gae Aulenti, Frank Gehry, Arne Jacobsen, Knoll, Ross Lovegrove, Herman Miller, Minotti, Gaetano Pesce, Karim Rashid, Carlo Scarpa, Ettore Sottsass, Philippe Starck, Vitra. The inventory also features licensed reproductions by such modern masters as Pierre Chareau, Charles and Ray Eames, Eileen Gray, Le Corbusier, Charlotte Perriand, Gerrit Rietveld, Eliel and Eero Saarinen, and Frank Lloyd Wright.

14 Rigo

One Tree, 1995
corner of 10th and Bryant Sts
bus: 47
Located on the side wall of a warehouse adjacent to the on-ramp of Highway 101 South, this mural is an incisive, clever commentary on the ever-declining state of nature within the urban environment. Characteristic of his signature mode, Rigo has adopted the familiar graphics of a one-way traffic sign, emblazoned it with an altered "one tree" message, and pointed the arrow at the lone arboreal specimen in the area.

15 Live/work lofts

architect: **STANLEY SAITOWITZ**, 1993
1022 Natoma St, 94103
Muni: Van Ness; bus 47
Located near the corner of 11th St.

This shabby, back-alley street, quite distant from the lively cultural and gentrified residential sectors of SOMA, is hardly the place where you'd expect to find one of the city's first adventurous live/work buildings by one of the Bay Area's leading architects. The facade of this building, wedged tightly into a narrow lot, is radically different from those of neighboring buildings, and yet its corrugated-aluminum-and-glass cube—an abstraction of a bay window—was directly inspired by them. However, the customary division of a Victorian into a cluster of small, dark rooms, gave way to double-height, open spaces capped by a central skylight.

Stanley Saitowitz, 1022 and 1028 Natoma Street

The common wood-frame construction of 19th-century housing was also abandoned in favor of an exposed steel frame.

15 Multifamily house

architect: **STANLEY SAITOWITZ**, 2006
1028 Natoma St, 94103
Muni: Van Ness; bus 47
Located near the corner of 11th St.

Like its next-door neighbor, this infill building retains the character of the Victorians in the South of Market area while simultaneously presenting a very modern, reductive image. Here Saitowitz defines the bay-window extension as a single rectilinear volume by covering the entire facade with a metal screen. The asymmetrical placement of the bay adds a bit of irregularity even as the flat concrete wall on the right side reasserts a minimalist appearance.

16 Linc Real Art

1632-C Market St, 94102
415-503-1981
www.lincart.com
hope@lincart.com
Tues–Sat, 12–6
Muni: F; bus 6, 7, 66, 71
Located across from Zuni Café on the corner of Rose St between Franklin and Gough Sts.

This off-beat, off-the-beaten-track gallery focuses on process-driven work that explores new ways of using materials. Emerging or mid-career, local and international artists are featured. The art is sometimes sophomoric, often quirky, witty, or satiric, and generally embracing a personal or fringe aesthetic. A prime example is found in the playful text-and-image compositions of Tucker Nichols, which reiterate commonplace absurdities even as they trigger conceptual associations.

Artists: Omar Chacon, Pip Culbert, Zack Davis, Allison Edge, Tim Evans, Graham Gill-

more, Tucker Nichols, Nils Nova, Gay Overfelt, MeeNa Park, Andreas Reiter-Raabe, Johanna St. Clair, Bob Van Breda, Anne Veraldi, Beatrice Wood.

17 RNM

architect: **MARC LAROCHE**, 2002
598 Haight St, 94117
415-551-7900 f: 551-7901
Tues–Thurs, 5:30–10; Fri–Sat, 5:30–11:30
bus: 6
Located in the Lower Haight on the corner of Steiner St.

This chicly styled restaurant, ensconced in a most unlikely funky-seedy neighborhood, has a design flair worth noting. (The food has also been highly praised!) You won't have any trouble identifying it since the renovated Victorian, painted gray with a black aluminum awning, contemporary signage, sidewalk planters, and cutaway corner, stands out from nearby storefronts and houses. Once inside, the floor-to-ceiling chain-mail curtains around the entry door and stairway and the oddball chandelier—a tangled mass of electrical conduit and tiny halogen bulbs (by Cattelani and Smith)—betoken eccentricity. This aura is, however, tempered by the elegance of dark wood (tables, chairs, floor) and moody, maroon-toned walls.

A mezzanine, furnished with comfortable couches, takes advantage of the high-ceilinged space by adding an intimate extra area to the compact ground floor. Similarly, chairs at the stainless-steel counters in front of the open kitchen and around the front bar— sleekly designed with a polished metal top and mosaic-tile base—expand the seating capacity while offering diverse enclaves around the main dining area. The setting is discreetly punctuated by such other design details as light-box inserts in the wall beside the bar and architectonic glass railings along the stair and balcony.

Tucker Nichols, *We Found Our Dog,* 2003; Linc Real Art

Hayes Valley

In recent years the Hayes Street corridor adjacent to the Civic Center has emerged as a haven of chic design boutiques, restaurants, cafés, and stores selling unusual clothing and shoes, antiques and collectibles, ethnic goods and crafts. Though it has been gentrified, evidence of the neighborhood's funky roots and its resistance to a chain-store invasion make this a unique, appealing place to visit. The art dynamic is at the other end of the spectrum from what you can find around Union Square, and the streetlife is livelier and more integrated than in SOMA.

18 Friend

architect: **YVES BÉHAR**, 2003
401 Hayes St, 94102
415-552-1717 f: 472-6195
www.friend-sf.com
Mon–Sat, 11–7; Sun, 12–5
BART: Civic Center
Located on the corner of Gough St.

This design boutique bills itself as "a

Tord Boontje lamps, Philippe Starck stools; Friend

modern lifestyle and home furnishings store," whose goal is "to showcase great products in a warm, open atmosphere." The atmosphere is set by Yves Béhar's stylish interior with wraparound windows facing the streets on both sides of the corner and a gently angled back wall sheathed in hardwood boards and inset with intermittent display shelves. The space is further articulated by a timber-patterned floor and concrete pillars encased in plexiglass inscribed with repetitions of the phrase "all things are in common among friends."

The array of products scattered about more than equal the chic, unusual setting. Included are items from such renowned brands as Alessi, Kartell, Quinze & Milan, Vitra, Herman Miller, as well as Sausalito-made Heath ceramics and cutout-paper chandeliers by Tord Boontje. The staff is well-informed and helpful, but do not hesitate

to meander about on your own to view the diverse assortment of dinnerware, home and office accessories, lighting, and furniture.

19 Propeller

555 Hayes St, 94102
415-701-7767
www.propellermodern.com
contact@propellermodern.com
Tues–Sat, 11–7; Sun, 12–5
Muni: F; bus 21, 47, 49
Located between Octavia and Laguna Sts.

Propeller specializes in emerging and independent designers. The emphasis is on Americans though the displays are enriched by a diverse selection of products by innovative Europeans. The store, which opened at the end of 2002, has a casual, friendly atmosphere, and the merchandise—furniture, lighting, accessories, and some personal items—is refreshing and adventurous.

Standouts that warrant attention are Jonas Damon's *Open Clock* fashioned from a string of four cubes, Orange 22's metal *Botanist* tables accentuated with a flower-pattern cutout, Chris Kabel's *Sticky Lamp*—a light bulb encased in plastic packaging, and William Earle's *Hal* table—an architectonic block topped by a glass plate. Since new objects are continuously added to the displays, you can always expect to see something different when visiting here.

20 Loft residence

architects: **MARIA MCVARISH**, 2001
292 Ivy St, 94102
Muni: F; bus 21, 47
Located just off the corner of Gough St.

Should you wish to see a noteworthy variant of the ever-proliferating in-fill loft buildings while you are in the Hayes Street neighborhood, this one is just around the corner from the Civic Center Plaza. Although the inventive interior and rooftop garden of the penthouse that was carved out of the

old brick factory lying at the center of the plot is not visible, the street-side addition containing a two-story loft is telling. Clad in wood-resin panels, the facade is a planar surface with a simple window arrangement and inset balcony at the far end. But in its midst, a bay-window block juts out. Distinctive in its slanted front extending from the ground up to the roof, it adds spice without being flamboyant. Indeed, its verticality and surface of concrete and glass are an effective counterpoint to the horizontality and wood grain of the rest of the facade.

Nikolai Moderbacher, *Schwing, Jr.*; Propeller

21 Citizen Cake

399 Grove St, 94102
415-861-2228 f: 861-0565
www.citizencake.com
Tues–Fri, 8 am–10 pm; Sat, 10–10; Sun, 10–9
Muni: F; bus 21, 47
Located on the corner of Gough St.

With a pastry-chef-owner trained in film at the San Francisco Art Institute, what would you expect but a name that is a play on Orson Wells's *Citizen Kane* and a signature cake called *Rosebud*—a rose-scented crème brûlée tart! And the art attitude doesn't end there. There's an edgy flair to the design of all the edibles served in this imaginative dessert shop and restaurant, and a creative zest in the mix and choice of ingredients. Even the airy, industrial-rustic character of the interior steps outside the norm.

Since many of the pastries are openly displayed in glass cases and on the bar, you can walk in, peruse the selection, and decide if you are just going to look or if you are up for a take-out or sit-down indulgence. A favorite worth noting is the *After Midnight Chocolate Cake*. Don't even think about the calories as your mouth waters when considering the devil's food and dark- and milk-chocolate mousse cake glazed with chocolate ganache and decorated with chocolate straws, pulled sugar shards, and edible gold leaf!

22 Bucheon Gallery

389 Grove St, 94102
415-863-2891
www.bucheon.com
Tues–Sat, 11–6
BART: Civic Center
Located near the corner of Gough St.

The art presented at Bucheon is not mainstream or avant-garde, though it goes beyond

Harris Diamant, *Dosed*, 2002; Bucheon Gallery

established conventions often verging into realms of quizzical expression. Multiple styles and techniques abound with imagery being diversely manifest in extreme realism, collage fragments, ribald narratives, and total abstraction. Many of the artists imbue their creations with a surrealist slant.

Artists: Laura Ball, Stephen Beal, Rebecca Bird, Merrilee Challis, Julie Chang, Annie Costello, Whitney Cowing, Jenny Dubnau, Eckhard Etzold, Hilary Harp/Suzie Silver, Cynthia Hooper, Ken Kirsch, Steve MacDonald, David McDermott,Ethan Murrow, Lucho Pozo, Margaret Wall-Romana, David Gremard Romero, Thad Simerly, Elena Sisto, David Tomb.

Civic Center

While sustaining the Beaux-Arts mode of classicism set forth in the early 20th century, in recent years the Civic Center has added new buildings and rehabilitated old ones. Masonry facades and monumental architecture still reign supreme, but if not on the exteriors, for sure in the interiors, the infiltration of contemporaneity is pronounced.

23 Henry Moore

Reclining Figure in Four Pieces, 1973
corner of Van Ness Av and Grove St
Muni F; bus 21, 47
Located in front of Davies Symphony Hall.

From the 1920s until his death in 1986, reclining figures were a staple of Henry Moore's prolific output. His bronzes are among the most popular, ubiquitous public art choices for civic and corporate buildings in the United States.

Composed as a cluster of curvaceous volumes with sensuous surfaces and rhythmic, organic shapes, this 1973 sculpture is a classic example. Its evocation of a primordial sensibility in which body segments are in dialogue with one another goes beyond figuration to embrace a universal, archetypal consciousness.

24 Peter Voulkos

Hiro II, 1967
401 Van Ness Av, 94102
Muni: F; bus 21, 47
Located opposite City Hall on the south side of the Veterans Building next to the courtyard gates.

Peter Voulkos, who has been called "the father of California ceramic sculpture," turned his attention to bronze in 1961 and began casting large-scale works in his own foundry. The two writhing pipes stretching forward and rising up from the ground to confront one another in *Hiro II* capture the grand gesture and macho physicality that was a hallmark of the artist.

25 San Francisco Arts Commission Gallery

401 Van Ness Av, 94102
415-554-6080 f: 554-6093
www.sfacgallery.org
Wed–Sat, 12–5
BART: Civic Center
Located across from City Hall on the ground floor, northeast corner of the War Memorial Veterans Building at McAllister St.

Exhibitions in this city gallery display an uneven mix of art ranging from the provocative to the mundane, the sophomoric to the highly theoretical. The program barely scratches the surface of its mission to represent San Francisco visual art culture. Nevertheless, the gallery offers a venue for emerging local artists at an early stage in their careers. Sample exhibitions: *1906–2006 Rebuilding—Then & Now, Conversations (Oliver Herring & Tim Sullivan, Marcel Dzama & Alice Shaw, Amy Globus & Cynthia Ona Innis), The Dust Never Settles, Facing Fear—Jules Greenberg, Immediate Future, Meat Show, Bari Ziperstein.*

In addition to this location, the SFAC has a second space around the corner at **155 Grove Street**. The space displays experimen-

Claudia Tennyson, Untitled (Table & Chairs Set), 2006; SF Arts Commission Gallery

tal, site-specific, and multimedia installations that are only visible through the building's street-front window. Exhibitions typically let the public view the artist at work on a project over the course of its development. Patricia Diart's poignantly futile reconstruction of a kitchen from the debris of a recent demolition (*Rate of Transfer*, 2006) and Andrew Junge's *Styrofoam Hummer* (2005–06) are prime examples.

26 Lewis deSoto

Jury Assembly Room, 1997–98
Civic Center Courthouse, 400 McAllister St, 94102
BART: Civic Center
The building is located at the corner of Polk St and the jury room is in the basement, just off the grand staircase descending from the rotunda entrance.

Bay Area artist Lewis deSoto wanted to honor jurors by providing an elegant environment for their assembly room. Using enriching cherry wood for furnishings, he organized the space with a circular reading area in the center and rows of benches on

either end. Depictions of the signing of the Declaration of Independence, etched on glass wall panels, and the California seal, projected as a light image onto the floor at the doorway, convey the serious, historical aspect of jury duty.

27 Earl Warren Building and Hiram W. Johnson State Office Building

350 McAllister St and 455 Golden Gate Av, 94102
BART: Civic Center
Located on the block facing Civic Center Plaza between Larkin and Polk Sts.

As part of the renovation, retrofit, and expansion of the California state building complex (**SKIDMORE, OWINGS & MER-RILL**, 1998), a collection of art was installed in public spaces. In the Archive Room (a small lobby in the Warren Building, at the end of the main circulation route just before you enter the Great Hall), a documentary installation by **ANN CHAMBERLAIN** references California's judicial and legal history. (The state's Supreme Court and related organi-

zations are housed upstairs.) Comprising a frieze of carved words relating to areas of the law, slide projections showing portraits of witnesses and shapers of the law, a stone vessel with a changing screen of images, and a display case with court papers, the work is like a mini history museum. As an art installation, it is a bit didactic, though the golden aura in the wall projections makes you stop and take notice.

As you proceed ahead, you enter the Great Hall, where the monumental *Conical Light Sculpture* (1998) by **JAMES CARPENTER** is the centerpiece. Inspired by the giant sequoia trees that are native to California and engineered as a sophisticated tension network of steel rods, the form was conceived as a metaphor for the state's natural wonders and its leadership in advanced technology. Although it stands 40 feet high and takes full command of the setting, the transparent construction doesn't visually block or physically assert itself as an overwhelming mass. Further spatial integration derives from the mirrored base that reflects views of the surrounding architecture and the circular wood bench around the bottom that gives the sculpture a functional aspect.

The central atrium also contains *Mizu* (1996–2000) and *Kinkakuji II* (1995–96) by **BRIAN ISOBE**—compositions rooted in the Japanese screen-painting tradition—and *IVA3.3* (1995), a lush abstract painting by **NAOMI KREMER**. If you continue up the stairs at the north end of the atrium, cross the lobby of the Johnson Building, and go up the half-flight of stairs to the east mezzanine of the second floor, you will find additional artwork of note. Immediately visible (on the wall outside the day-care center) is a group of mixed-media assemblages by Mildred Howard (1993–97). In the adjacent corridor is an impressive selection of photographs by Jedd Brouws (interstate highway images, 1996), Roger Minick (*Sightseer* series, 1980), and Richard Misrach (*Desert Canto* series, 1983–84). As you continue ahead into the cafeteria, you will encounter lithographs (1991) by Ed Ruscha and photos from the *Mulholland Drive* series (1993) by Karen Halverson.

28 Plaza, Philip Burton Federal Building

architects: **JARED DELLA VALLE, ANDREW BERNHEIMER**, 2000
450 Golden Gate Av, 94102
BART: Civic Center
Located between Larkin and Polk Sts one block north of Civic Center Plaza.

This is a worthy example of a plaza design that's mainly paved but isn't just a flat, undifferentiated expanse. The architects dealt with the property's slope by replacing the existing street-side steps with inclined boundary walls and ramps. A large triangular span of grass lying atop the front parapet accentuates the diagonal rhythms of circulation paths, railings, vehicle barriers, rows of trees, and seating. Other triangular patches—grass and water—are the focal points of discrete relaxation areas. These island-like areas and the variety of seating—freestanding wood and built-in concrete benches, stainless-steel Z-chairs and posts—establish a small-scale, human dimension in the otherwise open, austere setting. (Here, as elsewhere in the city, the installation of skateboard guards on the concrete walls unfortunately bastardizes the minimalist aesthetic.)

29 Asian Art Museum

architect: **GAE AULENTI**, 2003
200 Larkin St, 94102
415-581-3500 f: 581-4700
www.asianart.org
Sun, Tues–Wed, Fri–Sat, 10–5; Thurs, 10–9
admission: $12/8/7; $5, Thurs after 5; free first Tues
BART: Civic Center
Located between Fulton and McAllister Sts facing Civic Center Plaza.

With grand fanfare, the Asian Art Museum moved into its new home in the spring of 2003. Having previously been situated in Golden Gate Park, it now occupies the city's former Main Library, which was completely rehabilitated and skillfully reconfigured to meet museum needs. The so-called "adaptive reuse" project was headed by Gae Aulenti, the pioneering Milanese architect who transformed an old train station into the Musée d'Orsay in Paris and the Palazzo Grassi in Venice into public spaces for art exhibitions. Her approach, based on respecting the integrity of the historic structure and inserting new into old with blunt juxtapositions rather than blendings, is vividly manifest in the San Francisco renovation.

On the exterior, the granite-clad Beaux-Arts building (1917) remains intact. Upon entering, the old style still dominates in the travertine-walled foyer, barrel-vaulted loggia, and grand staircase. Landmark preservation mandated that these historic areas and some details, like the plaster decoration and chandeliers, be unmodified and restored. But almost immediately, the sun-filled central court comes into view and a whole different dynamic is set forth. Without being flamboyant, Aulenti took advantage of the majestic height of the space and imbued it with airy openness by adding huge V-shaped skylights. Ribbed in steel, which has been painted icy pistachio (her signature color), the dazzling ceiling emphasizes both the longitudinal span within the structure and the twin-winged layout. The long, narrow escalator climbing diagonally along the glass-walled rear corridor of the south wing further asserts the new, while the soft-toned sycamore paneling and off-white walls reiterate the spare, refined character of the setting.

Temporary exhibition galleries, education rooms, and a café with an outdoor dining terrace are positioned around the periphery of the ground floor, and a glass-enclosed museum store is resourcefully placed under the staircase in the center. Beginning at the

Gae Aulenti, Asian Art Museum -

top of the escalator and continuing in a well laid-out circuit around the third and second floors are the permanent collection galleries. Arranged in geographical and chronological sequences, the installation is pan-Asian in scope, representing the diverse cultures of some 30 countries. Text panels also highlight the history of Buddhism as a thematic link. With its prestigious holdings from the Avery Brundage donation, which is especially rich in Chinese bronzes, and a fine selection of Korean ceramics, Indian sculptures, Thai painting, and Japanese clay tomb figures, scrolls, and bamboo baskets, the collection is varied and comprehensive. There's even a Japanese tea house and meditation niche.

Aiming to display a large number of works has unfortunately meant that the art is often crowded with little room for viewing

or circulation and virtually no seating. A nice effect is created, however, by the clean-line cases and pedestals that disappear into the background, focusing all attention on the objects. The compact rooms, wall partitions, and dark or muted colors produce an appropriately intimate setting, though the lack of natural light is regrettable, especially after the stunning skylight infusion in the central court.

By horizontally bisecting the high-ceilinged reading room of the former library, Aulenti created the current third floor. Since the old ceiling, decorated with a floral and geometric pattern, had to be preserved, it is still visible, forming one of the old/new juxtapositions in the renovation design. Likewise, the old card-catalogue room, now called Samsung Hall, recalls the grandeur of Beaux-Arts architecture even as sight lines into the surrounding areas bring the steel-and-glass elements into view.

As inclusive as the collection is, it is conspicuously weak in modern and contemporary art. Recognizing this, the museum sought to remedy the situation with a continuous stream of special exhibitions devoted to these eras. Since recent years have witnessed a frenzy of attention to Asian, especially young Chinese artists within international art circuits, the museum's redirection follows a pervasive trend. Traveling shows—like *Montien Booma*, *Tezuka: The Marvel of Manga*—are welcome additions to the program. The same cannot be said for the contemporary art exhibitions organized by the museum itself, which favor artists of marginal importance who hardly represent the innovative work being done in Asian cultures.

30 George Rickey

Double L Excentric Gyratory, 1982
corner of Fulton and Larkin Sts
Following the artist's signature style, this Rickey sculpture entails balance, movement, and light reflection. The two L-shaped, stain-less-steel arms pivot on a base in response to wind currents, and the highly polished, burnished metal catches changing light patterns that further animate the work. The artist, who gained attention in the 1960s as a theorist and practitioner of kinetic sculpture, has continued to develop the genre in variants of the basic format he generated (see pp. 91, 133, 233).

31 Main Library

architects: **JAMES INGO FREED, CATHY SIMON**, 1996
100 Larkin St, 94102
415-557-4400
www.sfpl.org
Mon, Sat, 10–6; Tues–Thurs, 9–8; Fri, 12–6; Sun, 12–5
BART: Civic Center
Located between Civic Center Plaza and United Nations Plaza in the block bordered by Larkin, Fulton, Grove, and Hyde Sts and angling into Market St.

Viewed from the west and north, the granite facades of the Main Library echo the classicism of surrounding buildings—at least at first glance. A closer look reveals that decorative features are derivative but reinterpreted in a modern idiom. (For example, frontal columns are now inset and made of steel.) Moreover, on the south and east, contextual harmony with the Civic Center's Beaux-Arts character gives way to a contemporary mode of architecture foregrounding diversely ordered planes and voids, tonal patterning, and angular shapes. These facades were meant as a response to the adjacent commercial district. To be sure, the contrasting aesthetics inject an unortho-dox dynamic into the exterior. However, the design is so toned-down that the punch of the disjunctive irregularities is devitalized.

Do not let the lackluster appearance of the outside dissuade you from going inside. It is here that edgy, unconventional creativity—a hallmark of James Ingo Freed's acclaimed

Holocaust Museum in Washington, D.C.—is dramatically manifest. The centerpiece is a five-story, circular atrium with an asymmetrical skylight. Overhanging balconies, a grand staircase, catwalk bridges, light wells, diagonal walls, and a second, linear atrium add vitality while establishing the open, airy character of the architecture. Contrasts and disconnects abound, uprooting traditional rectilinear order with playful, labyrinthian complexity. It is a delightful space to investigate, but though the design is inventive and intriguing, it has proven functionally inefficient and not very user-friendly.

Several major art commissions were part of the library construction. *Constellation* (1996) by former San Francisco resident **NAYLAND BLAKE** is a five-story steel wall set in the middle of the main staircase. This work was inspired by the Bibliothèque Saint Geneviève in Paris (a model for the old Main Library), where authors's names are inscribed on the facade according to the location of their works inside. In his turn, Blake has updated the design by sandblasting the names on oval glass shades lit from behind by fiber-optic light beams. As in the source, the index is organized to correspond with the floors where the books by each author are located. A public and advisory process determined the first 160 names, and space exists for 200 more.

Also taking the library as its subject matter, the artists **ANN HAMILTON** and **ANN CHAMBERLAIN** created a poignant covering (Untitled, 1995) for the long, diagonal walls on the third, fourth, and fifth floors. Using the old catalogue cards made obsolete by computer database systems, the artists had some 200 volunteers annotate them with quotes from the corresponding books or whimsical drawings. The 50,000 cards displaying a wide diversity of handwritings in a dozen different languages and appearing alternatively dense with text and sparse, were then set on the walls as a continuous floor-to-ceiling surface protected by a thin

Nayland Blake, *Constellation,* 1996

veneer of artisan plaster. With its historical dimension and noninstitutional, intimate character, the work provides a nice interface between the big public domain and the quiet activity of reading that transpires in the library environment.

Relating not to the library theme but to Freed's interconnected, open-space architecture—especially the conical skylight in the atrium—New York artist **ALICE AYCOCK** devised a dynamic two-part sculpture (1996) for the glass-enclosed reading room that projects into the library's grand atrium on the fifth and sixth floors. Shaped as a spiral winding around a cone with disparate geometric elements flailing about, *Functional and Fantasy Staircase* is a riveting structure likened by some to the movie sets of German expressionist films of the 1920s. The same

Alice Aycock, *Functional and Fantasy Staircase,* 1996

Enrique Chagoya, *Latino/America: Authors from Latin American Roots,* 1997

aesthetic prevails in *Cyclone Fragment*, a twisting, swirling form hanging over the reading room. Both sculptures are made from painted steel and aluminum.

Though not one of the original commissions for the library, **ENRIQUE CHAGOYA**'s *Latino/America: Authors from Latin American Roots* (1997), a large charcoal-and-pastel composition, was subsequently installed in the Grove Street entrance. Two hands holding fountain pens are shown writing the names of Latino authors in red ink. In contrast to their precise, neat inscription, the white ground shows smudges and hatches suggestive of erased, and scribbled-out notations—common aspects of the creative process.

Lower SOMA–Mission Bay–Potrero Hill

Lower SOMA

The South of Market area between Yerba Buena Gardens and the Embarcadero long remained a derelict zone, despite its close proximity to the downtown shopping and financial districts. Then, during the late 1990s, a dramatic turnaround began, spurred by the construction of a new baseball stadium and the dot-com boom. Ugly rail yards and a barren industrial wasteland were transformed into fashionable new housing complexes and office towers. And desolate warehouses were renovated into live/work lofts and commercial properties suitable for high-tech startups. Sadly, the architecture is pretty humdrum, and the urban plan follows a rigid grid in which the component structures are self-contained and separated. It is almost a new wasteland, since storefront businesses are lacking and green areas are dispersed like islands rather than being integrated into the community fabric.

1 Topher Delaney

Lobby and courtyard art, 2001
Marriott Courtyard Hotel, 299 2nd St, 94105
415-947-0700 f: 947-0800
BART: Montgomery
Located at the corner of Folsom St.

When walking up to the Marriott Courtyard by way of the circular driveway, it is easy to overlook two bronze suitcases inconspicuously placed just outside the door and next to the porters's stand. These works are part of Topher Delaney's art installation comprising 20 additional bronze sculptures in the lobby and bar, two large quilts in the atrium, four photographs in the bar, and a large globe in the courtyard.

Delaney's verisimilar casts of commonplace objects—umbrella, bag of golf clubs, pen, cell phone, eyeglasses, laptop, shoes, in-line skates, gloves, camera, baseball cap and mitt, hatbox, hat, wallet, ice cream soda—are scattered about as if mistakenly left behind by previous guests. Taking the hotel theme as a point of departure, they serve as humorous reminders of the disoriented mindset of travelers, even provoking a kind of treasure hunt testing your ability to discern artworks from real objects.

Whereas several of the objects and the photographs relate to the hotel's proximity to the Giants baseball stadium, the quilts contextualize the setting by being composed of scarves and ties donated by Marriott associates from around the United States, and the globe sculpture, an open form shaped by intertwining bronze ribbons bearing stenciled quotations, incorporates ten literary portraits of northern California.

Topher Delaney, *Turning on a World of Words*, 2001

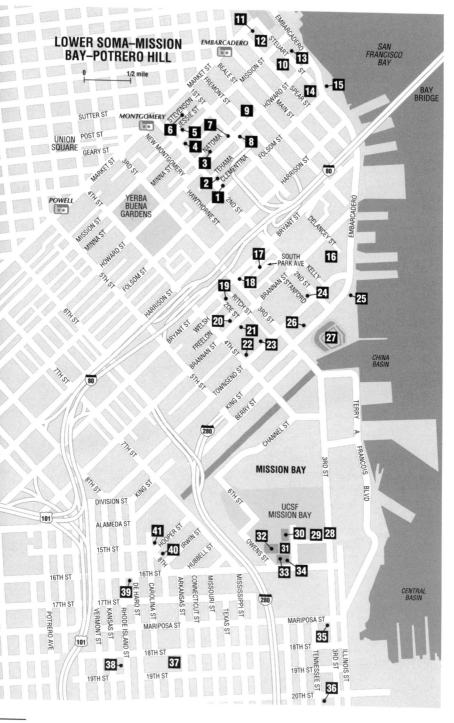

LOWER SOMA–MISSION BAY–POTRERO HILL

0 1/2 mile

2 CNET Building

architect: **CHRISTIAAN MAARSE**, 2001
235 2nd St, 94105
415-344-2000
BART: Montgomery
Located in the block between the Tehama
and Clementina Sts.

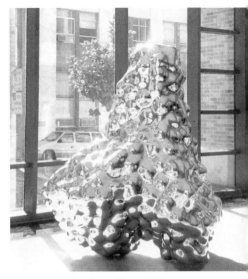

Anish Kapoor, *Making the World Many,* 1997

While blending with the old industrial
buildings in the area, this new seven-story
structure evinces a fresh contemporane-
ity. It combines traditional brick with glass
curtain walls, and historical arches with a
sleek aluminum canopy. (The bricks were,
in fact, customized in seven shades and set
in place on the spot by professional bricklay-
ers, not applied as prefabricated panels as
is customary today.) Though the building's
bulk virtually fills the entire block, an outdoor
courtyard adds an openness, further ampli-
fied by the adjacent glazed lobby with its
public table-and-chair seating. A border of
live bamboo on one side of the plaza and
a streamlike fountain along the lobby wall
also bring nature into the setting.

Be sure to walk inside the lobby so you can
get a close view of the stainless-steel sculp-
ture, *Making the World Many* (1997), by the
British artist **ANISH KAPOOR**. Its amorphous
shape, with a high-gloss, reflective surface
of bulging bubble forms, manifests spatial
illusion and visual distortion—hallmarks of
Kapoor's widely esteemed work.

The design of the lobby, rich in per-
spectival plays, and the inclusion of chic
furnishings, like the corrugated orange
polypropylene chairs by Ron Arad, distinguish
it from the bland minimalism of so many
modern office buildings.

3 Steel Arc Lofts

architect: **JIM JENNINGS**, 2002
85 Natoma St, 94105
BART: Powell, Montgomery
Located just off the corner of 2nd St.

Adding an upbeat flavor to an otherwise
bleak alley, this nine-unit residential building

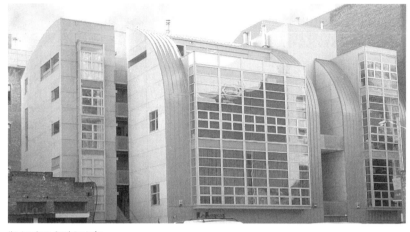

Jim Jennings, Steel Arc Lofts

offers a welcome divergence from the boxy, suburbanized designs that have emerged as the norm for San Francisco lofts. In contrast, Jim Jennings, one of the Bay Area's outstanding architects, has created a metal-sheathed structure whose sweeping curves and irregular composition inject pizzazz and refinement into industrial aesthetics. He also averts the ubiquitous facade composed of repetitive rows of narrow bay windows by setting a wide cantilevered bay in the center and flanking it with segments that recede and project as contrapuntal rhythms.

Although this building is a bit off the beaten track, it presents an architectural vision that is well worth a special trip or short detour.

4 Office Tower

architect: **CRAIG HARTMAN**, 1999
101 2nd St, 94105
BART: Montgomery
Located on the corner of Mission St.

The grand glass-enclosed atrium that fronts this 26-story office tower, gives it a very public orientation. Although such a conceit is not new—the Ford Foundation Headquarters in New York (1967) is an early example—Craig Hartman's design is

an admirable interpretation. The four-story pavilion, modulated by horizontal delineations, reduces the mass of the high-rise behind it, even as it accentuates the stepped architecture and the refined grid pattern that prevail throughout. Glass curtain walls predominate, but the back segment of the tower, clad in buff limestone, offers contrast and variation.

In addition to trees, a café-like setting, and a mezzanine restaurant, the atrium—officially called the Art Pavilion (Mon–Fri, 8–6)—features commissions from **CHARLES ARNOLDI** and **LARRY BELL**, two well-established Los Angeles artists known, respectively, for linear abstract paintings and iridescent glass-box sculptures. But do not expect to see these signature modes here. For *Core* (1999), an enormous work that commands an entire wall, Arnoldi created an animated, richly colored composition of ovoid, clover-like, and splashed forms set within a geometrically divided field. And for *Sumer* (1999), a monumental bronze (26 feet tall), Bell devised a bouncy, sinuous, calligraphic figure inspired by ancient Mesopotamian culture.

5 JP Morgan Chase Building

architect: **CESAR PELLI**, 2002
560 Mission St, 94105
BART: Montgomery
Located between 1st and 2nd Sts on the corner of the alley-like Anthony St.

Heralded by an astute architectural critic as "possibly the most attractive new building to rise during the recent boom in San Francisco," this 31-story tower is a tall, dark, and handsome exemplar of minimalist Modernism updated to the 21st century. The glass surfaces of its austere, boxy form is not a pure curtain wall, but an integral part of a classy grid framework delineated by a plaid pattern of hunter-green bands of steel. At the ground level, the building accommodates the street with a narrow, two-story arcade punctuated by a row of glass canopy panels extending over the sidewalk.

A spacious lobby, paneled in a light-toned African wood with Brazilian stone covering the floor, lies behind the facade. Elegance combines with utterly reductive aesthetics. Though there are no furnishings, one side of the lobby is intermittently used to display work by emerging Bay Area artists. Hanging on the other side is a vinyl-and-felt banner featuring an Art Deco entablature design by **ROY LICHTENSTEIN** (Untitled, 1966).

For the right side of the building, Pelli and landscape architect **HART HOWERTON** created an inviting stone courtyard with three tiers of grass, potted Japanese maple trees, and a bamboo grove. A bedazzling salmon-colored wall serves as a backdrop. At the front edge of the plaza, set in a shallow pool, is *Annular Eclipse* (1999–2000), a large kinetic sculpture by **GEORGE RICKEY** consisting of two parallel, polished-aluminum rings that rotate slowly in the wind. The circular rhythms offer a nice contrast to the rectilinear grid of the building while also interfacing with the natural rhythms of the garden.

6 Manuel Neri

Escalieta I, 1987
49 Stevenson St, 94105
BART: Montgomery
Located on a small plaza fronting an office building at the corner of Ecker St, a pedestrian passage, and Stevenson, an alley one block south of Market St in the stretch between 1st and 2nd Sts.

You'd hardly expect to find a sculpture tucked away in this off-the-beaten-track location. Indeed, its sensuous, and stark white form stands in dramatic contrast to the darkness of the surrounding narrow streets and the nondescript, block-shaped buildings that border them. Set high atop a pedestal, the marble nude with chiseled and polished surfaces blends classical ideals with contemporary expressiveness. Allusions to the passage of time are hallmarks of Manual Neri, a member of the Bay Area Figurative

Larry Bell, *Sumer,* 1999; 101 Second Street

School, who has been exploring modes of representing the human body since the 1950s.

7 Richard Deacon

Not Out of the Woods Yet, 2003
500 Howard St, 94105
BART: Embarcadero
Located under the front arcade of the Foundry Square IV building on the northwest corner of Howard and 1st Sts.

British artist Richard Deacon was originally commissioned to create a sculpture for the corner plaza, a stone platform with a grid of eight trees. However, he preferred the location where his sculpture now stands, tucked into the building under the arcade. The dark, confined, and claustrophobic setting parodies the placement of trees in a regimented pattern on a nonnatural ground plane. The title of the sculpture, a decidedly nonvegetal object made of aluminum tread plate, further suggests absurd parallels between its configuration and the geometric alignment of the adjacent bosk.

The open, linear form of the sculpture is composed of six polygon elements, tightly abutting one another and stacked on two levels. Though the object is methodically arranged, it hovers between the appearance of order and disorder, simplicity and complexity. Characteristically, Deacon also manifests

Richard Deacon, *Not Out Of The Woods Yet,* 2003

a concern with scale, fabricating a work that interrupts our experience of space.

8 Joel Shapiro

Untitled, 1996–99
405 Howard St, 94105
BART: Embarcadero
Located on the plaza in front of Foundry Square II, an office building at the southeast corner of Howard and 1st Sts.

Set within an otherwise empty paved plaza, this cast-bronze sculpture resembling a stick figure adds a welcome bit of animation to the environment. Its thrusting, twisting rhythms defy the usual stasis and austere geometry of art associated with the reductive concepts of Minimalism, and its evocative imagery teeters on the line between abstraction and representation.

Although the work's linear form gets lost in the profusion of horizontals and verticals on the building's facade, San Francisco has gained a prime example by one of America's most celebrated artists with the public display of this sculpture.

9 Paul Kos and Robert Hass

Poetry Sculpture Garden, 2001
199 Fremont St, 94105
BART: Embarcadero
Located in the plaza fronting an office building set back from Fremont St and bordering Howard and Beale Sts. The work also occupies the narrow passage leading into the plaza from Fremont St.

If you are looking for a respite that is also a soothing, meditative setting, where you can escape from the high-rise cityscape and urban congestion, this is just the place. Even if you are not in need of a relaxation spot but want to see a well-conceived public art project, put this high on your list of places to visit.

The work, designed by San Francisco artist Paul Kos, begins with a pedestrian

passageway off Fremont St, bordered by a beige-toned concrete wall inscribed with a poem by Robert Hass, Bay Area resident and former U.S. poet laureate. The title "Daisy Laps" spreads in large letters across the full expanse of the long wall, and the verse, diversely incised and set in relief as four flowing lines of text, is superimposed on it. Eliciting images of San Francisco, the poem creates a wondrous ambience: *an echo wandered through here what? an echo wandered through hear it? there was morning and later there was evening days elapse what? a neck oh? wan where are we going in this city of stone and hills and sudden vistas and people rushing to their various appointments what points the way? it's raining no it was foggy no the sun was out it was windy spring what? an echo wandered through here.*

Large rocks, a few trees and plants dot a narrow strip of ground in front of the wall, and several stones set atop wood planks serve as seats on the opposite side of the walkway. The plaza, situated at the end of the passage, is a paved space, empty except for the serene, nature-oriented zone in the

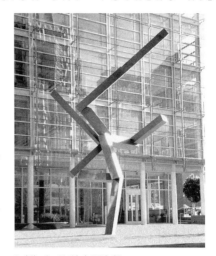

Joel Shapiro, Untitled, 1996–99

corner abutting the poem wall. Recalling the aura of Japanese gardens, the plaza's centerpiece is a giant boulder fronted by a cascade of small stones, which again double as seating. Plants and trees form a backdrop, further elaborated by tonal images and the words "rock & water" on a border wall lying behind the greenery.

Paul Kos and Robert Hass, *Poetry Sculpture Garden*, 2001

Doug Hollis, *Rain Column*, 1988; Scott Johnson, Rincon Center

10 Rincon Center

architect: **SCOTT JOHNSON**, 1989
99 Mission and 101 Spear Sts, 94111
BART: Embarcadero
Located on the city block bordered by Mission, Spear, Howard, and Steuart Sts.

From one end, Rincon Center has the appearance of a charming Art Deco building with a black granite base, limestone sculpture, concrete reliefs, and aluminum grillwork. But from the other end, the view is of a decidedly contemporary, glass-sheathed high-rise. The linking of the two sectors and redevelopment of the site into a mixed-use office/retail/residential complex, as well as the restoration of the historic component—the Post Office Annex, constructed in 1938—is an impressive example of architectural potency and constraint.

Although you can enter from any of the perimeter streets, if you start in the old

building you pass through corridors whose original ceramic tile walls, terrazzo floors, decorative metalwork, and murals (Anton Refregier, 1946–48) have been finely preserved. You then come upon the dramatic atrium designed by Los Angeles architect Scott Johnson. By adding two U-plan floors above the existing three stories, surrounding the central core with overlooking balconies, and topping the space with a glass roof, he skillfully revitalized the old interior.

New art incorporated into the architectural program also exemplifies a degree of sensitivity not often seen in big developments of this kind. Most notable is the water sculpture *Rain Column* (1988) by **DOUG HOLLIS**. Composed of an intriguing stream of water falling from the 85-foot-high skylight into a shallow pool in the middle of the atrium, the work is masterfully attuned to the space and setting. It is also visually, conceptually, and sensorially arresting. Complementing the sculpture are **RICHARD HAAS**'s illusionistically painted friezes (1988) that reference and update the historic murals in the old lobby by depicting images of culture, science, and technology in modern-day San Francisco.

If you continue back behind the atrium, you pass through a new addition and come to a garden courtyard that serves as the interface between the office area and the pair of 16-story apartment towers comprising the south end of Rincon Center.

11 Mark Lere

Float, 2001
1 Market St, 94105
BART: Embarcadero
Located in the small vestibule of the Market St entrance to the Landmark office building (between Steuart and Spear Sts).

In this three-part sculpture, Los Angeles artist Mark Lere explores issues of balance. Two of the forms are built from stacked layers of metal in progressively increasing and decreasing sizes. One takes the image of

a tall, tornado-like swirl, and the other of an elongated spinning top. Both stand upright, resting on a pinpoint where they touch the ground. In contrast, the third component is a small polygon of green-toned bronze topped by a spherical element. It, too, rests on a point, similarly appearing to resist the force of gravity that would topple it to the ground.

12 One Market Plaza

architect: **CESAR PELLI**, 1996
1 Market St, 94105
BART: Embarcadero
Located in the block bordered by Market, Spear, Mission, and Steuart Sts.

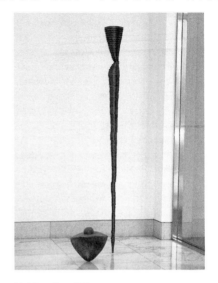

Mark Lere, *Float*, 2001

A massive neoclassical brick structure facing Market Street, originally called the Southern Pacific Building (1916), was enlarged in 1976 by the construction of two non-descript high-rises, the Spear and Steuart Towers. The resulting ensemble fills an entire city block. In 1996, Cesar Pelli was enlisted to renovate and accentuate the building's public spaces on the ground level. His design is highlighted by a succession of lattice-like sculptures of white-painted steel that take command of the interior and exterior entry spaces.

If you walk back from Mark Lere's installation, passing through the Market Street building, you will enter an 11-story, glass-roofed hexagonal atrium lined by Pelli's screen-like architectonic sculpture. Sometimes called the *Lattice Pavilion*, it rather dramatically transforms the space, effectively reducing the massiveness and blandness of the surrounding facades. The centerpiece in a side courtyard, by landscape architect **PETER WALKER**, further aims to embolden the space, but its object-like character only adds to the forbidding ambience of the architectural surrounds. Comprising an open, linear grid of tall stainless-steel pipes, the structure is set upright in a square pool, the rigorous geometry of which is assaulted by

an inverted giant pyramid of Plexiglas that rests like a fallen iceberg in its midst.

As you continue walking down the long concourse that extends back from the atrium to Mission Street, you pass through Pelli's

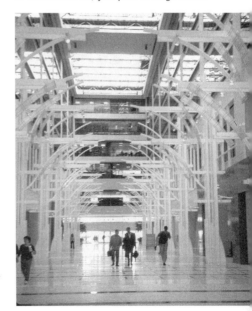

Cesar Pelli, *Lattice Gateway*, 1996

gateway of light-post sculptures. They are designed in the same lattice mode as the pavilion sculpture, but are shaped as lofty piers with curving elements at the upper reaches and transparent shields fronting the light fixtures. Another alignment of gateway structures, together with a six-story-high tower, borders the outdoor plaza at the Mission Street entrance.

To be sure, Pelli's sculptural installation adds theatrical stature to the building complex. It also challenges the usual renovation tactics by focusing on detached objects rather than surface treatments or spatial reconstruction. Sadly, the results are more interesting conceptually than aesthetically pleasing.

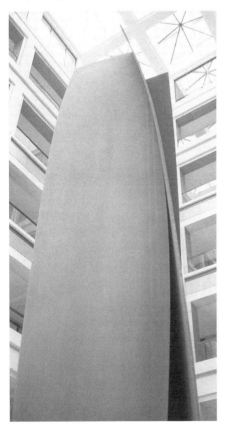

Richard Serra, *Charlie Brown*, 1999

13 Contemporary Jewish Museum

121 Steuart St, 94105
415-591-8800 f: 591-8815
www.jmsf.org
Sun–Wed, 12–5; Thurs, 2–7
admission: $4/3
BART: Embarcadero
Located between Mission and Howard Sts.

Prior to completion of its new building in 2008 (see pp. 45–46), the Contemporary Jewish Museum continues a limited exhibition program at this location. Based on its mission of exploring Jewish culture and identity in contemporary society, the museum presents art exhibitions that broadly manifest related concerns, images, and issues. For example, *100 Artists See God* (2004) featured the work of a spectrum of contemporary talents invited by its curators, the celebrated artists John Baldessari and Meg Cranston, to respond to the challenge of picturing the divine; and *The Jewish Identity Project* explored the hybrid and complex racial, national, and cultural identity of contemporary Americans through a Jewish lens.

14 Gap Headquarters

architect: **ROBERT A. M. STERN**, 2001
250 Embarcadero and 2 Folsom St, 94105
BART: Embarcadero
Located at the corner of Folsom St and Embarcadero. The public entrance is on Folsom St.

With a facade fronting the Embarcadero and offering panoramic views of the Bay Bridge and beyond, this 15-story building is supremely situated. Its architect, one of the leading names of the current era, might have given San Francisco a landmark design, but instead produced a mainstream structure so rooted in historical styles that it barely attracts attention. As a card-carrying postmodernist, Robert Stern has rejected the austere, reductive forms and rationalist

design of Modernism in favor of compositional complexity entailing heterogeneous spaces, hybrid borrowings, and allusions to or distortions of past traditions. In this instance, however, conservatism overshadows the merger of a ziggurat form, a tower cued to the four-stage belfry of the nearby Ferry Building, a brick facade with oversized warehouse windows (meant to blend with old industrial structures in the area), and a 1930s-style limestone entryway.

Even if you are not inclined to come and see the architecture, a visit here is an absolute must for anyone interested in contemporary art. The drawing card is the astounding, 60-foot-tall, 118-ton sculpture *Charlie Brown* (1999) by **RICHARD SERRA**. Though named in honor of *Peanuts*, whose creator Charles Schulz died as the work was being installed, its brutalist form and rugged Cor-ten steel material bear no relation to the beloved comic-strip character. The sculpture is pure Serra. Set as the centerpiece of a six-story atrium, it takes full command of the space. Because of its monumental scale and the sensation of uncertain balance, the object has both an awesome and an ominous presence. Like similar sculptures of an earlier vintage, this one is composed of long plates (four in this case) set upright, leaning against one another to form a frame around an enclosed space—only now the plates are torqued, and the size has increased manifold. An entryway between two of the segments invites movement within—into a mystical zone created by light shining down into the dark, tightly bounded interior from an opening, a perfectly defined square shape, at the top of the structure.

You may have noticed some prints by Roy Lichtenstein hanging among the framed Gap ads in the lobby area. Indeed, the Gap has a large collection of contemporary art, selections of which are displayed in a gallery just inside the Folsom Street entrance. Unfortunately, the gallery is not open to the public, but should you learn about a special

tour, try to join it. You will see a wealth of museum-quality objects by many leading artists of the past several decades.

15 Claes Oldenburg and Coosje van Bruggen

Cupid's Span, 2003
Rincon Park, Embarcadero, 94105
BART: Embarcadero
Located at the foot of Folsom St in a narrow grassy field alongside the waterfront promenade.

Claes Oldenburg and Coosje van Bruggen, celebrated for their witty, grand-scale public sculptures of common objects chosen with reference to a particular setting, here play with San Francisco's reputation as a city of love—denoted in such song lyrics as "I left my heart in San Francisco" and "If you come to San Francisco, summertime will be a love-in there." Symbolizing love by the stereotypic image of Cupid's bow and arrow, they, however, skew its meaning by partially burying the golden bow and pointing the 60-foot-tall silver arrow festooned with red feathers down into the earth rather than up toward the celestial realm.

In addition to its symbolic associations with love, the sculpture's image evokes the shape of sailing ships, typically present in the surrounding seascape. The taut bowstring and vertical arrow also echo the cables and towers of the nearby Bay Bridge. An association between the bow and arrow and Native Americans further contextualizes the image in terms of California history.

According to a statement by the artists, the arrow's position "gives the effect of connecting the earth and sky and makes a sort of writing quill out of the feathers. It also strengthens identification with the suspension bridge by placing emphasis on the bowstring. In its location on the incline of Rincon Park, the bow provides a frame for the spectacular landscape, and at the same time makes a broad wing-like gesture which

Claes Oldenburg & Coosje van Bruggen, *Cupid's Span*, 2003

embraces the sky. The form of the bow links up with a slice of the Moon, a Rainbow, a ship's keel, a nautical quadrant, and the shape of the park itself. The feathers, which are the most free, most elaborate and most colorful part of the work suggest the birds soaring along the waterfront and become the focus of the composition."

16 Oriental Warehouse

architect: **FISHER-FRIEDMAN**, 1997
650 Delancey St, 94107
Muni: N
Located between Brannan St and Embarcadero.

Gutting the interior has been a common mode of renovation for warehouse buildings in the SOMA area. In this case, the treatment of the shell as a preserved ruin along with blatant juxtapositions of old and new create a notable architectural statement.

As the bold white lettering painted across the brick facade notes, this 1868 structure housed the Oriental Warehouse, Bond and Freight—an enterprise dealing with incom-ing trade from Asia. Although exterior walls remained, albeit in a derelict, toppled condition, after a fire in 1988 and the Loma Prieta earthquake in 1989, a major overhaul was required to transform the building into the 66 live/work units that now occupy the premises. Historic preservation was coupled with radical reconfiguration entailing the creation of a second exterior, clad in corru-gated metal and separated from the original frame by a 15-foot-wide, open-air street. To make the double skin an emphatic, visible aspect of the outer design, Fisher-Friedman converted upper-level windows along the side brick walls into cut-out voids.

Besides the brick exterior, salvaged parts of the original heavy-wood construction, including timber roof trusses, likewise call attention to the building's history, while the high-tech glass, stainless-steel doors, steel I-beams, and tension cables that shape the main entrance and lobby reinforce the contemporary flavor proclaimed in the metal-faced walls. Not only do past and present dramatically abut one another, but paradoxically, an old industrial structure has

been converted into a residential dwelling designed with an industrial appearance and the latest cult of industrial materials..

17 Jack London–South Park Building

architect: **TOBY LEVY**, 1996
86–96 South Park Av, 94107
bus: 30, 45
Located at the intersection of South Park Av and Jack London Alley.

Laid out in 1856 in the style of London squares, South Park is an oval-shaped bit of greenery ringed by a hodgepodge of three- and four-story, eclectically styled buildings. The neighborhood became a lively hotbed of dot-com startups during their heyday years, but has returned to its former low-key existence and almost desolate state since the bust.

Situated on a corner lot, Toby Levy's design adopts the European urban tradition of placing housing over storefront commercial and office units. The structure is a conglomerate of syncopated materials (galvanized metal, slate, copper, glass), colors, shapes, and spatial relationships. Each segment is individualized yet part of the dynamic interplay that enlivens the whole.

Having gutted the preexisting building, the architect inserted a courtyard and garage into the layout, strongly articulated an interior colonnade of bright orange steel beams that replaced the original bearing wall, and added tension to the design by rotating a set of interior spaces 45 degrees. The project is also ecologically attuned in its use of nontoxic, renewable, and recyclable construction materials.

18 Gallery 16

501 3rd St, 94107
415-626-7495 f: 626-8439
www.gallery16.com
griff@gallery16.com
Mon–Fri, 9–5; Sat, 11–5
bus: 15, 30, 45
Located on the corner of Bryant St.

The gallery occupies the spacious ground floor of a renovated brick warehouse with large windows, a high wood-beam ceiling, and lots of natural light. Founded in 1995, the exhibition space is run in partnership with Urban Digital Color, a high-tech printing company situated in the back room and visible through glass doors. Though digital design is not necessarily shown in the gallery, artists who experiment with new modes of creation and deviate from sanctioned attitudes are favored. Exhibitions draw from both mid-career and young talents. The work tends to express a quirky but engaging sensibility.

Sample exhibitions: *Elliot Anderson, Adriane Colburn, Lowell Darling, A Group of Mostly Unrelated Things, Instant Messaging, William Laven, Charles Linder, Rex Ray, Carol Selter, Rudy VanderLans, Alex Zecca.*

Rex Ray, *Chrysotomentum*, 2005; Gallery 16

19 Live/work building

architect: **RICHARD STACY**, 1992
25 Zoe St, 94107
bus: 30, 45, 47
Located between Bryant and Brannan Sts.

If you are curious about the new live/work structures that have become a ubiquitous part of SOMA, take a little detour down Zoe Street to see an early example. Like many in-fill projects, it is situated on a narrow plot and takes its cues from old warehouse and industrial buildings in the area. Adopting a bare-bones aesthetic, the facade is demarcated by an exposed I-beam framework; the staircase tower, articulated as a separate block on the right side of the front elevation, is clad in metal; the ground floor (garage and office) has a steel exterior; and the two upper levels (residence and studio) are faced with a window wall. The exterior of low-cost materials used in a raw state is thus composed to differentiate interior spatial functions. The industrial image continues on the side wall, a metal surface with irregularly placed window openings.

20 Bacar

architect: **JAMES ZACK**, 2000
448 Brannan St, 94107
415-904-4100 f: 904-4113
www.bacarsf.com
dine@bacarsf.com
Mon–Sat, 5:30–12; Sun, 5:30–11
bus: 30, 45, 47
Located on the corner of Zoe St between 3rd and 4th Sts.

Big brick arches filled with black mullioned windows create an inviting facade for this renovated 1924 warehouse now occupied by an upscale restaurant named Bacar—the Latin word for "wine glass." Wine, signified by a giant, vertical wine cellar, is also a focal point of the interior. Having an incredible presence and visual impact, over 1,000 different bottles are set horizontally, face out behind a glass wall that doubles as the side of the central staircase. Whether you go up to the bar and main dining room, further up to the top-level mezzanine, or down to the basement lounge, you pass directly in front of the wine display. Linear rhythms, articulated in mahogany and steel, also enhance the image of both the cellar and staircase.

Brick reappears as the back wall of the spacious, high-ceilinged main room, though wood used elsewhere softens the ambience. The front mezzanine, with its glass parapet wall and arched-window backdrop, is another nice touch that adds elegance without being ostentatious. And should you prefer something more enclosed, there's the downstairs room with a club flavor.

In addition to food, drink, and architectural finesse, Bacar offers live jazz seven nights a week.

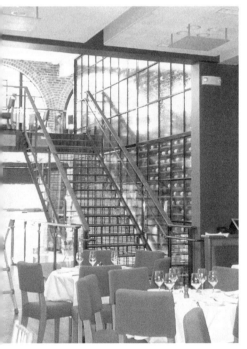

James Zack, Bacar

Peter Pfau, SFMultiMediaCenter

21 SFMultimediaCenter

architect: **PETER PFAU**, 2000
475 Brannan St, 94107
www.475brannan.com
bus: 30, 45, 47

Located between 3rd and 4th Sts across from Bacar in the heart of an area dubbed "multimedia gulch" to signify the glut of computer wizards, techies, and digital designers gathered there in the heyday of late-1990s activity.

You can't miss this eye-catching structure—a three-story, post-1906, mustard-toned brick warehouse with royal-blue trim topped by a new two-story addition sheathed in red corrugated metal with segments slanting forward and back. Designed during the dot-com craze, it reflected the unconventional spirit of its cutting-edge inhabitants, most of which are companies that no longer exist.

Do not just wonder at the exterior. Step into the lobby and see how Peter Pfau has carried out his bold architectural vision. Immediately inside, you are confronted with eye-popping perspectival grandeur derived from a long entry hall made to appear even longer and more orthogonal by the steel-and-glass space divider running down its center. No simple wall, it has a jazzy surface with wavy, zigzagging, and striped segments. It also functions as the office directory for the building. Although its material and design foreground a contemporary, industrial aesthetic, the surrounding space lays bare the brick walls, wooden slat ceiling, and large timber posts of the original building. The floor, a gently sloping, black-and-white-striped concrete ramp on the right and a stepped passageway on the left, exaggerates the length of the lobby. (A series of mammoth tarp paintings inspired by Diego Rivera's murals of Mexican workers, which hang across the side walls, are unfortunately at odds with the architecture and offer little artistic enhancement in their own right.)

At the back of the lobby, a metal-screen staircase and bank of elevators set into walls faced by the same red corrugated steel as on the exterior, lead to a U-shaped open-air courtyard landscaped as an interior plaza. The ground-floor office area in the back (suite 110), albeit no longer occupied by the high-tech gurus who spent megabucks to outfit the interior, still references that bygone era.

Devised as a loft environment with a mez-zanine level (architect: **JAMES BARRETT**), it is shaped by exposed structural elements, chic indirect lighting panels, and snazzy aluminum fittings.

22 Limn

290 Townsend St, 94107
415-543-5466 f: 543-5971
www.limn.com
Mon–Fri, 9:30–6; Sat–Sun, 11–6
Muni: N; bus 30, 45
Located on the corner of 4th St, a block away from AT&T Park.

Begun in 1981, Limn now claims to be the largest contemporary furniture store in North America. Indeed, the San Francisco showroom is a vast emporium filled to the gills with an eye-popping array of design-driven furniture, lighting, and accessories. Given this description, you may think you are at the wrong address when you come upon a dreary, blockhouse-like concrete structure with uninviting glass-brick windows. (The building was formerly a food-processing plant.) The Limn sign—a gilded, volumetric heart covered by a black cloth and bound by cords—extends out in front of the entrance door, itself shielded by handcrafted steel gates. The surreal character of the entrance is no more inviting than the bleak exterior of the building, though it sets the stage for the artsy eccentricity of many of the objects displayed within.

Limn represents over 1,200 international manufacturers, primarily of European origin. The list includes such top-of-the-line names as Alessi, B&B, Balthup, Cappellini, Cassina, Droog, Herman Miller, and Molteni; and such illustrious designers as Charles and Rae Eames, Arne Jacobsen, Xavier Lust, Ingo Maurer, Isamu Noguchi, Philippe Starck, and Marcel Wanders. The seemingly end-less selection abounds in objects merging innovative ideas with unorthodox forms, materials, techniques, and aesthetics. Among the treasures are *Moraine*—a long, twist-ing sofa "derived from dynamic landscape formations like glaciers and erosions," by the ever-adventurous architect Zaha Hadid; *Zeppelin*—a shell-like chandelier by Marcel Wanders; *Witch Chair*—a seat draped with fabric made of cut-leather strips by Tord Boontje; and the Airstream vacation trailer retrofitted with Italian furnishings by Cec-cotti.

Limn's inventory spreads across two floors in several interconnected spaces and on a rooftop garden. What's more, objects are everywhere—hang-ing from the ceiling, enclosed in vitrines, stacked on shelves, and organized as room instal-lations. Although the entire showroom used to be totally accessible, security concerns now limit free public access to a single room behind the front entrance and an area in back specifically devoted to B&B products. Should you wish to

Limn

see more, you can do so by asking for a sales escort at the reception desk.

Not only does Limn continuously change its displays, but it presents special exhibitions several times a year. (Since these are in the front space, they are open to the general public.) Sample exhibitions: *Le Corbusier for Cassini, Piero Lissoni, Venini Glass, Zanotta*. An art gallery, located in a rear building, aims to bring art and design together, but it functions more like a stepchild of the furniture enterprise offering second-tier works suited more to an interior decorating mentality than to artistic creativity in its own right.

23 Tart

47 Lusk St, 94107
415-203-5865
www.tartsf.com
info@tartsf.com
Sat, 1–6
Muni: N
Located in a renovated warehouse in a secluded back alley off Townsend between 3rd and 4th Sts.

Operating out of a loft-residence with a very limited schedule of open hours, Tart runs a low-key program—more cerebral than most galleries in San Francisco. The exhibitions favor technically crafted objects, video, and multimedia installations by young and established, but relatively unknown international artists. The presentations are often quite spare, featuring only a few, small works that call forth a given theme or point of reference. Indeed, Tart functions as a curatorial project space, non-commercial in its orientation, not representing a set group of artists, and mainly concerned with raising awareness about contemporary art practice and issues.

Sample exhibitions: *Luke Fowler, Hot Sty, I don't know my name, Panic in Detroit, Spiritual America, Eve Sussman & Anne-Marie Copestake, Stephen Sutcliffe, Unspooled Stories*.

24 Tres Agaves

architect: **JAMES ZACK**, 2005
130 Townsend St, 94107
415-227-0500 f: 227-0535
www.tresagaves.com
info@tresagaves.com
Mon–Fri, 11:30–10; Sat–Sun, 3–11
Muni: N
Located near the corner of 2nd St.

Three stone fingers symbolizing the three types of 100% Blue Agave tequila mark the entrance of this upscale Mexican restaurant. On entering the lobby, a rock wall framed by a wire-mesh case with a cut-out center enabling views into the main space sets forth a rustic/contemporary atmosphere. The aesthetic is elaborated in the dining room by the family-style banquet tables, bench seats, 20-foot ceilings, timber posts, brick walls, concrete floors, exposed metal air ducts, and an overscale black lantern. Some features remain from the building's original life as a turn-of-the-century fire department carriage house; others reference traditional Jalisco style and the ambience of a Guadalajara street. In the bar area, the long, wire-and-glass storage case containing premium bottles of tequila (the top end of 100 different varieties of over 30 brands available in the restaurant) serves as yet another signifying feature within the architectural layout.

The Tasting Room, an enclosed dining area for small private parties, and The Plaza, a spacious event room outfitted with mobile taco carts and large video-projection screens, complement the front areas.

25 Mark di Suvero

Sea Change, 1995
South Beach Park, 94107
Muni: N
Located between Townsend and 2nd Sts, where Embarcadero turns into King St.

The park faces the harbor adjacent to Pier 40 and lies at the foot of the AT&T baseball

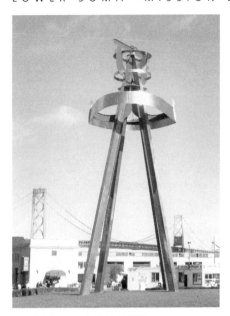

Mark di Suvero, *Sea Change*, 1995

stadium. Set in the midst of a grassy field, this 60-foot-high, red-painted steel sculpture commands a view from all directions. Its towering four-legged form is crowned by circular rings, one of which is a shiny stainless-steel band. The top elements, which move gently around with wind currents, give evidence of Mark di Suvero's signature creation of monumentally scaled works with carefully engineered balance systems. Although his bold adaptation of industrially fabricated materials (especially I-beams) is notable here, this particular work lacks the dynamic expressiveness of trusting diagonals and sophisticated suspensions that characterize his most renowned structures.

26 Anna Murch

Muni shelter, 1998
King St
Muni: N
Located at the Muni station between 2nd and 3rd Sts in front of Pac Bell Park.

The Muni Metro line, which extended the public transportation network along the Embarcadero, includes Anna Murch's design for passenger shelters. Alluding to rhythms in the bay and hills beyond, she created wave-shaped laminated-glass canopies. They offer protection from the elements and add a touch of visual identity, but do not block views or loom large in the setting. The branching form of the columns supporting the roofs reflects the trees that line the rail line.

27 AT&T Park

24 Willie Mays Plaza, 94107
Muni: N
Located between 2nd, 3rd, and King Sts and China Basin.

Opened in 2000 to a lot of hoopla, the new home of the San Francisco Giants was widely praised by baseball experts and fans and rapidly became one of the city's most popular sites. The retro-style brick-paneled structure was meant to conjure the intimate aura of historic stadiums, like Fenway Park and Wrigley Field. It is not adventurous contemporary architecture by any stretch of the imagination. But it is an urban- redevelopment success story.

Situated within walking distance from downtown and conveniently served by various modes of public transportation, the stadium is nestled within a small bay-front plot of land, previously considered an end-of-the-earth location. Not only does the ballpark itself take full advantage of the spectacular views, but the adjacent, nicely landscaped promenade running along the marina likewise offers a sweeping panorama of the bay. In addition to rescuing and then enhancing a forsaken bit of urban property, AT&T Park was the catalyst for transforming a bleak industrial area into a diversified neighborhood. Restored old warehouses plus a rash of new construction have revitalized nearby streets, now composed of housing, retail businesses, and office buildings.

28 3rd Street Light Rail Platforms

Located along 3rd St from Mission Bay to Visitation Valley.

Three artist teams created various designs to be architecturally integrated into the 28 boarding platforms of the new 3rd Street Light Rail. The basic template features glass-and-metal canopies, shadow-casting and windscreen panels, metal pole sculptures, paving elements, and a red-and-black banded trackbed extending the length of the transit route.

The artwork is generally unobtrusive and fairly bland. Most notable are the *Helix* and *Flight* pole sculptures by **BILL and MARY BUCHEN** at the UCSF and 20th Street platforms.

Mission Bay

The section of the 303-acre Mission Bay development project to the south of Mission Creek Marina is a sprawling stretch of industrial wasteland, formerly occupied by the Southern Pacific rail yards. Long neglected, it is being reinvented as a new neighborhood with a biotech-centered campus of the University of California San Francisco as its centerpiece. The plan calls for surrounding the campus with housing intermixed with offices, retail businesses, parks, a hotel, a school, and other community facilities. Anticipating that the university's presence will attract medical-research and pharmaceutical corporations, the property developer hopes to establish Mission Bay as a premier focal point of the life-sciences industry.

Construction within the area began in 1999 and is expected to continue for 20 years. Already it is evident that this enormous urban-reuse project is radically changing the geography and socio-economic landscape of the city.

UCSF Mission Bay

3rd St Light Rail: UCSF; bus: 15, 30, 45
UCSF is developing a 43-acre research and teaching campus on the stretch of land between 3rd and 7th Streets bordered on the south by 16th Street. The project encompasses various office and laboratory buildings, a community center, a housing-retail complex, and a campus green. With no existing structures as constraints, a prime inner-city location, and open acreage with commanding views, it was a golden opportunity for enhancing San Francisco architecture and embracing revisionist thinking with regard to the urban planning.

High-profile architects and landscape designers were selected to design the individual structures: Bohlin Cywinski Jackson, Ricardo Legorreta, Cesar Pelli, Stanley Saitowitz, Skidmore Owings & Merrill, Rafael Viñoly, Peter Walker, Zimmer Gunsel Frasca. Unfortunately, bureaucratic priorities told precedence over creativity, resulting in buildings that are, for the most part, bland, exceedingly institutional, and retrograde in appearance. In contrast, artwork, commissioned as part of a 1%-for-art program, is world-class and exciting—the best, most visionary public art in the Bay Area by far.

29 Richard Serra

Ballast, 2004
UCSF Mission Bay
3rd St Light Rail: UCSF; bus: 15, 30, 45
Located in the plaza bordering Gene Friend Way at the east entrance to the UCSF Mission Bay campus. This entrance is adjacent to the UCSF station on the 3rd Street Light Rail.

This monumental sculpture is a classic example of the Cor-ten steel-plate creations by world-renowned, San Francisco-born artist Richard Serra. Set along the centerline of a plaza the size of a football field, *Ballast* consists of two vertical plates spaced equidistant from one another and the cross-streets at

LOWER SOMA — MISSION BAY — POTRERO HILL

Richard Serra, *Ballast*, 2004

30 Liz Larner

2001, 2001
Rock Hall, UCSF Mission Bay
1550 4th St, 94158
3rd St Light Rail: UCSF; bus: 15, 30, 45
Located in the main lobby of the research building at the northeast corner of Koret Quad.

Issues of transmutation with reference to color, shape, solidity, mobility, uniformity, and identity lie at the core of this large, heteromorphic object of iridescent purplish-green color. In the words of the artist: "I developed it using computer animation: the sphere gets animated into a cube and then spins back into a sphere again. There's only one cube in the whole thing. The rest of the forms are combinations of those two seemingly opposite forms. There's really no name for those forms, because they're hybrids of a cube and a sphere. The entire shape itself is really spherical because of the motion and rotation it suggests. . . . I was interested in an 'attack' on the cube, opening it up and revealing its instability."

In its density, this fiberglass-and-steel sculpture is unusual for Liz Larner, an esteemed Los Angeles artist whose unconventional creativity has ranged from presentations using organic matter to objects composed of steel chains. Although the work wasn't specially created for UCSF, its conceptual underpinings share a common ground with current studies in genetics and related fields.

31 Koret Quad

landscape architect: **PETER WALKER**, 2003
UCSF Mission Bay
3rd St Light Rail: UCSF; bus: 15, 30, 45

The quad, the main outdoor plaza of the Mission Bay campus, is a green space larger than Union Square. It is designed as two oval areas, one a grassy knoll with a stone platform at its base, and the other a bowl

either end. The weathering plates, which are over 49-feet high each weighing 70 tons, tilt 18 inches, one to the north and one to the south. According to the artist, the work was designed "to hold the vastness of the space, emphasizing its horizontality and holding the space and volume between the two pieces." As with other of Serra's seemingly simple works, the sculpture defines viewpoints even as it heightens awareness of scale, structural dynamics, and space. It also yields an experience that is physically, psychologically, and emotionally engaging.

This work alone is worth a visit to the UCSF campus. Its presence adds significantly to the university's public art program and to the reputation of art in San Francisco.

conducive to frisbee and other field games. A tree-lined walkway crosses in between, and more heavily wooded zones surround the ovals, creating a forest-like setting along the path that borders the entire quad. The formal layout of the landscape conforms with the geometric rigor of the buildings, though a counterpulse exists in Roy McMakin's unconventional, randomly positioned seating.

31 Roy McMakin

Untitled, 2003
Koret Quad, UCSF Mission Bay
3rd St Light Rail: UCSF; bus: 15, 30, 45

Outdoor furnishings were specially designed for the landscape in the campus quad by Seattle-based Roy McMakin. The benches and chairs made in stone, wood, bronze, concrete, fiberglass, steel, and porcelain enamel reveal the incredible craftsmanship and finely tweaked forms that have established the artist's widespread reputation. Added to this is a quirky, outside-the-norm sensibility marked by cleverness in the morphing of a single form into variant configurations, and humor in the adaptation of such things as refrigerators, banker's boxes,

Liz Larner, *2001*, 2001

and desk chairs (common to science labs) for garden seating. As one critic has observed, McMakin alters familiar forms "just enough to throw perception off balance" and raises the ordinary "to new heights by small adjustments of scale and a sense of play."

Irregularity prevails in the idiosyncratic mix of elements, and informality reigns in their casual placement, clustered alongside

Roy McMakin, Untitled, 2003

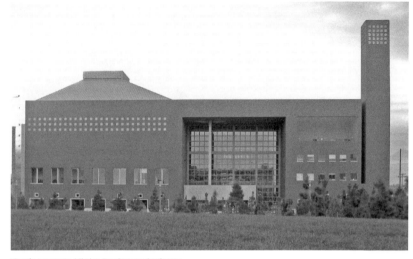

Ricardo Legorreta, Mission Bay Community Center

pathways or scattered about. The arrangement is defiantly illogical, nonlinear, and

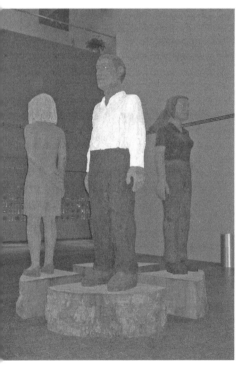

Stephan Balkenhol, Untitled, 2004

congenially haphazard in contrast to the formal, right-angled design of the garden.

32 Mission Bay Campus Community Center

architect: **RICARDO LEGORRETA**, 2004
1675 Owens St, 94158
3rd St Light Rail: UCSF; bus: 15, 30, 45
Located just north of 16th St and east of Owens St along the western edge of Koret Quad.

Visually, this building stands out amid the conservative architecture elsewhere on the campus. Instead of a beige-toned surface and uniform fenestration, the structure is richly colored in red and hot pink and punctuated by grids of diversely sized inset windows. The slender tower on the right, pyramidal roof on the left, and the entrance portico in the center—a monumental cut-out space, faced by a glazed wall and topped by a pie-shaped skylight—are distinctive. Color and design pizzazz are also features of the interior, which is organized around a dramatic, royal-blue atrium suffused with natural light from above and overlooked by balconies, bridges, and a grand orange staircase.

Intended as a gathering place for informal interactions among students, faculty, and the local community, the versatile building incorporates a range of facilities: a fitness complex, conference center with a large auditorium, library, dining rooms and cafés, offices, student services, retail spaces, relaxation terraces, and such recreation areas as outdoor and indoor swimming pools, tennis courts, basketball and volleyball courts, and a game room. Not only is the scope extraordinary, but the building's design gives them an allure that far exceeds the conventional and functional. For example, the basketball court is set on the top floor under the pyramidal skylight, and the outdoor swimming pool lies nestled within a palm-tree-lined patio on the roof.

Although based in Mexico City, Ricardo Legorreta is well represented in the Bay Area by designs that have a decidedly contemporary, individualistic flair without the industrial aesthetic that has become the trendy style of much vanguard architecture. (See pp. 188, 193–95, 220–21)

Jim Iserman, Untitled, 2003

32 Stephan Balkenhol

Untitled, 2004
Campus Community Center
1675 Owens St, 94158
3rd St Light Rail: UCSF; bus: 15, 30, 45
Located in the main atrium.

Created by the internationally renowned German artist Stephan Balkenhol, these four, crudely carved wood figures standing eight to ten feet tall and positioned so that each faces a different direction, present empathetic images of common individuals. The idea of likeness and difference implicit in this composition has an intriguing undercurrent, since all four figures come from the same tree trunk. The ensemble is a compelling presence within the high atrium space.

33 Jim Iserman

Untitled, 2003
Genentech Hall, UCSF
600 16th St, 94158
3rd St Light Rail: UCSF; bus: 15, 30, 45
Located in the main atrium of the grandiose structure on the corner of Owens St. You can gain access to the atrium from the entrance to Genentech Hall off of Koret Quad. Should the building be closed or the lobby inaccessible, take the grand staircase leading up to the outdoor amphitheater, and you can get a good view of the work through the glass curtain wall fronting the atrium.

Los Angeles-based Jim Iserman—a leading name in the development of innovative mergers between fine art, craft, and interior design—created a chandelier as the focal

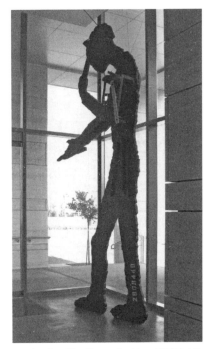

Jonathan Borofsky, *Hammering Man at 2,908,440*, 1984

as a five-part ensemble, both accentuating the verticality of the setting and serving as a vitalizing point of interest. The brilliant red-orange coloration and geometric imagery is typical of Iserman's art, though the lattice chains enveloping connecting spheres are akin to molecular structures, a reference to the research specialty of the laboratories in Genentech Hall.

34 Jonathan Borofsky

Hammering Man at 2,908,440, 1984
QB3 Byers Hall, UCSF
1700 4th St, 94158
3rd St Light Rail: UCSF; bus: 15, 30, 45
Located in the main entry of QB3 Byers Hall on the corner of 4th and 16 Sts.

Hammering Man, a lanky, silhouette in black-painted steel, is an iconic work of Jonathan Borofsky. Since its inception in 1980, the image, diversely sized, has been installed as a public artwork in museum lobbies, corporate headquarters, outdoor plazas, and shopping centers throughout the world.

The motorized figure, its head bent down, repeatedly strikes a piece of metal with a hammer held in his moveable left arm. The activity recalls the monotony and drudgery of

point of the five-story atrium, the circulation hub and social center of this research building. But whereas chandeliers usually hang from the ceiling in open space, here the light fixture floats in front of a side wall

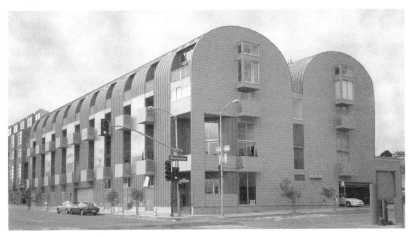

Stanley Saitowitz, 3rd St Lofts

the assembly-line even as it suggests endurance, unremitting energy, and fortitude. According to the artist, the figure was conceived as a universal image celebrating the worker. The number imprinted on the figure's leg, which is Borofsky's mode of signing his work, derives from his practice of counting to quiet the mind.

Amanda Hughen, *Disparate Classification,* 2005; Ampersand International Arts

34 Vincent Fecteau

Untitled, 2007
QB3 Byers Hall, UCSF
1700 4th St, 94158
3rd St Light Rail: UCSF; bus: 15, 30, 45
Located on floors 1 through 5; only the first floor fountain is accessible to the public.

Working in the interface between art, architecture, and design, Fecteau re-imagines everyday objects by flaunting or eradicating their banality. Here, he treats the drinking fountain as a "found object," which he incorporates into an angular structure.

35 3rd Street Lofts

architect: **STANLEY SAITOWITZ**, 2002
2002 3rd St, 94107
bus: 15, 22
Located on the corner of Mariposa St.

This 38-unit structure is one of the live/work buildings shaping a new residential community in the midst of a heavy industrial zone one block from the docks and waterfront. As in other projects by Stanley Saitowitz (see pp. 68, 76, 209, 211, 228), metal siding clearly references the urban, industrial setting. Two barrel-vaulted roofs, which run down the length of the structure, and a facade of inset windows and projecting balconies distinguish the design, especially as they deviate from the ubiquitous cube form. Configuring the units as three-level spaces with separate live and work areas also gives them an unusual flair.

36 Ampersand International Arts

1001 Tennessee St, 94107
415-285-0170 f: 285-6856
www.ampersandintlarts.com
bruno@ampersandintlarts.com
Fri, 11–5
bus: 15, 22
Located just south of 20th St in the residential/industrial area of Potrero Hill on the east side of Interstate 280.

Although it is way off the beaten track and has very limited hours of public operation, this gallery offers yet another perspective on the San Francisco art scene. Occupying the main floor of a renovated tile factory, now a live/work dwelling, the display space is an airy, open stretch divided into two rooms. Usually the gallery presents a pair of concurrent solo shows, mainly featuring young, local artists. Whether abstract or figurative, the work tends to be well crafted and visually engaging.

Artists: Victor Cartagena, Nilus De Matran, Uli Gassmann, Lisa Goldschmid, Lori Gordon, Tanya Hastings Gill, Amanda Hughen, Jeff King, Christine Lando, Dharma Strasser MacColl, Jen Pack, Al Reyes, James Sansing,

Sarah Smith, Jennifer Starkweather, Rebecca Szeto, Andy Vogt, Megan Wilson.

37 Housing complex

architect: **DAVID BAKER**, 1995
1601–95 Arkansas and 310–390 18th Sts, 94107
bus: 19, 22

Abutting a school playground on its west side, this complex fills the block between 18th and 19th Streets along Arkansas Street. It is located on the site of an old railway tunnel and encompasses a mix of 30 live/work lofts, ten townhouses, and 24 flats. Aiming to avoid the standardized look and aura of uniformity that typifies most multi-unit housing, architect David Baker infused the whole and its parts with visible marks of variety.

Lofts, which occupy the 18th Street boundary, are designed in an industrial aesthetic with sheet-metal siding and large windows. Color accents, suspended balconies, and slanted skylight walls syncopate the facade, though a repetition of vertical delineations establishes the predominant rhythm. Whereas this segment of the complex makes reference to warehouses in the factory district at the base of Potrero Hill,

Daniel Solomon, Gleeson-Jeanrenaud House

the townhouses stepping up the hill along Arkansas Street are allied with the domestic architecture of the upper residential zone. There's a prevalent blandness and yet diversity is evident in decorative touches and in geometric permutations of the boxy, clapboard-covered forms comprising the house fronts.

A high point in the project is the garden area nestled in the middle. (A small path cutting through the units lining Arkansas Street leads to the back.) A density of plants tumbles down the steep terrain, and walkways make the landscaped setting an integral part of the L-shaped complex of buildings that encloses it.

38 Gleeson-Jeanrenaud House

architect: **DANIEL SOLOMON**, 1991
610 Rhode Island St, 94107
bus: 19
Located between 18th and 19th Sts.

This quirky house, set into a steep hillside in a funky neighborhood of mundane dwellings, pushes vernacular bay-window, shingled architecture to an eccentric extreme. Totally devoid of the decorative and multicolored embellishments that typify San Francisco Victorians, it is a monochromatic, box-shaped structure entirely clad in black asphalt shingles except for the ground level, where raw concrete blocks and three perforated-steel garage doors form a gray-toned base. No attempt has been made to mask the common, inexpensive, raw industrial materials. (The clients wanted "something strong, harsh, and unhouselike . . . a kind of antibourgeois bourgeois house.")

Despite the somber exterior, a glass-roofed rotunda in the middle of the house fills the interior with natural light. The tower, which contains spiral staircases, adds curving rhythms to the cubic structure while serving as an airy passage between the living area in front and two studio wings facing a garden in back.

The facade has been described as "deliberately ambiguous." The entrance is barely evident, hidden behind an unassuming door off to the side of the structure; square windows in the bays are stacked five levels high, though they correspond to three floors of interior space; and the miniaturized size of these windows, radically disproportionate to the large window expanse alongside, renders the building scaleless. In addition, the tonal and material disconnect between the top and bottom of the house produces an eery, levitating effect, causing the main structure to appear as if it is floating above the ground.

Without doubt, the most idiosyncratic feature of the facade is its centerpiece: a metal chimney and fireplace box painted black to blend with the shingles and attached as add-ons to the exterior of the building. Cutting lengthwise through the window wall in the middle of the front elevation, the long, narrow chimney tube becomes a spinal column, absurdly exaggerating the utter symmetry of the facade.

Should this house look familiar, you might have seen it in *The Joy Luck Club*. In the movie, Lena's mother laments that a home costing a million dollars still has crooked walls!

39 San Francisco Center for the Book

300 DeHaro St, 94103
415-565-0545 f: 565-0556
www.sfcb.org
info@sfcb.org
Mon–Fri, 10–5
bus: 19, 22

Located in a big corrugated-metal shed painted royal blue with the entrance on 16th St under the black awning. Originally a train station (two old trains still parked outside have been appropriated for use as offices), the building is now nestled beneath an industrial- design condo/retail complex clad in shiny metal.

The interior space of the Center for the Book is largely used for workshops, classes, and lectures on bookmaking. However, periphery walls and display cases are devoted to exhibitions of one-of-a-kind or small-edition books of exceptional design, including artists' books. Shows are modest in scale and focus on a particular format, bookmaker, historical period, printing workshop, or seasonally relevant topic. The contemporary era is often represented, as in *Revealing the Mysteries: The Development of the Artist's Book in the Bay Area*, a project featuring wondrous examples of unbridled creativity by Wallace Berman, Richard Brautigan, Jess, and others.

Sample exhibitions: *50 Books/50 Covers*, *Found in Translation*, *Handmade Books from Cuba*, *Multiplicity for Millions*, *Photo Books Now*, *Swiss Impressions*, *X Libris*.

40 California College of the Arts

1111 8th St, 94107
architects: **TANNER LEDDY MAYTUM STACY**, 1999
bus: 10, 19, 22

Located between Hooper and Irwin Sts in an industrial district at the base of Potrero Hill. Although a large building, it is difficult to find since this segment of 8th St is disconnected from the segment running through the SOMA area. If you use the intersection of 16th and Wisconsin Sts as a guide and then go one short block north, you will arrive on the spot.

In response to a space crunch at its Oakland campus, California College of the Arts (previously called California College of Arts and Crafts) decided to convert an abandoned, cavernous Greyhound Bus maintenance garage (originally designed by **SKIDMORE, OWINGS & MERRILL**, 1951) into a solar-heated, multi-use facility. The transformation retained the building's industrial character, preserving its monumental

The world

reduced to
order of
able to leave

Thomas Hirschhorn, *Utopia, Utopia=One World, One War, One Army, One Dress*, 2006; CCA Wattis Institute

volume, unimpeded interior, skylights, glass curtain walls (on three sides), and massive concrete beams arched across the roof. A new steel framework (seismic V-braces) was added without devitalizing the light-filled hangar space. Indeed, its vast openness is emphasized by the creation of a wide central "street"—used for circulation, exhibitions, makeshift teaching zones, social activities—and the installation of wall partitions to produce a maze of interconnected studio and work areas. Attached to the main structure on the south side is a second building with a two-floor, balcony-like arrangement. It houses an auditorium, library, offices, shops, and meeting rooms. Of particular note is the boat-shaped Helzel Boardroom with mahogany-slat walls and a long, curve-sided table (**JENSEN & MACY**).

The architecture clearly prioritizes interaction, accessibility, and flexibility. This is immediately evident at the entrance, where you pass directly into a terrace with a café on the right and gallery on the left. Not only does the terrace, furnished with tables and chairs, serve as a gathering place, but its glass-enclosed space also permits views out to the surrounding neighborhood and into the social setting of the café, the main passageway of the building, and exhibitions in the gallery.

40 CCA Wattis Institute

Logan Gallery, 1111 8th St, 94107
415-551-9210 f: 551-9209
www.wattis.org
wattis@cca.edu
Tues–Sat, 12–5
bus: 10, 19, 22
Located to the left, just after you pass through the main entrance.

Although the gallery entrance is separated from the enticing window wall in the entry terrace and oddly hidden down a passage, a bright orange screen hanging over the doorway signals the location. Created by experimental designer **THOM FAULDERS** (2003), the screen accentuates surface expression with its rhythmic flows across vertical bands of perforated aluminum.

Under the direction of Ralph Rugoff (2000–06), the CCA gallery offered a top-notch program, providing rich exposure to edgy, international contemporary art. More than being a display space, it saw itself as "a kind of exhibition laboratory that experiments with different ways of presenting and developing contemporary art and design." This approach was apparent in the prevalence of thematic shows (often with oddball titles) that broadened the scope of artistic consideration while challenging thinking about the definition and nature of art. Hopefully, the program will be as energetic and stimulating when a new director takes the helm.

Sample exhibitions: *A Brief History of Invisible Art*, *Thomas Hirschhorn*, *How to Build a*

Universe That Doesn't Fall Apart Two Days Later, Humans Were Here!, Prophets of Deceit, Radical Software, Rethinking Conceptual Art. Small catalogues with pithy, informative texts accompany many gallery shows.

The exhibition program also encompasses adventurous installations created as part of the Capp Street Project, a residency program begun as an independent San Francisco entity (1983) and then incorporated as a facet of the Wattis Institute (1999). Tariq Alvi, Jeanne Dunning, Brian Jungen, and Michael Stevenson have been recent participants.

The Wattis Institute and CCA also organize an impressive, full menu of free lectures, symposia, performances, and events. These bring renowned and emerging artists, architects, designers, and filmmakers to San Francisco, offering enlightening presentations as well as lively Q&A exchanges. Visitors have included Janet Cardiff & George Burus Miller, Andrea Fraser, Jeanne Gang, Michael Kimmelman, Yvonne Rainer, Bridget Riley, Lebbeus Woods.

41 CCA Graduate Center

architects: **JENSEN & MACY**, 2003
188 Hooper St, 94107
bus: 10, 19, 22
Located across from the main CCA building at the corner of 8th St.

Transformed from a dilapidated warehouse, this simple but striking facility now houses 32 artist studios, two large meeting areas, and a courtyard earmarked as an outdoor workspace. The exterior had been economically reclad on the lower section with corrugated cement and wrapped on the upper level with a continuous band of translucent polycarbonate panels. The latter fill the interior with natural light during the day and imbue the building with a mystical glow at night.

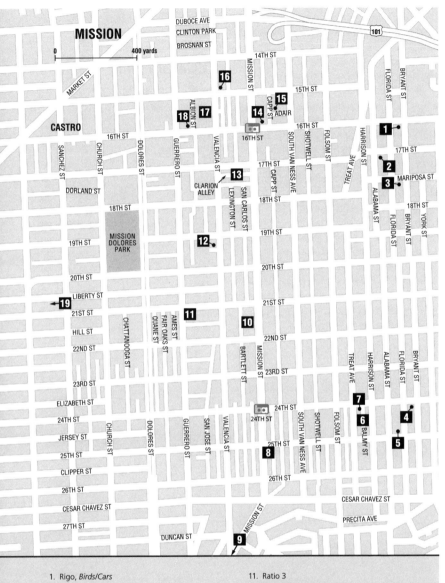

MISSION

0 ————— 400 yards

1. Rigo, *Birds/Cars*
2. Southern Exposure
3. Bay Area Video Coalition
4. Galería de la Raza
5. Eleanor Harwood Gallery
6. Balmy Alley
7. Triple Base
8. Southern Exposure
9. Queens Nails Annex
10. Foreign Cinema
 Modernism West
11. Ratio 3
12. Paxton Gate
13. Clarion Alley murals
14. The Lab
 CAMP Murals
15. 65 Capp Street
16. Jack Hanley Gallery
17. Intersection for the Arts
18. Backroom Gallery
19. Brown residence

Mission

The Mission district is home to many young artists and the nesting place of a vernacular mode that emerged around the turn of the millennium. Grounded in a street aesthetic dubbed "urban rustic" or "Mission School," it is characterized by an unrefined directness and grassroots perspective, regardless of whether the artist creates graffiti-style or cartoon-format compositions, paints outdoor murals, sketches scenario depictions on notebook paper, uses rough-hewn, often recycled and found materials, adopts angst-ridden content, or portrays uncontrived, amateurishly drawn figures. Several artists working in this mode (Chris Johanson, Margaret Kilgallen, Barry McGee) have received international attention, in the process bringing new visibility to the contemporary art scene in San Francisco.

Though evidence of gentrification keep cropping up in the Mission district, it is still a working-class, ethnically diverse area. Especially around Valencia Street between 16th and 24th Streets, an artsy overlay prevails in imaginative business ventures, vintage furniture and clothing stores, shops selling handmade goods of every variety, and multifarious exhibition spaces.

1 Rigo

Birds/Cars, 1997
1712 Bryant St, 94110
bus: 27
Located on the side wall of a residential building, just off the corner of 16th St.

Once again, Rigo cleverly twists the imagery of common traffic signage to heighten awareness about the loss of nature in the urban environment. (See pp. 70–71, 73, 75 for other murals.) In this work, he uses two of his familiar one-way arrows, setting them against sky-blue fields and juxtaposing each with a yellow-and-black, diagonally striped hazard symbol. One arrow points upward, labeled with the word "birds." The other points downward and reads "cars."

2 Southern Exposure

401 Alabama St, 94110
415-863-2141 f: 863-1841
www.soex.org
soex@soex.org
Tues–Sat 11–5
bus: 22, 27, 37
Located between Mariposa and 17th Sts. To enter, press the buzzer alongside the iron gate in the wooden fence. This will place you in a scruffy parking and garden area, but just take the stairs immediately to your right for the gallery.

In 1971, artists created the first live/work studios in San Francisco in this building, a former brick factory. Originally built in 1925 for the American Can Company, it was then vacant. The artists formed a collective and named it Project Artaud after the avant-garde French actor, poet, playwright, director, and artist. Theater Artaud, a performance center, developed space in the building in 1972, and a gallery, eventually called Southern Exposure, joined the enterprise in 1974. It was one of the city's earliest artist-run alternative spaces focused on supporting and exposing the work of emerging artists.

Exhibitions typically showcase art with a raw character. It tends to be exuberant, experimental, eclectic work, bursting with creative energy and not yet slickened by the commercial systems. Nonthematic group and solo shows selected by a curatorial committee from open submissions are the norm. To be sure, the offerings are very uneven and quite unpredictable. In recent years, interactive or computer-based projects with a decidedly socio-cultural, community-oriented bent have been incorporated into the program.

ADVISORY: The Southern Exposure gallery at Project Artaud is closed until late 2007 or

2008, while the building undergoes a seismic retrofit. During the interim, the gallery is organizing various public art projects and operating a small informational space at 2901 Mission St. (See p. 120.)

3 Bay Area Video Coalition

2727 Mariposa St, 2nd flr, 94110
415-861-3282 f: 861-4316
www.bavc.org
bavc@bavc.org
bus: 9, 22, 27, 33, 53
Located just off the corner of Bryant St.

BAVC is the largest independent media-arts center in the Untied States. It has a long history of making technology, tools, and training accessible to both neophytes and established videomakers. In addition to its production, preservation, and classroom facilities, the center also has a video archive. Works from the archive—which include incredible footage by Vito Acconci, Laurie Anderson, Ant Farm, Dara Birnbaum, David

Juan Navarro, *Electric Chair*, 2002; Galería de la Raza

Byrne, Nam June Paik, Twyla Tharp, William Wegman, James Welling, and Martha Wilson—are shown from time to time at Bay Area film centers. It is also possible to arrange to see works from the archive at the BAVC facility.

4 Galería de la Raza

2957 24th St, 94110
415-826-8009 f: 826-6235
www.galeriadelaraza.org
info@galeriadelaraza.org
Wed–Sat, 12–6
BART: 24th St
Located at the corner of Bryant St.

Walking the line between being a community center and an art gallery with a broader profile, Galería de la Raza bills itself as a "Chicano/Latino interdisciplinary space for art, thought and activism." Exhibitions range from shows of local artists to more ambitious projects like *Virology: Cultures of Violence/Violence of Culture* (2002), a well-curated presentation comprising conceptually rich, compelling work that both called attention to cultural issues and evinced engagement with contemporary-art dialogues. Of note: *Electric Chair* by Ivan Navarro, a sculpture in the form of a folding beach chair but constructed with a fluorescent-tube frame, tangled wires, and a paper seat inscribed with a seemingly interminable list naming people executed by the electric chair in the United States.

Sample exhibitions: *African By Legacy—Mexican By Birth*, *Digital Mural Project*, *Illegal Entry*, *Mind Maps*, *Trazos—Myth & Memory*, *Weede Teepo*. Brochures, artists' talks, lectures, symposia, and film/video programs accompany exhibitions. In addition to the gallery proper, Studio 24, located in the storefront space adjacent to the gallery, sells handmade products from Mexico and South America, as well as work by some local Latino artisans.

Beth Cook, *Hamburger Theory of Love* (detail), 2005; Triple Base

5 Eleanor Harwood Gallery

1295 Alabama St, 94110
415-867-7770
Thurs–Fri, 12–7; Sat, 1–6
BART: 24th St
Located on the corner of 25th St.

Eleanor Harwood Gallery, which opened in the fall of 2006, evinces the continual growth of grassroots artist activity in the Mission neighborhood. The space is a bit removed from the commercial zones of the district, but the inaugural shows suggest that the artists are among the best of those working in the local and extended community after graduating from Bay Area art schools.

Artists: Alison Blickle, John Chiara, Chris Cobb, Veronica De Jesus, Nickolas Mohanna, Emily Prince, Paul Wackers, Mary Elizabeth Yarbrough.

6 Balmy Alley

BART: 24th St
Located one block west of Harrison St between 24th and 25th Sts.

Community artists have been painting colorful murals all over the Mission district since 1971, and the festooned surfaces of the garage doors, fences, and building exteriors that line Balmy Alley are a premier example.

The panoply includes decorative abstraction, social-realist portraits, ideographic figures, surreal and fantasy scenarios, sci-fi drawings, political messages, imagery referencing local issues, ethnic depictions, sexual themes, and personal notations. Boldness in execution is the common thread, and intermittently the underlying influence of the Mexican mural tradition is evident. Few of the compositions are artistically significant, but in aggregate they are a noteworthy phenomenon. Most are part of a community project spearheaded by the Precita Eyes Mural Arts Center, which aims to prevent vandalized graffiti from becoming a neighborhood blight. (Contact Precita for tours of the Mission murals; 415-285-2287, www.precitaeyes.org.)

7 Triple Base

3041 24th St, 94110
415-643-3943
www.basebasebase.com
triplebase@gmail.com
Thurs–Sun, 12–5
BART: 24th St
Located at the corner of Treat Av.

Triple Base—a storefront project space largely focused on sarcastically autobiographical, visually intricate work by emerging Bay Area artists—has developed into a curatorial-oriented, community space.

Cross-disciplinary collaborations and installations are favored, and a cheeky attitude, characteristic of the Mission district, is often in evidence. In addition to its exhibition program, Triple Base organizes events and innovative activities aimed at instigating dialogues among artists and with the public. The gallery has also created a flat file where visitors can freely thumb through a plentiful collection of diverse creations—mainly works on paper—by local artists.

Sample exhibitions: *Todd Bura, Chris Cobb, Beth Cook, Cosmic Satellites, Tara Foley, Matt Gerring, Robert Jordan, Jay Nelson, Kottie Paloma, Zefrey Throwell.*

8 Southern Exposure

2901 Mission St, 94110
415-863-2141 f: 863-1841
www.soex.org
soex@soex.org
Tues–Sat, 12–6
BART: 24th St
Located at the corner of 25th St.

This storefront houses the offices and a small exhibition space for Southern Exposure during an interim period while its usual gallery at Project Artaud undergoes a seismic retrofit. (See pp. 117–18.) A series of public art projects located throughout the city, a spectrum of programs, and informational exhibitions at this location are ongoing until the gallery reopens in its newly renovated space.

9 Queens Nails Annex

3191 Mission St, 94110
415-992-2041
www.queensnailsannex.com
info@queensnailsannex.com
Fri–Sat, 12–5
BART: 24th St
Located in Bernal Heights (south of Cesar Chavez St) between Fair and Powers Avs.

If you are looking to see irascible work by feisty young artists, this is the place. Be forewarned that the location is well off the beaten path, and the gallery is famous for not being open during advertised hours.

QNA, an artist-run space, developed a word-of-mouth reputation for showcasing fresh, provocative work and unconventional projects, not to mention the electronic music at its opening-night parties. The primary participants and audience are Mission district artists, though some exhibitions have featured curators and artists from Los Angeles and San Diego. Sample exhibitions: *Christopher Culver, Good Times for Never, Desiree Holman, Isaac Lin, Jim Jocoy, Jennifer Locke, Marcela & Gina, overundersidewaysdown, Queremos Rock, Marcos Rios.*

10 Foreign Cinema

architects: **PRAXIS**, 1999
2534 Mission St, 94110
415-648-7600 f: 648-7669
www.foreigncinema.com
Mon–Fri, 6–10; Sat–Sun, 11–10
BART: 24th St
Located between 21st and 22nd Sts in a scruffy stretch of Mission district storefronts.

The entrance to Foreign Cinema is somewhat inconspicuous, though the double stainless-steel doors with round window cutouts give it a contemporary cast, and the flanking poster cases suggest the identity of an old-style movie theater. As you walk from the street front down a long hallway lined with votive candles, the ambiguous aura only intensifies. Ultimately you reach a large hostess stand, and enter the restaurant proper. Behind, on the left, is a bar; on the right, is a cavernous dining room bookended by another bar and an open kitchen with a mezzanine above; and straight ahead is a spacious outdoor courtyard. The trappings of a chic architectural renovation (the building was originally a women's department store) are in full view: bare concrete walls,

hardwood floors, high ceiling with skylights, edgy lightbulb chandeliers (*85 Lamps* by Droog Design), and a rustic fireplace.

But this is not just a classy, upscale restaurant—it is also an art-film house, an ersatz reincarnation of the cinemas that once flourished in the Mission. Now, in a unique amalgam, patrons can watch movies and dine simultaneously. The courtyard functions as a theater with films (foreign classics, independent features, animated shorts) projected on the large back wall (the rear of an adjacent building) and sound emitted from drive-in-movie speakers placed at each table. Sight lines are not great, but the screenings—as well as the big communal picnic tables, which complement small cozy ones—induce a convivial, vibrant atmosphere.

Since 2005, **Modernism West**, an annex of Modernism Inc. (see pp. 47–48) has been organizing exhibitions in a back room at Foreign Cinema. The focus is on projects that explore experimental paths or showcase work that may not be suitable for the gallery's commercially-oriented main space. Sample exhibitions: *Gottfried Helnwein, Naomie Kremer, Deborah Oropallo, Valentin Popov.*

Should the bars within Foreign Cinema's dining area not suit your fancy, you can always go to Laszlo, a separate but connected space in the storefront location next door to Foreign Cinema's entrance (2526 Mission). Also designed by Praxis, the bar repeats the spare, stripped-to-the-core aesthetic of the restaurant. Concrete is again the favored surface material. But here interior accentuation takes the form of a long metal bar and a catwalk balcony, which provides an appealing perch for people-watching even as it cleverly expands the standing and seating capacity of the bar's compact footage. Although the venue is named after the existential antihero in Jean-Luc Godard's *Breathless*, DJ music, not film, is the ambient pulse.

11 Ratio 3

903 Guerrero St, 94110
415-821-3371
www.ratio3.org
ratio3@mac.com
Sun, 12–5
BART: 24th St
Located on the corner of 21st St.

Mitzi Pederson, Untitled, 2006; Ratio 3

Clarion Alley Mural Project

12 Paxton Gate

824 Valencia St, 94110
415-824-1872 f: 824-1871
www.paxton-gate.com
Mon–Thurs, 12–7; Fri, 12–8; Sat, 11–8;
Sun, 11–7
BART: 16th St, 24th St
Located between 19th and 20th Sts.

This store has the weirdest merchandise you are likely to find anywhere. Self-defined as having "treasures & oddities inspired by the garden & the natural sciences," it does not showcase art in the usual sense, but there is a lot here that is visually titillating and a challenge to conventional ideas about form, function, identity, and aesthetics. Among the phantasmagoric specimens are fossilized shark teeth, birdwing butterflies with phosphorescent coloring, beaver and porcupine skulls, toothpicks made from coyote or raccoon penis bones, taxidermied animals decked out in witty costumes (e.g., the Edwardian Raccoon and Porcupine Shriner), and a diverse stock of orchids.

13 Clarion Alley Mural Project

Clarion Alley, 94110
BART: 16th St
Located between Mission and Valencia Sts, parallel to 17th and 18th Sts.

For about a decade beginning in 1992, an artist collective called CAMP (Chris Johanson, Barry McGee, Aaron Noble, Isis Rodriguez, Andrew Schoultz, and others) converted Clarion Alley into a public artwork by covering all surfaces lining the narrow back street—garage doors, fences, walls of buildings—with murals. When several structures and murals were demolished in the spring of 2001 as part of the gentrification that was taking place in the Mission, CAMP painted new murals and became active in saving the alley.

Functioning in a spare, second-floor walkup in a residential neighborhood, with business hours limited to Sunday afternoons, this is not your typical art gallery. On the one hand, it has the character of a low-grade, seat-of-the-pants operation. On the other, it is a slovenly-chic art space with a roster of intriguing young talents, including some who have achieved attention on the national scene. Of note, the techno-surreal landscapes of Robert Guttierez; the elongated skulls and distorted sewer covers of Robert Lazzarini; and the precariously balanced, aerial and stacked constructions of Mitzi Pederson.

Artists: Jose Alvarez, Robert Gutierrez, Robert Lazzarini, Ryan McGinley, Takeshi Murata, Mitzi Pederson, Ara Peterson, Ben Peterson, Jonathon Runcio.

Without question, the Clarion project has historical roots in the Mexican mural tradition, manifest locally in Diego Rivera's wall paintings (see pp. 137–38, 148), which are highly esteemed by the Latino community in the Mission. Stylistically and conceptually, however, the Clarion imagery bears closer alliance with the mode of graffiti street art and tags that originated in New York in the late 1960s. Like its East Coast counterpart, it includes blown-up calligraphy, repetitive patterns, and interconnected psychedelic images and designs. In addition, borrowings from pop, comic-strip, and kitsch sources are apparent in witty depictions and commentaries related to contemporary urban existence.

accommodate small solo exhibits and large group shows. Some projects that are the result of residencies, present work made on-site specifically for the space.

Exhibitions introduce young Bay Area artists or revisit the work of under-recognized, older-generation names. The selections span a wide, uneven range, encompassing technically inexpert and trendy compositions as well as feisty projects with evocative undercurrents. More than presenting great art, The Lab gives access to exploratory creativity. Sample exhibitions: *Bayennale*, *Détourned Menu—Food in the Form of Activism*, *Fabulandia—Fauna*, *Fabulandia—Terra*, *The Man Box and Beyond*, *Material Matters*, *National Pysche*, *Recording Carceral Landscapes*.

14 The Lab

2948 16th St, 94103
415-864-8855 f: 864-8860
www.thelab.org
Wed–Sat, 1–6
BART: 16th St
Located at the corner of Capp St, one block east of Mission St.

Founded in 1984 by a group of inter-disciplinary artists, The Lab joined other alternative spaces in San Francisco as an organization supporting the development and presentation of new and experimental work. Given its interest in art that crosses boundaries, exhibitions typically include a wide range of media, and gallery shows are but one part of a multifaceted program that also encompasses theater, music, sound, film, lecture, poetry, and performance events.

With its seedy exterior, the building, a 1914 union hall initially named the Labor Temple (renamed Redstone Hall when sold in 1968), is not very inviting. Similarly, the gallery, a serviceable space best described as funky, has a linoleum floor and spare, rudimentary decor. It includes a lobby area and large open room, which respectively

14 CAMP murals

2940 16th St, 94103
BART: 16th St
Located in the same building as The Lab. The murals are accessible from the main entrance to Redstone Hall; from the lobby of Theater Rhinoceros (2926 16th St); or from a door off to the side of The Lab's main gallery.

In 1997, as part of its support of local artists and as a way to enhance the dreary appearance of the entry areas in its building, The Lab commissioned leading artists from the CAMP collective (see p. 122) to create murals for the public stairwells and mezzanine-level corridors. While some depictions focus on significant moments of San Francisco's labor history, others address contemporary history pertaining to the building and the nonprofit groups that inhabit it. No attempt was made to produce a cohesive whole; instead artists explored particular subjects in their own style and conceptual manner. The participating artists were Carolyn Castaño, Matt Day, John Fadeff, Susan Greene, Barry McGee, Ruby Neri, Aaron Noble, Sebastiana Pastor, Rigo, Isis Rodriguez, Chuck Sperry, and Scott Williams.

15 65 Capp Street

architect: **DAVID IRELAND**, 1981
65 Capp St, 94103
BART: 16th St
Located on the corner of Adair St, between 15th and 16th Sts.

It is worth taking a detour from a neighborhood visit or making a special trip to see 65 Capp Street, an architectural work by esteemed San Francisco artist David Ireland. Known widely for his conceptual approach to process and materials, which is variously manifest by an embrace of raw industrial or archeological aesthetics, Ireland radically transforms things. In this instance, the thing was a single-story, cracker-box dwelling, and the resulting artwork is a rigorously geometric, two-story house clad in corrugated metal. Appearing somewhat like a miniature barn, warehouse, or fortress, the design features a pitched roof, barren wall expanses, and windows positioned in tall, light-oriented dormers or conversely shaped as horizontal slits that add punctuation to the facades and produce sun streaks in the interior. Indeed, Ireland has created a light sculpture as much as a residential structure.

When finished, the building served as the initial home of the Capp Street Project. It is now a private residence. (Capp Street Project subsequently moved to other locations and eventually was absorbed within the CCA Wattis Institute; see p. 115).

16 Jack Hanley Gallery

395 and 389 Valencia St, 94103
415-522-1623 f: 522-1631
www.jackhanley.com
info@jackhanley.com
Tues–Sat, 11–6
BART: 16th St
Located just off the corner of 15th St.

If you are familiar with the international art scene and therefore know of the Jack Hanley Gallery, you would not expect to find that it is a small, grungy storefront shielded with security bars and located across the street from a housing project. Nevertheless, this is San Francisco's most edgy gallery. Its edginess does not derive from a program of trendy, big-name stars, but from its being a gallery with its fingers on the pulse of emerging ideas and unconventional sparks of creativity. The art typically appears raw, invariably challenging, perplexing, or even suspect. It goes against the grain of familiar aesthetics and exalted content, and clearly transcends local interests, even when produced by local artists.

The artist roster includes Erwin Wurm, an Austrian whose absurd, witty sculptures and photographs are wrought from the human body; Chris Johanson, a San Francisco resident whose irreverent portraits and crude objects communicate poignant, humorous and mundane thoughts derived from street culture; and Keegan McHargue, another hotshot San Franciscan celebrated for his small paintings of intense, imaginary figures in scenarios saturated

David Ireland, 66 Capp Street

with a twisted world view.

Artists: Carter, Anne Collier, Simon Evans, Harrell Fletcher, Christopher Garrett, Piotr Janas, Jo Jackson, Chris Johanson, Jim Lambie, Saskia Leek, Ed Loftus, Camilla Løw, Euan MacDonald, Andrew Mania, Alicia McCarthy, Adam McEwen, Keegan McHargue, Mathieu Mercier, Jonathan Monk, Muntean/Rosenblum, Scott Myles, Shaun O'Dell, Bill Owens, Will Rogan, Michael Sailstorfer, Peter Saul, Mathew Sawyer, Leslie Shows, Hayley Tompkins, Anna Von Mertens, Chris Ware, Erwin Wurm.

Keegan McHargue, Untitled, 2006; Jack Hanley Gallery

by focusing on the myth and legacy of Che Guevara in the multimedia project *This World is Beginning to Tremble: Che+R+Evolution* (2003); and Marcos Ramírez Erre questioned

17 Intersection for the Arts

446 Valencia St, 94103
415-626-2787 f: 626-1636
www.theintersection.org
info@theintersection.org
Wed–Sat, 12–5
BART: 16th St
Located in the middle of the block between 15th and 16th Sts.

Housed in a rundown building with a black-painted facade, Intersection—the city's oldest alternative interdisciplinary art space—has a long history of presenting experimental work in literature, theater, music, and the visual arts, and of encouraging debate and critical inquiry. Daring content, typically with a sociopolitical orientation, predominates. Indeed, the art exhibitions (installed on the second floor) are centered on topics that arouse awareness about social inequities and political maleficence. For example, Claudia Bernardi explored qualities that define revolutionary action and change

April Banks, *Free Chocolate*, Intersection for the Arts

the phenomenon of war, using images that reference the accidental bombing of food-drop targets and the dropping of food on bombing targets in Afghanistan in *Multiplication of Bread* (2002).

Other exhibitions: *Battle Emblems*, *Blueprints*, *Free Chocolate (April Banks)*, *Perpetual Motion*, *Terror?* Since there is a long downtime between art exhibitions, be sure to check calendar listings or call before planning a visit.

18 Backroom Gallery

Adobe Book Shop
3166 16th St, 94103
415-864-3936
www.adobebooks.org
Sun–Thurs, 11–9; Fri–Sat, 11–11
BART: 16th St
Located between Albion and Guerrero Sts.
Adobe is a very grungy, low-key used

bookshop. It became a popular hangout for the neighborhood arts community during the 1990s as a result of its parties and live-music events, many of which doubled as exhibition openings for art hung on the store's walls. In 2000, the Backroom Gallery was inaugurated in a closet-sized space hidden behind the main room of the bookstore. Shows at Adobe are curated by a team of local artists and present work mainly by up-and-coming artists associated with the Mission scene. Since the space is extremely small, works on display are limited in size. A refreshing intimacy tends to characterize both the art and the viewing experience. On occasion, exhibitions expand into the main space of the bookstore and its front window.

Sample exhibitions: *Alison Blickle*, *Suzanne Husky*, *Jason Mercier*, *Nicolas Mohanna*, *Donal Mosher*, *Mat O'Brien*, *Oliver Halsman Rosenberg*, *Johanna St. Clair*, *Clint Taniguchi*, *Liz Walsh*.

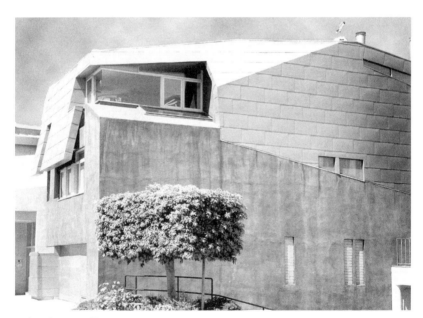

Frank Israel, Brown residence

19 Brown residence

architect: **FRANK ISRAEL**, 1997
69 Grand View Av, 94114
bus: 48

Located in a winding road, hilly residential area of the Castro between Romain St and Grandview Terrace, just below upper Market St and north of 21st St.

Frank Israel, a trailblazing architect from Los Angeles, is only represented in the Bay Area by a few modest residential projects. This one pushes mundane vernacular architecture, quite visible in houses in the surrounding area, into an innovative stratosphere without becoming a flamboyant, disjunctive presence in the neighborhood. That is not to say that the design blends into the prevailing fabric, but rather that Israel reinvents forms while adhering to contextual markers.

Retaining the basic box volume, the architect destroyed its integrity by slicing away corners, configuring walls with acute angles, and punctuating them with irregularly shaped windows highlighted by pistachio-colored frames. Moreover, he wrapped the upper section of the house in an eccentric, mansard-like overhang clad with metal shingles, repeated this material on the garage door, and faced the rest of the house in taupe-toned concrete.

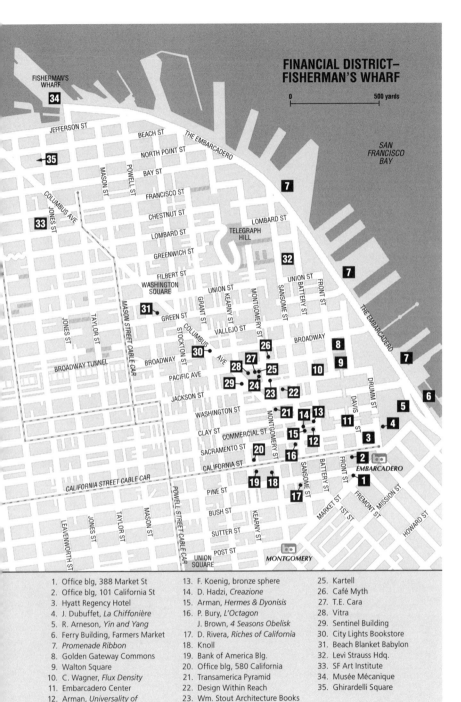

FINANCIAL DISTRICT– FISHERMAN'S WHARF

0 500 yards

1. Office blg, 388 Market St
2. Office blg, 101 California St
3. Hyatt Regency Hotel
4. J. Dubuffet, *La Chiffonière*
5. R. Arneson, *Yin and Yang*
6. Ferry Building, Farmers Market
7. *Promenade Ribbon*
8. Golden Gateway Commons
9. Walton Square
10. C. Wagner, *Flux Density*
11. Embarcadero Center
12. Arman, *Universality of Wisdom*
13. F. Koenig, bronze sphere
14. D. Hadzi, *Creazione*
15. Arman, *Hermes & Dyonisis*
16. P. Bury, *L'Octagon*
 J. Brown, *4 Seasons Obelisk*
17. D. Rivera, *Riches of California*
18. Knoll
19. Bank of America Blg.
20. Office blg, 580 California
21. Transamerica Pyramid
22. Design Within Reach
23. Wm. Stout Architecture Books
24. Artemide
25. Kartell
26. Café Myth
27. T.E. Cara
28. Vitra
29. Sentinel Building
30. City Lights Bookstore
31. Beach Blanket Babylon
32. Levi Strauss Hdq.
33. SF Art Institute
34. Musée Mécanique
35. Ghirardelli Square

Financial District– Fisherman's Wharf

1 Mixed-use high-rise

architects: **SKIDMORE, OWINGS & MERRILL**, 1987
388 Market St, 94111
BART: Embarcadero
Located in the triangular plot bordered by Front and Pine Sts.

Though not edgy, this sleek structure, which totally fills a triangular plot, presents an elegantly nuanced version of the flatiron building. By gently curving the acute-angled corner and shaping the wide end as an expansive cylinder, the architects disavowed the severity of boxy modernist forms. Polished red granite creates horizontal bands between the glazed walls of the lower 16 office floors, but the design shifts on the top seven residential floors, where windows are inset with balconies. Nothing fancy or eccentric, but corporate architecture with a flair.

2 Office building

architects: **JOHNSON & BURGEE**, 1982
101 California St, 94111
BART: Embarcadero
Located between Davis and Front Sts with a corner intersecting at Market St.

This office building disconnects with the perimeters of the street grid by positioning a cylindrical tower in one corner of the square plot, extending a low-rise structure diagonally out to the opposite corner, where its far end is shaped as an acute angle, and leaving an expansive triangular space as an open-air plaza. Not only does this arrangement subvert the rectilinear conformity that is so prevalent in the financial district, but it dethrones the usual fill-the-block mentality of urban real estate. Indeed, the plaza—enhanced by potted trees, a fountain, and stepped plat-

forms for seating and seasonal plantings—is a welcome public space that has become a popular gathering and relaxation spot in the area.

The most dramatic feature of the architecture is the slanted-roof glass atrium that slices into the base of the tower and is set among tall structural piers. The tower itself stands out by being configured with sawtooth setbacks alternately clad in reflecting glass and pink granite so the whole reads as one or the other material or as vertical stripes, depending on your line of sight. In contrast, the seven-story structure alongside has a horizontal articulation, with inset square windows creating an emphatic geometric pattern in the stone frame.

3 Hyatt Regency Hotel

architect: **JOHN PORTMAN**, 1973
5 Embarcadero Center, 94111
788-1234 f: 398-2567
www.hyatt.com
BART: Embarcadero

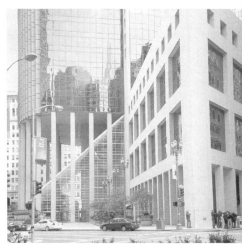

Johnson & Burgee, 101 California St

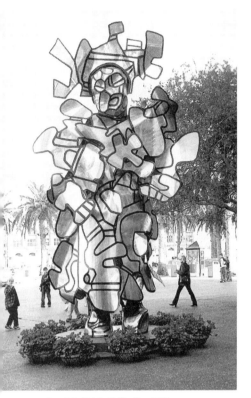

Jean Dubuffet, *La Chiffonière*, 1978

reflecting pool topped by *Eclipse*, a giant geodesic sculpture fabricated from aluminum tubing (**CHARLES O. PERRY**, 1973) further condition the environment.

4 Jean Dubuffet

La Chiffonière, 1978
Justin Herman Plaza
BART: Embarcadero
Located at the south end of the plaza facing Sacramento Alley—the food court adjacent to the Hyatt Regency Hotel.

Composed as a haphazard assemblage of jigsaw-shaped elements made from curved, bent, and molded stainless steel outlined in black, *La Chiffonière* (*Rag Lady*) is a whimsical depiction of the discombobulated state and tattered dress of a street person. With her wild hat and forlorn, quizzical face, she is a compelling image. Though different from Dubuffet's well-known figures with red, black, and white surfaces and volumetric shapes, this one still captures the exuberance and childish fantasy of his art.

As you look at the Dubuffet, you can't help but notice **ARMAND VAILLANCOURT**'s *Fountain* (1971), the domineering centerpiece at the other end of the plaza. Looking like a collapsed framework spewing water from the hollows of its concrete-block components, its unappealing aesthetics are all the more disturbing because of its grandiose size and prominent location.

Located in the block bordered by Sacramento, Drum, and California Sts, and Justin Herman Plaza.

The soaring atrium of this hotel was a trailblazing design, a radical departure in hotel architecture that not only established a paradigm for the Hyatt chain but was adopted by countless others as well. Contrary to the usual layout of a ground-level lobby and upper floors with rooms lining long corridors, here a 17-story grand space is tiered with ivy-lined balconies that give access to individual rooms even as they offer views down into the lobby. The dramatic effect is heightened since one segment of the atrium is shaped like an inverted pyramid with sides slanting inward at a 45-degree angle. Trees, a pebble-bottom canal, circular glass elevator cars sliding up and down a wall, and a

5 Robert Arneson

Yin and Yang, 1991–92/2002
Embarcadero
BART: Embarcadero
Located across the street from the Ferry Building in front of Justin Herman Plaza.

One upright disembodied cartoon head screams from a curled mouth at a wincing second head toppled on its side. These madcap Humpty-Dumpty creations are part of the *Egghead* series, commissioned for the

UC Davis campus and installed there shortly before the artist's death in 1992. The San Francisco edition is a postmortem (bronze) cast from the original mold. Though not the best example of Arneson's sardonic wit, *Yin and Yang* is emblematic of the endless stream of self-portrait caricatures he created, largely in ceramic sculpture and drawings.

6 Ferry Building & Farmers Market

1 Ferry Building, Embarcadero, 94111
415-291-3276
www.cuesa.org
info@cuesa.org
Tues, 10–2; Sat, 8–2
BART: Embarcadero
Located at the foot of Market St.

It behooves you to expand your concept of art to include food when in San Francisco. As noted by civic boosters: "San Francisco is a city that celebrates food as sustenance and art," and "Food is San Francisco's art form" (!). Though vividly manifest in the region's celebrated restaurants, especially those serving the widely touted California cuisine,

the obsession with food and its valuation as art is also laid bare at the Saturday morning Farmers Market at Ferry Plaza. A visit here need not be a grand expenditure—assuming you can resist the temptation of buying rather than looking at the incredible fresh fruits, vegetables, related culinary items, and extraordinary gustatory pleasures, all presented in abundant arrays in a festive atmosphere.

This is not just any outdoor market. It is *the* showcase for Northern California's premier artisan-produced and organic food, sponsored by the Center for Urban Education about Sustainable Agriculture. The market began as a one-day event in September 1992 (just after the demolition of the Embarcadero freeway) and then established itself as a beloved, weekly Saturday morning happening. More than being just an assembly point for farmers, merchants, chefs, and food afficionados, it became a social gathering for a spectrum of illustrious individuals and a fun event for the community at large.

Initially located in a parking lot across from the Ferry Building, the market had to move down the road to accommodate construction

Robert Arneson, *Yin and Yang*, 1991–92/2002

Ferry Building, interior

a two-story bank of repeating arches. Do not overlook the bayside walkway, which offers great views and a nice place to sit and relax.

The building began its history as the primary portal for San Francisco. From the time of the Gold Rush until the 1930s, it was the only entry point—except from the Peninsula—for visitors arriving from the East and commuters coming from the East Bay or Marin. Not only did its primacy plummet with the opening of the Bay Bridge (1936), the shift to car transportation, and the construction of the elevated Embarcadero freeway (1957)—which virtually severed the waterfront from the city—but the building became a dismal, cheapened shadow of its former self. The impetus for its restoration came when the disastrous freeway, which suffered irreparable damage in the Loma Prieta earthquake (1989), was removed in 1991. The roadway's demise also served as a catalyst for reviving ferry service and redeveloping the waterfront as an integral, people-friendly part of the city.

in the area. It then moved again in April 2003 to its current, ennobled home. Filling the plaza in front of the Ferry Building, as well as the back terrace areas alongside the bay and the interior arcades that line the main hall, the market is a panoply of individual stands and shops. Those located indoors, which include some to-go and sit-down restaurants, are open throughout the week. And though the Saturday market ranks as an acclaimed phenomenon, a smaller version takes place on Tuesdays, with additional markets variously occurring from May through October.

While meandering about the food displays, you can also enjoy a bit a of the city's architectural heritage in the Ferry Building itself. Designed by **A. PAGE BROWN** (1898), the steel-framed structure has a tall clock tower modeled after the 12th-century campanile of the Seville Cathedral in Spain. The interior features an airy central nave stretching the length of two football fields and bordered by

7 Vito Acconci, Stanley Saitowitz, Barbara Stauffacher Solomon

Promenade Ribbon, 1995
Embarcadero, from Townsend to Bay Sts
BART: Embarcadero

Fusing art, infrastructure, and urban design, this two-and-a-half-mile linear sculpture adds both visual and pragmatic components to the waterfront promenade. It appears as a five-foot-wide band of concrete that intermittently rises up from being flush with the pavement to become cubic benches and platforms of varying lengths. A continuous strip of glass blocks, which runs the distance of the ribbon and is illuminated at night by fiber-optic lights, further emphasizes the sculpture's orientation as a path mark and border delineating the edge of the city. (Unfortunately, skateboard guards added by the city disrupt the clean, clear integrity of

the design. Wear and tear have also taken a toll on segments of the work.)

Even a short walk along the promenade provides great views of the city and bay. Should you want to learn more about the natural and cultural history of the waterfront, it is all described in photos, stories, poetry, drawings, and data signage on the black-and-white striped pylons and bronze sidewalk plaques that span the length of the promenade. Though the city has not yet taken full advantage of this spectacular stretch of land by refurbishing the piers and sprucing up adjacent areas, the walkway still attracts an abundance of pedestrian traffic.

Golden Gateway Redevelopment

Like many cities, San Francisco passed urban renewal laws in the 1950s that enabled it to raze blighted areas and redevelop them with segregated-use projects, especially big housing and office blocks. In this case, the area bordering the waterfront had previously been transformed into a wholesale produce market in the early 20th century in order to clean up the seedy residue of the Barbary Coast—a notorious Gold Rush-era district overrun with dance halls and saloons, prostitution and thievery. The first phase of redevelopment, launched in 1961, entailed the construction of austere high-rises of bleak modernist design. Subsequent projects fortunately brought forth better results, and enhancements of the waterfront in the wake of the Embarcadero freeway demolition have injected new life into the district.

8 Golden Gateway Commons

architects: **FISHER-FRIEDMAN**, 1980–84
bounded by Embarcadero, Jackson St, Front St, and Broadway
BART: Embarcadero

Avoiding the mistakes of the first phase of redevelopment, this project substituted low-rise townhouses for slab towers and created a people-based, multipurpose complex. Responding to the street grid, the architects configured the layout with three square-block buildings and a park on the fourth quadrant. Each block consists of a two-story podium for offices and stores, topped by three-story housing units. Parking is situated in the interior of the base, and landscaped courtyards lie in the middle of the residential zones. Although each block is a separate entity, they are interconnected by alleys and pedestrian bridges that also reinforce a relationship to the street environment. In terms of design, the red brick and arches reference the architecture in Jackson Square and old warehouses just north.

9 Sydney C. Walton Square

landscape architect: **PETER WALKER**, 1980
bordered by Davis, Front, and Jackson Sts, and a pedestrianized segment of Pacific St
BART: Embarcadero

Designed as an urban square providing green space and tranquility in the midst of a high-density area, this small park adds art into the mix. As you meander along its curvilinear paths, you come upon sculptures dispersed within undulating and flat fields of grass or positioned against the backdrop of the poplar trees that ring its outer edges. These are not monumental objects, nor are they elevated and distanced atop big pedestals, like so much public art. Although still conceived as objects (as opposed to land art or installation projects), they become part of the total environment.

Set on a berm in a corner of the park, the tall, slender, linear form of **GEORGE RICKEY**'s *Two Open Rectangles, Eccentric Variation VII, Triangle Section* (1977) almost gets lost in the surrounding tree growth. Yet, as with other works by this artist (see pp. 84, 91, 233), the movement of its component

Joan Brown, *Pine Tree Obelisk*, 1987

embraced universal themes, merging the commonplace with the spiritual, the here-and-now with the hereafter.

Like many modernist sculptors of the mid-20th century, the Frenchman **FRANÇOIS STAHLY** embraced abstraction but endowed his forms with an anthropomorphic presence. In *Fountain of the Four Seasons* (1962), the grouping of totemic figurative columns set in a labyrinth of stones and a shallow pool suggests a sense of emergence, change, continuity, and timelessness.

Though *Portrait of Georgia O'Keeffe* (1982) by the French-Venezuelan artist **MARISOL** evinces the humorous pop spirit that earned her an international reputation in the 1960s, this work is not a strong example. It attempts to translate her signature block construction, carved surfaces, and penciled details from her favored medium of wood into bronze, but the freshness and eccentricity get lost in the process. Like others in Marisol's series representing artists in old age, this portrait of O'Keeffe seated on a tree stump, dangling a walking stick, and flanked by a pair of furry dogs is both satirical and reverential.

Using one of his signature images, the heart, **JIM DINE** created a rounded bronze version with a textured surface and quirky contextual association in *Big Heart on the Rock* (1984). Its strong silhouetted shape is made more inviting by being set on a brick base that serves as seating. (Sadly there is only one bench in the entire park.) Although this work is positioned on the periphery of the square, its location alongside the pedestrian passage at a major residential entryway (160 Pacific St) gives it high visibility.

elements, caused by wind forces, attracts attention. Not only does the sculpture's shape continuously change, but the polished steel also responds to nature, catching the light and emitting reflections in all directions.

For **JOAN BROWN**, a revered Bay Area artist, public art was a way to make a difference in the everyday lives of ordinary people. In her series of obelisks placed in outdoor settings, she adapted the ancient pillar form and covered it with brightly colored mosaic tiles, surface patterns, and images of fish, birds, and trees. As *Pine Tree Obelisk* (1987) reveals, her depictions are playful and yet they also seem to bear symbolic meaning. Inspired by Egyptian and Eastern art, she

10 Catherine Wagner

Flux Density: A Narrative of Bubbles, 2003–05
Frisson, 244 Jackson St, 94111
415-956-3004 f: 956-3661
Mon–Fri, 11:30 am–2 am; Sat, 4 pm–2 am
BART: Embarcadero
Located near the corner of Battery St.

This back-lit, 30-foot-long mural behind the bar in Frisson—a high-energy restaurant chicly designed to resemble the interior of an early-20th-century ocean liner—has the semblance of a continuous field of champagne bubbles. Actually, the bubbles are from water poured into a fish tank, photographed in extreme close-up precision, and then transferred onto three Plexiglas panels. The artist, who variously seeks to "reveal the internal structure of the organic world" in her work, has here created a meditative, mesmerizing image—an interesting focal point for diners waiting to be seated in the plush lounge ambience of the adjacent, dome-covered room.

11 Embarcadero Center

architect: **JOHN PORTMAN**, 1971–82
bordered by Sacramento, Battery and Clay Sts, and Justin Herman Plaza
BART: Embarcadero

Encompassing the Hyatt Regency Hotel, four office towers, and a three-story shopping mall, this enormous project covers five city blocks. Its distinction lies in the interconnections between the parts and the creation of unified and diverse environments. Indeed, the elevated walkways, pedestrian alleys, and plazas that link the individual units create a welcome separation from city traffic, despite the fact that three city streets actually cross through the complex.

Most appealing are the public terraces atop the commercial/entertainment zones. Readily accessed by spiral staircases, escalators, elevators, and pedestrian bridges and furnished with seating, tables, and plants, the terraces provide intimate outdoor spaces for relaxation in the midst of a densely populated area. The open-air atriums, with their monumental sculptures and fountains, further enhance the setting.

As in the case of Portman's Hyatt Regency Hotel (see p. 129–30), space and concept are more noteworthy than surface design. A brutalist concrete construction, popular in the late 1960s, prevails. Although the towers are simple slab-like forms, their slender profiles are distinctive from those of the boxy buildings that dot the city skyline. Their vertically layered shapes differentiate and refine them even more.

For the atriums within Embarcadero Center (EC), big, bold abstract sculptures that sit firmly atop pedestals were the art of choice. Taking full command of the surrounding space, they are visually overwhelming in their scale. Portman's own design, *The Tulip* (1981), a 28-foot-tall concrete sculpture outlined in lights and encircled by a spiral ramp, occupies 4EC.

Sky Tree (1977), a weak example by assemblage artist **LOUISE NEVELSON** rises up in the courtyard of 3EC. Constructed of spare, facile shapes cut from black steel, it lacks the irregularity, layering, and mystery of her legendary work.

In 2EC, a kinetic tower titled *Chronos XIV* (1975) by the Hungarian-French artist **NICOLAS SCHÖFFER** creates a fluctuating world of light and movement. In addition to the 49 light projectors shining on 65 movable discs of varying sizes and shapes, the water in the pool below and the sun or clouds in the sky above produce the symphonic rhythms.

The sculpture *Two Columns with Wedge* (1971) by **WILLI GUTMANN** is the centerpiece of the atrium in the cinema building of 1EC. Comprising upright tubular forms of polished stainless steel, the work bears witness to minimalist aesthetics, except that cut-out and twisting elements near the top diverge from pure reductivism by introducing applied detail, if not decorative embellishment. For the artist, the process of cutting sections from a single cylinder and then reassembling the parts addressed issues of displacement and transformation.

Although other sculptures and tapestries were originally installed throughout the shopping mall and lobbies, most have been removed. A few staid modernist objects—like

the bronze *Mistral* (1981) by **ELBERT WEINBERG** (located in the plaza between 4EC and the Hyatt Regency Hotel, at the corner of Drumm and Sacramento Sts)—remain.

12 Arman

The Universality of Wisdom, 1989
301 Battery St, 94111
BART: Embarcadero, Montgomery
Located on the front steps of the old Federal Reserve Building between Sacramento and Commercial Sts.

Sophomoric or satiric contextualizing seems to have played a role in the placement of Arman's sculptures on the front and back steps of a grandiose neo-classical building styled in an ersatz colonnaded-temple mode. Using a bronze cast of Greek figures wearing classical robes and helmets, the French artist known for his accumulations and dissections of objects, has here sliced through the solid

Arman, *The Universality of Wisdom*, 1989

carapace of the form, thus exposing a hollow interior and transforming a poised, unified image into a frenzied mass of disjunctive segments.

13 Fritz Koenig

Untitled, 1989
Commercial St, 94111
BART: Embarcadero, Montgomery
Located under a staircase at the Battery St entrance to the pedestrian passageway alongside the old Federal Reserve Building.

This bronze sphere etched with black hieroglyphic-like markings was created to complement the curves of the surrounding staircase. Such formalist concerns dominated art of the post-World War II era and has continued to reign supreme in many commissions for public art in big urban projects. Koenig's name came to the fore after 9/11 since another of his sphere sculptures was found in the wreckage of the World Trade Center.

14 Dimitri Hadzi

Creazione, 1988
Commercial St, 94111
BART: Embarcadero, Montgomery
Located in the pedestrian passageway between Battery and Sansome Sts, facing a colonnaded ramp going up to the terrace of 1 Embarcadero Center.

This abstract bronze sculpture is typical of work created in the mid-20th century and placed in public spaces as inoffensive examples of modern art. Adapting the assemblage mode, this object, inspired by Mozart's "K458 The Hunt," was formed from pieces of scrap metal lying about the artist's studio.

15 Arman

Hermes and Dyonisis: Monument to Analysis, 1986
400 Sansome St, 94111
BART: Montgomery
Located on the back steps of the old Federal Reserve Building between Commercial and Sacramento Sts.

See above (p. 136). Here Arman has appropriated a bronze cast of the famous classical sculpture showing Hermes, the messenger god, holding the infant Dionysus, future god of wine.

16 Pol Bury

L'Octagon
343 Sansome St, 94104
BART: Montgomery
Located in the lobby of the tower annexed to 343 Sansome St with an entrance on Sacramento St.

Though not well-known in the United States, the Belgian artist Pol Bury is widely recognized in Europe. Kinetic sculpture, often configured as a group of spheres, is his signature mode. In *Octagon* this takes the form of glistening stainless-steel balls set upon a platform covered with flowing water that falls into a shallow, octagonal-shaped pool. If you watch for a while, you will see the spheres move—indiscernibly but perpetually such that the compositional appearance of the cluster keeps changing.

16 Joan Brown

Four Seasons Obelisk, 1990
343 Sansome St, 15th flr, 94104
BART: Montgomery
Located on the public roof garden of the building accessed by lobbies off Sacramento St (the location of the Bury, see above) and Sansome St. The main elevators take you directly to the 15th-floor terrace.

This is one of the last ceramic-tile obelisks that Joan Brown created before her tragic death at age 52 when installing a sculpture in a museum in India. Using the image of an evergreen tree bound tightly with a rope, forming a swirling, checkered surface pattern, she has established a liaison between nature and the spiritually symbolic man-made form of the obelisk. Characteristic of the artist's style are the colorful butterflies that counter the taut, contained image with a free-and-easy tone. (See p. 134 for another work in her obelisk series.)

A visit up to see this sculpture also offers a good vantage point for viewing the Transamerica Pyramid and for relaxing amid potted olive trees and flowering plants.

17 Diego Rivera

Riches of California, 1931
155 Sansome St, 10th flr, 94104
Mon–Fri, 3–5
BART: Montgomery
Located at the corner of Pine St.

Though hardly avant-garde in style or concept, the Depression-era murals of Mexican artist Diego Rivera earned a place in history when his blunt interpretations of Marxist revolutionary themes rattled the American establishment. Notably, the work he created for the Pacific Stock Exchange Lunch Club, now The City Club of San Francisco, was his first mural in the United States. Using heroic, expressionist figures and an allegorical approach, Rivera centered his composition on an earth goddess (modeled after the tennis star Helen Wills Moody) who holds the produce of agriculture in one hand and lifts the soil with the other to reveal mining resources and laboring workers of industry. As was Rivera's custom, the painting includes important historical figures—Luther Burbank, the innovative horticulturist, and James Marshall, whose discovery of gold at Sutter's Creek launched the Gold Rush.

The presence of Rivera's murals in San Francisco (see p. 148) has been an impetus

for and influence in the development of contemporary mural activity in the city.

18 Knoll

317 Montgomery St, 94104
415-837-2100 f: 837-2116
www.knoll.com
Mon–Fri, 9–5
BART: Montgomery
Located between Pine and California Sts at the base of the Bank of America building.

If you want to see many of the classics of modern furniture, this is the place to go. The name Knoll became virtually synonymous with modern design in the 1940s and 1950s. This New York company produced a range of chairs, tables, and light fixtures by such pioneers as Henry Bertoia, Marcel Breuer, Isamu Noguchi, Mies van der Rohe, and Eero Saarinen. They have become signature museum pieces. The showroom displays many of these classics as well as recent designs—like Frank Gehry's bentwood objects inspired by woven baskets, and Maya Lin's stones from *the earth is (not) flat* series.

Frank Gehry, *Powerplay Chair* and *Off-Side Ottoman*, 1990; Knoll

19 Bank of America Building

architects: **WURSTER BERNARDI & EMMONS; SKIDMORE, OWINGS & MERRILL; PIETRO BELLUSCHI**, 1969
555 California St, 94104
BART: Montgomery
Located between Montgomery and Kearny Sts.

This 52-story high-rise—one of San Francisco's trophy buildings—asserts itself as a dominant silhouette on the skyline. Though the design adopts the city's signature bay-window form, this feature is manifested in a sawtooth configuration that rises the entire height of the structure. The facade's tinted glass and polished granite are set flush, comprising integrated, planar surfaces. Also distinctive is the red carnelian color of the stone. Its darkness and the building's bulk have been criticized for not relating to the urban fabric of the city, but its elegance and the fine-tuned detailing of the architecture have been praised.

On the ground, the building commands attention by occupying most of an entire city block. An austere stepped plaza, which abuts the northern facade of the tower, leads down to a separate annex. Devoid of the refining touches of the tower, this structure's glass curtain walls and enormous piers broadcast grandiosity. A monumental black granite sculpture, *Transcendence*, by **MASAYUKI NAGARE**, reinforces the uninviting, stark setting. Despite the artist's inspiration from Japanese garden and Zen traditions, the work is so isolated and objectified that it becomes a foreboding presence.

20 High-rise office building

architect: **PHILIP JOHNSON**, 1986
580 California St, 94104
BART: Montgomery; cable car
Located at the corner of Kearny St across from the Bank of America building.

You probably would not look twice at this building if it did not bear the name of the internationally renowned architect Philip Johnson. Indeed, it is a weak example of his work. Though not as egregiously postmodern as his famed AT&T Building in New York, it, too, borrows from past architectural styles and has a quirky roof design. If you stand back and look up, you can see the glass mansard that crowns the granite-clad tower and the eery statues set atop the three columns fluting the facades on each side of the structure. Made to appear like classical, robed figures—the artist has called them "corporate goddesses"—they are, however, fiberglass shrouds, hollow and faceless.

21 Transamerica Pyramid

architect: **WILLIAM PEREIRA**, 1972
600 Montgomery St, 94104
BART: Montgomery
Located on the corner of Washington St at the base of Columbus Av.

Like many eccentrically shaped buildings that may or may not be great works of architecture, this one caused a ruckus when first proposed, but became a city trademark and corporate logo (Transamerica Corporation) soon after it opened. With its distinctive silhouette, the pyramid diversifies the skyline and serves as a beacon in the landscape.

Measuring 48 stories, with an additional 212 feet of height deriving from the aluminum-clad spire on top, this is the tallest building in San Francisco. Though sleek from a distance, up close it has a decidedly clunky appearance due to the massive concrete-paneled piers and exposed structural framework (heavy diagonal trusses) that constitute its

five-story footing. Only atop the spider-leg base does the form taper. Then, beginning at the 29th floor, it sprouts a pair of flared wings. Appearing like sci-fi appendages, they are actually functional with one housing an elevator shaft and the other a stairwell.

The architect delighted in pointing out that the sloped walls allow more sunlight to reach the street. Though a small park on the east side of the tower is a further response to open space, it was curiously designed to provide a shady outdoor setting for office workers. Nevertheless, Redwood Park, landscaped by **TOM GALLI** with some 80 trees from the Santa Cruz mountains, is a welcome nature-oriented oasis. If you are sensitive about public art, you are bound to cringe at the sight of the cutesy leaping frogs adorning the fountain.

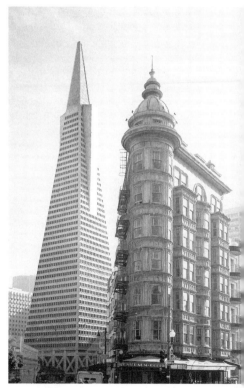

William Pereira, Transamerica Pyramid (left); Sentinel Building (right)

Jackson Square

Do not expect to find a defined plaza or park named Jackson Square. The original square, the hub of the bawdy Barbary Coast, is long gone. The name now refers to a historic district of well-preserved 19th-century buildings located in the area bounded by Columbus Avenue on the west, Washington Street on the south, Sansome Street on the east, and extending just beyond Pacific Avenue on the north. Overflowing with the kind of charm you find in European side streets, the neighborhood comprises a rich mixture of two- and three-story brick buildings, some with cast-iron or stucco facades. Most of the interior- design establishments responsible for refurbishing the buildings and upgrading the area were forced out by high rents in the late 20th century. Many of the law offices and business ventures that displaced them have in turn been supplanted by design showrooms. Indeed, in 2002–03, an impressive core of illustrious European firms, renowned for commissioning and producing avant-garde furniture and lighting, opened flagship stores in the area. Though occupying modest-sized settings, these showrooms offer an incredible spectrum of the most adventurous, creative work being done today in the design realm.

22 Design Within Reach

455 Jackson St, 94111
415-837-3940 f: 835-9970
Mon–Fri, 10–6; Sat, 10–5
www.dwr.com
info@dwr.com
BART: Montgomery
Located just east of Montgomery St on the corner of Hotaling Pl, a small alley.

Since its inauguration in 1999, Design Within Reach has rapidly emerged as a major, American-based resource for classic and new furniture and lighting. Indeed, the company has become a chain store, expanding from this, the original DWR, to numerous locations throughout the country. Unfortunately, growth has been accompanied by increased focus on conservative designs with popular appeal. Nevertheless, the product offerings still includes a fair number of historic works by renowned masters (Charles and Ray Eames, Eileen Gray, Le Corbusier, George Nelson, Isamu Noguchi, Jean Prouvé, Mies van der Rohe), as well as innovative objects by hotshots from the contemporary era (Ron Arad, Michele De Lucchi, Frank Gehry, Karim Rashid, Philippe Starck).

Whether your taste leans toward finely crafted wood, leather, glass, high-tech steel, brightly colored fabric, or molded plastic,

Design Within Reach

you will find intriguing creations in every medium. Objects are scattered all about the two-room space, with a three-tiered display of chairs and blow-up photos adding zing to the layout. On the one hand, there are elegant but simple designs—Sori Yanagi's *Butterfly Stool* (1954) and Eileen Gray's side table (1927). On the other, there are playful forms—Philippe Starck's *Eros* swivel chair (2001), a tribute to the martini glass; and Isamu Noguchi's *Prismatic Table* (1957) with its origami-like structure.

See pp. 153, 207 for two other locations in the Bay Area.

23 William Stout Architecture Books

804 Montgomery St, 94133
415-391-6757 f: 989-2341
www.stoutbooks.com.
libri@stoutbooks.com
Tues–Fri, 10–6:30; Sat, 10–5:30
BART: Montgomery
Located between Jackson and Gold Sts in one of the district's historic brick buildings.

If you are at all interested in architecture, this bookstore is a must-visit site. The collection includes new and used books relating to architecture. The scope is extensive and eclectic, embracing buildings, landscape, urban planning, interior and industrial design, furniture, graphics, photography, sculpture, and even travel.

Do not be surprised if you arrive with a particular title in mind or just want to look around and end up buying an armful of books you may never have heard of on topics you know nothing about! It is not easy to find things in the well-stocked floor-to-ceiling shelves and tightly stacked piles on tables, but that is half the fun. And just when you think you have perused every nook and cranny on the ground floor, you discover there is an equally large selection downstairs.

24 Artemide

855 Montgomery St, 94133
415-393-9955 f: 393-9959
www.artemide.com
Mon–Fri, 9–5
BART: Montgomery
Located just south of Pacific Av.

As is evident from the displays at Artemide, lighting fixtures need not be boring or merely functional. Throughout its history, dating back to the 1960s, this prestigious Italian company has produced a range of finely engineered products with sophisticated, innovative designs. Both its collection of modern classics and its most recent creations are included in the San Francisco showroom, a chock-a-block display of ceiling, floor, wall, and table objects.

Among the outstanding items are *DZ*, a 15-foot-high, outdoor aluminum pole lamp in the shape of a calla lily (by Michele De Lucchi and Gerhard Reichert); *Logico*, a chandelier formed as a wavy ribbon of opalescent hand-blown glass; and the classic *Boalum*, a flexible, white plastic coil, six-and-a-half feet long, that can be tangled into a ball and set on a table, stretched out on the floor or defined as a line or curve on a wall (by Livio Castiglioni and Gianfranco Frattini).

25 Kartell

501 Pacific Av, 94133
415-839-4025 f: 680-1647
www.kartell.com
info@kartell.com
Mon–Fri, 11–6
BART: Montgomery
Located at the corner of Montgomery St.

When Kartell, a cutting-edge Italian firm whose products are created by some of the most prestigious names in the design sphere, opened this flagship store in 2003, it greatly elevated the status of the San Francisco design scene and gave new cachet to the Jackson Square neighborhood.

Kartell

You can't miss Kartell's one-story building. The Montgomery St side is painted bright red with the company name in big white letters, and the windows fronting Pacific Avenue enable full views of the striking displays inside. If you are at all curious about innovative design or want to see some of the most talked-about, futuristic, high-tech furniture and related products of international renown, this is the place to visit.

Kartell's specialty is plastics—not the old-fashioned kind, but new materials with super luminosity and suppleness that can be molded into incredible curvatures or shaped into eccentric forms with razor-sharp angles. The display of products at Kartell showcases each item by showing it in multiples, in combination with other items, in isolation, or in a full spectrum of colors. Chairs are displayed three levels high on clear shelves lining the long walls. Light-box platforms are also used to intensify the transparency and intense tonalities of the objects.

Among the highlights of the collection are *LCP*, a curvaceous chaise longue by Maarten van Severen; *Book Worm*, a sinuous bookcase by Ron Arad; and *La Bohème*, a lush amphora-shaped stool by Philippe Starck. Not to be overlooked are the wondrous mundane items—magazine racks, bottle holders, umbrella stands, stepladders—where visual and functional inventiveness sets new standards.

26 Cafe Myth

architect: **MARK CAVAGNERO**, 1998
490 Pacific Av, 94133
415-677-8986
Mon–Fri, 8–4
BART: Montgomery
Located at the corner of Montgomery St.

Though this pleasant little café, formerly called Zero, has undergone a facelift, it still retains the essence of Mark Cavagnero's original design. (This is not the case with the sibling restaurant next door, where Cavagnero's renovation of a historic brick building—a survivor of the 1906 earthquake—has lost the industrial, high-tech, minimalist, Japanese character that gave it distinction.) The café's compact interior is resourcefully laid out, with seating in the front, side, and back; self-service counters off to the right; and the kitchen set behind a cylinder-shaped zone in the midsection. The latter, a cleverly designed bit of architecture, enables an interface between the front

and back spaces through an acute-angled slit that widens into a glazed opening. The curved form adds a rhythmic aspect to the setting, and blond wood used for wall and floor coverings provides a nice contrast to exposed brick surfaces.

This is a relaxing place where you can enjoy a light meal or cappuccino and sit undisturbed while reading or having a private conversation.

27 Thomas E. Cara

517 Pacific Av, 94133
415-781-0383 f: 781-7224
Tues, Sat, 12–3; Wed–Fri, 9:30–5
BART: Montgomery
Located between Montgomery and Kearny Sts.

No, this is not an art-related shop per se, but if you like cultural, aesthetically engaging curiosities or if you are a European-style-coffee fanatic, this place will be of interest. The storefront window offers full voyeurism of the interior, so you do not even have to go inside to absorb the store's delights.

Thomas E. Cara is a little shop selling fine coffee machines by Pavoni and Riviera (vintage Italian companies) and a single Neo-

politan blend of coffee (in pound bags only, not by the cup). Most interesting, however, is the archival (not for sale) collection of old espresso machines and coffee grinders displayed across the back wall. In the middle of the shop, two other historic objects are on view. One, a big chrome Pavoni machine (carried to San Francisco from Italy by Thomas Cara in 1946 when he returned home from World War II) became the catalyst for founding the business. The other, an equally large brass-and-copper machine is a historic gem from Argentina. (For those in the know, the decorative eagles atop these machines look to the right in the American-eagle fashion, not to the left as do fascist Italian and German eagles.)

28 Vitra

557 Pacific Av, 94133
415-296-0711 f: 296-0709
www.vitra.com
Mon–Fri, 9–5
BART: Montgomery
Located between Montgomery and Kearny Sts.

Chairs and chairs and more chairs (plus a smattering of tables and office furniture).

Vitra

Vitra, a Swiss company, is renowned for fabricating the extraordinary creations of famous architects and designers, past and present. Tadao Ando, Ron Arad, Richard Artschwager, Norman Foster, Nicholas Grimshaw, Zaha Hadid, Shiro Kuramata, Gaetano Pesce, Jean Prouvé, Alvaro Siza, Ettore Sottsass, and Philippe Starck are but a few of the illustrious names represented in the collection.

A visit to this rather modest showroom will bring you in direct contact with such eye-catching and historically important items as La Chaise—an organic, floating lounge originally designed by Charles and Ray Eames for a 1948 competition at the Museum of Modern Art, New York; Vernon Panton's bright red Heart Cone (1959); and Frank Gehry's Easy Edges (1972) table and chairs made from corrugated cardboard.

Even if you are not interested in buying new seating, check out the miniature models of all the chairs manufactured by Vitra. Installed in a long inset shelf running down the side wall of the showroom, these mind-boggling creations are not only a visual delight but also a great overview of the history of modern design.

29 Sentinel Building

916 Columbus Av, 94133
bus: 12, 15, 41
Located at the triangular intersection of Columbus Av and Kearny St.

This nine-story, steel-framed, copper-clad, flatiron building, a survivor of the 1906 earthquake, is a charming old-world structure with angled and curved bay windows and a corner dome-topped tower. Restored and in pristine condition, it now holds significance in film history. Since 1971, it has been the home of American Zoetrope, Francis Ford Coppola's production company. It was here that Godfather I and II, Apocalypse Now, and his other films were written and edited and their sound mixed. The facilities have also been used by such other renowned filmmakers as Kenneth Branagh, Robert Duvall, Jean-Luc Godard, Werner Herzog, and George Lucas.

In addition to the film studios, the ground floor is occupied by Cafe Zoetrope—an upscale, European-style bistro that is a satellite of Coppola's food-and-wine enterprise in the Napa Valley (see pp. 231–32). Trivia buffs can add to their encyclopedic knowledge with the tidbit that Coppola's rehabilitation of the building entailed stripping paint from the copper surfaces and applying 100,000 gallons of horse urine to them in order to speed the oxidization process and give the metal a green color. The copper facade is particularly amazing at night, when theatrical lighting makes the building stand out in the cityscape. (What else would you expect from the producer of epic films?)

30 City Lights Bookstore

261 Columbus Av, 94133
415-362-8193 f: 362-4921
www.citylights.com
staff@citylights.com
daily, 10 am–midnight
bus: 12, 15, 41
Located between Pacific Av and Broadway on the corner of Jack Kerouac Alley.

Perusal of the contemporary art scene in San Francisco would not be complete without recognition of the Beatnik generation. Though far less associated with the visual arts than with literature, this movement was a seminal part of the American avant-garde that rose to prominence in the post-World War II era. A good place to touch base with this aspect of local culture is at City Lights.

Founded in 1953 by Beat poet and publisher Lawrence Ferlinghetti, the bookstore was a literary meeting place and pilgrimage destination for avant-garde writers, left-leaning intellectuals, and anyone espousing antiauthoritarian politics. It was also the first all-paperback bookstore in the United States. Though the alternative-culture flavor

has diminished over time and the stock now includes hardcovers and more mainstream titles, City Lights still embodies the spirit of the freewheeling, rebel-rousing Beat generation. Cluttered shelves, a meandering layout, cosy nooks, and a poetry room with comfortable chairs are vivid reminders that this independent bookstore is a far cry from the corporate chains. (Sadly, the selection of art, architecture, and design books is quite paltry.)

While you are in the area, you might enjoy seeing another popular hangout of the Beat poets—the Vesuvio Café next door (255 Columbus Av). It is a veritable saloon, described as having a "magpie decor" encompassing all sorts of Beat memorabilia. Of historical note, it was the place where Jack Kerouac, Philip Lamantia, Michael McClure, Kenneth Rexroth, Gary Synder, and friends gathered before going to hear Allan Ginsberg read *Howl* on October 7, 1955 at the Six Gallery. (Ferlinghetti's publication of the poem caused him to be tried on obscenity charges in 1957.)

31 Beach Blanket Babylon

Club Fugazi, 678 Green St (Beach Blanket Babylon Blvd), 94133
415-421-4222
www.beachblanketbabylon.com
Wed–Thurs, 8; Fri–Sat, 7 and 10; Sun, 3 and 7
admission: $25–77
bus: 30, 41, 45
Located between Stockton and Powell Sts off Columbus Av.

Yes, this is one of the main tourist attractions in the city, a theater where busloads arrive nightly to see the zany, high-energy musical spoof of pop culture that is world-renowned for its extravagant costumes and outrageously huge hats and hairdos. Though *Beach Blanket Babylon* is not generally considered in an art-world context, the masterful visuals, astute portrayals, and incisive bor-

rowings from all aspects of contemporary life—high, low, and otherwise—can readily be likened to images and ideas in recent art, performance, installation, and video work.

Founded by Steve Silver in 1974, *Beach Blanket Babylon* twists the basic story of Snow White searching for her Prince Charming into a whirlwind of clever vignettes filled with social and political satire. Constantly updated to incorporate topical events and current newsmakers (George W. Bush, Hillary Rodham Clinton, Harry Potter, Martha Stewart, Bill Gates), the shows reveal amazing wit and boundless creativity—a delightful escape from the usual viewing experience for art afficionados of any stripe.

32 Levi Strauss Headquarters

architects: **GYO OBATA; LAWRENCE HALPRIN** (landscape), 1982
1155 Battery St, 94111
Muni: F
Located at the foot of Telegraph Hill on an eight-acre plot stretching from Battery to Sansome and Union to Greenwich Sts.

Although office campuses with low-rise buildings surrounded by landscaped plazas and fountains have become commonplace, when Levi Strauss created its headquarters it was a radical idea. And the company did not stop there in transforming the corporate office domain into a people-oriented setting. The design incorporates lots of open space in the interior and features large window expanses and balconies with views overlooking the bay.

Aiming to harmonize with the neighborhood, Obata derived inspiration for the stepped facades from the terraced character of the houses tumbling down the precipitous slope of Telegraph Hill—the dramatic backdrop of the complex. His use of red brick also echoed the historic warehouses in the area. Contextualizing did not, however, involve stylistic appropriations that might give

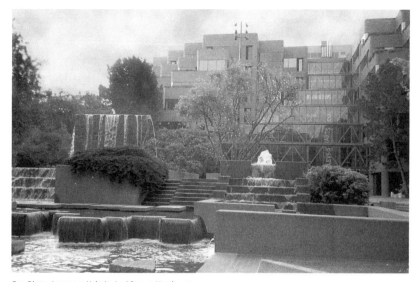

Gyo Obata, Lawrence Halprin, Levi Strauss Headquarters

the complex a retrograde or paraphrased appearance. Elements like the dark glazing, especially the glass-enclosed main lobby, and the wraparound windows and walls with rounded corners imbue the design with a decidedly modern and fresh aspect.

The urban plaza and green park, by the venerated Lawrence Halprin, are not only outstanding creations in and of themselves, but beautifully integrated with the surrounding buildings. An expansive tiered fountain with a raw-cut slab of granite as its high point serves as the centerpiece of the plaza. Plants add greenery and stone blocks add seating to both the fountain and the extended area. A crisscross pattern of bricks inlaid into the ground surface (a signature element in Halprin's vocabulary) not only refines the pavement but also acts as a unifying agent, articulating connections among the various buildings and to access routes from adjacent streets.

The green park on the east side of the campus offers a totally different ambience from that of the plaza. Spacious and bucolic, this more of an escape from people, work, and the urban environment than is the plaza,

which is a social and circulation place where people mill about and gather together. Grassy berms, trees, and clusters of lush plants give the area a sense of enclosure, while granite blocks scattered about provide aesthetic linkage with the plaza. Here, too, there's water but it is a modest fountain set off in a corner, which is, however, the source of a man-made stream that meanders throughout the park.

Visually attractive, humanistic in concept, the Levi Strauss Headquarters is also an admirable example of corporate architecture truly opening itself to its surroundings and embracing public space.

33 Walter and McBean Galleries, San Francisco Art Institute

800 Chestnut St, 94133
415-749-4563 f: 749-1036
www.sfai.edu
Tues–Sat, 11–6
bus: 30

The San Francisco Art Institute, a complex of buildings, occupies the lower section of

the block bordered by Chestnut, Jones, and Francisco Sts. To get to the gallery, enter at Chestnut Street and walk across the cloistered courtyard, designed in a Spanish colonial mission style (1926); continue along the passage to the hallway of a brutalist concrete building (1969); go past the lecture hall on the right; proceed a bit further, but not as far as the roof plaza; look left, and you will come to the gallery entrance.

Over the course of its history, SFAI has trained many of the city's leading artists and has been an active force in the local art community. The gallery, a two-tiered space, is part of the school's public programming, which aims to showcase art not otherwise accessible in the Bay Area, and artists (local, national, or international) who are emerging or under-recognized. Exhibitions feature solo and group shows as well as commissions of new art created on-site by visiting artists, many of whom also teach classes and give open lectures while in residency. In addition, the program contains annual faculty shows and the Adaline Kent Award Exhibition honoring a California artist.

The biggest hoopla in many years resulted from having Nicolas Bourriaud (past-director of the Palais de Tokyo in Paris) guest-curate an exhibition. *Touch: Relational Art from the 1990s to Now* (2003) included some gripping work by such hot names as Angela Bullock, Liam Gillick, Joseph Grigely, Carsten Höller, Jorge Pardo, Rirkrit Tiravanija, Gillian Wearing, and Andrea Zittel. Not only did the show set forth an interesting perspective on current art, but it embraced a disparate spectrum of adventurous artists. *William Kentridge,* a subsequent benchmark show (2006), featured two of his amazing animation films. Other exhibitions: *Steve Roden, Sarkis, Wherever We Go—Art, Identity, Cultures in Transit, World Factories.*

The SFAI lecture series also highlights art-world figures who are challenging the status quo. The roster has featured artists, filmmakers, critics, and curators—Matthew Barney, Diedrich Diederichsen, Karen Finley, Eric Fischl, Bruce Hainley, Laura Hoptman, Alfredo Jaar, William Kentridge, Martin Kersels, Barbara Kruger, Walter Murch, David Nash, Judy Pfaff. Lectures sponsored by PhotoAlliance (founded in 2002) also take place at the SFAI ($10/5). These have presented such speakers as William Christenberry, David Maisel, Naoya Hatakeyama, Joel Sternfeld.

William Kentridge, film still from *Ubu Tells the Truth*, 1997; San Francisco Art Institute

Laughing Sal; Musée Mécanique

34 Musée Mécanique

Pier 45, Fisherman's Wharf, 94133
415-436-2000
www.museemecanique.citysearch.com
Mon–Fri, 11–7; Sat–Sun, 10–8
Muni: F
Located at the end of Taylor St.

This delightful game palace is billed as "one of the largest privately owned collections of antique coin-operated automatic mechanical musical instruments in the world." Entrance is free, but be sure to bring a pocket full of quarters and dimes so you can partake of the fun. You can enjoy an amazing panoply of fortune-telling machines, strength testers, photo booths, player pianos, robots, peep shows and other Penny Arcade creations dating from the 1880s to the present. *Laughing Sal*, a redheaded, gap-toothed, lurching fat lady who cackles loudly, is clearly the centerpiece. But do not overlook *Bimbo Box* (a gyrating band of monkeys mimicking Herb Albert's Tijuana Brass), *See What the Belly Dancer Does on Her Day Off* (a viewing machine), or the one-cent *Sex Appeal Meter*! For diehards who prefer video and computer games, there is even a handful of these. And for those wanting to view this museum through an art lens, you will find imaginative, well-crafted works like *Toothpick Fantasy*, a miniature sculpture comprising a roller coaster, train, Ferris wheel, and other amusement park rides, all depicted in extreme detail out of toothpicks.

Musée Mécanique opened in its current location in 2002, having had to move from its longtime home in the basement of the Cliff House during that legendary building's renovation.

Should you wish to see student work, check out displays in the Diego Rivera Gallery (daily, 9–9), located alongside the cloistered courtyard. The high-ceilinged room also contains a large mural, *The Making of a Fresco, Showing the Building of the City* (1931) by **DIEGO RIVERA**. It depicts Rivera (seated on the scaffold in the center) and his workers painting a fresco of a towering, dungaree-clad laborer flanked by images of urban construction. In line with other urban murals he created (see pp. 137–38), the composition is in a social realist style and calls attention to the work ethic of common folk, while also depicting figureheads from the local community.

35 Ghirardelli Square

architects: **WURSTER BERNARDI & EMMONS; LAWRENCE HALPRIN** (landscape), 1967
900 North Point St, 94109
415-775-5500
bus: 10, 19, 30
Located on the block bounded by Polk, Larkin, Beach, and North Point Sts.

Though commonplace today, adaptive reuse of industrial buildings for an upscale shopping and dining complex, with a people-oriented courtyard as its centerpiece, was revolutionary when developed at Ghirardelli Square in 1967. The project not only preserved the historic integrity of the brick architecture, but created a premier landmark that gave new life to the waterfront area. From the original electric sign on the rooftop (1915) and chateau-inspired clock tower (1923), to the gracefully landscaped stepped terraces with **RUTH ASAWA**'s mermaid fountain (1966), the combination of old and new is tasteful and enticing. The plentitude of benches, plus the outdoor cafés and live musicians who entertain in the plaza, make this a delightful destination for relaxation.

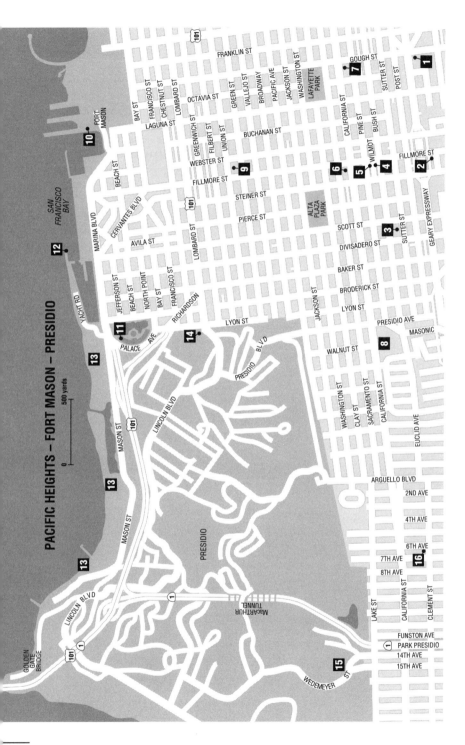

PACIFIC HEIGHTS – FORT MASON – PRESIDIO

GOLDEN GATE BRIDGE

SAN FRANCISCO BAY

PRESIDIO

MacARTHUR TUNNEL

1
7 GOUGH ST
10 FORT MASON
9
6 **5** **4**
2 FILLMORE ST
3
8
11 PALACE AVE
14
12
13
13
13
15
16

FRANKLIN ST
BAY ST
FRANCISCO ST
CHESTNUT ST
LOMBARD ST
OCTAVIA ST
LAGUNA ST
GREEN ST
VALLEJO ST
BROADWAY
PACIFIC AVE
JACKSON ST
WASHINGTON ST
LAFAYETTE PARK
SUTTER ST
POST ST
GREENWICH ST
FILBERT ST
UNION ST
BUCHANAN ST
CALIFORNIA ST
PINE ST
BUSH ST
WEBSTER ST
FILLMORE ST
WILMOT
STEINER ST
PIERCE ST
ALTA PLAZA PARK
SCOTT ST
DIVISADERO ST
SUTTER ST
GEARY EXPRESSWAY
BEACH ST
CERVANTES BLVD
MARINA BLVD
AVILA ST
LOMBARD ST
BAKER ST
BRODERICK ST
LYON ST
JACKSON ST
PRESIDIO AVE
MASONIC
WALNUT ST
JEFFERSON ST
BEACH ST
NORTH POINT
BAY ST
FRANCISCO ST
RICHARDSON
LYON ST
PRESIDIO BLVD
WASHINGTON ST
CLAY ST
SACRAMENTO ST
CALIFORNIA ST
EUCLID AVE
YACHT RD
MASON ST
LINCOLN BLVD
MASON ST
ARGUELLO BLVD
2ND AVE
4TH AVE
6TH AVE
7TH AVE
8TH AVE
LINCOLN BLVD
WEDEMEYER ST
LAKE ST
CALIFORNIA ST
CLEMENT ST
FUNSTON AVE
PARK PRESIDIO
14TH AVE
15TH AVE

0 500 yards

Pacific Heights–Fort Mason–Presidio

1 St. Mary's Cathedral

architects: **PIETRO BELLUSCHI, PIER LUIGI NERVI,** 1971
1111 Gough St, 94109
bus: 38
Located on the corner of Geary Blvd.

Bold, big, and shaped unlike any other city building, St. Mary's Cathedral figures prominently in the San Francisco skyline. Its volumetric, squat structure with parabolic curves bears witness to sculptural architecture and engineering feats of the modern era, though this particular example lacks the finesse of celebrated designs by Le Corbusier, Eero Saarinen, and Frank Lloyd Wright.

The building's austerity, conveyed by the cool exterior of white travertine, and its severe symmetry, coupled with the large barren plaza surrounding it, exaggerate the monumental scale of the structure. This impression is reiterated in the interior. While coffers in a diamond lacework pattern modulate the surface of the concrete shell inside the cathedral, the sight of sweeping arches rising upward from four massive piers situated in the corners of a square base is staggering. Color derives from narrow bands of stained glass that slice through the middle of the curves, forming a cross in the domed ceiling high overhead. The glass is the creation of **GYORGY KEPES**, a Hungarian-born American who founded the Center for Advanced Visual Studies at MIT. Above the altar, a kinetic sculpture by **RICHARD LIPPOLD** serves as a spatial centerpiece. Composed of 14 tiers of triangular aluminum rods suspended by gold wires, the object is large but transparent and animated by reflected light.

2 The Fillmore

1805 Geary Blvd, 94115
415-346-6000
www.thefillmore.com
fillmore@sfx.com
bus: 22, 38
Located at the corner of Fillmore St.

Should you want to get a taste of the hippie scene that put San Francisco on the map as a center of 1960s counterculture, The Fillmore is a good place to touch base. Indeed, this concert hall—made famous by the impresario Bill Graham and performances by Jefferson Airplane, Jimi Hendrix, Janis Joplin, Otis Redding, Santana, Lenny Bruce, and the Grateful Dead (prime exemplar of the "San Francisco sound")—is still alive and kicking.

As a means of promoting its music events, The Fillmore produced brilliantly colored, eye-catching posters, many of which are classics of graphic design that were—and are still—influential in all realms of visual creativity. The complete span of these historical posters is on display in a dazzling floor-to-ceiling installation in the upstairs

Poster lounge; The Fillmore

poster room and balcony of the music hall. Unfortunately, the exhibit is only open during concerts and only accessible to concert-goers. But hey, why not indulge in a sound experience combined with some archetypical San Francisco eye candy, the likes of which you won't find elsewhere!

3 Ann Chamberlain

Storywall, 1998–99
UCSF Women's Health Center
2356 Sutter St, 94115
bus: 24
Located between Divisadero and Scott Sts.

In recent years, various artists have rejected the austere, minimalist, and often industrial character of much contemporary art in favor of an aesthetic centered on the personal and narrative. Such is the case here, where the entrance corridor to a health center is lined with creamy-white ceramic tiles, each embedded with the likeness of a flower or plant and a poem, memory, or story reflecting feelings about illness, death, and healing as expressed in handwritten form by patients, family, staff, and friends.

4 Zinc Details

1905 Fillmore St, 94115
415-776-2100 f: 776-2232
www.zincdetails.com
info@zincdetails.com
Mon–Sat, 11–7; Sun, 12–6
bus: 3, 22
Located between Bush and Pine Sts.

Whether you are an irrepressible collector of finely crafted objects and creative gadgets, or a curiosity seeker out for a pleasure tour, this store will more than satisfy your whims, fantasies, and pragmatic needs. It is filled to the gills with a vast array of accessories, furnishings, and miscellaneous design items. Contemporary classics share space with up-to-the-moment

Tord Boontje, *Table Stories*; Zinc Details

innovations. What's more, almost everything is affordable.

Since opening in 1994, Zinc expanded its premises (2003) to become a double store-front. In 2001, it opened a second store in Berkeley (see p. 207), and in 2006, enlarged its presence in the Fillmore neighborhood with a store focused on furniture, rugs, and lighting. In all its venues, Zinc offers quality objects with clean lines and intriguing, pure forms. Among the highlights are Vitra's *UtenSilo*, a clever, every-little-thing-has-its-special-place wall storage unit; the *Too Young To Die* giant ashtray by Yoshitomo Nara, a well-known Japanese artist who traffics in cartoon images; an array of George Nelson clocks, including the classic *Ball Clock* (1947); and an extensive collection of Knoll furniture and products using Marimekko fabrics.

5 Design Within Reach

1913 Fillmore St, 94115
415-567-1236 f: 567-5238
www.dwr.com
info@dwr.com
Mon–Sat, 11–7; Sun, 12–6
bus: 3, 22
Located between Bush and Pine Sts.

This branch of DWR, a contemporary furniture and lighting store with a wide array of designer objects, opened in 2004. See pp. 140–41 for descriptive details regarding DWR.

6 Zinc Details

2410 California St, 94115
415-776-9002 f: 776-2232
www.zincdetails.com
info@zincdetails.com
Mon–Sat, 11–7; Sun, 12–6
bus: 3, 22
Located just west of Fillmore St.

Featuring the same high-quality design approach of its store around the corner, this location specializes in furniture, rugs, and lighting.

7 Anthony Meier Fine Arts

1969 California St, 94109
415-351-1400 f: 351-1437
www.anthonymeierfinearts.com
gallery@anthonymeierfinearts.com
Tues–Fri, 11–5
bus: 1

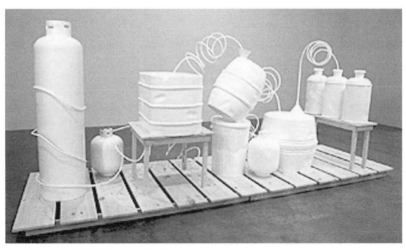

Gary Simmons, *Big Still*, 2001; Anthony Meier Fine Arts

Located between Octavia and Gough Sts.

If you are interested in adventurous contemporary art that is not bombastic, shocking, aggressive, or theoretically obtuse, this is the gallery to visit. It is located on the ground floor of a 1915 English Tudor Gothic residence, designed by the famous San Francisco architect Willis Polk for Constance de Young. The curious facade with only half an arch resulted because a twin structure, planned for de Young's sister, was never built.

As suggested by the non-commercial location and limited hours, the public face of the gallery is somewhat subordinate to Meier's operation as a private dealer specializing in the secondary market. Do not be intimidated, however, since a visit here affords the opportunity to see artists with major international reputations, and relatively unknown talents who have caught the eye of art-world insiders. The gallery favors work with a certain edginess that is centered on formal and process concerns or conceptual matters related to materials. For example, the obsessive drawings by John Morris that combine meandering doodles with exquisite pattern designs, mundane notations, and glistening baubles of color; and the seductive, witty constructions of Richard Tuttle.

Artists: Robert Beck, Sarah Cain, Rosana Castrillo Diaz, Jeremy Dickinson, Tony Feher, Barnaby Furnas, Jim Hodges, Seth Kaufman, Donald Moffet, John Morris, Dave Muller, Kate Shepherd, Jasmin Sian, Gary Simmons, Matthew Sontheimer, Tam Van Tran, Richard Tuttle.

8 Rebeca Bollinger

Permanent Slide Show, 2005
UCSF, Laurel Heights Campus
3333 California St, 94118
bus: 1, 2, 3, 4, 43
Entrance to the campus is at Walnut Street, and the work is located in the reception lobby of the main building.

This DVD wall projection, a streaming montage of images captured at the Laurel Heights and Parnassus campuses of UCSF, merges digital technology with a conceptual

approach to image presentation, especially techniques based on disjunction and deconstruction. Quotidian scenes, objects, close-ups, vistas, lush fields of color, and textural detail come in and out of focus while full-screen images create sequences or juxtapositions with small depictions appearing on five shadow boxes affixed to the wall. For people working in the building, the work offers a different view each time they pass through the lobby. For visitors waiting at the reception desk or anyone intent on watching the entire 40-minute loop, it is a kaleidoscopic diary of UCSF environments.

Rebeca Bollinger, *Permanent Slide Show*, 2005

9 Atys

2149-B Union St, 94123
415-441-9220 f: 643-1050
www.atysdesign.com
Mon–Sat, 11–6; Sun, 12–5
bus: 22, 41, 45
Located between Webster and Fillmore Sts
in back of an inner courtyard.

Promoting itself as "a museum of architecturally designed, well-made objects for everyday use," Atys is indeed a big step above the normal home-furnishing and accessory boutique. The objects, handpicked from European trade shows, are the products of visionary architects and industrial designers from around the world. Beyond the rich selection of utilitarian items, imaginatively reconfigured in high style, there are clever products that push the envelope with regard to function, materials, shape, size, and character. Notable examples are the sleek, desktop accouterments by Norman Foster; the rubber straps for creative storage on walls by Droog Design; the svelt, elegant *Linea Chaise* by Paola Lenti; *Oregon Scientific*, an all-purpose time-and-weather clock by Philippe Starck; and the classic condiment set by Marc Newson.

Norman Foster, Desk-top accessories, 1997–2000; Atys

Fort Mason Center

www.fortmason.org
bus: 28
Located at the foot of Fort Mason, on the bayshore facing Alcatraz. Enter at the intersection of Marina Blvd and Buchanan St and cross the parking lot to get to the buildings and piers.

Originally a United States Army installation (1850), Fort Mason is today a cultural center comprising various nonprofit organizations involved with the visual and performing arts, humanities, education, ecology, and recreation. The mix includes several small specialty museums, theater space—at times used for art-related lectures and film, video, and performance activities—and huge exhibition halls that host various arts fairs. In addition to culture, the center offers spectacular views and options for walks along the yacht basins. If food is your passion, you can also indulge in gourmet vegetarian cuisine at the world-famous Greens restaurant.

There are five buildings in the complex, A (west end) to E (east end). Of the three piers, the Herbst Pavilion and Cowell Theater (middle) and the Festival Pavilion (east) house arts events.

10 SFMOMA Artists Gallery

Fort Mason Center, bldg A, 94123
415-441-4777 f: 441-0641
www.sfmoma.org
artistsgallery@sfmoma.org
Tues–Sat, 11:30–5:30; first Wed, 11:30–7:30
bus: 28
Bldg A is on the far left of the Fort Mason complex.

Though this gallery, founded in 1978, operates as a subsidiary business associated with SFMOMA, its exhibitions and rental and sales activities function independently of the museum. The main space on the ground level and a balcony area are used for monthly exhibitions. These feature Northern California artists from the young to the well-established. Often three solo presentations

occur simultaneously. The common fare is painting and sculpture, nothing very edgy but well-made, original works of art that are affordable.

11 Exploratorium

3601 Lyon St, 94123
415-397-5673 f: 561-0307
www.exploratorium.edu
Tues–Sun, 10–5
admission: $13/10/8; free first Wed
bus: 28, 30, 43

Located within the Palace of Fine Arts on a landscaped plot bordered by Marina Blvd, Baker St, and Richardson Av. The entrance is at the north end of the lagoon, where Lyon intersects with Marina Blvd.

Before going inside, be sure to explore the spectacular rotunda and peristyle alongside the building. Designed by **BERNARD MAYBECK** for the 1915 Panama-Pacific International Exposition, it is a masterful stage set of imposing size and sublime creativity. Meant to evoke an overgrown Roman ruin, the architecture is wondrous and idyllic, tempered by melancholy. In the aftermath of the 1906 earthquake, the image asserted a spirit of renewal and sophistication. The structure was retained at the close of the exposition and became a favored city landmark. When the original—conceived as a temporary building and constructed of only stucco and chicken wire—reached a point of severe deterioration, it was exactingly rebuilt in concrete and steel (1967).

Having taken a detour into Maybeck's historicized fantasyland, you will need to shift gears to enter a different order of the fantastic as set forth in the Exploratorium, "the museum of science, art and human perception." Its province is the realm of the imagination rooted in the realities of the physical, experiential world. Should you be thinking that this is a place for kids and science buffs and not very relevant to art-loving adults, think again! The trendsetting, world-renowned Exploratorium is a totally unique museum—an experimental laboratory entailing hands-on participatory activity. Not only do all exhibits have an art and culture component, but many exhibits are specifically focused on visual dynamics.

Be prepared for a totally nonmuseum encounter. The interior space is a cavernous hangar with a balcony and visible workshop along the right side. There is no established circulation path (an advisory suggests you use curiosity as your compass), and kids (of all ages, including those with gray hair) run and scream in and around every display with unfettered exuberance. It is a busy, unpretentious hub with some 650 exhibits punctuated by ongoing live demonstrations, films, and handy instruction/informational cards.

In addition to covering such scientific topics as electricity, weather, and thermodynamics, there are permanent displays and special exhibitions that treat such art-related topics as the body, tactility, patterns, and seeing (color, depth, light, shadow, motion, image interpretation). For example, in *Heat Camera* you will see a large-screen image of yourself in vivacious colors, determined by the differing temperature emissions from each anatomical part; and in *Vortex* you can marvel at a spiraling tornado in a standing glass column, inspired by Leonardo da Vinci. Regardless of the topic, staff artists and

Colored Rooms; Exploratorium

artists-in-residence are actively involved in creating all the objects and installations. Exhibits specifically devised by artists are also scattered throughout the museum. (See the "Self-Guided Arts Tour" brochure for a list and locations of these.) As noted by Frank Oppenheimer, the physicist who founded the Exploratorium, "Both artists and scientists help us notice and appreciate things in nature that we had learned to ignore or had never been taught to see. Both art and science are needed to fully understand nature and its effects on people." By its deliberate intermingling of these two realms, the Exploratorium offers an amazing, unconventional experience. It is an eye-opener for art lovers, artists, and virtually anyone who is confounded or intrigued by the visual dynamics of the modern era and contemporary art.

Peter Richards, *Wave Organ*, 1986

12 Peter Richards

Wave Organ, 1986
jetty at the end of Yacht Rd
bus: 30
Walk out toward the bay from the intersection of Lyon St and Marina Blvd (just north of the Palace of Fine Arts); turn right onto Yacht Rd, which runs alongside the boat harbor, goes past the St. Francis and Golden Gate Yacht Clubs, and turns into a path atop a short jetty; keep going until the end.

Wave Organ, a wave-activated acoustic sculpture, is a superb example of site-specific environmental art. It is one of the best-kept secrets in the city and ought not to be missed. Not only is the work conceptually and aesthetically engaging, but the site itself is magical. It offers quietude plus a spectacular 360-degree panorama of the city, bay, Golden Gate Bridge, Alcatraz, and Marin.

Created as an artist-in-residence project at the Exploratorium, the work (the visible component, at least) was constructed from an assortment of carved granite and marble taken from a demolished cemetery. Master stone mason George Gonzalez collaborated with Peter Richards in developing the site into terraces with seating areas. The sound component emanates from 25 organ pipes set deep into the water, protruding up at various elevations to allow for the rise and fall of the tides. Depending on the intensity of the waves and movement of the water within the pipes, the endless symphony will be deeply resonant, barely audible, or totally varied. Should the water be calm, the tide low, or the pipes clogged by sand, you may not hear much sound. No matter; the installation itself is worth a visit.

Presidio

Encompassing prized acreage overlooking the Golden Gate Bridge and having been designated a historic landmark district (1962) and national park (1972), the Presidio is a unique parcel of urban property. Its preservation and development have been hotly debated since the United States military pulled up its stakes in 1994. Although only a handful of projects have yet to be sanctioned (mostly interior renovations), these include the Crissy Field restoration, which has dramatically revivified a forsaken, deteriorated area; and the Letterman Digital Arts Center, which has added non-army-related buildings and a high-styled landscape design.

13 Crissy Field, Golden Gate Promenade

landscape architects: **GEORGE HARG-REAVES, MARY MARGARET JONES**, 2001
Presidio, waterfront southeast of the Golden Gate Bridge, 94129
www.crissyfield.org
bus: 28, 29
Located north of Doyle Dr (Hwy 101) and Mason St with an entrance at the intersection of Marina Blvd and Lyon St.

This major project entailed the restoration of dunes and wetlands—a one-and-a-half-mile stretch of wild, windswept shoreline at the base of the Presidio bluffs. After the removal of tons of rubble, hazardous waste, dirt, and chain-link fencing, an open-space landscape was established. It showcases a historic grass airfield (1921–36), tidal marsh, small amphitheater, and simple but appealing and very popular shoreline promenade. There is nothing flashy or edgy, just a no-nonsense, people-friendly design focused on natural habitat. Needless to say, a walk, jog, bicycle ride, dog walk, or picnic here has the added advantage of incredible views.

14 Letterman Digital Arts Center: Lucasfilm

architects: **KEVIN HART; LAWRENCE HALPRIN** (landscape), 2006
Letterman Dr, Presidio, 94129
bus: 29, 43
Located in the northeast corner of the Presidio, just inside the Lombard St gate, with its main pedestrian entrance at the Chestnut St gate.

Given all the restrictions and preservation concerns circumscribing Presidio projects, it is hardly surprising that the architecture of the Letterman Digital Arts Center is so traditional and unassuming. The complex, which houses Lucasfilm, a multicompany enterprise owned by movie mogul George Lucas, has a bowl-shaped open space as its center and four large low-rise buildings forming a wedge-like periphery on two sides. Designed to reflect the "simple, repetitive, and restrained" character of the Presidio heritage, the buildings are red brick and white stucco with terra-cotta roofs. Such period details as framed porches, gables, and rows of multipane windows recall the architectural styles of the former military base. They aim not just to harmonize with their surroundings but to be as unobtrusive as possible—a noble goal for a corporate complex in the midst of a park, but also a lost opportunity. Once again, San Francisco's conservatism has favored retro, bland design over the possibility for innovative creativity and world-class distinction.

The landscape design, by venerated Lawrence Halprin, is more engaging, even if it reprises key elements from his previous masterpiece, the Levi Strauss Headquarters (see pp. 145–46). Conceived as a neighborhood

Lawrence Halprin, garden, Letterman Digital Arts Center

park, the design encompasses an expansive meadow with undulating berms, tree clusters, winding paths, and stone boulders. An artificial stream and lagoon further enhance the grassy area, and a promenade establishes an inviting access route with direct links to city streets.

15 Arion Press

1802 Hays St, Presidio 94129
415-561-2542 f: 561-2545
www.arionpress.com
Mon–Fri, 9–5
bus: 1, 4, 28
Located in the southwest corner of the Presidio above Baker Beach. Enter from the 15th Av gate off Lake St; turn right at the first intersection onto Wedermeyer St; follow the curve around various buildings; and turn left at Hays, the first street.

Though artists' books are increasingly gaining attention, Arion Press is involved with another side of the artist-book phenomenon. Employing letterpress production, it creates limited editions using fine paper (sometimes handmade), setting the type and stitching the bindings by hand, and enhancing the texts with original illustrations by contemporary artists. According to the publisher, "The books really are readable works of art."

Classics old and new constitute the list of titles, but it is hardly a selection adhering to any logical pattern. Indeed, the range of authors and the artist pairings are imaginative. Consider, for example, *Poems of W. B. Yeats* with etchings by Richard Diebenkorn; Richard Brautigan's *Trout Fishing in America* with a frontispiece by Wayne Thiebaud; James Joyce's *Ulysses* with art by Robert Motherwell; and John Ashbery's *Reflections in a Convex Mirror* printed on circular pages with lithographs by Richard Avedon, Alex Katz, Willem de Kooning, R.B. Kitaj, Larry Rivers, and others; and Jim Dine's *Ape & Cat,* a boxed book with a lead-alloy bas-relief sculpture on the cover and an accordion-fold album of 18 photogravures plus Henry James's *The Madonna of the Future* inside.

Founded in 1974, Arion Press moved into its current home, a former steam plant, in 2001. In addition to housing all production facilities, the building has a light-filled, spacious gallery and display lobby, where original artworks associated with book projects as well as books and other materials are exhibited.

16 Green Apple

506 Clement St, 94702
415-387-2272 f: 387-2377
www.greenapplebooks.com
info@greenapplebooks.com
Sun–Thurs, 10 am–10:30 pm; Fri–Sat, 10 am–11:30 pm
bus: 2
Located near the corner of 6th Av.

If you are a bookstore afficionado and you are in the area of the Presidio, you might want to save time for a visit to Green Apple. Laid out on several disjunctively connected levels with overflowing bookcases and tables lining tightly packed, narrow aisles, this labyrinthian emporium specializes in used books. (It also carries a judicious selection of new titles, records, and CDs.) In the art and architecture realm, the selection is broad and invariably quirky. Unfamiliar and hard-to-find treasures share space with schlocky-slick publications, high-minded treatises, and popular picture books. International art periodicals are located in the annex, a few doors down at 520 Clement St.

If you are after a specific title, you may have to search through disorderly stacks and several different sections, since the organizing system seems firmly rooted in happenstance. Best to resign yourself to the frustrations of the disorganization and marvel at all the unexpected oddities you are bound to discover.

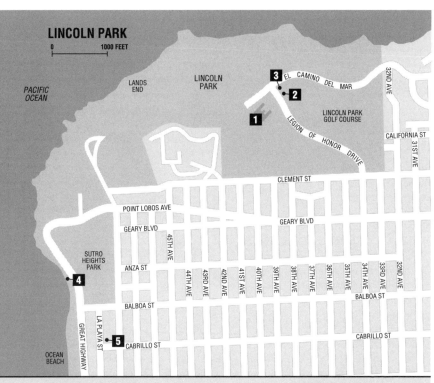

LINCOLN PARK

0 1000 FEET

PACIFIC
OCEAN

LANDS
END

LINCOLN
PARK

3 EL CAMINO DEL MAR

2

32ND AVE

1

LEGION OF HONOR DRIVE

LINCOLN PARK
GOLF COURSE

CALIFORNIA ST

31ST AVE

CLEMENT ST

POINT LOBOS AVE

GEARY BLVD

GEARY BLVD

45TH AVE

SUTRO
HEIGHTS
PARK

ANZA ST

44TH AVE
43RD AVE
42ND AVE
41ST AVE
40TH AVE
39TH AVE
38TH AVE
37TH AVE
36TH AVE
35TH AVE
34TH AVE
33RD AVE
32ND AVE

4

BALBOA ST

BALBOA ST

LA PLAYA ST

GREAT HIGHWAY

5

CABRILLO ST

CABRILLO ST

OCEAN
BEACH

1. Legion of Honor
2. M. di Suvero, *Pax Jerusalem*
3. G. Segal, *Holocaust Memorial*
4. Cliff House

5. R. Beldner, *Playland Revisited*
6. de Young Museum
7. CA Academy of Sciences
8. Le Video

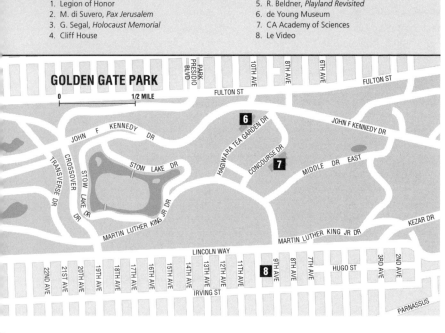

GOLDEN GATE PARK

0 1/2 MILE

PARK
PRESIDIO
BLVD

10TH AVE
8TH AVE
6TH AVE

FULTON ST

FULTON ST

JOHN F KENNEDY DR

6

HAGIWARA TEA GARDEN DR

JOHN F KENNEDY DR

CROSSOVER DR

TRANSVERSE DR

STOW LAKE DR

STOW LAKE DR

CONCOURSE DR

7

MIDDLE DR EAST

MARTIN LUTHER KING JR DR

KEZAR DR

MARTIN LUTHER KING JR DR

LINCOLN WAY

22ND AVE
21ST AVE
20TH AVE
19TH AVE
18TH AVE
17TH AVE
16TH AVE
15TH AVE
14TH AVE
13TH AVE
12TH AVE
11TH AVE
10TH AVE
9TH AVE
8TH AVE
7TH AVE

HUGO ST

3RD AVE
2ND AVE

8

IRVING ST

PARNASSUS

Lincoln Park–Golden Gate Park

1 Legion of Honor

architects: **EDWARD LARRABEE BARNES, MARK CAVAGNERO**, 1998
Legion of Honor Dr, Lincoln Park, 94121
415-863-3330
www.thinker.org/legion
guestbook@famsf.org
Tues–Sun, 9:30–5
admission: $10/7/6; free first Tues
bus: 18

Located in Lincoln Park at the end of Legion of Honor Dr, where it abuts El Camino del Mar. You can access Legion of Honor Dr, an extension of 34th Av, at the southeast entrance to the park along Clement St.

With its spectacular setting high atop windswept cliffs overlooking the Golden Gate Bridge and Marin headlands, the site alone—known as Land's End—is worth a visit. The Legion of Honor is an encyclopedic museum covering the medieval to modern eras in Europe with a particular concentration on French art. Indeed, the French connection is immediately manifest in the building itself—a modified replica of a grand Parisian residence designated by Napoleon as the Palais de la Légion d'Honneur. Placement of Rodin's *Thinker* (c. 1850) front and center in the entrance courtyard reinforces the espoused kinship while also underscoring the museum's outstanding collection of work by this preeminent sculptor.

Recent renovation added underground gallery space without disrupting the starkly symmetrical U-shaped layout of the original building (1924) or the colonnaded entry plaza. Even the pyramidal skylight, which provides natural illumination in the new exhibition galleries, is a restrained, low-lying design.

Though hardly as comprehensive or masterpiece-ridden as New York's Metropolitan Museum of Art or the Chicago Art Institute, the Legion's collection has many notable objects with marked historical and artistic significance. Among these are works

Ed Ruscha, *Us*, 1995; Legion of Honor

by Titian, Rubens, Rembrandt, van Dyck, El Greco, de la Tour, Tiepolo, Watteau, Boucher, Fragonard, Gainsborough, David, Constable, Cézanne, Degas, Manet, Monet, Renoir, and Picasso. Special exhibitions feature fine and decorative art from various countries and eras. Occasionally the focus is on work from the 20th century. Sample exhibitions: *Artwear—Fashion & Anti-Fashion, Bonjour Monsieur Courbet, Annie Liebovitz, Claude Lorrain, Masterpieces of French Jewelry, Monet in Normandy, Richard Pousette-Dart.*

The Legion is not the place to survey modern and contemporary art—except in the realm of graphic arts. The museum's Achenbach Foundation contains extensive holdings of works on paper by a multitude of artists from recent decades. Of particular note are the archives of Crown Point Press and Ed Ruscha, and the Anderson and Logan donations. Intermittently, drawings, prints, illustrated and artists' books from the collection are featured in impressive exhibitions, which typically focus on a single artist, theme, or stylistic grouping. For example, *Black and White—Big Prints from the 1970s and 1980s, Howard Finster—Image+Words=God, Philip Guston's 'Poor Richard', Picasso as Book Illustrator, Martin Puryear.* The Achenbach also has a dedicated exhibition gallery at the de Young Museum (see p. 166).

2 Mark di Suvero

Pax Jerusalem, 1998–99
Legion of Honor Dr, Lincoln Park, 94121
bus: 18
Located in the middle of the parking area facing the Legion of Honor.

The ring and thrusting components of this monumental sculpture are well suited to its placement in a circular area with views looking out over the city skyline. The artist has an international reputation as well as strong roots in the Bay Area. (He grew up here, attended UC Berkeley, and has a home in Sonoma County.) Too bad, then, that this isn't a prime example of his work. Composed of steel plates and I-beams painted cadmium orange, it bears the signature markings of Mark di Suvero's brand of expressive (some

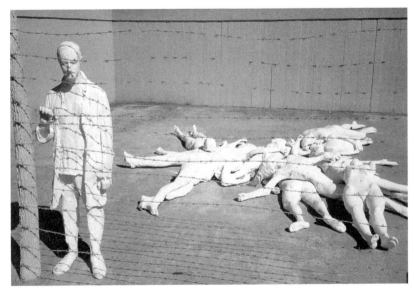

George Segal, *Holocaust Memorial,* 1984

C. David Robinson, Cliff House

call it macho) sculpture, but it lacks the tenuous balance, asymmetry, and dynamism of his prime works.

3 George Segal

Holocaust Memorial, 1984
El Camino del Mar, Lincoln Park, 94121
bus: 18
Located at the intersection with Legion of Honor Dr just below the parking area fronting the Legion of Honor museum.

Unlike public art that is contextualized to the history of a place or its architectural and natural ambience, George Segal's *Holocaust Memorial* dramatically contrasts with the majestic, leisure-oriented landscape and panoramic views in Lincoln Park. (Prior to becoming parkland, however, the acreage served as the city cemetery.)

The sculpture presents a ghostly, wrenching scene of naked bodies lying dead on the ground with a lone survivor looking out through a barbed-wire fence. The imagery recalls Margaret Bourke-White's famous *Life* magazine photographs (1945) documenting the liberation of Buchenwald, though biblical associations are also evoked in the figure holding an apple (Eve), the figure covering another's eyes (Abraham and Isaac), and the figure with arms outstretched in a crucifixion posture (Christ).

Segal made life casts using his friends as models and then translated the plaster forms into bronze with a white patina. The unidealized, anonymous character of the bodies captures the brutal atrocity of the Holocaust even as the standing figure and the wondrous setting surrounding the memorial elicit existential thoughts about the continuity of life. Needless to say, this provocative and emotional sculpture was controversial from its inception and still arouses commentary.

4 Cliff House

architect: **C. DAVID ROBINSON**, 2004
1090 Point Lobos Av, 94121
415-386-3330 f: 387-7837
www.cliffhouse.com
Sutro's: daily, 11:30–3:30, 5–9:30
The Bistro: Mon–Sat, 9 am–9:30 pm; Sun, 8:30 am–9:30 pm
bus: 38, 18
Located at the north end of Ocean Beach just south of Sutro Baths where Point Lobos Av meets the Great Hwy.

Ray Beldner, *Playland Revisited*, 1996

There have been several incarnations for this seaside landmark and popular tourist site. The original 1863 structure, a modest building, burned down after only one year and was replaced in 1896 by a grandiose, chateau-like edifice, only to burn down again in 1907. The 1909 reconstruction, a neoclassical structure designed for sumptuous dining, survived and became part of the Golden Gate National Recreation Area in 1977. In 2004, it underwent a major renovation that included the addition of a spectacular new wing with a two-story dining room offering breathtaking views through its panoramic, glass-curtain walls overlooking the cliffs of Point Lobos and the ocean.

The renovation also expanded the building's seafront terraces and restored the Bistro, a casual café-bar whose past is recalled in the old tile floor and walls laden with photos of celebrities who visited in years gone by. Historical charm also characterizes the Terrace Room, a private space seeped in turn-of-the-century flavor with a newly enlarged outdoor patio.

Should you wish to dine at the Cliff House, reservations are highly recommended. If you just want to meander along the seaside paths to take in the windswept cypress trees and vistas, it is advisable to bring a coat to fend off the cold and fog. A short detour to the lower terrace of Cliff House (accessible from outdoor staircases) will bring you to the

GIANT CAMERA OBSCURA, a periscope-like lens housed in a room-sized structure in the shape of a camera (open daily, 11–5, weather permitting). Built in 1948–49 as part of the Playland at the Beach amusement area, the camera site has recently been restored to its original design. For those who are more adventurous, a walk down into the adjacent ruins of Sutro Baths is a unique experience. And should you want a hilltop view of the coastline from a most dramatic overlook (also a great place for a picnic), continue along Point Lobos Avenue to Sutro Heights Park, once the palatial gardens of Adolph Sutro—engineer, real estate entrepreneur, philanthropist, and mayor of San Francisco.

5 Ray Beldner

Playland Revisited, 1996
corner of La Playa and Cabrillo Sts, 94121
bus: 5, 18, 31, 38
Located one block east of the beachfront and Great Highway, and one block north of Golden Gate Park.

Playland—a popular amusement park equipped with a giant roller coaster, a carousel, dance halls, and a spectrum of entertainment booths and rides—occupied this area of the city from the 1920s until 1972. In the midst of the housing development and Muni bus turnabout that have replaced it, San Francisco artist Ray Beldner has installed an ensemble of five sculptures commemorating the history of the site: a carousel horse, a clown head from the Funhouse, Laughing Sal (the mechanical cackling lady), a rooster from the nightclub Topsy's Roost, and a Muni bus. Each figure, made of perforated stainless steel and standing ten feet high, includes historical photographs and reminiscing quotes from Bay Area residents.

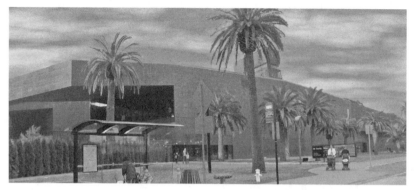

Herzog & de Meuron, de Young Museum

6 de Young Museum

architects: **HERZOG & DE MEURON**;
WALTER HOOD (landscape), 2005
50 Hagiwara Tea Garden Dr, 94122
415-863-3330
www.thinker.org/deyoung
guestbook@famsf.org
Tues–Sun, 9:30–5
admission: $10/7/6; free first Tues
bus: 5, 44

Located in Golden Gate Park facing the Music Concourse just south of John F. Kennedy Dr. Access is from 10th Av off Fulton St on the north side of the park, or from 9th Av off Lincoln Way on the south side.

The new de Young is a masterful work of architecture, widely acclaimed as one of the great buildings of recent times and a welcome landmark in San Francisco. Inaugurated in October 2005, it occupies the same site as the museum's former structure, which was irreparably damaged in the 1989 Loma Prieta earthquake. Designed by Jacques Herzog and Pierre de Meuron—the celebrated Swiss team who created the Tate Modern in London and won the esteemed Pritzker Prize in 2001—the new de Young showcases their refined, modernist approach and its innovative use of materials and surfaces.

This approach is immediately apparent, both in the simple form of the building—a long, low, boxlike structure—and in its unusual sheathing—copper panels embossed and perforated to create a dappled effect. Over time, the copper will oxidize in the salt air, ultimately producing a blue-green tone that harmonizes with the greenery of the surrounding park. Subtle angles modulate the far-reaching front facade, while eccentric shapes at either end provide points of drama. At the east, a striking tower, twisting as it rises up to its 144-foot height and clad so the copper plates have translucency, functions as a beacon. The observation deck on its top floor, which is totally encased by a window wall, offers expansive views across the park and city beyond. (Access to the tower is free and independent of an admission ticket to the museum, but be aware that you may encounter long queues for the elevator ascent.) On the ground level, a children's garden extends back in the area around the tower. Similarly, the west end with its cantilevered canopy over an outdoor café-terrace that opens onto a sculpture garden, integrates the building with its surroundings and makes it more inviting to the public.

The vast lobby, entered through an open-air courtyard set behind an aperture in the middle of the long facade, gives evidence of Herzog & de Meuron's penchant for shaping forms and spaces as polygons, rather than as simple rectangles. This is notable, for example, in the angled sweep of the lobby itself, in the grand, trapezoidal staircase that

Andy Goldsworthy, *Drawn Stone*, 2005; de Young Museum

ascends to the upper level, and in the oblique position of the elongated stair-corridors that stretch across the rear of the reception area, descending to the lower level. Not only does the divergence from straight lines add diversity and rhythm to the spaces, but the angled elements also exaggerate long, majestic vistas. Indeed, the entire interior was conceived as a tripartite structure having parallel bands like the fingers of a hand. The bands interconnect in places and the interstices between them are filled with narrow, terrarium-like gardens (ferns, eucalyptus, slate shards) enclosed in glass. The presence of nature in these interior courtyards gives further recognition of the museum's park setting. As in the plantings outside, the landscaping of Walter Hood offers an appealing but unimposing complement to the built forms

The de Young's collection represents many different eras and a variety of cultures from all over the world: fine and decorative American art from colonial times to the modern age; art from the native cultures of North, Central, and South America; art from the Pacific Islands and Africa; and textiles. Highlights include the world-class Rockefeller Collection of American art and the Jolicka Collection of New Guinea art. In developing the building's layout, the architects sought to undermine hierarchies by providing an uninterrupted flow of movement throughout and by communicating the diversity through distinctive spaces. Thus, the Oceanic galleries are spot-lit, open spaces, punctuated by floor-to-ceiling, wood-framed vitrines, and the American galleries are classically appointed rooms suffused with natural light.

The de Young has only recently begun to collect contemporary art, and its holdings, mainly displayed in a sequence of galleries on the ground level, are as yet scant and largely unexceptional. The presentation includes interesting but minor works and a few treasures by such big-names as Willem de Kooning, Richard Diebenkorn, Mark di Suvero, Robert Motherwell, Mark Rothko, David Smith, and Wayne Thiebaud. Should you be a fan of contemporary crafts, the galleries devoted to the Saxe Collection offer some outstanding examples. There is also a gallery featuring contemporary works on paper from the Achenbach Foundation (see p. 162), and a space on the upper level that shows new work by local artists. Sample exhibitions: *John Bangston*, *Armando Rascon*, *Catherine Wagner*.

Of special note, are the works the museum commissioned for the new building. Foremost is **ANDY GOLDSWORTHY**'s *Drawn Stone* (2005, also called *Faultline*). Encompassing a hairline crack leading from the front sidewalk into the entrance courtyard and then cutting

through several rough-hewn stone slabs that double as seating, the work references the seismic history of the Bay Area and, more specifically, the earthquake's effect on the museum's former building. Another major commission, displayed on the monumental west wall of the main lobby, is a mural by the esteemed German artist **GERHARD RICHTER**. Composed of 130 digitally manipulated photographs, *Strontium* (2005) derived its imagery from the atomic structure of a synthetic material (strontium titanate) used to make artificial diamonds. The blurred imagery and repetitive grid bears witness to the artist's preoccupation with mirrored representation and pictorial realism, replication, and abstraction.

In an unusual commission, **ED RUSCHA** transformed his classic, 1983 word-image painting, *A Particular Kind of Heaven*, into a triptych by continuing the luminous, sunset sky onto two side panels. The work hangs off to the side of the lobby at the entrance to the 20th-century galleries. Another commission, suspended from the ceiling of the Saxe Gallery, is the sculpture *Near* (2005) by **KIKI SMITH**. One section is a shower of glass teardrops, and a second part is a cast-aluminum framework containing two gilded figures suggestive of votive images and echoing the women in *The Mason Children* (1670) by The Freake-Gibbs Painter, a work in the de Young's American art collection.

For the sculpture garden, the museum commissioned a skyscape project from the distinguished earth artist **JAMES TURRELL**. *Three Gems* (2005) is a small, cylindrical, subterranean room inside a stupa (a dome-shaped mound) that contains an oculus through which you can view the sky and observe changing light, colors, and weather effects. Also included in the garden are works by Robert Arneson, Barbara Hepworth, Joan Miró, Henry Moore, Juan Muñoz, Louise Nevelson, Isamu Noguchi, Claes Oldenburg and Coosje van Bruggen, Beverly Pepper, Joel Shapiro, Zhan Wang. (Note: visitors can access the sculpture garden and adjacent

Juan Muñoz, *Conversation Piece V: 3 Figures* (detail); de Young Museum

café without an admission ticket.)

Special exhibitions have long been a popular element in the de Young's program, and now they are installed in spacious, flexible galleries on the lower level. The offerings range from scholarly shows with extraordinary art treasures, to presentations of work from a particular ethnic sector of American culture, to a focus on a historical period through its craft production in diverse materials, to monographic retrospectives. Among the selections are exhibitions focused on major artists from the contemporary era. Sample exhibitions: *Ruth Asawa*, *Chicano Visions*, *Gilbert and George*, *International Arts and Crafts*, *Nan Kempner—American Chic*, *Louise Nevelson*, *The Quilts of Gee's Bend*, *Charles Sheeler*, *Hiroshi Sugimoto*, *Vivienne Westwood*.

Don't overlook the well-stocked Museum Store.

7 California Academy of Sciences

architect: **RENZO PIANO**, 2008
Golden Gate Park, 94118
www.calacademy.org
info@calacademy.org
Located on the south side of the Music Concourse across from the de Young Museum.

The California Academy of Sciences, which comprises the Morrison Planetarium,

Renzo Piano, California Academy of Sciences

Steinhart Aquarium, and Natural History Museum, will reopen at this site in 2008 in a building by Renzo Piano—the acclaimed Italian architect whose designs for the Centre Pompidou (Paris) and the Menil Foundation (Houston) contributed to his winning of the Pritzker Prize in 1998. Instead of the former, disjunctive maze of 12 structures erected piecemeal over an 80-year period, the new facility will be a well-integrated complex of spaces under a unified contoured roof. Indeed, the undulating, "living" roof—which will sustain the growth of a variety of native plants—will echo the hilly topography of the city, therefore making nature and environmental responsibility an intrinsic aspect of the building's structure. The largest swellings in the roof will cover the planetarium and a rain forest exhibit, while glass walls in the high-ceilinged areas in between and around the central courtyard will open the interior to sunlight and the surrounding environment.

Piano's innovative, eco-sensitive, sustainable design is entirely fitting since the academy was one of the country's first institutions dedicated to exploring and protecting the natural world. Though not embracing the flamboyant, techno-industrial appearance favored by many trendy architects, the project promises to be world-class.

Maya Lin, the artist-architect esteemed for her design of the Vietnam Memorial in Washington, has been commissioned to create an installation project for the building.

During construction, the Academy has a temporary home at 875 Howard St in the South of Market district.

8 Le Video

1231 9th Av, 94122
415-566-3606
www.levideo.com
daily, 10 am–11 pm
Muni: N, bus 44
Located a block south of Golden Gate Park between Lincoln Way and Irving St.

This is the premier video-rental store in the city. With its huge selection of foreign films, Hollywood classics, and esoteric or hard-to-find films—in addition to new releases—this is the place to go if you are in the mood to see a movie but do not want to go to a commercial theater or wait for a rental from Netflix. The crammed-together shelves make searching for a particular title a detective-like pursuit, but the well-informed staff and commonsense system of categorization prevent undue frustration.

Stern Grove

architect: **LAWRENCE HALPRIN** (landscape), 2005
415-252-6252 f: 252-6250
www.sterngrove.org
info@sterngrove.org
bus: 23, 28
Muni: K, M
Located at the corner of 19th Av and Sloat Blvd in the Sunset district.

Stern Grove was established as a city park by philanthropist Rosalie Meyer Stern, who also determined that the site, with its natural amphitheater and superb acoustics, be used for public enjoyment of admission-free music,

dance, and theater performances. The Stern Grove Festival, launched in 1938, instantly became a popular summer attraction. The annual series of concerts features everything from opera, symphony, and ballet to pop music and hip-hop.

Nestled under a forest of eucalyptus, redwood, and fern trees, the steep hillside and meadow area containing the amphitheater received a major facelift in 2005 by world-renowned, San Francisco-based landscape architect Lawrence Halprin. In his signature mode, Halprin incorporated lots of granite—as terrace seating, walls, paving, picturesque piles of boulders, and entry pillars—to create a sumptuous setting inspired by the amphitheaters in ancient Greece. The new design is more amenable to crowds than the former situation, particularly since people no longer slide down the hillside during a performance. Also included in the renovation is an expanded stage with a steel lattice truss for sound equipment and lighting, a charming set of wooden backstage structures, picnic tables, new service facilities, and circulation improvements.

Fine Arts Gallery, SF State University

Rm 238, Fine Arts Building, 1600 Holloway Av, 94132
415-338-6535 f: 338-0502
www.sfsu.edu/~gallery
gallery@sfsu.edu
Tues, Thurs–Sat, 12–4; Wed, 12–6
Muni: M, bus 28

The campus is located at the southwest end of the city between 19th Av and Lake Merced. To get to the gallery, proceed down Holloway Av past the Creative Arts Building, turn right into Tapia Dr and you will see the Fine Arts Building on your right.

The SFSU gallery program is not high-powered, but offers a good way to expand awareness about the Bay Area art community. Of particular interest are the thematic exhibitions with a socioethnic base, and the shows exploring a particular medium. Sample exhibitions: *AfroCuba, Bent—Gender & Sexuality in Contemporary Scandinavian Art, Eco—Art About the Environment, Endless War, Jan Kaneko.*

Lawrence Halprin, Stern Grove

San Francisco Airport

BART: SFO

Though you probably won't make a special trip to SFO to see the art, when you are spending those endless hours waiting for your flight to leave or when you are passing through the interminable arrival and departure corridors, you can relieve the boredom and frustration by perusing the wide range of art objects and exhibitions on view or by visiting the airport's aviation museum. Not only is the airport location for art exhibitions distinctive, but the SFO museum and art displays are all free and open 24 hours a day, seven days a week.

Because the airport falls under a city ordinance requiring that 2% of construction costs be allocated for public art, a big boon occurred when the new International Terminal was built (2000). This entailed the commissioning of 17 large-scale works for the lobbies, immigration area, gate rooms, and passageways. Previous construction projects had resulted in the purchase of art for other airport terminals.

San Francisco Airport Museums

650-821-6700 f: 821-6777
www.sfoarts.org
daily: 24 hrs

From modest beginnings in 1980, the museum program at SFO has grown into a huge enterprise. Its mission to "capture the unique culture of the San Francisco Bay Area and humanize the airport environment" is evident in the 40-plus exhibitions presented annually in various locations throughout the airport's four terminals and connecting corridors. The projects cover diverse general-interest topics, some of which include art from the current era. Regardless of the subject, displays typically feature a wondrous array of materials— documentary photographs, folk art, ethnographic artifacts, memorabilia, quotidian products, crafts, scientific specimens, historical objects, and fine art from museum collections.

Sample exhibitions: *Bali & Java—Folk Art and Tradition*, *Dining Aloft—Airline Meal Service Settings*, *Katsinam*, *Magical Spectacles—Optical Entertainment of the Precinema Era*, *The Photography of Harold Edgerton*, *Silver & Metalwork of the 20th Century*, *Varying Vessels—Contemporary Glass*.

International Terminal

architect: **CRAIG HARTMAN**, 2000

Aiming to create an iconic identity for SFO, Hartman gave the new terminal a tripartite winged roof that echoes the forms of Bay Area hills and symbolizes flight. Set atop a system of trusses, the roof spans a cavernous area and seems to float above the building. Should you miss the effect on the exterior, you can't help but experience the breathtakingly open space once you step inside the main lobby. Four boat-shaped skylights and an expansive glass-and-metal wall fronted

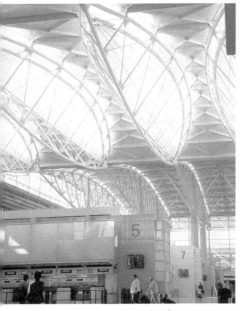

James Carpenter, *Sculptural Light Reflectors*, 2000

Ik-Joong Kang, *Gateway* (detail), 2000

by 40-foot-high bamboo trees on one side and a long cherry-wood wall on the other produce a striking grandeur.

The five-story vertical structure, which straddles 16 lanes of highway, was designed to maximize scarce land and become a well-integrated, visually dominant centerpiece for the entire airport. Efficiency and a passenger-friendly layout were also primary considerations in organizing the services. The key components include common-use ticket counters arranged on six islands, shops and a food court along the back and side walls, two boarding concourses with additional shopping-restaurant services, a two-level station for BART, and a new AirTrain (light-rail system) linking all the terminals and parking facilities.

James Carpenter

Sculptural Light Reflectors, 2000
International Terminal, Departures Lobby, ceiling

Working with the terminal's architect, James Carpenter (a New York artist who specializes in glass and emerging material technologies) developed the ceiling sculpture for the building's main lobby. The form of the four components, inspired by the aircraft flown by the Wright brothers, is created from translucent white silicone fabric stretched over the metal frame of the skylights. Indeed, the segments are inserted within the trusses

and totally integrated with the roof structure. Edged in strips of blue-and-magenta colored glass, they further become part of the space when the sun shines through and casts long arcs of prismatic light onto the floor (best observed during the midday hours).

Ik-Joong Kang

Gateway, 2000
International Terminal, Departures Lobby, seating lounge (rear area).

Gateway is a mural configured as a grid containing 5,900 individual elements, each a three-inch square of ceramic tile, painted canvas, carved wood, cast acrylic, plywood paneling, or found objects. The endless array of different images, abstract designs, words, and evocative phrases ("white shadow," "fecund idea," "death threats") creates a colorful, playful compendium related to the dreams, thoughts, and experiences of Ik-Joong Kang, a young Korean-born, New York–based artist.

SFMOMA MuseumStore

architects: **McCALL DESIGN GROUP**, 2001
International Terminal, Departures Lobby (rear area)
650-553-8040
daily, 9–6

In case you forgot to get a gift for someone, crave an art book to read on your flight,

or want information about the current exhibitions at SFMOMA, head here before leaving the lobby area. Not only does the store sell a spectrum of art-related merchandise, but its chic design is crafted to simulate a museum. Backlit cases, wall niches, white laminated metal shelves, frosted glass, video displays, artful installations, and, of course, art reproductions, custom objects, designer furnishings, and luxury picture books shape the setting. More particularly, the striped floor, featured posters, and catalogues relate to the architecture and programs at SFMOMA.

San Francisco Airport Commission Aviation Library and Louis A. Turpen Aviation Museum

International Terminal, at the entrance to Boarding Area A, level 3
Mon–Fri, Sun, 10–4:30

Replicating the waiting room in the 1937 terminal of San Francisco's original commercial airport, the architecture alone—especially its intimate scale in comparison to that of the voluminous adjacent hall—is worth a visit.

Squeak Carnwath, *Fly, Flight, Fugit,* 1999

Marble walls and floors, arched doorways, iron grillwork, a grand staircase, and balconies give the design a refined splendor.

Changing exhibitions feature documents and historic artifacts as well quirky items, such as airsickness bags, that focus on the human experience of flight. If you are interested, you can also do serious research using the library on the mezzanine.

Boarding Area A

International Terminal

As you walk down the long corridor, large-scale works commissioned from Bay Area artists are visible on the side walls within the gate rooms. These include *Salty Peanuts* (2000) by **MILDRED HOWARD**, *World Civilization* (1998) by **VIOLA FREY**, *Love Letters* (2000) by **ENRIQUE CHAGOYA**, and *Waiting* (1999) by **MIKE MANDEL** and **LARRY SULTAN**. Using imagery and themes relating to travel or San Francisco, the works are contextualized for the setting, though they also reveal individual and regional styles and aesthetics.

Boarding Area G

International Terminal

The gate rooms along this concourse display *Fly, Flight, Fugit* (1999) by **SQUEAK CARNWATH**, *Dreaming of Balmy Area* (1999) by **RIGO**, *Bird Technology* (1999) by **RUPERT GARCIA**, *Santuario/Sanctuary* (1999) by **JUANA ALICIA** and **EMMANUEL MONTOYA**, and *Baile!* (1999) by **CARMEN LÓMEZ GARZA**.

Although the selections in Boarding Area A and G represent a spectrum of contemporary Bay Area artists, it is a rather conservative overview heavily weighted toward work with convivial subject matter. To be sure, the objects have colorful visual appeal, serving well to enliven the big public spaces of the airport, and yet they give little evidence of more innovative modes of creativity exemplifying the forefront of art activity in the current era.

Ann Preston

You Were in Heaven, 2000
International Terminal, Sterile Corridor A,
level 2

The airports "Sterile Corridors" are the secure hallways through which passengers walk after deplaning on their way to customs. They are only accessible to people arriving on international flights.

Los Angeles artist Ann Preston aimed to recall associations with the sky—or to imply a return to Earth from the heavenly sphere—by covering the dome at the far end of Sterile Corridor A with crystalline patterns suggestive of stars and by placing cast-plaster reliefs having the semblance of clouds on the walls of intermittent concave segments of the long corridor. Using a mathematical formulation for the cloud imagery, she created two basic shapes that were then variously positioned and juxtaposed into multipartite compositions, each with a different appearance. Most notably, grooves energize the surface with a medley of rhythmic waves, short ripples, and concentric circles.

Keith Sonnier

Ceiling Flood, 1999
International Terminal, Sterile Corridor G,
level 2

In contrast to Preston's concentration on the walls, New York artist Keith Sonnier developed a light installation for the ceiling that plays with perspectival dynamics in the long hallway. Red and blue horizontal bands deriving from neon tubes set within wedge-shaped coves at the wall/ceiling juncture create a progression down the corridor. Since the colors do not follow a consistent order, but are randomly alternated, paired or arranged in a monotone line, they are a provocative presence. A yellow glow running down the entire length of the corridor in the middle of the ceiling adds another color element to the setting. For this, Sonnier set a track of fluorescent tubes above a suspended light fixture, itself a long white strip that emphasizes the linear character of the hall. The slanted ceiling contributes yet another dimensional rigor to the space, further countering the bland, rectangular

Keith Sonnier, *Ceiling Flood*, 1999

regularity of its basic form. Characteristically, Sonnier used minimal means and a minimalist approach to affect spatial reorientation that does not fall prey to being decorative.

Su-Chen Hung

Welcome, 2000
International Terminal, Immigration Hall

After leaving Sterile Corridors A or G, passengers enter another secure area (not accessible to the general public)—the Immigration Halls where passports are checked. For this space, Su-Chen Hung designed a series of ribbed glass panels within which "welcome" is written in various different languages. Although the panels are set in front of structural columns in the midst of the area where passengers wait in lines, the words can only be read at certain angles due to the prismatic, rippled nature of the glass. This either causes the artwork to go unnoticed, or it has a surprise effect that redoubles the message.

Vito Acconci

Light Beams for the Sky of a Transfer Corridor, 2003
International Terminal, Transfer Corridor, Arrivals, level 2

The Transfer Corridor, which leads out of the baggage-claim room, is the first nonsecure area for passengers who have just cleared customs. For this 800-foot-long hallway, Vito Acconci designed a prominent light-sculpture installation. It comprises sixteen lines of light emanating from sharp-angled, translucent acrylic boxes lit from within by fluorescent tubes. Twelve originate at the ceiling on the side wall, diagonally cross the corridor to the window wall, and then zigzag into standard phone booths; and four hug the side wall and descend into wheel-chair-accessible phone booths. Expressly conceived as lighting for the corridor and explicitly associated with a service—the first public telephones available for arriving passengers—the installation does not bear a clear-cut identity as artwork, though it clearly adds an artistic dimension to the surrounds.

Renowned internationally for his early performance and conceptual work, Acconci has progressively directed his attention to large-scale outdoor and interior installations for public spaces. Rejecting the idea of the autonomous art object, he has pursued the creation of functional art/architectural projects that directly involve people and incorporate infrastructure and/or purposeful activity as inherent, dominant aspects of their design.

Vito Acconci, *Light Beams for the Sky of a Transfer Corridor*, 2003

Lewis deSoto

On the Air, 2000
International Terminal, Arrivals Lobby, floor
Taking the expansive terrazzo floor of the lobby as his canvas, Bay Area artist Lewis deSoto delineated a weather- and flight-oriented map of the world. Large flowing shapes defined by tonal gradations represent atmospheric pressure zones, brass strips outline land masses, and medallions show pilot charts for landing and takeoff from the world's busiest airports.

You probably won't realize you are walking on an artwork as you pass through the lobby, but should you look down and focus on one of the enigmatic configurations, you may be tempted to stop and decipher the systems.

Joyce Kozloff

Bay Area Victorian, Bay Area Deco, Bay Area Funk, 1982–83 International Terminal, South Pedestrian Bridge, Arrivals, level 2
Originally commissioned for another location in the airport, this mural was moved to the entrance of the corridor linking the International Terminal with Terminal 1 as part of the public art program for the new building. The work, composed from ceramic tile and glass mosaic, features three medallions, each depicting a different era of Bay Area style—Victorian, Deco and funk.

As a leading figure in the Pattern and Decoration movement of the 1970s, Kozloff sought to make ornamental design—creativity rooted in cultural expression, historical change, and ideological difference—a valid art form.

Ned Kahn

Wind Portal, 2003
International Terminal, BART and AirTrain stations
Located in the circular stairwell connecting the BART and AirTrain platforms in the International Terminal station. Concourse H, a pedestrian walkway, links the stations with the terminal.

You may not identify this installation as an artwork, but you will surely perceive the visual effect it produces. Wind Portal is an environment of billowing waves, not unlike those in the waters around San Francisco. It is made from curtains of one-inch stainless-steel discs that shimmer, shake, and sparkle in response to wind currents. Needless to say, its location within the curving walls of an open-air stairwell results in lots of animation, especially when trains arrive at and depart from the station.

As is evident here, Ned Kahn—who has created indoor and outdoor projects in collaboration with architects, scientists, performance artists, and civic organizations—has an abiding interest in heightening awareness of natural phenomena.

Terminal 1

Various artworks are positioned in the lobby and boarding areas of this terminal, with a concentration in Concourse C, where sculptures, set in vitrines in front of structural columns in each gate area, line the central passageway. The installation includes objects by **JAN KANEKO**, **FRAN MARTIN**, **MANUEL NERI**, **ISAMU NOGUCHI**, and **JACK ZAJAC**. In addition, one of **DEBORAH BUTTERFIELD**'s signature horse sculptures, Pohina (2001), stands near the beginning of the concourse.

Terminal 3

From 1977 to 1987, the airport actively engaged in purchasing and commissioning art for this terminal, with the specific aim of showcasing contemporary Northern California artists. The collection, mainly paintings, includes significant works by **ROBERT BECHTLE**, **SAM FRANCIS**, **ROBERT HUDSON**, **RAYMOND SAUNDERS**, **WAYNE THIEBAUD**, and **WILLIAM T. WILEY**.

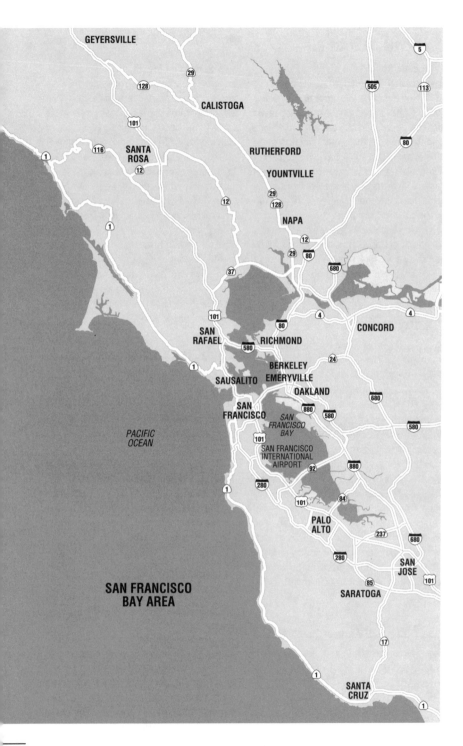

GEYERSVILLE

CALISTOGA

RUTHERFORD

YOUNTVILLE

SANTA
ROSA

NAPA

SAN
RAFAEL RICHMOND

SAUSALITO

BERKELEY
EMERYVILLE

OAKLAND

CONCORD

SAN
FRANCISCO

*SAN
FRANCISCO
BAY*

PACIFIC
OCEAN

SAN FRANCISCO
INTERNATIONAL
AIRPORT

PALO
ALTO

SAN
JOSE

SARATOGA

SAN FRANCISCO
BAY AREA

SANTA
CRUZ

Bay Area

South Bay
Palo Alto
Stanford University

CalTrain: exit at California Av or Palm Dr, then take the Stanford shuttle (Marguerite, line A) to the campus. The train only runs on weekdays. SamTrans bus: KX, 280, 281, 295, 390. Car: I-280; exit at Sand Hill Rd east; turn right on Santa Cruz Av, which immediately becomes Junipero Serra Blvd; turn left at Campus Dr West; continue around and turn left onto Lomita Dr, a visitor-parking street fronting the museum.

Located about one hour south of San Francisco on railroad magnate Leland Stanford's old horse ranch (popularly known as "The Farm"), this campus is well worth a visit for art and architecture enthusiasts. The campus plan, originally created in 1888 by Frederick Law Olmsted, revered designer of New York's Central Park, has a grand entrance along Palm Dr leading to the main quad, around which sits a complex of sandstone buildings with Spanish Romanesque arches and covered walkways. Although numerous buildings, quads, and connecting malls

have proliferated in all directions, the initial architectural vocabulary has remained in place—for better or for worse. Mediocrity and oddities are evident as attempts were made to merge the prescribed materials and style with modern design ideas. Nevertheless, some new structures and the idyllic, human-based character of the campus are noteworthy.

A distinctive aspect of Stanford's campus is the presence of outdoor sculpture in many locations throughout the landscape. An extraordinary collection of Rodin bronzes, some works by modern masters, late-20th-century names, and commissions from contemporary talents are the hallmarks. Should you wish to see all the outdoor sculptures—including 19th- and 20th-century figurative and abstract works with a generic modernist flavor, as well as Native American and Papua New Guinean objects—take a walking tour using the map in the free brochure available at the Cantor Arts Center or the Visitor Center. The most significant sculptures in terms of historic value and contemporary art interest are noted below.

James Stewart Polshek, Cantor Center for Visual Arts; Rodin Sculpture Garden

Cantor Arts Center

architect: **JAMES STEWART POLSHEK**, 1999

328 Lomita Dr, 94305

650-723-4177 f: 725-0464

www.museum.stanford.edu

Wed, Fri–Sun 11–5; Thurs, 11–8

Located to the west of Palm Dr, where Museum and Roth Ways abut Lomita Dr.

Following a long recovery from major damage sustained in the Loma Prieta earthquake (1989), the Stanford Museum reopened in 1999 with a new name in a newly restored and expanded building. The original neoclassical structure was complemented by a contemporary wing with a glass, steel, and stucco exterior, inner and outer garden courtyards, new exhibition galleries, terraces, an auditorium, a bookstore, and a café. Though the colonnaded portico on Lomita Drive still designates the main entrance, visitors tend to gravitate to the south side of the museum, where the **RODIN** Sculpture Garden and entry to the new wing are found. Not only do the garden's 20 bronzes—including the monumental, masterful *Gates of Hell* (1880–1900)—form a unique viewing experience, but the well-orchestrated setting, with grass and gravel surfaces on modulated levels, trees, picnic tables, and benches, is a superb enhancement to the art.

If you enter the museum from the garden door, you can either go off to the right, first encountering a room filled with more (smaller) sculptures by Rodin and then proceeding through the permanent-collection galleries in the old building, or you can turn left into the new wing. Encompassing a broad spectrum from ancient to modern, European, American, Asian, Oceanic and African cultures, the Stanford museum offers a general survey of art. It is a teaching collection exemplifying major stylistic trends largely with works by lesser-known artists.

Art from the most recent decades is in the long spacious gallery on the second floor of the new wing. The focus is on Bay Area artists, mainly those associated with the figurative, funk, and abstract modes that emerged in the mid-20th century. Included are works by Joan Brown, Bruce Conner, Roy De Forest, Richard Diebenkorn, Frank Lobdell, Manuel Neri, Nathan Oliveira, David Park, Wayne Thiebaud, William T. Wiley, and Paul Wonner. A section of the gallery is also devoted to changing displays of prints from the mid-20th century and photographs.

Ceramic sculpture from the contemporary era, including a plentiful display of works by Robert Arneson, is exhibited on the upper level of the south rotunda, and the inner courtyard on the ground floor features two of Claes Oldenburg's witty objects: *Soft Inverted Q* (1977) and *Floating Peel* (2002). As you continue to the north side of the museum, you will find **BEVERLY PEPPER**'s *Split Pyramid* (1971) in a back area of the garden lawn. It is a Cor-ten steel structure in which planes, space, and viewer positioning suggest volumetric form in an activated state. And somewhat hidden on the upper terrace is **RICHARD LONG**'s *Georgia Granite Circle* (1990)—a major work that should not be overlooked. Created by the esteemed British artist who was one of the founders of the land art movement, the sculpture references a nature walk taken by the artist. The material—several hundred boulders from a particular geography—signifies the

Richard Long, *Georgia Granite Circle*, 1990; Cantor Center

experience of the journey, and the circular composition imbues the stones with a primal, generic, man-made, and artistic character.

Be sure to take note of Polshek's architecture on this side of the building. It provides unqualified evidence of his design excellence. Recalling the domed atriums that punctuate entrances to the old building, he adopted a cylindrical form to shape the auditorium on the interior, and then reconfigured it as a dramatic image on the exterior. The surrounding wall extends up to become the freestanding enclosure of a rooftop terrace. But the wall's front section is cut away, with a glass curtain wall sheathing the space on the ground level and an open-air zone visibly manifest above. Cut-out windows, an eccentric side staircase, and a stepped-plaza further enhance the design.

Temporary exhibitions in the Cantor Center often address the contemporary era. Sample exhibitions: *Richard Avedon—The American West*, *Edward Burtynsky*, *Conflict and Art*, *Contemporary Chinese Artists Encounter the West*, *Richard Diebenkorn*, *Gordon Parks*, *Vision of Dharma—Thai Contemporary Art*, *H.C. Westermann*, *Yosemite's Structures & Textures—Photographs by Muybridge, Watkins, Adams, and Others*.

Mark di Suvero

The Sieve of Eratosthenes, 1999
Located in front of the Cantor Center at the far north end, just past the juncture of Lomita Dr and Campus Way.

Reiterating his signature style of using giant steel beams to create a sculpture involving structural balance, with poised elements held aloft within and by the intersecting parts, Mark di Suvero here distinguishes one element from the otherwise red-painted parts. In fact, the stainless-steel ring bears a symbolic association with Eratosthenes, the Greek philosopher, mathematician, and astronomer named in the work's title. He was the first to estimate accurately the diameter

of Earth, though his other renown—conceiving a "sieve" that filters out prime numbers from composites—is more relevant today in terms of its application to computers.

Andy Goldsworthy

Stone River, 2001
Located across the street from the Cantor Center on the east side of Lomita Dr just past the juncture with Museum Way. Look for a narrow passage below ground level that cuts through the tall grass.

This topnotch work by Andy Goldsworthy, the celebrated British artist who is the standard-bearer of environmental art, expanding ideas initiated in the 1970s by Michael Heizer, Richard Long, Robert Smithson, and others, is in itself worth a trip to Stanford.

Stone River is a 320-foot serpentine wall that snakes its way through a low earthen trough. Rising up and descending into the sunken plane, it appears somewhat like an unearthed structure in an archeological dig. Since it is constructed out of the sandstone rubble from campus buildings destroyed in the 1906 and 1989 earthquakes, it bears historical as well as visual reference to Stanford's ubiquitous architectural material. The stone's pale yellow color also blends with the surrounding grasses, thus asserting a link with nature. This duality follows the artist's intention: "I strive to make connections between what we call nature and what we call man-made. I hope that this sculpture will reside somewhere between a building and a quarry."

With its precisely cut triangular capstones, which create a fossil-like spine along the top, and its carefully composed, mortarless base, spanning out to a four-foot width at the bottom, the sculpture was hardly intuitively formed from found fragments. Indeed, the stones were cut and set by eight master masons.

Be sure to walk down into the trough and follow the wall along its full length in order

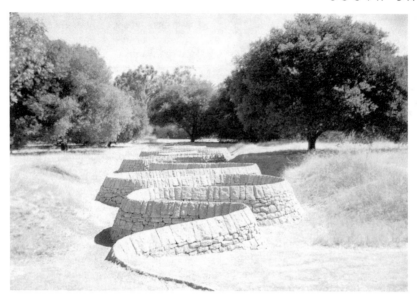

Andy Goldsworthy, *Stone River*, 2001

to appreciate the power of the image—a synthesis of line, movement, and form— and experience the range of perceptions from different vantage points.

Meg Webster

Native Garden, 2003
Located across from the Cantor Center on the southwest parcel of land at the corner of Lomita Dr and Roth Way.

Commissioned to complement a museum exhibition on the American garden, this environmental artwork has become part of the university's outdoor sculpture collection. As a garden, it contains a rich variety of indigenous California plants in tree-shaded, sunny, moist, and dry areas, with a winding granite path meandering through the terrain. But it is also conceived as art, the land having been sculpted into a gently sloping berm with a ravine in its center and a pair of undulating, multisectioned seating areas of molded concrete set into its inner and outer sides. The design as a whole aims to create an intimate space that raises awareness of

the natural surroundings while engaging the senses of touch, smell, sound, and sight.

Clark Center for Biomedical Engineering and Sciences

architect: **NORMAN FOSTER**, 2003
318 Campus Dr West, 94305
Located in the southeast corner of the Medical School campus, perpendicular to the west end of Serra Mall.

Stanford's decision to hire renowned architects and to allow greater divergence from the campus's Romanesque, sandstone paradigm has resulted in two noteworthy buildings by Norman Foster, the Pritzker Prize laureate (1999) from Britain who designed the German Parliament in the Reichstag and the Great Court for the British Museum.

For the Clark Center, Foster radically reconceptualized the layout of a research-laboratory facility by creating open, shared, adaptable interior spaces uninterrupted by corridors. In addition, he oriented the whole structure inward to an expansive courtyard.

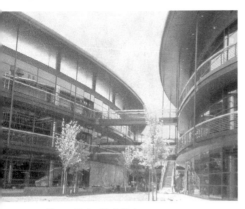

Norman Foster, Clark Center

collaboration among scientists. Here, too, the architecture features an open floor plan and focal courtyard. But the CCSR building is a rectangular structure with two symmetrical wings visually distinguished by the open-air, roof-level sunscreen that extends out as a canopy across the north facade and shades the entry plaza and center space.

Though the wall of opaque and clear glass that stretches the length of the front is surprisingly bland, once you enter the atrium-like inner courtyard the breathtaking setting reveals the potency of Foster's creativity. The design features a long, four-story-high, light-filled area, with semicircular bays demarcating offices along one side and rows of 50-foot bamboo trees lining the other. Benches, tables, and chairs add to the peaceful, Asian-inflected atmosphere. In the middle, an elevator shaft and a span of bridges connect the two wings and various levels.

Despite a dominant glass-and-steel appearance, intermittent wall panels of beige-toned concrete provide a link to surrounding buildings and the Stanford aesthetic. Foster also countered the structure's boxy form with barrel-vaulted roofs and an arcade of diagonal awnings running along the back (south) facade.

Visually, the building stands out because it is not the usual boxy volume. Instead, it is composed of three pods defined by horizontal bands on the outer perimeters and sweeping curves around the inner core. Exterior walkways on each level and an aluminum-clad canopy projecting out from the roofline articulate and unify the overall shape while also serving as integral aspects of the carefully modulated glass, steel, and stone facade.

With its unusual configuration, the open-air courtyard is the architectural, physical, and social heart of the building. Surrounded by glass curtain walls fronting the laboratories, crossed by walkway bridges, landscaped with greenery, furnished with seating, and offering a terrace for the ground-floor cafeteria, it furthers the interactive milieu set forth in the innovatively designed interior.

Center for Clinical Sciences Research

architect: **NORMAN FOSTER**, 2000
Governor's Ln, 94305
Located west of the Beckman Center behind parking lot L-15 (which abuts Campus Dr West), and facing the North Garden and Pasteur Dr on the Medical School campus.

As in the Clark Center, Foster shaped this research facility to encourage interaction and

North Garden

landscape architect: **PETER WALKER**, 2000
Located between the Center for Clinical Sciences Research and Pasteur Dr.

Following axes laid out in Olmsted's original campus plan, Bay Area landscape architect Peter Walker has designed a very formal, geometrically ordered garden. A flat area of open space is divided into a sequence of "outdoor rooms" separated by hedges and crossed by gravel or flagstone paths. Oak trees provide some shade, but for the most part, the acreage is a large expanse of grass lawn.

This is not a place conducive to group

gatherings or casual relaxation. Indeed, the immovable, backless wood benches that line the walkways are not comfort-oriented or arranged for interpersonal exchange.

Mark di Suvero

Miwok, 1981
North Garden

Positioned as the centerpiece of the North Garden, Mark di Suvero's monumental sculpture is a welcome point of interest in the otherwise stark, regimented environment. Characteristically, it is made from industrial I-beams welded and bolted together. Here the steel is unpainted, left in a raw, rusting state, and the assembly of circular and thrusting elements includes suspended and tenuously balanced parts that move in space according to wind currents.

While in the area you might want to walk to the adjacent area across Pasteur Dr to see *Song of the Vowels* (1931) by **JACQUES LIPCHITZ**, a classic modern sculpture inspired by the motif of the harp.

Allen Center for Integrated Systems

architect: **ANTOINE PREDOCK**, 1996
420 Via Palou Mall, 94305
Located between Via Pueblo and Serra Mall, just inside Campus Dr West.

This was the first Stanford building produced by an architect chosen as the result of a design competition. It inaugurated a stream of buildings that decisively reinterpret, if not subvert, the university's Romanesque tradition. Interestingly, Antoine Predock, who lives in New Mexico and derives strong influence from the desert landscape and adobe structures, is an architect who bridges early Spanish and contemporary aesthetics.

Though retaining a sandstone facade and arcaded walkways, the building's bold, solid form, with only a few, fortress-like openings cut deep into the exterior surface, diverges

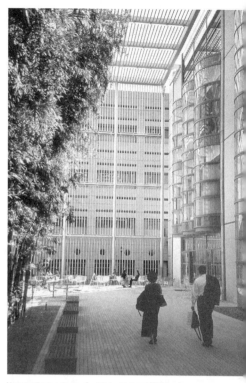

Norman Foster, Center for Clinical Sciences Research

significantly from the campus norm. Even more overtly, the exaggerated barrel-vaulted entrance and copper-shingled roofing call attention to and then transform familiar stylistic features.

A distinctive aspect of Predock's architecture is the interplay of light and shadow. It not only tempers the austerity but also imbues the building with a timeless, magical quality.

Maya Lin

Timetable, 2000
SEQ Plaza
Located in front of the Packard Electrical Engineering Building at the intersection of the Serra and North-South Malls, which is the entrance to the Science and Engineering Quadrangle (SEQ).

Maya Lin, *Timetable*, 2000

In keeping with the inquisitive, probing spirit of Stanford's engineering and science departments, which spawned Hewlett-Packard and numerous Silicon Valley enterprises, Maya Lin has created a sculpture-fountain that arouses thinking about the ideas of time and indeterminate states. Widely known for her eloquent, stirring design of the Vietnam Veterans Memorial (1982) in Washington, D.C., Lin favors simple forms and a refined shaping of compositional parts and conceptual evocations.

Set off-center on a circular gravel base, *Timetable* is a sleek, drum-like shape (10½ feet in diameter, 21 inches high) of polished black granite with gently slanting sides. A thin sheen of water covers the top and spills over the sides. As you get close and inspect the tabletop, the time feature becomes apparent: several revolving metal rings and discs and sets of engraved numbers track seconds, minutes, and hours in Pacific Standard, Pacific Daylight Savings, and Greenwich Mean (universal) time. Each part turns at a different speed, the slowest being the whole sculpture, which imperceptibly pivots in an elliptical path, tracing the passage of months over the course of a year.

Focusing on the unfixed nature of time, the work is a device that shows time not as an absolute, but as an abstract conceit. By specifically denoting the relativity of time to place, the sculpture also raises awareness about the oddities of time in the contemporary world, where the Internet enables instant access, thus collapsing time and place differences.

Packard Electrical Engineering Building

architect: **JAMES INGO FREED**, 1999
SEQ Plaza
Located alongside Serra Mall at the juncture with the North-South Mall behind the Maya Lin sculpture.

In 1993, Stanford began planning a new science-and-engineering campus that would unify and upgrade an important domain of teaching and research at the university. It selected James Freed, widely acclaimed for his Holocaust Museum in Washington, D.C., as the architect for the quad and constituent buildings. The Packard Building, housing classrooms, offices, laboratories, and the Bytes café (which spills out onto the adjoining plaza), is the flagship of the SEQ. An elongated four-story structure, it has a striking glass-enclosed stair tower at its entrance. Though this "prow" audaciously signifies a departure from Stanford's architectural conservatism, the rest of the building is largely business-as-usual.

Hewlett SEQ Teaching Center

architect: **JAMES INGO FREED**, 1998
SEQ Plaza
Located on the east side of the plaza across from the Packard Building.

Paired with the Packard Building as the gateway to the new quad, this Freed design is a far more daring and dynamic creation. Indeed, the aluminum-clad curving structure with its outwardly slanting wall is downright futuristic. This aura is sustained inside, in the two lecture halls connected by revolving-turntable stages and in the three technologically equipped classrooms. Even the back side of

the building, though sheathed in the more conventional limestone and buff-colored stucco and not as radically shaped as the west facade, is nonetheless configured with bold cubic forms deriving from a minimalist aesthetic.

George Segal

Gay Liberation, 1981
Lomita Mall
Located in front of the Geology Corner of the Main Quad, just south of the entrance to the central courtyard.

Commissioned to commemorate the Stonewall riot at a gay bar in Greenwich Village, New York, Segal sought to represent the everyday existence of two same-sex couples rather than to focus on the violence of the event that played a seminal role in the founding of the gay liberation movement. Casting figures from life in casual, ordinary postures was Segal's way of communicating universal themes. In this case, he sought to convey the emotional intimacy shared by loving individuals rather than sexual expression or a particularized type of pairing. The women sit hand in hand and the men stand in quiet conversation one with his arm resting on the shoulder of the other. Segal placed the figures in a setting that incorporates a non-art prop (the bench) in order to encourage direct, unceremonious interaction with the sculpture. Of course, the white patina on the bronze not only imbues the work with a stark, ghostly appearance, but also foregrounds the plaster (art-based) origin of the imagery.

Auguste Rodin

Burghers of Calais, 1884–85
Memorial Court
Located just north of the inner courtyard of the Main Quad, along the central axis that cuts through the campus.

In case you did not get enough of Rodin from the rich display of his work in the Cantor

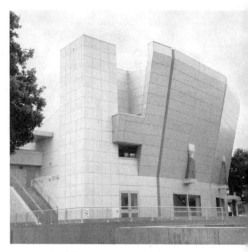

James Ingo Freed, Hewlett SEQ Teaching Center

Center and Rodin Sculpture Garden, or if you want to expand your experience by viewing one of his major works, this is your chance. The sculpture, an ensemble of ebony bronze figures, commemorates an incident in the Hundred Years' War (1347), when six citizens of Calais volunteered themselves as hostages in exchange for King Edward III lifting the siege on their city. Rodin chose not to glorify the individuals in a heroic monument, but to show them in a human state, dressed in sack cloth with their emotional, twisted bodies expressing fear. Though grouped together, each figure is isolated as he prepares to go

George Segal, *Gay Liberation*, 1981

forth, surrender, and face death. Like George Segal (see previous entry), Rodin wanted the figures to be placed at ground level, directly on the paving stones of the town square so they would mix with passersby and become part of everyday activity.

Thomas Welton Stanford Art Gallery

Lasuen Mall
650-723-3404
Tues–Fri, 10–5; Sat–Sun, 1–5
Located just south of the intersection with Serra Mall.

If you want a dose of up-to-the-moment creativity to complement the more staid selections at the Cantor Center, stop in here. The gallery is devoted to student and faculty exhibitions. The work may not be museum-quality, but it typically reflects issues and modes of exploration that currently hold sway in the art world. You never know what you will find—sound installations, digital photographs, traditional silkscreens, or anything in between.

Kenneth Snelson, *Mozart I*, 1982

Joan Miró

Oiseau, 1973
Cummings Art Building
Located in the sunken courtyard that is part of the entryway to the Annenburg Auditorium.

This bulbous figure with popping eyes, stubby protrusions, and three oversized legs is unlike any known creature, except those conjured in the ever-fertile, surrealistically shaped imagination of an artist such as Joan Miró. Though bearing the titular identity of *Oiseau* (*Bird*), the playfully shaped being is unlikely to fly. All the more reason that his idiosyncratic form, which bears signature traits of the inventive mind of a vintage modernist, is eye-catching and thought-provoking.

Arnaldo Pomodoro

Three-Panel Bas-Relief, 1967
Cummings Art Building
Set on the exterior wall alongside the main, ground-floor entrance to the building.

The Italian artist Arnaldo Pomodoro, who taught at Stanford, UC Berkeley, and Mills College, gained recognition in the mid-20th century for his bronze sculptures with mirrorlike surfaces lacerated by slits and cavities filled with intricate details resembling gear teeth and other machine parts. Though never a groundbreaking leader, his work became popular as mainstream public art representing a slick, abstract variant of Modernism.

Henry Moore

Large Torso: Arch, 1962–63
Located between the Cummings Art Building and Green Library.

This upright, jagged image, a sharp contrast to the artist's lounging biomorphic figures with sensuous bodies, was inspired by a bone fragment. Still, it possesses the same organic quality and monumentality unrelated

to size or weight that made Moore one of the masterful artists of the modern era. As he stated: "I would like to think my sculpture has a force, a strength, a life, a vitality from inside it, so that you have the sense that the form is pressing from inside trying to burst or trying to give strength from inside itself . . . this is, perhaps, what interested me most in bones as much as in flesh because the bone is the inner structure of all living form."

Kenneth Snelson

Mozart I, 1982
Canfield Court
If you turn east off Lasuen Mall at the Clock Tower, you will find an open, lawn-covered area stretching back behind Meyer Library and the Bookstore. Several sculptures are installed here, among them *Mozart I*.

Constructed of stainless-steel rods strung together with taut wires, this sculpture is rigorously engineered on the one hand, and lyrically expressive on the other. Kenneth Snelson developed this structural system, which he called "tensegrity," after working at the historic Black Mountain College in Appalachian North Carolina with Buckminster Fuller, the mid-20th-century promoter of the geodesic dome.

The reference to Mozart in the title is indicative of the artist's deep inspiration from music. More than creating objects where the floating elements are orchestrated like sounds, notes, and rhythms in a musical composition, Snelson compared the construction of his sculptures to making music: "The wires and metal tubes are my keyboard, on which I play my three-dimensional spatial game. It's like playing a violin."

Charles Ginnever

Luna Moth Walk I, 1982
Canfield Court
This and two other Stanford sculptures by Charles Ginnever (see p. 189) reveal his

interest in disparately orienting elements of the same size (planes, volumes, lines) so that they produce eccentric, dynamically shaped objects. His aesthetic, derived from Japanese paper-folding techniques (origami), reduces the massiveness of the Cor-ten steel forms, instead emphasizing profile and internal rhythms, light and shadow. Transformative in nature, Ginnever's sculpture possesses an imagery that changes as you move around and view it from diverse perspectives.

James Rosati

Column I, 1983–84 Canfield Court In a variant of Constantin Brancusi's famous *Endless Column* (1937–38), James Rosati (an artist from the postwar, David Smith generation) uses flat and curved planes of burnished steel to create a light-sensitive totemic sculpture. The symmetry of its soaring form with flared top and bottom is accentuated by the cubic block positioned at the juncture point in the middle. Unlike most steel artwork of recent decades, this one has an elegance that gives it visual appeal but defies the industrial associations set forth by vanguard artists who have adopted the material.

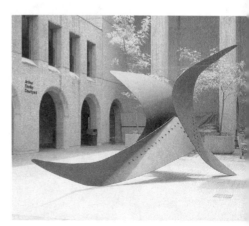

Alexander Calder, *The Falcon*, 1963

Alexander Calder

The Falcon, 1963
Law School Courtyard
Located at the south end of Canfield Court.

As popular and familiar as Calder's sculptures are (they became the objects of choice for public art throughout the world), they never cease to reveal his ingenious, inventive creativity. In *The Falcon*, he characteristically used a few bold, simple shapes cut from flat sheets of black-painted steel to define volume without mass and to suggest movement in a fixed structure. Indeed, the abstract form, arching lines, curved planes, and upward elevation off the ground give a witty semblance of a bird in flight.

Schwab Residential Center

architect: **RICARDO LEGORRETA**, 1997
680 Serra St
Located one block west of Campus Dr East.

Do not be misled by the conventional, bland appearance of this residential complex as seen from the outside. While the sand-toned surfaces and red-tile roof conform with Stanford tradition, the primacy of solids over voids, of flat planes over decorative accouterments, and the assertion of privacy by turning the building inward give evidence of the "wall culture" architecture favored by Ricardo Legorreta—a venerated talent from Mexico whose work is well represented in the Bay Area. The street facade is intentionally treated as an enclosure aimed at fostering communal life in the neighborhood setting that lies within.

Once you enter the complex, which houses MBA students and participants in executive programs at the Graduate School of Business, the walled exterior gives way to a maze-like, open layout of interconnected buildings and interspersed courtyards. There is nothing splashy, nothing even dramatically contemporary, but lots of Mediterranean charm and an intriguing lack of standardization. Common-area and apartment structures are variously one, three, and four stories high. Color, a Legorreta trademark, includes a range of soft earthy tones plus bright blue and purple. Courtyards, intended for relaxation and socializing, are large or intimate and diversely landscaped, each with a distinctive ambience, different vegetation (a palm forest, a fruit-tree orchard, clusters of olive, pine, and cypress trees, grass lawns) and special focal points (a reflecting pool, a field of Spanish-style columns, picnic tables).

Joseph Albers

Stanford Wall, 1980
Located in a remote, overgrown field bordered by Roth Way and Lasuen St, north of Littlefield Center and west of The Oval.

If you approach this work by walking in front of the nearby Graduate School of Business, you will pass by **DIMITRI HADZI**'s *Pillars of Hercules III* (1982), a mainstream modernist bronze grounded in classicism and imbued with an expressionist character, and **CHARLES GINNEVER**'s *The Three Graces*

Joseph Albers, *Stanford Wall*, 1980

(1975–81) and *Chicago Triangles* (1979), two Cor-ten steel sculptures evincing his signature oblique-angled planar forms (see p. 187).

Though mostly known for his *Homage to the Square* paintings—an extensive series rigorously exploring optical effects of color using a formulaic framework of superimposed squares—Joseph Albers (whose career began as an influential teacher at the Bauhaus in Germany) also manifested his pioneering ideas about perception, space, line, and form in other media and diverse compositions. The mechanics of vision were his overriding, continuing concern.

For the Stanford commission, Albers created a long, freestanding wall with one side covered in polished black marble and the other in white brick. The former displays four geometric abstract designs based on illusionistic perspective delineations. The latter uses patterns of horizontal lines to suggest receding and advancing rhythms.

Saratoga

Montalvo Arts Center

15400 Montalvo Rd, 95071
408-961-5813 f: 961-5850
www.villamontalvo.org
grounds: daily, 9–5
gallery: Wed–Sat, 1–4; Sun, 10–4
car: take Interstate 280 to Rt 85 south; continue on Rt 85 for 4 miles; exit at Saratoga Av and continue for about 2 miles; turn left onto Saratoga Los Gatos Rd (Rt 9); turn right onto Montalvo Rd and follow the signs to the villa.
Located in the Santa Clara Valley, 50 miles south of San Francisco.

If you are looking for a respite from the urban setting with a bit of culture thrown in, this is a perfect option. Since it is still relatively unknown, far less of a tourist destination than Napa and Marin, you won't hit the crowds and traffic. Montalvo began as the weekend retreat of Senator James Phelan. He built a Mediterranean-style villa on 175 acres of woods and grass in 1912 and then bequeathed it all (1930) to the citizens of California as a public park to be used for the development of art, literature, music and architecture. Although an artist-residency program was begun in 1939—making it the third oldest in the United States after MacDowell (N.H.) and Yaddo (N.Y.)—it, and other arts programs at Montalvo, suffered a rocky course over the years. Recent changes in direction and new construction have revivified Montalvo, making it a notable venue for contemporary art and architecture.

The Montalvo Gallery, a modest, airy space situated in the building adjacent to the villa (on its left side), serves as a project space and exhibition area. Since 2002, the art program has also included a "Sculpture on the Grounds" component, in which a large-scale sculpture is commissioned annually for temporary display. The works tend to be inspired by or directly related to nature and the setting, and though the artists are not major names, their creations are intriguing, adroit objects. For example, Shigeo Kawashima developed a monumental arch from strips of bamboo, and Patrick Dougherty constructed *A Cappella* (2003), a garden folly shaped like a baroque church but made of woven willow and bay laurel saplings.

Patrick Dougherty, *A Cappella*, 2003; Montalvo

The big new attraction at Montalvo is the artist-residency complex called The Orchard (2003). Encompassing five pairs of live/work studios and a commons building, it was designed by six architectural teams—each a collaboration between an architect and an artist, composer, or writer. The aim was to create dwellings that were respectful of the landscape, energy-efficient, architecturally adventurous, and functionally suited to creative work in various disciplines. Although the residency complex is normally off-limits to visitors, you can catch sight of the cottages from surrounding trails or schedule your excursion to coincide with an open-house event. Given the diverse and compelling character of the architecture, it is worth whatever effort it takes to visit. For the commons, **DONALD STASTNY** (with artist Tad Savinar) blended the old—a colonnaded veranda recalling Villa Montalvo—with the new—a facade of irregular shapes and disparate rhythms that herald the contemporary design of the live/work cottages scattered across the hillside behind. The building contains meeting spaces, dining facilities, and a manager's apartment.

Nestled into the hill above the commons are the pair of composers' studios by **DANIEL SOLOMON** (with composer Patrick Gleeson and artist Nellie King Solomon). With their sound-insulated open interiors, sliding-glass-door facades, and canopied frontages, they are like mini theaters. A stepped area in between the two units adds an outdoor space for private, social, or performance endeavors.

An eccentric pair of writers' cottages by Los Angeles architects **CRAIG HODGETTS** and **HSIN-MING FUNG** (with playwright Lee Breuer, a founding member of Mabou Mines) lies across the street and a bit further up the hill. With dynamic, unpredictable forms and a range of rich colors (watermelon, mango, peach), the units are respectively introverted and extroverted, one inspired by Breuer's *Prelude to Death in Venice* and other by his *Sister Suzy Cinema*. A spiral staircase, a tower, terraces, a wooden bridge, sharply angled roof segments, and interconnected interior spaces with no right angles are but some of the features that give the design its riveting, capricious character.

Back across the road and further up the hill is a pair of live/work studios for visual artists by **MARK MACK** (with artist David Ireland). Clad in corrugated metal and stucco painted bright red, yellow, and blue, the units are equipped with high ceilings and sliding panels that provide hanging surfaces while also covering window areas or allowing the interior to be flooded with sunlight.

A second set of visual-artist accommodations by **ADELE NAUDÉ SANTOS** (with artist Doug Hollis) lies a bit higher up the hillside. Marked by white exteriors and curving rooflines, these units are composed of separate light-filled living and work spaces.

The topmost pair of dwellings, by **JIM JENNINGS** (with artist Richard Serra and poet Czeslaw Milosz), includes a high-ceilinged writer's cottage and a stunning artists' studio walled in vertical bands of translucent glass. Conceived as a composition of four cubes, the block-shaped unit has an intriguingly lightweight support structure of thin wood posts and tension rods that lie against the

Hodgetts & Fung, Montalvo writer's cottage

glazed surfaces as exposed delineations on the interior.

Since you may wish to roam about the hiking trails and picnic in the arboretum, wear good walking shoes and bring food and drink. (There is no restaurant on the property.) Although the villa, which stands as a centerpiece within the landscape, is not open to the public, you can circle around it and perhaps catch a performance in the outdoor amphitheater (seats 1,150) built into the hillside behind the house. A less intimate setting, the sprawling front lawn, is also used for summer concerts. In its Performance Series, Montalvo presents an incredible array of jazz, comedy, rock, country, family, folk, pop, bluegrass, and classical stars—for example, Laurie Anderson, Joshua Bell, Bill Crosby, Earth Wind and Fire, Herbie Hancock, India.Arie, Etta James, Kronos Quartet, Kenny Loggins, Marcel Marceau, Wynton Marsalis, Diana Ross, Ringo Starr, George Winston. Alternatively, you might plan to attend an event in the Literary Program, held in the carriage house. These feature renowned writers (Po Bronson, Seamus Heaney, Adrienne Rich, David Sedaris) who read and discuss their work.

Santa Cruz

Kresge College, UC Santa Cruz

architect: **CHARLES MOORE, WILLIAM TURNBULL**, 1972–74

UCSC is 75 miles south of San Francisco, and Kresge College is located on the upper north side of the campus off Heller Dr. Shuttle and Metro buses connect the campus with the city of Santa Cruz, and shuttles connect the various colleges, which are spread across an extensive, mountainous site overlooking Monterrey Bay. You can get to Santa Cruz from San Jose on public transportation using the Highway 17 Express or Amtrak Thruway Bus Rt 22 (831-459-2190; www2.ucsc.

edu/taps). By car, take the scenic, coastal Rt 1 from San Francisco or the alpine Rt 17 from San Jose.

The oddity of a bucolic residential college set amid a heavily wooded redwood forest and styled in the image of a Mediterranean village, albeit with eccentric exaggerations of scale and axial placement like those seen in 16th-century Mannerism, is a prime, early expression of Postmodernism by one of its leaders, Charles Moore. Designed as a noninstitutional, alternative type of college, it defies the conventional format of block buildings arranged in a grid layout. A twisting, rambling pedestrian street is instead adopted as the organizational element, and color, syncopated rhythms, irregular shapes, and whimsy are used as defining factors.

Although the college is not a fully walled community, an exterior wall at the entrance and the recurring appearance of freestanding walls elsewhere give the impression of a secluded enclave. The internal street furthers the communal orientation. Indeed, residents must regularly traverse the full length of the complex to get from the office/service buildings at the entry end to offshoot plazas containing classrooms, to the dining/assembly facilities at the far end, and to their housing units in between. Staircases streaming off the street and arcaded porches overlooking it also transform the passageway from a circulation path into a veritable focal point, public activity hub, and integrative agent.

Though the large expanses of white stucco and arcades recall the architecture of an Italian hill town, the picturesque merges with the sense of being on a Hollywood set of an Alice-in-Wonderland production. Without question, the loggias with their unevenly spaced columns and two-story heights, appear as false fronts, and the oversized gates, autonomous doorways, oddly placed or asymmetrically shaped cutouts (pseudo windows), and crooked sequence of buildings are purposefully eccentric and decidedly playful. Originally, bright primary colors (now

Charles Moore, William Turnbull, Kresge College, UC Santa Cruz

toned down to more muted hues in the red, brown, yellow, orange range with accents of royal blue) and supergraphics (removed) also added a decidedly 1960s touch. Amazingly, the design still appears quite contemporary. It played a major role in loosening the bonds of austere Modernism.

San Jose

As the capital of Silicon Valley, San Jose has experienced both a meteoric rise and a thunderous downturn during the past decade. Urban development and arts activity have been on a parallel roller-coaster ride. The upside produced some interesting new buildings and a spate of contemporary art sites that make a nice day trip. Since the relevant places are all quite near one other in the revitalized downtown area (which has no hills), it is easy to do a walking tour.

San Jose is 55 miles south of San Francisco, 80 minutes away by CalTrain or about one hour by car.

San Jose Museum of Art

architects: **SKIDMORE, OWINGS & MER-RILL, C. DAVID ROBINSON** (interior), 1991
110 South Market St, 95113
408-271-6841 f: 294-2977
www.sjmusart.org
info@sjmusart.org
Tues–Sun, 11–5
admission: $8/5
light rail: Santa Clara
Located on Fairmont Plaza at the corner of West San Fernando St, one block north of Plaza de Cesar Chavez.

Rather than use the Market Street door in the historic Romanesque building, which became a lesser annex when the new wing was added, the architects situated the main entrance between the two structures and established the adjacent plaza as the front. The sandstone base coordinates the new with the old. However, the monumental freestanding portico with giant columns, the overall reductive character, and the aluminum-sheathed, barrel-vaulted roof are pure Postmodernism, albeit in a tame form.

A striking juxtaposition of old and new recurs in the entry atrium, where three

glasswork chandeliers in bright red, yellow, and blue by **DALE CHIHULY** (1995) create a bedazzling welcome. Though the layout is fairly straightforward, with permanent collection galleries extending off the lobby on the ground floor, and temporary exhibition galleries occupying the upper level, do not overlook the spaces off to the left of the atrium in the old building.

The museum's focus is Bay Area art, with some incursions into the broader West Coast region. The collection is quirky and uneven, mainly favoring a formalist, figurative, or craft orientation. It is not a strong overview of regional art, but it does contain some notable selections, like Joan Brown's *The Journey #1* (1976), Jim Campbell's *Photograph of My Mother* (1996), Bill Viola's *Memoria* (2000), and Catherine Wagner's *Onion* (1998).

Multiculturalism and topical subjects, a seminal aspect of the exhibition program, are manifest in thematic shows that deal with issues and ideas. These alternate with retrospectives of well-established local artists or small presentations of emerging or lesser-known figures. Many exhibitions are accompanied by catalogues. Sample exhibitions: *Edge Conditions*, *E.C. Escher*, *Family Legacies—The Art of Betye, Lezley, and Allison Saar*, *Il Lee*, *It's A Small World*, *Jess*, *Op Art Revisited*, *Suburban Escape*

The museum shop and a charming café are located off the atrium on the main floor.

Dale Chihuly, *Glass Chandeliers*, 1995; San Jose Museum of Art

Italo Scanga

Figure Holding the Sun, 1988
Fairmont Plaza, 95113
light rail: Santa Clara
Located at the Market St periphery in front of the San Jose Museum of Art.

This colorful sculpture adds an upbeat flavor to the plaza. Although Scanga developed his reputation from carved-wood objects with an expressive rawness and folk-art character, here he borrowed a cubist aesthetic from Pablo Picasso and Fernand Léger. Fragmented parts combine with abstract color patterns to enliven the generic figure, who stands firm, assertively displaying a yellow disc—the sun—on high.

Tech Museum of Innovation

architect: **RICARDO LEGORRETA**, 1999
201 South Market St, 95113
408-294-8324 f: 279-7167
www.thetech.org
info@thetech.org
Tues–Sun, 10–5
admission: $8
light rail: Convention Center
Located on the corner of Park Av on the west side of Plaza de Cesar Chavez.

What else would you expect in Silicon

Valley but a high-powered museum focused on technology with great interactive exhibits for both kids and adults. Even if you just step inside the lobby, you will get the buzz of the place and be able to glimpse Ricardo Legorreta's mesmerizing interior. Should you choose to partake more fully, there are four theme galleries, an IMAX theater, educational center, café, and store. There is even a zone related to visual creativity in the digital studio, where you can film yourself and explore facets of animation, sound, and video technologies.

You won't have trouble identifying the museum when in the neighborhood, since its mango-colored facades and domed roof of sheet metal painted blue are a dominant presence. As you walk around the building, you can see more evidence of the architect's indomitable use of color—hot-pink walls and bright blue and red mosaic surfaces. His propensity for simple shapes and planar expanses is also apparent, for, apart from the cut-out entrance that opens onto a giant cylinder, the structure is basically a mammoth cube.

Color and openness also define the interior spaces, though here drama derives from two wondrous atriums that extend from basement to rooftop. One is accentuated by an enclosed cantilevered staircase that runs along the side of the blue-tiled cylinder

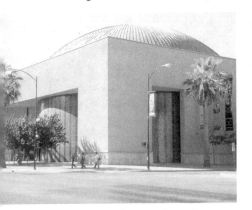

Ricardo Legorreta, Tech Museum of Innovation

housing the IMAX theater. The other has an asymmetrical dome skylight up above and a diagonal thrusting escalator in its midst. This south atrium is also the site of *Origin* (2000), a commissioned sculpture by **BELIZ BROTHER, BRAD GOLDBERG,** and **JOE McSHANE**. Comprising a tall tower adorned in gold leaf (one of the essential elements in microprocessors), with a tree root suspended inside (referring to the orchards that once filled the Santa Clara Valley) and three boulders (signifying the earth) resting on the surrounding terrazzo floor (patterned to replicate a Fairchild semiconductor and made with silicon chips), the installation embraces the agricultural past and technological future of the San Jose area.

Hilton Hotel

300 Almaden Blvd, 95110
408-287-2100 f: 947-4489
www.sanjose.hilton.com
light rail: Convention Center
Located on the corner of East San Carlos St and connected to the west end of the McEnery Convention Center.

The hotel has artwork on display within the main lobby and mezzanine. Though the artists are well recognized (Peter Alexander, Billy Al Bengston, Stephen De Staebler, Rupert Garcia, Barbara Kasten, Ed Moses), the particular objects here are not significant pieces. An exception is *Sensor III* (1992) by esteemed New York conceptualist **DOROTHEA ROCK-BURNE**. Like most of her spare but elegant wall drawings, many of which are based on mathematical set theory, this three-part composition is a symphony of line—looping, rhythmic flows—and color—background fields of yellow, violet, and turquoise. (The mural is at the south end of the lobby, on the walls above the bar and grill.)

Darren Waterston, *Was and Is Not and Is to Come*, 2006, San Jose Institute of Contemporary Art

Children's Discovery Museum

architect: **RICARDO LEGORRETA**, 1990
180 Woz Way, 95110
408-298-5437 f: 298-6826
www.cdm.org
contactus@cdm.org
Tues–Sat, 10–5; Sun, 12–5
admission: $7/6
light rail: Children's Discovery Museum
Located at the intersection of Auzerais Av, just west of the Guadalupe River, at the south end of Discovery Meadow.

Purple is Ricardo Legorreta's color of choice for this building, and yellow accents make it all the more striking. The structure itself is a massing of cubic and oblique-angled forms, all with large, uninterrupted wall expanses. But this is hardly an austere, regularized design. Eccentric elements—an oversized main doorway; a steep, narrow flight of stairs cascading down from a side wall; disparately scaled inset windows in assorted arrangements; a long covered walkway bordering the street—amplify the whimsy of the building's coloration. And though the windowless street facade makes the museum appear rather enclosed, around back, the glazed wall flanking the double-height lobby and skylights open it up to natural light and the surrounding park.

San Jose Institute of Contemporary Art

560 South First St, 95113
408-283-8155 f: 283-8157
www.sjica.org
info@sjica.org
Tues–Wed, Fri, 10–5; Thurs, 10–8; Sat, 12–5
light rail: Convention Center
Located between East William and East Reed Sts, just north of 280.

Having moved to a new, permanent home in late 2006, SJICA has expanded its exhibition space and enhanced its profile. (The premises are scheduled to open in the summer of 2007.) It is still be located in the area called SoFa (South First Area)—the three-block district along South First Street between East San Carlos and East Reed Sts, where storefronts have been renovated into restaurants, coffee houses, bars, design offices, galleries, and ethnic shops.

Established in 1980, this energetic alternative space showcases emerging artists from the Bay Area. The program explores electronic creations and edgy subjects, but also presents traditional printmaking and works in established modern styles. You never know what you will find, and in the venerated spirit of alternative spaces, half the fun is confronting the unknown and unexpected. The new location will have three galleries and a project space.

Sample exhibitions: *Hair Raising*, *Next-New2006—Art & Technology*, *Gustavo Ramos Rivera*, *Darren Waterston*.

San Jose Repertory Theatre

architects: **PAUL HOLT & MARC HINSHAW**, 1997
101 Paseo de San Antonio, 95113
408-367-7266 f: 367-7237

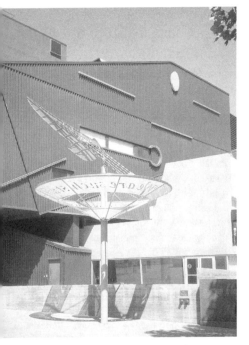

Doug Hollis, *Oionos*, 1998; Holt-Hinshaw, San Jose Repertory Theatre

light rail: Paseo de San Antonio
Located between South 2nd and South 3rd Sts.

With its marine-blue color and zappy form composed of cubic volumes set beside or atop one another, this building boldly stands out, even in a city where colored buildings are almost commonplace. The surface—ribbed metal appearing as a series of folded planes with the ribs set in different directions—is also distinctive, all the more so when you notice the lines, circles, and squares scattered across the facade like a geometric abstraction by Wassily Kandinsky. The complex, which includes a main auditorium, rehearsal hall, and ancillary spaces, has a public facade opening onto a pedestrian lane on its south side and main entrances on both adjacent streets. The whole design is animated and inviting.

Doug Hollis

Oionos, 1998
Paseo de San Antonio, 95113
light rail: Paseo de San Antonio
Located at the corner of South 3rd St.

Deriving inspiration from Shakespeare, Doug Hollis has created a high-tech steel sculpture for the plaza alongside the Repertory Theater. It is a pole structure with an upward-facing cone-like form in the middle and feather-like element, which moves around with wind currents, at the top. Cut into the surface of the cone is the quote "We are such stuff / As dreams are made on" from *The Tempest*.

Mixed-use housing

architect: **DANIEL SOLOMON**, 2003
101 East San Fernando St, 95113
light rail: Santa Clara
Located in the block between North 3rd and North 4th Sts.

As part of the revitalization of downtown San Jose, various housing projects that fill

entire city blocks were constructed. Daniel Solomon designed this five-story building with 322 rental units and commercial space rimming the ground level in accordance with the principles of New Urbanism, a movement he founded with other revisionist city planners in reaction to sprawl. Rejecting the autonomous apartment high-rise in favor of mixed-use, human-scale projects with a street presence linked to the urban fabric, this mode of urban development prioritizes light, open space, and privacy in housing complexes, also known as walkable communities. Evidence of this approach occurs here in the series of landscaped pedestrian lanes that cut across the block, dividing the whole into more individualized, smaller groupings and providing multiple entry points.

In addition to creativity in the organizational schema, design details add resonance to this housing complex. Of note are the cube-framed balconies, wraparound curvatures at the corners, and steel-screen canopies.

Mel Chin, *Sour Grapes*, 2003

Cork Marcheschi

Echo, 2003
Parking garage, corner of North 4th and East San Fernando Sts, 95113
light rail: Santa Clara

The city commissioned this light sculpture, which is only visible after dark, in order to define the building's nighttime identity and enliven the downtown cityscape. Indeed, Cork Marcheschi's design does just that with its animated composition of bright neons. The facade along San Fernando Street is illuminated as a grid of colored squares that continuously brighten, fade, and change tonalities. The elevator towers are also emblazoned, becoming monolithic volumes in a tricolor sequence.

Mel Chin

Recolecciones, 2003
Martin Luther King Jr. Library, corner of South 4th and East San Fernando Sts, 95113
light rail: Santa Clara

In an unusual move, the City of San Jose and San Jose State University created a joint new library to serve its constituent populations. For the project, New York artist Mel Chin produced a 33-part artwork whose components are scattered throughout the interior. His idea was to call attention to particular aspects of the library's collections and to encourage patrons to circulate throughout the building. Because many of the works are enigmatic and eccentric, they arouse curiosity while also humanizing the large, impersonal spaces.

The ensemble is quite varied. It includes both formal sculptures and functional installations, such as chairs, tables, shelves, sculptural ceilings, wall paneling, and light projections. Some add intimacy, and others

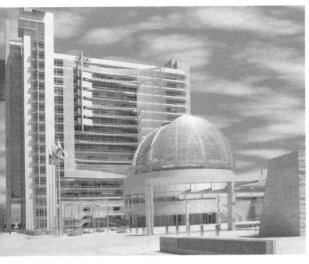
Richard Meier, San Jose City Hall

The new Civic Center is the first Bay Area building by Richard Meier, the celebrated New York architect of Getty Museum fame. This ambitious project encompasses a slender, 18-story, glass-and-steel tower; a three-story structure housing council chambers; and a free-standing super-size glass dome in the middle of a concrete, semi-circular plaza. The construction, stalled by repeated delays and budget crises, now stands as the centerpiece of a grand renewal project in the northeast sector of downtown San Jose.

Apart from consolidating city offices and services, the complex provides a symbolic image for the city and aims to be a gathering place for the public and city events. The controversial dome has, however, been viewed as an architectural folly, its megalomaniac form—devised at the insistence of the political honchos—being a far cry from Meier's clean brand of modernism, which would have given San Jose a world-class building.

The expansive plaza has a notable entrance along an ascending ramp, shaped as a sweeping arc and defined by a sandstone wall. A water sculpture created by **DOUG HOLLIS** and **ANNA MURCH** adds an animate element to the plaza. Sloping inward from Santa Clara Street, it comprises two topographic fields of stacked granite slabs, water flowing over stone boulders, and tall "vanes" (stainless-steel tubing) emitting mist into the air.

are grand visual statements. Some are whimsical and witty, and others provoke serious thought about sociopolitical, ecological, or intellectual issues. Among the highlights are: *Canary Couch* (lower level)—an overstuffed reading chair upholstered in yellow vinyl that makes reference to the popular Tweety Bird chair from Looney Tunes and mineshaft canaries (mining historically occurred in the region south of San Jose); *Hearth* (second floor)—a fireplace built from bricks in the shape of books to recall the history of book burning; and *Sour Grapes* (sixth floor, business and economics reading room)—a twisted, wrought-iron vine with glass fruit hanging from the ceiling that pays homage to Aesop's fox, who disparaged the grapes he was unable to reach, saying they were sour.

San Jose City Hall

architect: **RICHARD MEIER**, 2005
200 East Santa Clara St, 95113
light rail: Santa Clara
Occupying the block between North 4th and North 6th Sts.

East Bay
Berkeley

Berkeley Art Museum & Pacific Film Archive

architect: **MARIO CIAMPI**, 1970
2626 Bancroft Way, 94720
510-642-0808 f: 642-7724
www.bampfa.berkeley.edu
bampfa@uclink.berkeley.edu
Wed, Fri–Sun, 11–5; Thurs, 11–7
admission: $8/5; free first Thurs
BART: Downtown Berkeley
Located on the south edge of the Berkeley campus between Telegraph and College Avs with a back entrance at 2621 Durant Av.

The Berkeley Art Museum, the visual arts center of the University of California, Berkeley, is easy to identify, either by its multilayered raw-concrete form, or by the big black sculpture—*Hawk for Peace* (1968) by **ALEXANDER CALDER**—at the front entrance. At one time the museum was the center of contemporary art activity in the Bay Area. It produced internationally significant exhibitions, had its finger on the pulse of national avant-garde activity, and was an energizing hub for people and ideas. Though its character and role has shifted considerably, aspects of the program still focus on the current era, offering inroads into contemporary ideas and modes of expression.

Like many modernist museum buildings, Mario Ciampi's architecture is itself a bold, imposing statement not especially amenable to the display or viewing of art. The exterior sets the brutalist tone with austere, cold concrete walls and severely shaped, heavy forms, and this ambience reverberates throughout. Theatricality is also conveyed at the entrance as you pass under a dark, low overhang into a dark lobby and then find yourself in the midst of an overwhelming atrium with an expansive space below and sharply angled, box-shaped balconies jut-

ting out from all sides in a fan-like, stepped arrangement. Zigzagging ramps connect the various galleries that extend back from the balconies. Progressively, you move around, up, and down the periphery of the center space. Since it is easy to miss some galleries, be sure to check a layout map and program guide in advance. This is also helpful since nearly all galleries interchangeably house special exhibitions and installations of the permanent collection.

Having suffered major damage during the Loma Prieta earthquake (1989), the building was retrofitted with the huge black structural supports you see under the balconies and terraces. These were added as a stopgap measure, based on the assumption that the museum would relocate to a different site. Plans for a new building in downtown Berkeley are still in the works, though an architect, **TOYO ITO**, was named in 2006.

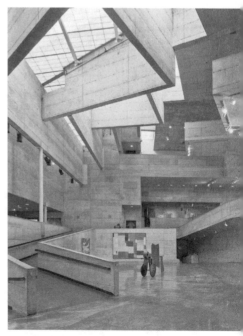

Mario Ciampi, Berkeley Art Museum

Bruce Nauman, *Self-Portrait as a Fountain*, 1966-67/1970; BAM

Contemporary art has an ongoing presence in the BAM schedule of exhibitions through its Matrix program—a series of small one-person shows or projects. Since its inception in 1978, Matrix has had an impressive history of presenting emerging artists or work not otherwise known or seen in the Bay Area. Of late, the program has developed a more global thrust, extending into distant countries off the beaten track from the dominant art centers. In an attempt "to predict trends," exhibits have also veered into marginal, untested zones where the quirky, outrageous, esoteric, iconoclastic, and experimental prevail. The art is often unconventional, but not always noteworthy. Brochures, which accompany each show, offer helpful essays and background information. Sample exhibitions: *Slater Bradley, Simryn Gill, Carla Klein, Mark Manders, Julie Mehretu, Now Time Venezuela—Media Along the Path of the Bolivarian Process, Revolutionary Television in Catia, Wilhelm Sasnal, Haim Steinbach, Althea Thauberger.*

In addition to Matrix, BAM presents large-scale, more comprehensive exhibitions. These range from thematic surveys to retrospectives, and are diversely focused on Asian, historical Western, modern, and contemporary art. Sample exhibitions: *Roger Ballen, Wallace Berman and his Circle, Blind at the Museum, Measure of Time, Bruce Nauman—Early Work, New Directions in 19th Century Shanghai, Allen Ruppersburg, Diana Thater.*

The display of BAM's permanent collection includes an uneven, spotty group of objects spanning the history of art. The 47 Hans Hofmann paintings donated by the artist, which became the catalyst for founding the museum (1963), still stand at the helm of the collection, along with major works from the same (mid-20th-century) era by Francis Bacon, Helen Frankenthaler, Philip Guston, Joan Mitchell, Ad Reinhardt, Mark Rothko, and David Smith. Representation of subsequent generations is spare and spotty, characterized by objects from Jonathan Borofsky, Robert Gober, Donald Judd, Joseph Kosuth, Shirin Neshat, Lorna Simpson, Diana Thater, Richard Tuttle, and various secondary figures. Since the collection is shown as a changing series of topical exhibitions, the content and nature of the display varies widely. One gallery is also devoted to an eclectic selection of historical (pre-1950s) objects—including *The Road To Calvary* (1632), a prime oil sketch by Peter Paul Rubens—and another usually showcases Asian art.

Tucked away off the side of the main lobby is the museum's **BOOKSTORE**. It occupies a small, cramped space, but the size belies its quality. In contrast to most trinket-oriented museum shops, this one specializes in serious books and magazines on a range of topics about or related to art, criticism, and film. If you are interested in a particular subject, ask the well-informed, helpful manager for suggested titles.

Beyond the atrium zone of the museum, there is a pleasant café, theater gallery, and auditorium on the lower level, and a garden stretching across the west side of the building. In addition, the Pacific Film Archive, BAM's renowned film division—second only to the one at New York's Museum of Modern Art—is located across the street (2575 Bancroft Avenue, section A of the Hearst Field Annex, a corrugated-metal structure with

bright yellow trim). The PFA has sustained its reputation by continuously presenting a rich program of matinee and evening screenings focused on particular themes, subjects, directors, actors, and genres or experimental videoworks. Often drawing from its own collection, which is especially strong in Japanese, American avant-garde, Soviet, and Eastern European cinema, PFA offers an incredible range of material from both past and present eras. As a main venue of the San Francisco International Film Festival, the archive annually presents a full schedule of hot new feature and documentary films by high-profile and neophyte creators. Guest appearances, lectures, and discussions, as well a study center and library enhance the screening programs.

Sample series: *Alternative Visions, Beat-Era Cinema, Janus Films, Arrr Matey—Pirates and Piracy, The Mechanical Age, The Road to Damascus—Discovering Syrian Cinema, Ousmane Sembane—Pioneer of African Cinema, A Theater Near You.*

Haas School of Business

architect: **CHARLES MOORE**, 1995
UC Berkeley campus
BART: Downtown Berkeley
Located along the upper (eastern) edge of the campus below Gayley Rd.

Though including many trademark elements of Charles Moore's pioneering, influential style of postmodern architecture, this project is a rather tame example. Indeed, it was a late work, finished after his death in 1993. Compared by some to a Bavarian hotel, it aimed to foster community and "reflect the particular circumstances of place and use."

In his characteristic mode, Moore turned against the sterile abstraction of Modernism by appropriating features from past and local traditions. Here, the pitched roofs, dormer and bay windows, and clapboard-looking walls (they're actually concrete) recall California vernacular architecture. The coloration

in turn reflects the somber brown and green tones of stone, wood, and earth in the natural environs.

As a means of encouraging community, the design sets a courtyard and open passage as its core and surrounds it with three interconnecting buildings. Monumental arches at either end serve as welcoming signs and a cascading series of landscaped stairways with wings angling off provides seating and niches for chance encounters. There is even a gazebo and sculpture (**FLETCHER BENTON**'s *Folded Circle Trio*, 1993—an abstract, geometric work of derivative 1960s style).

Hearst Mining Building

architect: **JOHN GALEN HOWARD**, 1907
UC Berkeley campus
BART: Downtown Berkeley
Located in the northeast sector of the campus facing Mining Circle.

Should you be strolling around the campus, be sure to meander inside this building, a creation of the architect who developed the early plan for UC Berkeley. It is a far cry from a modern building—indeed, Howard purposefully aimed to foreground traditional, classic features. Nevertheless, anyone who enjoys a glorious architectural space should not pass up the chance to see the lobby of this building. The three-story atrium, surrounded by balcony walkways and topped by three magnificent domed skylights, is an utterly simple and yet dazzling design.

C.V. Starr East Asian Library

architects: **TOD WILLIAMS & BILLIE TSIEN**, 2007
UC Berkeley campus
BART: Downtown Berkeley
Located of the north side of campus across from Doe Library and facing Memorial Glade.

The Starr Library is the first component

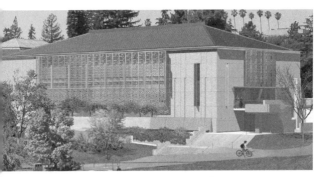

Tod Williams & Billie Tsien, C.V. Starr East Asian Library

Warhol, and Terry Winters for performances by Cunningham; sets by Howard Hodgkin and costumes by Isaac Mizrahi for dances by Morris), productions by performance artists (Laurie Anderson, Pina Bausch), and lectures by talents from the extended art world (Art Spiegelman).

of the Chang-Lin Tien Center, which will consolidate the university's vast resources and programs in East Asian Studies. The design by Williams & Tsien, esteemed architects of the American Folk Museum in New York, sets forth a reserved, minimalist structure meant to be harmonious with the neoclassical style of John Galen Howard's neighboring Doe Library. Topped by a slanted, red-tile roof, the four-story building is clad in granite slabs and accentuated with large bronze screens, reminiscent of Asian lattice work.

Cal Performances

UC Berkeley, Zellerbach Hall, 94720
510-642-9988
www.calperfs.berkeley.edu
BART: Downtown Berkeley
Located just below Telegraph Av, north of Bancroft Av, and fronting the plaza behind the Student Center.

This is one of the most cutting-edge performance centers in the Bay Area, presenting a diverse, topnotch program of theater, music, and dance. Premieres of new work by world-class international stars and emerging talents (Trisha Brown, Merce Cunningham, Yo Yo Ma, Winton Marsalis, Mark Morris) are included as regular events, and leading vanguard creators are annually in residence. Of particular relevance to contemporary art are collaborative projects with visual artists (stage designs by Rauschenberg,

Recreational Sports Facility

architect: **DONN LOGAN**, 1984
UC Berkeley, 2301 Bancroft Way, 94720
BART: Downtown Berkeley
Located between Dana and Ellsworth Sts.

This facility, which houses an Olympic-size pool, gyms, racquetball, squash, and basketball courts, and all sorts of other sports-related spaces, is basically a gigantic box. Logan has, however, visually reduced its bulk by adding color (terra-cotta, beige, taupe, aquamarine) and geometric patterning to the facade and setting the field house back from the street with a plaza in front. A colonnaded walkway, inset windows, and exposed air ducts further syncopate the exterior appearance, asserting the design's postmodern aura.

Moe's Bookstore

2476 Telegraph Av, 94704
510-849-2087 f: 849-9938
www.moesbooks.com
moe@moesbooks.com
daily, 10 am–11 pm; art and antiquarian shop, 10–6
BART: Downtown Berkeley
Located on the south side of campus between Haste St and Dwight Way.

Moe's is the place to go for used and out-of-print publications. They also stock an extensive selection of new books. Within the

four-floor emporium, the art section on the second level contains a wide range of titles on individual artists, historical styles, design, graphics, architecture, crafts, photography, and criticism. If you have the patience to peruse the cluttered shelves, you can often find old treasures and out-of-print books at reasonable prices. For higher-priced art books, megamonographs, hard-to-find museum catalogues, and rare editions, check the art and antiquarian shop on the fourth floor.

This incredible bookstore is a Berkeley landmark—a favorite hangout of bibliophiles, bargain hunters, and plain-ole book lovers. Prepare to spend time, since the selection is extensive and even the most casual search typically requires a bit of detective work in several different sections. The semi-regular schedule of poetry readings and author discussions is also worth checking.

Christian Science Church

architect: **BERNARD MAYBECK**, 1910
2619 Dwight Way, 94704
510-845-7199
BART: Downtown Berkeley
Located on the south side of campus, on the corner of Bowditch St, one block up from Telegraph Av.

It is well worth a short detour and leap back into California's architectural past to see this landmark building. Considered the masterpiece of the esteemed, pioneering, and eccentric Bernard Maybeck, it reveals a fusion with nature, a creative merging of diverse historical references, and a revolutionary use of new, industrial materials.

Immediately visible as you walk around the exterior are such borrowings as Gothic tracery in the grand windows, Romanesque piers, Japanese overhangs, and Craftsman heavy beams. Maybeck's acute sensitivity to space, light, structure, color, and ornament is also evident in the high gabled portico, redwood trellises covered with wisteria vines, multileveled roof heights, rose-toned patterns on segments of the facade, and plant-like leaded-glass designs on the entry doors. Most radical for its time was the use of cast concrete, often imprinted to appear like wood or stone, and prefabricated, factory-made elements, like the steel window sashes. To be sure, wood was also a material of choice, though it was intermixed with concrete with both having the same weathered appearance and color tone. It was Maybeck's genius to create a highly refined, astutely balanced, and imaginative synthesis of disparate components.

On your way up or back from viewing the Christian Science Church, you will pass by another of Berkeley's renowned monuments—the famous (or infamous) **People's Park** (located just across Bowditch Street between Dwight and Haste Streets). Since the embattled days of its beginning (1969), when the National Guard was called up to clear the area and end protest demonstrations, the park has continued to be a volatile and controversial piece of land. It has undergone various and simultaneous incarnations as an encampment for the homeless and runaway youths, a vegetable garden, sports fields, ill-fated university-city construction site, concert ground, activist plaza, and derelict, forsaken urban block.

The Judah L. Magnes Museum

2911 Russell St, 94705
510-549-6950 f: 849-3673
www.magnes.org
info@magnes.org
Sun–Wed, 11–4; Thurs, 11–8
admission: $6/4
Located near the corner of Pine Av, a few blocks above College Av in the Elmwood district.

Housed in a rambling Berkeley house, the Magnes Museum is focused on Jewish history, culture, and identity. It variously

Jonathon Keats, *First Intergalactic Art Exposition*, 2006; Magnes Museum

explores this subject, particularly as it relates to Jews in the American West, through its extensive collection of art and artifacts, public programs, and special exhibitions. The latter include shows that offer a contemporary take on historical subjects from the recent past. Among these, *The Danube Express*, a multimedia exhibition by the Hungarian artist/filmmaker Peter Forgacs; *My America,* a survey of work revealing social and political themes and modernist ideals as expressed by Jewish American artists during the years 1900–55; and *The Studio of Man Ray by Ira Nowinski* (2007), a photographic study of the environment of a modern master.

In 2004, the museum began *Revisions*, an exhibition series wherein an artist, scholar, or curator creates an installation inspired by an aspect of the museum's permanent collection. *Ann Chamberlain—Fragments of Travel in the Gold Country* inaugurated the series by turning to the cemeteries in California's Gold Rush country, which are under the stewardship of the Magnes. In turn, *Jonathon Keats: The First Intergalactic Art Exhibition* (2006)—a project created by decoding radio signals from outer space and transferring them to canvas—used paint-ings at the Magnes as a visual source for his imagery. The series has also featured *Larry Abramson, Amy Berk, Naomi Kremer.*

Berkeley Repertory Theatre

2025 Addison St, 94704
510-647-2949 f: 647-2975
www.berkeleyrep.org
BART: Downtown Berkeley
Located in downtown Berkeley between Shattuck and Milvia Sts.

Begun in 1968 as an actor-centered theater, Berkeley Rep has grown in stature and become the linchpin of the city's Addison Street Arts District. The facilities were both enlarged and enhanced in 2001 with the construction of a new 600-seat auditorium (Roda Theater) and courtyard space to complement the existing 400-seat stage. Ambitious programming includes adaptations of seldom-seen classics as well as commissions of new work by dramatic voices who deal with controversial topics and innovative modes of presentation. Such leading performance artists as Rinde Eckert, Sarah Jones, Paul Dresher, and Anna Devere Smith are also featured.

Romare Bearden

Berkeley—The City and its People, 1973
Old City Hall, Council Chambers, 2nd flr
2134 Martin Luther King Jr. Way, 94704
Mon–Fri, 9–5
BART: Downtown Berkeley
Located opposite Center St in downtown Berkeley. Although the Council Chambers room is typically locked, you can gain entry by getting the key from an adjacent office.

Romare Bearden, a preeminent artist of the mid-20th century, captured the life and environment of Harlem, the rural south, and the African-American experience in his storytelling collages. This mural, based on a week he spent meandering around Berkeley, is

Bearden's largest known collage. Made from colored paper and photographs applied to seven fiberboard panels, it includes images of political rallies, worship services, sailing vessels, the Bay Bridge, early settlers and miners, important contemporary figures, and architectural details of community and university landmarks. The four overlapping heads in the lower right quadrant—a representation of Berkeley's diversity—were adopted as the city's logo.

Tipping Building

architects: **FERNAU & HARTMAN**, 1998
1900 Shattuck Av, 94704
BART: Downtown Berkeley
Located just north of downtown Berkeley, on the corner of Hearst St.

A collage aesthetic with keynote parts deriving inspiration from vernacular Northern California rural architecture has become the signature style of Richard Fernau and Laura Hartman. This mixed-use project, combining a café and parking garage on the ground floor with an engineer's office and apartment on the upper levels, is a good example.

The shed-like forms with simple, geometric shapes and slanting roofs are boldly articulated, though sunscreens, windows, and other demarcations modulate the facades, cutting the mass to a more human scale and syncopating the whole with horizontal and vertical rhythms.

Chez Panisse

1517 Shattuck Av, 94709
510-548-5049 f: 548-0140
www.chezpanisse.com
webmaster@chezpanisse.com
café: Mon–Thurs, 11:30–3, 5–10:30; Fri–Sat, 11:30–3:30, 5–11:30
restaurant: Mon–Sat, two seatings, 6–6:30 and 8:30–9:30
BART: Downtown Berkeley
Located in North Berkeley between Cedar and Vine Sts.

It is hard to believe that such an unassuming dwelling bears international renown as the birthplace of California cuisine (1971), one of the world's leading restaurants, and the centerpiece of Alice Water's ever-expanding food-related endeavors. From its reputation,

Romare Bearden, *The City and Its People*, 1973

Asparagus with kumquat and spring onion; Chez Panisse

you'd expect a big, fancy emporium. Instead, both the high-end ground-floor restaurant (which serves a set menu that changes daily) and upstairs café (à la carte) are set in cozy, compact spaces, formerly the rooms of a modest house. The domestic, country milieu allies with Water's culinary focus on the intense flavors of fresh local ingredients and her advocacy of sustainable agriculture.

Sherri Martin, *Thadeus Lake*, 2006; Kala Gallery

So what does all this have to do with art? The minute you see an appetizer, dinner, or dessert, you will understand that artistic presentation is as much a part of the Chez Panisse allure as taste, produce quality, recipe originality, and food preparation. Not only is each ingredient carefully chosen for its shape, color, and textural character, but the chefs devote considerable time to arranging each plate as a visually delectable composition.

Reservations are highly advisable for the café and virtually required for the restaurant, where it is best to call weeks or months in advance.

Kala Gallery

1060 Heinz Ave, 94710
510-549-2977 f: 540-6914
www.kala.org
kala@kala.org
Tues–Fri, 12–5; Sat, 12–4:30
AC Transit bus: 6, 72, 73
Located in west Berkeley on the third floor of the old Heinz ketchup factory, a large building facing 10th St, one block west of San Pablo Av.

The gallery occupies an ample room at the back of the vast printmaking studios of the Kala Art Institute (founded in 1974). The focus of the institute (and gallery) is on the craft and technical aspects of printmaking, especially intaglio and lithography. A digital-media center with video and sound facilities stretches the print genre in more edgy directions.

Most exhibitions feature work by fellowship recipients and artists-in-residence, the preponderance of whom are from the Bay Area or elsewhere in California. Traditional printmaking with a conservative orientation to image and concept holds sway, though an occasional sculpture or mixed-media installation rattles the boat.

Sample exhibitions: *Drawn Together by Line, Future Tense, North by Northwest, The Real World, Sherrie Martin, The White Album*.

4th Street Corridor

Once a grungy industrial zone, hardly a place
to spend time in or consider as a destination,
this 16-block area north of University Avenue
is now an upscale commercial district with
an artsy flavor and people-oriented streetlife.
The preponderance of local enterprises, rather
than chains, and the variety of specialty
boutiques selling imported and local crafts,
artisan products, or unusual goods give the
corridor distinctive appeal. An emphasis
on home and garden relates to the lumber
company that anchored the area as it was
becoming gentrified, but the furniture,
kitchen, stained-glass, housewares, plant,
and textile stores are now interspersed with
pet, gourmet food and wine, clothing, book,
and music shops. There are also restaurants
and cafés, many of which have outdoor tables
and take-out service to accommodate people
who use the area for socializing and casual
on-the-go dining.

As an urban development, the success
of 4th St derives as much from the mix of
merchants as from the open plazas and
wide sidewalks furnished with benches and
parapets that double as sitting and gathering
areas.

Builders Booksource

1815 4th St, 94710
510-845-6874 f: 845-7051
www.buildersbooksource.com
service@buildersbooksource.com
Mon–Sat, 8:30–7; Sun, 10–7
AC Transit bus: 9, 51, 65
Located just north of Hearst St.

In addition to books and reference
materials related to the construction and
engineering aspects of building, this niche
bookstore stocks a range of publications
concerned with architecture, urban planning,
landscape, and interior design. It also has a
limited selection of art books.

The Gardener

1836 4th St, 94710
510-548-4545 f: 548-6357
www.thegardener.com
store@thegardener.com
Mon–Sat, 10–6; Sun, 11–6
AC Transit bus: 9, 51, 65

It may be called The Gardener, but plants
and garden tools are only a small part of the
things you will find in this spacious store. The
underlying theme of country living embraces
a spectrum of objects, both functional and
decorative, that can hold, display, or service
"the beauty and bounty collected from
outdoors." Some are one-of-a-kind items,
others are clever curiosities, but most are
mass-produced products of unusual design
with a handcrafted look.

Zinc Details

1842 4th St, 94710
510-540-8296
www.zincdetails.com
info@zincdetails.com
Mon–Sat, 10–6; Sun, 11–6
AC Transit bus: 9, 51, 65

This is the East Bay outlet for the San
Francisco store on Fillmore Street (see pp.
152–53) that offers a wondrous array of
designer lighting, furniture, and objects for
the home.

Design Within Reach

1779 4th St, 94710
510-524-1994 f: 524-1791
www.dwr.com
info@dwr.com
Mon–Sat, 10–6; Sun, 11–6
AC Transit bus: 9, 51, 65

This is a Berkeley outlet for DWR, a fur-
niture and lighting store with a wide array
of designer objects. See pp. 140–41.

Paulson Press

1318 10th St, 94710
510-559-2088 f: 559-2085
www.paulsonpress.com
info@paulsonpress.com
Tues–Fri, 12–5; Sat, 12–4
AC Transit bus: 9, 52, 72
Located in northwest Berkeley, just south of Gilman St and two blocks west of San Pablo Av.

Founded in 1993, Paulson Press added to the realm of high-quality printmaking establishments in the Bay Area. Specializing in intaglio, it invites artists to work directly with professional printmakers in an on-site studio. The resulting work is then shown in the adjacent gallery. Selected artists range from emerging to well-known names, national stars to Bay Area talents. If you are unfamiliar with the work of Chris Johanson, a hot young San Franciscan, check out the witty aquatints he has created at Paulson. They reveal his whimsical, graffiti-based style and optimistic attitude in images attuned to social issues, human eccentricities, and urban realities. For a different aesthetic, you can view the exquisitely refined, vessel-like forms in Martin Puryear's etchings, or the stark, richly colored portraits that Kota Ezawa has devised from flat color planes and images reworked from photography.

Artists: Mari Andrews, Edgar Arceneax, Taura Auerbach, Radcliffe Bailey, Donald Baechler, Chris Ballantyne, Lynn Beldner, Louisiana Bendolph, Mary Lee Bendolph, Ross Bleckner, Steve Briscoe, Christopher Brown, James Brown, Squeak Carnwath, Greg Colson, Kota Ezawa, Caio Fonseca, Isca Greenfield-Saunders, Salomon Huerta, Chris Johanson, Amy Kaufman, Margaret Kilgallen, Hung Liu, Enrique Martinez Celaya, Keegan McHargue, Shaun O'Dell, Deborah Oropallo, Martin Puryear, Lava Thomas, Robert Yoder.

East Bay Hills

After the horrendous firestorm of October 1991, which raged for three days and destroyed over 3,300 homes and every bit of vegetation in a three-square-mile area, rebuilding efforts produced a mixed bag of largely humdrum housing and a few adventurous designs by name-brand architects. Most notable was the shift from the previous stock of modestly sized, unremarkable, if not tacky structures surrounded by greenery to monumental, garishly styled dwellings that fill as much of the land area as possible. With hefty insurance settlements as a catalyst, many residents opted for grandeur—one might say grandiosity. For the most part, individuals and developers acted independently, constructing autonomous units without concern for orchestrating a community and with nary a thought about remaking the neighborhoods into architectural utopias.

Unless you are in the mood for a good hike in very steep terrain, it is best to drive around

Kota Ezawa, *Wanda*, 2006; Paulson Press

the area to see the notable buildings and get a sense of the whole situation. (The area is not serviced by public transportation.) Be forewarned that driving entails negotiating hairpin turns, precipitous descents, and a confounding road system. If you stop and look across the canyons whenever possible, you will be able to see the cascading aspect of the hillside architecture, otherwise invisible from street-side views. There are two main areas, one stretching back behind the Claremont Hotel on the north side of Rt 24 in Berkeley, and the other in the Upper Rockridge (also called Claremont Pines) neighborhood on the south side of Rt 24 and east of Broadway in Oakland.

Frank Israel, Drager House

Residence

architects: **MOORE RUBLE YUDELL**, 1994
225 Alvarado Rd, 94705
Located east of Tunnel Rd above the Claremont Hotel at the intersection of Vicente Rd. This street was the borderline of the firestorm.

Related to the vernacular-inspired style that Charles Moore developed at Sea Ranch, this house uses simple, shed-like volumes and view-enhancing towers. A bridge connects separated sections, and garden terraces step down the sloped area in between. The layered placement of rooms linked by passageways and staircases is the most striking element of the design.

Residence

architect: **STANLEY SAITOWITZ**, 1995
181 Vicente Rd, 94705
Located on the corner of Alvarado Rd.

Taking full advantage of the plot, this massive house wraps around the corner, with an extra floor at one end providing panoramic views and covered walkways across the back overlooking a garden. Window groupings and horizontal bands of wood define and accentuate the facades.

Drager House

architect: **FRANK ISRAEL**, 1994
160 Vicente Rd, 94705
Located between Alvarado Rd and Grandview Dr.

This aggressively angular design by maverick architect Frank Israel came to signify both the horrors and vanguard achievements of fire-zone architecture. The eccentric boomerang that juts around the front corner, ambiguously appearing as surface and volume, and the flamboyant copper shingles are unquestionably outside the bounds of Bay Area tradition. To be sure, the high-energy design composed of shapes within shapes, planes unfolding around one another, and a dynamically layered surface commands attention. Initially, when the house stood alone, visible in its entirety against the backdrop of a barren hillside, the eccentric features were exceedingly pronounced. With time, however, an adjacent residence, built in close proximity, has concealed virtually all of the striking left side, and the gradual turn of the copper to a green tone has reduced the disjunction between the house and its setting, which also has been transformed into a vegetal landscape.

To accommodate the sloping terrain, Israel terraced the structure up the hillside and

Philip Banta, XYZ House

stacked the component areas (garage, guest, living, and sleeping zones). Like the exterior, the interior is unconventional. Interpenetrating levels join in dramatic ways, and slanting walls, high windows, and incredible skylights disrupt regularity in individual rooms.

XYZ House

architect: **PHILIP BANTA**, 1995
43 Perth Pl, 94705
The best way to see this house is from across the canyon at the intersection of Vicente Pl and West View Dr.

Set against a steep hillside with its back to the street, this house outfits a vertical box with a three-story glazed wall overlooking the canyon, curving decks that sweep around a corner of the structure, a projecting roof that functions as a sunscreen while adding a bold horizontal to the design, diagonal steel braces for earthquake protection, and a windowed stair tower that extends out from one side. Throughout, outdoor and indoor

spaces merge and interpenetrate. Like many replacement houses in the area, this one fully occupies its lot, a narrow parcel of land.

Becker House

architect: **JIM JENNINGS**, 1994
119 Strathmore Dr, 94705
Located high on the hillside just past the intersection with Kenilworth Rd.

Jennings, a master of refined minimalist architecture using industrial materials, has divided this house into two utterly reductive, cubic structures, one clad in cement-board panels and the other in corrugated aluminum. The design deals with the location—a small lot situated on a steep slope with bay vistas—by placing the upper floor and entrance at streetside but then orienting the entire house toward the canyon. (The best way to see the house is to walk around the corner and look up from Kenilworth Road.) A bridge connects the two units on the top level, and a deck spans between them on the lower level. Large windows accent the views and fill the interior with natural light, though some glass is sandblasted to give privacy.

Cotten House

architects: **ACE**, 1997
1985 Tunnel Rd, 94705
Located on the meandering, steep section of Tunnel Rd that winds around near the top of the hillside just below Grizzly Peak Open Space.

Borrowing a page from the postmodern handbook that advocated a turn away from the sterile, purist designs of late-Modernism to an architecture shaped by narrative and humor, Ace created a house with mammoth gold-toned twin towers styled after the flared and curving metal tube of a woodwind instrument. The image makes reference to the owner, a jazz musician, and his saxophone found in the ruins of the firestorm. Upbeat

and idiosyncratic, the structure has been personalized not by spatial or functional dictates, but by a signifying motif, intimately and historically allied with the client-occupant and place.

Oakland
McLane-Looke House

architect: **STANLEY SAITOWITZ**, 1994
6131 Ocean View Dr, 94618
Located in Upper Rockridge between Manchester Dr and Brookside Av.

Perhaps it is the carport running under the front of the building, or else the tall naked poles supporting roof overhangs—whatever, this house has a decidedly 1950s suburban or motel-modern appearance at first glance. On closer inspection, as you discern anomalies in the shaping of the structure's long, narrow form and roof, or note how one side is clad in stucco with horizontal bands and the other sheathed in corrugated aluminum arranged as a patchwork, it is clear that this is hardly a mass-production house from a bygone era.

Compared to acclaimed Saitowitz buildings, which are rooted in clear-cut shapes and a modulated interplay of contrasting elements, this house has a disjunctive, indulgent character.

Ace, Cotten House

House on a Hilltop

architect: **MARK HORTON**, 1995
140 Alpine Tce, 94618
Located in Upper Rockridge off Ocean View Dr.

Set on the crest of a hill, with panoramic and framed views in multiple directions, this house is itself an object of attention due to its enormous size, rigorously geometric design, and quirky features. Two cubic volumes, clad in white cement-board panels and connected by a glass passageway, form the basic structure. The austerity and simplicity of the minimalist core is, however, punctuated by

Mark Horton, House on a Hilltop

such irregularities as protruding balconies and bays, an asymmetrical roof curve on one segment, a pyramidal skylight thrusting upward at an odd angle on the other, and a disparate assortment of window configurations.

Jordan House

architect: **ACE**, 1994
6356 Broadway Tce, 94618
Located across from the intersection with Florence and Proctor Avs just west of Rt 13. This is the southeast border of the firestorm zone.

Quite small in comparison to other replacement structures, but attention-getting because of its unusual appearance, this house has elicited such names as the "lizard-skinned taqueria" and "chapel with outhouse." True to form, Ace created an eccentric design using appropriated imagery and having symbolic relevance. In this case, the structure's pointed arch and tower are components derived directly from Bernard Maybeck's Hearst Hall (1899)—a building consumed by fire in 1922. The redwood beams and vaulted Gothic space of the main room also bear witness to this source, but the copper shingles and polychrome exterior are pure Ace.

Tara Daly, Untitled, (Bugs), 2005; 21 Grand

Clifton Hall

architect: **MARK HORTON**, 2002
CCA, 5276 Broadway, 94618
BART: Rockridge
Located between Clifton St and Broadway Terrace on the northeast border of the California College of the Arts Oakland campus, just past the juncture with College Av.

Set on a trapezoidal plot, this three-story dormitory is articulated on its north side by a progression of bays—two-stories high and walled across the midspan, and one-story high and windowed on the top floor. On the short side facing Broadway, the facade is demarcated by large expanses of opaque and translucent glass (dramatic planes of light at night). But around the corner the wall angles back, forming a terrace behind which sits a large cylindrical structure wrapped in zinc panels. A cutaway section in front enlivens the design while also opening the contained space (lounges and kitchens) to natural light.

Barclay Simpson Sculpture Studio

architect: **JIM JENNINGS**, 1993
CCA, 5212 Broadway, 94618
BART: Rockridge
Located with its back to Clifton St abutting the parking lot on the corner of Broadway.

In an imaginative mode of minimalist industrial-style architecture, Jennings designed a studio housing a glassblowing workshop and metal foundry as a pure, cubic volume with a concrete base topped by glass-brick walls set within a framework defined as a double-height grid by slender steel beams. The sense of both mass and lightness prevail.

Downtown Oakland

An energetic art scene, centered around the lower Telegraph Avenue area of downtown Oakland, has been asserting itself as the hotspot of the East Bay. It encompasses a spate of bare-bones galleries, several having developed from studios in low-rent storefronts. A grassroots, ad-hoc spirit prevails and socially engaged work is often in evidence. Indeed, most of the galleries are artist-run collectives and many double as performance spaces offering a broad spectrum of evening events and live music presentations. The focus is on experimental work by emerging local artists, who tend to favor all sorts of eccentric and commonplace materials and personal narratives. The range stretches from craft artistry to high-tech media, from mediocre to innovative creativity. Be forewarned that exhibition schedules are erratic, and most galleries are open only on weekend afternoons.

Papa Buzz Café (2318 Telegraph Av) is the neighborhood gathering place, and a main hub of activity is Oakland Art Murmur, a communal opening for gallery exhibitions held on the first Friday of each month (7–10 pm). See www.oaklandartmurmur,com for a list of participating galleries and a current schedule of events.

21 Grand

416 25th St, 94612
510-444-7263
www.21grand.org
21grand@21grand.org
Thurs, 4–8; Fri, 4–6; Sat–Sun, 1–6
BART: 19th St Oakland
Located near the corner of Broadway.

Among the Oakland exhibition spaces, the programming at 21 Grand—a non-profit, volunteer-run, interdisciplinary organization founded in 2000—stands out for its versatility and consistent presentation of strong work by upwardly mobile, young talents.

Jill Sylvia, Untitled (Book); detail; 2005; Oakland Art Gallery

Though occupying a somewhat dreary, industrial setting with a less-than inviting entryway, gallery exhibitions are well installed and selected with an eye toward creative edginess. Most shows are loosely thematic featuring two or three artists. In addition to the visual arts presentations, 21 Grand offers a full schedule of multimedia, mixed-genre, literary, and performance events, film and video screenings, and lots of live music of all types.

Sample exhibitions: *Absencescape, Circle Depiction, Games We Play, Multiples, Reach Out and Touch Somewhere, Supernatural.*

Oakland Art Gallery

199 Kahn's Alley, 94612
510-637-0395 f: 637-0398
Tues–Fri, 11–6; Sat, 11–5
Wed–Thurs, 11–6; Fri, 11–5; Sat, 12–4
www.oaklandartgallery.org
info@oaklandartgallery.org
BART: 12th St
Located just off the rotunda at the corner of 150 Frank Ogawa Plaza, the large open space in front of City Hall in the block bordered by Broadway and 14th St.

This nonprofit space is far more refined and upscale than others in the neighborhood. Though responsive to East Bay artists, its purview extends to the larger Bay Area and beyond. Since opening in 2001, the gallery

has presented mainly group and thematic exhibitions of art displaying both conceptual depth and skillful artistry. The mix embraces both emerging and mid-career artists, and shows typically juxtapose work in diverse styles, media, and approaches. Wall signage or brochures provide helpful information, and artist's talks, dialogues, and performance events enrich the program. The annual juried exhibition, *Bay Area Currents,* does not rock any boats but offers a cogent survey of new faces in the local art scene. Sample exhibitions: *Continuation, Elsewhere/Anderswo, Form/Reform, Hidden Order, Inscape, Photoo, Playful Poetics, Visual Alchemy.*

Oakland Museum of California

architects: **KEVIN ROCHE; DANIEL KILEY** (landscape), 1968
1000 Oak St, 94607
510-238-2200 f: 238-2258
www.museumca.org
artdept@museumca.org
Wed–Sat, 10–5; Sun, 12–5; first Fri, 10–9
admission: $8/5; free second Sun
BART: Lake Merritt
Located off 10th St, one block east of the BART station and just west of Lake Merritt.

Though the museum was constructed in the 1960s, its design still offers a refreshing vision. According to the architect Kevin Roche: "The building, which occupies four blocks, is conceived as a walled garden with large welcoming entrances. The galleries are so arranged that the roof of one becomes the terrace of another. A pedestrian street connects the different levels and the other functions. Each area opens directly onto lawns, terraces, trellised passages and broad flights of stairs." Indeed, plants grow over the entire building, countering the harsh, austere appearance of the concrete structure while injecting green space into a bleak urban neighborhood. The horizontal orientation further harmonizes the building

with its surroundings, and the tiered layout brilliantly accommodates the museum's three departments (History, Natural Sciences, and Art each occupy a different floor), with the cascading rooftops providing both semi-secluded and expansive zones for use as a sculpture park.

The permanent art collection is displayed on the third level. (This is the first floor you encounter when entering from Oak Street. If you use the 10th Street entrance, you will come in at the bottom level, which houses Natural Sciences.) Spanning the period from the mid-1800s to the present, the collection offers a broad overview embracing painting, sculpture, photography, and decorative arts. Of particular note is the Dorothea Lange archive.

In terms of the contemporary period, concentration is on the postwar years as represented by figurative, abstract, funk, pop, and assemblage art by such figures as Larry Bell, Elmer Bischoff, Joan Brown, Vija Celmins, Bruce Conner, Roy De Forest, Richard Diebenkorn, Lynn Foulkes, Sam Francis, George Hermes, Robert Hudson, Jess, Frank Lobdell, Manuel Neri, David Park, Mel Ramos, Raymond Saunders, and Wayne Thiebaud. Coverage of recent decades is slim, with only a handful of works on display. And although the museum is nominally dedicated to California art, the focus is strongly rooted in the Bay Area, with only scant recognition of Los Angeles artists or Southern California developments.

In the back of the collection installation, two small galleries present one-person or thematic exhibitions. In addition, major shows occur from time to time (alternating with history and science exhibits) in the museum's Great Hall on the second level. Sample exhibitions: *Bruce Beasley, Enrique Martinez Celaya, David Ireland, Edward Weston.*

Be sure to save time to meander around or relax in the sculpture park on the terraces. Although the display hardly surveys leading

California artists or topnotch examples of cutting-edge creativity, it does present a range of aesthetics favored by Bay Area artists. Included are works by Robert Arneson, Bruce Beasley, Fletcher Benton, Stephen De Staebler, Mark di Suvero, Viola Frey, David Gilhooly, Michael Heizer, George Rickey, Peter Voulkos, and William T. Wiley. (Unfortunately, many works are quite weathered, in poor condition, and missing identifying labels.)

If you are not familiar with California history and nature, you will easily expand your horizons by perusing the rest of the museum. There is also a store, a gallery selling contemporary California art and crafts, and a restaurant on the lower levels.

Leviathan

architect: **ACE**, 1990
330 2nd St, 94607
BART: Lake Merritt, 12th St
Located between Harrison and Webster Sts, a few blocks east of Jack London Sq and the Oakland waterfront.

Taking features of the local environs and a maritime theme as reference points, Ace created the design for this small commercial building that houses its own architectural offices. The whole is a collage of symbolically laden forms riven with humor and overtly defiant of right-angled, staid, reductive structures with uniform parts.

The front section, with its slanted metal walls, aims to suggest a ship's bow, or more particularly, the big, gray-toned military tankers like the retired ships docked across the estuary. In back, the boxy corrugated-steel component with a cantilevered lookout area borrows its image from container vessels, and the red-and-white checkerboard pattern derives from the tank towers at the former naval base in Alameda. Most eccentric is the top segment, where the dome, projecting bridge, freestanding steel beams, up-thrusting skylight structures, and green-toned copper shingles are meant to suggest the head, beak, tentacles, humps, and fish-scale surface of a mythic sea creature.

The design is unquestionably self-determined and contextualized to a specific setting, though the use of industrial materials and appropriated, narrative characteristics bear witness to precedents in the work of Frank Gehry, Rem Koolhaas, and postmodern theory.

Mills College Art Museum

5000 MacArthur Blvd, 94613
510-430-2164 f: 430-3168
www.mills.edu/museum
museum@mills.edu
Tues, Thurs–Sat, 11–4; Wed, 11–7:30; Sun, 12–4
Located near the back of the campus, down Kampiolani Rd and adjacent to the Aron Art Center.

Over the course of its history, dating back to 1925, the Mills College Art Museum has mainly served as a teaching institution.

Andrea Bowers, *Political Slogans & Flower Magick: Kiss My Feminist Ass*, 2006; Mills College Art Museum

As such, it has amassed a sizeable collection highlighted by ceramics, California regionalist painting, Asian textiles, African art, Native American basketry, 20th-century graphics, and photography. In tandem with installations of work from the collection, the museum developed a program of low-key loan exhibitions, which occasionally featured art from the contemporary period. Sample exhibitions: *Sam Easterson*, *Love and Betrayal—Bollywood*, *Gay Outlaw*, *Rapture Is A Cool Place*.

In August 2006, the college announced its intention to beef up the museum's exhibition program. Tentative evidence of this appeared in shows like *Particulate Matter* and *Take Two: Women Reworking Art History*. These projects included work by venerable and emerging artists of national and international renown.

Chabot Space and Science Center

architects: **FISHER-FRIEDMAN**, 2000
10000 Skyline Blvd, 94619
510-336-7300 f: 336-7491
www.chabotspace.org

info@chabotspace.org
Wed–Thurs, 10–5; Fri–Sat, 10–10; Sun, 11–5
admission: $13/10/9 (exhibits and planetarium); $8/7 (MegaDome Theater)
car: Rt 13 south (towards Hayward); exit at Joaquin Miller Rd; turn left up the hill to the crest; turn left onto Skyline Blvd and continue 1.3 miles.

Viewing the architecture of the Chabot Center is worth a trip, even if you are not interested in space science. Should you want additional motivation, the building is situated in a wooded parkland with wonderful trails through sequoia and redwood groves.

To accommodate a 243-seat planetarium, a 210-seat theater with a 360-degree overhead screen, an observatory complex, exhibit halls, classrooms, labs, and related facilities, Fisher-Friedman created an imaginative multipartite ensemble of alluring design, so astutely positioned that it takes full advantage of the surrounding landscape without becoming an intrusive presence within it. Although the two main buildings are basically rectangular, other structures with circular forms—recalling the shape of planets in our solar system and their trajec-

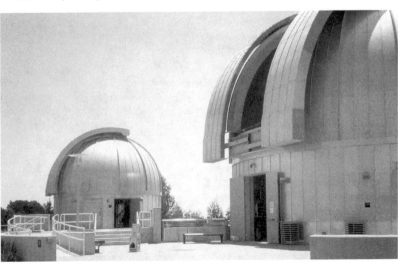

Fisher-Friedman, Chabot Space and Science Center

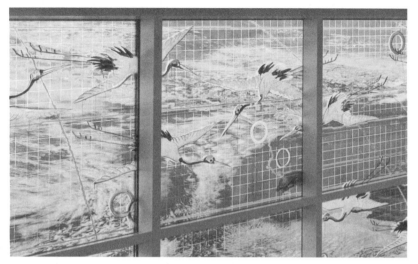

Hung Liu, *Going Away, Coming Home*, 2006; Oakland International Airport

tory about the sun—recur throughout. The leitmotif begins with the round front plaza and arched canopy over the entry bridge, and continues in the lobby rotunda, cylindrical auditoriums, amphitheater (which doubles as a solar calendar and sundial), curving terraces in the courtyard, and barrel-vaulted roof over the astronomy hall. It reaches a pinnacle in the telescope domes. The core structures are also punctuated by a few triangular elements, such as the balcony viewpoints that jut out from the skybridge and cantilevered walkways around the theater.

In addition to the compelling orchestration of geometric forms, the design is enhanced by an open spatial flow. Not only do interior sections spread into one another, but indoor-outdoor realms interconnect by means of unenclosed corridors, suspended staircases, multistoried atriums, skylights, transparent curtain walls, and a vista-oriented layout. Because the whole is a well-proportioned, skeletal structure made of poured concrete, steel, and glass, the prevailing impression is of a raw, simple, and yet fine-tuned environment.

Chabot is clearly a science center, and yet it has an art component in the 14 interactive sculptures by **NED KAHN** that constitute the *Planetary Landscape* exhibit. Using elements like fog, air, water, and sand, the works reveal constantly varying patterns resembling natural and astronomical phenomena.

Oakland International Airport

Terminal 2 Extension
BART: Coliseum/Oakland Airport and Air-BART shuttle

Should you have time to spare while waiting for your plane to depart or for your luggage to arrive, you can view projects commissioned for the expansion of Oakland Airport's Terminal 2 (2006–07) from Bay Area artists. Just inside the security checkpoint area, on the wall adjacent to the escalators, is *Birds in Flight* by **ALAN RATH**. This kinetic sculpture includes three pairs of aluminum wings that glide and flap as they traverse the sky-blue wall behind. In the main transit corridor leading to the new gates, a moving walkway passes in front of *Going Away, Coming Home*—a 160-foot-long glass mural by **HUNG LIU**. The work features a flock of 80 red-crowned cranes soaring through space.

Hand painted on a grid of window panels, the bird imagery forms a front layer that streams across satellite photographs showing views of the West Coast and Pacific Rim. These have been sand-blasted, enameled, and fired onto a second layer of glass panels.

Further along the main concourse, the entrance to the restrooms is marked by a suite of four wall reliefs by **ROBERT ORTBAL**. Using magnified images of fig-leaf patterns and fingerprints formed in limestone plaster and reflected in mirrors and glass, the work creates a panoply of ever-changing visual sensations. The blurry depictions and ambiguous details of gender and identity allude to the kind of imagery set forth in the Beatles's song from which the work derives its title—*I am you, he is she, we are all together*.

Though video monitors are a common element within airport environments, a media wall in Terminal 2's new baggage claim area offers something quite different than the usual arrival and departure lists. Here, a bank of 18 screens presents a continuous loop of four 20-minute video creations. The segment by **REBECA BOLLINGER** is based on water imagery; in his video, **ARTHUR CARSON** treats the monitor window like a doll house; **CAUSE COLLECTIVE** uses the multiple-screen format to reveal the diversity of people who live and work in Oakland; and the video of **MATEEN OSAYANDE KEMET** relates a love story that meanders through Oakland's neighborhoods.

Concord
Sleep Train Pavilion

architect: **FRANK GEHRY**, 1975 and 1996
2000 Kirker Pass Rd, 94524
BART: Concord, free shuttle to Pavilion for events
Located in Diablo Valley between Concord Blvd and Myrtle Dr.

Frank Gehry, the architect renowned for building's with sweeping, curvaceous forms wrapped in reflective metal, such as the Gug-

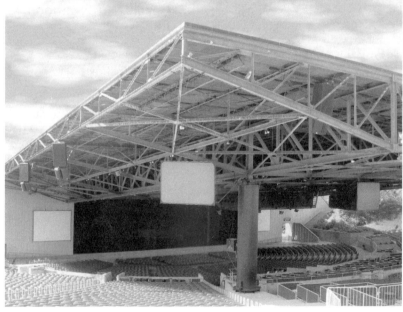

Frank Gehry, Sleep Train Pavilion

genheim Museum in Bilbao (Spain) and the Walt Disney Concert Hall in Los Angeles, is represented in the Bay Area by his design for the Sleep Train Pavilion in Concord (formerly known as the Concord Pavilion and Chronicle Pavilion). Though this early, more austere work—completed before he began using computer-aided design software—hardly exemplifies the radical flair for which he became famous, it does reveal his penchant for architecture that is visually removed from the surrounding landscape and other man-made forms. In fact, Gehry and landscape architect **PETER WALKER** had a mammoth semicircle of dirt poured around the periphery of the space to further insulate it and sculpt its sense of rural seclusion.

In marked contrast to the undulating, soft-toned foothills of Mt. Diablo, the Pavilion has a square black roof that juts out in front of the stage and over sunken seating. Its industrial network of exposed trusses and beams is braced by two large columns in front and a blunt concrete wall in back. The bold, geometric roof structure appears all the more striking since it is set in the midst of an uncovered expanse of lawn seating.

Designed for symphonic concerts, community events, and an annual jazz festival, the Pavilion sought to accommodate the larger audiences of rock concerts by undergoing a massive renovation in 1996. For this, Gehry enlarged the stage and improved service facilities while preserving the principal features of the original design.

Emeryville

This 1.2-square-mile city, bordered by an ever-expanding highway network at the foot of the Bay Bridge, has risen like a phoenix from its former existence as an ugly, contaminated, polluting industrial town renowned for its card-room bars. It is now a megashopping hub for the East Bay. As one commentator observed, the evolution was "from dump to destination." In addition to

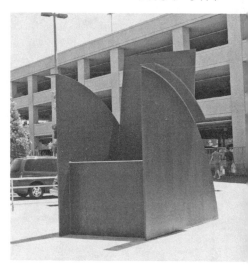

David Ireland, *Big Chair*, 2000

the retail stores and malls that conspicuously announce their presence with bold graphics and neon signs, the city is awash with condominium developments, office buildings, and corporate campuses. A few artists' cooperatives—live/work studios created in rehabilitated factories—were established at the beginning of the city's transformation (1970s) and are still part of the mix.

David Ireland

Big Chair, 2000
IKEA, 4400 Shellmound St, 94608
BART: Montgomery
Located in the outdoor plaza between the store and adjacent parking garage.

Esteemed for his conceptual and installation work and his architectural transformations (see pp. 124, 222), David Ireland has continuously sought to challenge thinking about distinctions between art and non-art. Often this occurs through his use of commonplace materials—concrete, dirt, old brooms, bent wire, peeled wallpaper. With *Big Chair* it is also related to size. The 12-foot-high, Cor-ten steel sculpture is an oddball, eye-catching version of a familiar

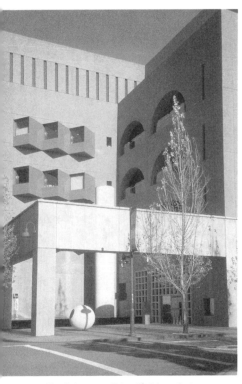

Ricardo Legorreta, Chiron Life Science Center

esteemed Mexican-based architect with numerous designs to his credit in the Bay Area—radically changed both the look and layout of a laboratory structure.

The ensemble contains diversely sized cubic volumes punctuated by distinctive window shapes (wide arches, upright rectangles, slits, squares), some inset and others projecting out from the perimeter as zigzag and box forms. The walls are variously concrete—colored with rose, purple, or yellow pigment and molded so the slatted definition and texture of the wood forms remain visible—and red brick—discreetly patterned by inserting a line of square units into the rows of long ones. Such attention to detail and nuanced contrast accentuates the surfaces without making them appear decorative or audacious. This is also evident in the silo-like cone that crowns the building. While adding an eye-catching element to the rooftop, the screened form also hides an unappealing cluster of fume exhausts.

Legorreta enhanced the ground level of the exterior by adding a covered walkway with a barrel-vaulted roof along Hollis St and plazas at the two main entrances off 53rd Street. The front plaza, paved with a few trees and a curving stone bench, has a sculpture installation—*Two Figures: Three Columns* (1998) by **STEPHEN DE STAEBLER**. The seated woman and standing man, lost in quiet contemplation as they face the enigmatic tall pillars, imbue the setting with a serene, if not otherworldly aura. The far plaza, at the corner of Chiron Way, is more minimalist, but also meditative and evocative. Outlined by a lavender-toned rectangular frame, it features a lattice grid around the entrance door; a tall, massive column; and a giant sphere. All these elements are colored bright yellow. A narrow pool with water flowing in from a small, cube-shaped box jutting out from the side wall of the building adds another curiosity to the setting.

On the interior, a central atrium and courtyard are rimmed with offices while an open

object. Its minimalist design and placement at the entrance to a big-box furniture store makes it all the more provocative.

Chiron Life Science Center

architect: **RICARDO LEGORRETA**, 1999
5300 Hollis St, 94608
BART: MacArthur (then the free shuttle, Emery Go-Round)
Located on the northwest corner of 53rd St.

As you glance across the Emeryville skyline, the colorful, conglomerate character of the Chiron Life Science Center stands out. Situated at the heart of the company's sprawling biotech campus, it defies the norm of bland, four-sided industrial research buildings containing autonomous, self-enclosed workspaces. Indeed, Ricardo Legorreta—the

lab system of shared, flexible work spaces lies on the periphery. This arrangement, which creates a communal, airy, light-filled atmosphere throughout, aims to encourage interaction.

Richmond
Susan Schwartzenberg and Cheryl Barton

Rosie the Riveter Memorial, 2000
Marina Bay Park, Richmond
AC Transit bus: 74
car: Interstate 580 to Richmond; take the Marina Bay Parkway exit south; turn right at Regatta Blvd; turn left at Melville Sq. The memorial is in the middle of the park on the left.

You probably will not find many tourists at this off-the-beaten-track location, even though it offers a shoreline park, marina, and esplanade with sweeping views of the bay. Richmond's Kaiser Shipyards, the most productive during World War II, previously occupied the acreage. Among those working in such assembly-line plants, helping in the war effort on the home front, were some 18 million women. They were symbolized in the image of Rosie the Riveter, and this memorial is now dedicated to them.

The design includes two stainless-steel structures—a hull-shaped form and a ship-stack-like tower—with a walkway connecting them and leading out to a taffrail hanging over the water. The skeletal aspect of the sculptural parts aims to evoke a ship under construction. Additional attention to the shipbuilding activity and the role played by women in it is elucidated in "image ladders"—panels containing Rosie the Riveter photographs, newspaper articles, memorabilia, and letters. A timeline of events on the home front and quotes from women workers are also sandblasted into the granite stones of the walkway.

Marin

Sausalito

Headlands Center for the Arts

944 Fort Barry, 94965
415-331-2787 f: 331-3857
www.headlands.org
staff@headlands.org
daily, 10–5
Muni bus: 76 (Sun only)
car: Hwy 101; exit at Alexander Av, the first turn-off after the Golden Gate Bridge; turn left onto Bunker Rd; pass through the tunnel and continue for two miles; take a left fork onto Field Rd; turn left at Bodsworth Rd (a short hill), then left at Simmonds Rd; continue to second building on the left, at the intersection with Rosenstock Rd.

Located in the Marin headlands, a segment of the Golden Gate National Recreation Area just north of the Golden Gate Bridge. Since public transportation is limited, it is best to visit by car, combining this with other excursions north of the city.

Founded in 1982, Headlands Center for the Arts sought to develop an artist-in-residency program that would provide a supportive working environment for artists and programs that would broaden discussion about the creative process. Over the years, a mix of live-in participants and affiliates (local artists) from various disciplines (visual arts, literature, dance, music) have occupied the studios, experimenting with new ideas independently or collaboratively. A lively calendar of events—lectures, artist's talks, performances, open studios—opens the dialogue to the broader community, and an exhibition room (added in 2001) enables an ongoing display of art. In fact, the Project Space (3rd flr; Tues–Fri, Sun, 12–5) is a working studio where visitors can observe creativity in the making and interact directly with artists.

The site alone is remarkable—a spectacular, pristine landscape of rolling hills and high cliffs overlooking the ocean, with unparalleled views of San Francisco. Having been home to various military facilities (including a Nike launch site during the Cold War era), the acreage and historic buildings gained protective preservation status when the land became part of the Golden Gate National Recreation Area in 1972.

Two clusters of military buildings in the Fort Barry complex now house HCA. In keeping with its mission, conversion of the structures has been a veritable art activity with artists planning and implementing the work. For the three-story, wood-frame headquarters, which houses the public spaces and offices, HCA commissioned renowned artists **DAVID IRELAND** and **ANN HAMILTON**, designers **BRUCE TOMB** and **JOHN RANDOLPH**, and architect **MARK MACK**.

Ireland, who derived inspiration from the avant-garde projects of Gordon Matta-Clark, spearheaded the endeavor (1987) by applying a process-oriented, archeological mode in rehabilitating the entry foyer, stairwell, second-floor Rodeo Room, and East Wing. This entailed stripping back surfaces to reveal layers of past histories. The old stamped-tin ceilings, pillars, railings, and plaster walls were all laid bare, with years of variously colored paint surfaces, stains, and cracks made visible as part of the raw, historicizing aesthetic. The former barracks was thus simultaneously returned to its original state (1907) and given new life. In collaboration with Mack, Ireland also furnished the rooms with curving, multitiered bench seating and matching tables made of aluminum frames and wood planks.

Following Ireland's lead, Tomb and Randolph rehabilitated the latrine room (first floor, west side, 1988) by scraping paint layers from the walls, adding a concrete wall to match the existing raw concrete floor, exposing old radiator equipment, and

Bruce Tomb and John Randolph, *Latrine Room*, 1988; Headlands Center for the Arts

retaining the militaristic processional alignments of urinals, toilets, sinks, and showers. Many of the objects are only relics, kept in place but rendered nonfunctional. Elements of new plumbing—oversized pipes hung from the ceiling—were expressly designed to exaggerate the harsh, utilitarian character of the room. Though privacy and male/female mixed-usage have been accommodated by the installation of a few partitions, the irregularly shaped, oddly proportioned steel stalls only heighten the disquieting, surreal tenor of the room.

Ann Hamilton's restoration of the kitchen and mess hall (first floor, east side, 1989) was the third commissioned renovation in the main building. Aiming to create a comfortable, communal space sensitive to historical elements, she restored some old features and kept the feel of an unadorned, institutional setting. She also added two hearths and generally opened up the space. Going beyond military and architectural references, she also embraced the environmental context of Fort Barry by covering the north wall with a mural of faintly painted images of plants and animals.

To date, the only other major renovation

to take place has been done in the HCA complex at Building 960. This project, developed by architect **MARK CAVAGNERO** and artist **LEONARD HUNTER** (1999), involved dividing the open space of a three-level army supply depot into some 20 studios by inserting steel-rod partitions (from which plywood panels can be hung for privacy) and a cantilevered steel staircase into the shell. Though the historic structure is still noticeable, the emphatic presence of metal gives the interior a decidedly different aura. (Building 960 is only accessible to the public during the seasonal Open Studio events.)

San Rafael
Rafael Film Center

1118 4th St, 94901
415-454-1222
www.cafilm.org/rafael
info@cafilm.org
Golden Gate Transit bus: 20, 23, 26
car: Hwy 101; exit at Central San Rafael; go west on 4th St.
Located between A and B Sts in downtown San Rafael.

Frank Lloyd Wright, Marin County Civic Center

Marin County Civic Center

architect: **FRANK LLOYD WRIGHT**, 1957–72
3501 Civic Center Dr, 94903
415-499-6646
Mon–Fri, 8–5
Golden Gate transit bus: 1, 23, 75
car: Hwy 101; exit at North San Pedro; take the first left onto Civic Center Dr.
Located 15 miles north of San Francisco, alongside Hwy 101.

Since it is easy to get a visual sense of this building as you pass by along the highway, you may assume there is no reason to stop and make an extended visit. Perhaps you also think it is not really a Frank Lloyd Wright structure, since he died in 1959, three years before the first phase was completed. Erase both these misconceptions and put this site high on your list of must-see places if you are at all interested in modern and contemporary architecture, design, and landscaping—or if you just want to see an amazing, utterly humanistic, and still futuristic work-and-public-space environment. And yes, the design is a veritable Wright creation, one of his most impressive late works. He detailed his vision in a master plan that was submitted in 1957 and implemented after his death under the supervision of senior associates at Taliesen, his architectural firm.

Inspired by the surrounding landscape, Wright developed a long, horizontal form with repeating, aqueduct-like arches that echo the curvature of the hills. Indeed, the low-lying, sandy-toned structure, which stretches out in two wings bridging three hills, is expressly integrated into the setting.

Though the fine-tuned scale changes in the facade arches (they diminish in size and increase in number from ground to top floors), the tunnel entrances cutting through the building, and the elaborate gold grillwork around the main door hint at the compelling character of Wright's design, nothing prepares you for the eye-popping

The Rafael Film Center is a three-screen cinemathèque operated by the Film Institute of Northern California. Its mission—to showcase independent films—encompasses the presentation of first-run American and international releases by independents, as well as retrospectives, film festivals, curated special programs and film-related educational seminars. Guest appearances by film personalities (directors, actors, etc.) are a regular part of the program, and the Mill Valley Film Festival is a major annual event.

A 1938 movie house, the building was painstakingly restored in 1999 to reflect the original Art Deco style. Murals, chandeliers, hardware, colors, the curvilinear railings and staircase in the domed lobby, and the sleek tower on the facade all recall the theater's architectural heritage.

experience that lies within. Barrel-vaulted, skylit atriums widen as they rise run down the center of each wing. The airy spatial effect is dazzling, all the more so because plantings at the base level imbue the interior with an orientation toward the outdoors. Walkways along the length of the atriums are unlike the confined corridors in most office buildings (a second stream of covered walkways complement these on the exterior), and evidence of Wright's total orchestration of detail to achieve harmony and rhythmic flow is visible throughout.

A circular structure sits at the intersection of the two wings. Of note on the top floor is the public library, with a radiating arrangement of stacks and an 80-foot-diameter dome. And be sure not to miss the fountain-garden patio, accessed through the café just adjacent to the library in the north wing. Extending out into the landscape, it is a relaxing, beautiful setting and a great vantage point for viewing the architecture. From here, the sci-fi character of Wright's design is most vivid in the dome's flying-saucer appearance and the other-worldly character of the tall triangulated spire next to it.

Additional evidence of the close coordination between building and landscape is found in the Conservation Garden at the far south end of the fourth floor. This is where Wright first viewed the site and conceived of his "organic architecture" plan.

Napa–Sonoma

Although the Napa and Sonoma Valleys are only about 45 miles northeast of San Francisco, they are not easily accessible by public transportation. The drive, which takes about an hour, can be tedious since long stretches are on two-lane roads that get very congested, especially on summer weekends.

Sonoma

Cornerstone Festival of Gardens

23570 Arnold Dr (Hwy 121), 95476
707-933-3010 f: 933-3856
www.cornerstonegardens.com
info@cornerstonegardens.com
mid-Mar–mid-Dec: daily, 10–5
admission: $9/7.50/6.50/3
Located 6 mi. north of the intersection with Hwy 37.

With its mix of experimental, ecological, architectural, horticultural, and whimsical land creations, Cornerstone Festival of Gardens offers an unusual place to experience the artistic imagination. The site—inspired by international garden festivals in Chaumont-sur-Loire (France) and Grand Metis (Quebec)—presents a changing array of some 15–20 gardens by renowned and offbeat landscape architects and designers. As a visitor, you are free to meander through the nine-acre property, arranged in a gallery-style layout with each garden occupying a discrete space along a circuit of interspersed walkways.

Although the term garden is used, do not expect to find lush flower displays and exotic plants ordered formally in symmetrical settings that glorify nature. The gardens at Cornerstone favor steel and plastic, dead and lifeless plants, garish and unnatural colors, geometric forms and odd structures, painted and kitschy accessories.

Among the highlights are Andrea Cochran's woven willow maze; Walter Hood's series of aromatic fences embedded with eucalyptus detritus, Andy Cao's undulating hills covered with glistening carpets, Topher Delaney's serene setting with giant rope balls and a bar-coded wall connoting "garden play," and Pamela Burton's excavation with a lily pool at its base point. Other gardens are by Marco Antonini, Thomas Balsley, Kate Frey, Moore Iacofano Goltsman, Roger Raiche

Andrea Cochran, *Wind in the Willows*, 2006; Cornerstone Festival of Gardens

& David McCrory, Rios Clementi Hale, Yoji Sasaki, Mario Schjetnan, Martha Schwartz, Ken Smith, James van Sweden.

Plaques next to each installation provide helpful descriptions about the projects and designers. There is also a café, nursery, and retail shops, and a covered barn gallery, where you can relax and enjoy a picnic.

Napa

di Rosa Preserve: Art & Nature

5200 Carneros Hwy, 94559
707-226-5991 f: 707-255-8934
www.dirosapreserve.org
info@dirosapreserve.org
Gatehouse: Tues–Fri, 9:30–3
tours: Tues–Sat, variable hrs, call for reservations
admission: $15/10–tours; $3–Gatehouse; free Wed
car: Hwy 101 north to 37 east; turn left onto 121 north, which merges with 12 east and is also called the Carneros Hwy.
Located across from Domaine Carneros Winery on the left side of the road as you travel east. Whimsical cutouts of sheep grazing on the hillside serve as a signpost, and the entrance driveway is marked by a rust-colored gate. (If you pass Duhig Rd on the right, you have gone ¼ mile too far.)

A visit here combines a unique art adventure with a walk through an awesome stretch of the Napa-Sonoma landscape. The preserve claims to be "an outstanding private collection of art produced in the greater San Francisco Bay Area during the latter part of the 20th century." If you are a serious art lover expecting to see a first-rate survey of contemporary and/or Bay Area art, be forewarned that you will need to set aside widely held value judgments.

Opened in 1997 as a natural wildlife preserve and exhibition space under the aegis of the di Rosa Foundation, the entity presents art in a bucolic setting. It was after Rene di Rosa sold a major portion of the 460 acres of grazing land he had purchased in 1960 and converted to vineyards, that the preserve and much of the collection came into existence. The environs include 217 acres of vineyards, olive groves, and a manmade lake. Art fills a front building—the Gateway Gallery, a large shed-like structure—the Main Gallery, and a charming stone house from 1886 (originally conceived as a winery). Sculptures are also situated in the landscaped courtyard, garden areas, open spaces, and along a trail through the meadow.

You get a good sense of the collection from di Rosa's boastful description that characterizes it as "divinely regional, superbly parochial, wondrously provincial—an absolute native glory." Indeed, his taste in art favors work that is garish, kitschy, funky, figurative, pedestrian, comic, flamboyant, excessive, and detritus-oriented. The collection also has a sweeping, egalitarian character revealing an impulse for all-inclusiveness rather than selectivity, quantity more than quality. To be sure, leading regional names from the mid-20th century (Robert Arneson, Joan Brown, Bruce Conner, Roy De Forest,

Richard Diebenkorn, Mark di Suvero, Robert Hudson, David Ireland, Manuel Neri, Peter Saul, William T. Wiley), as well as notable talents from subsequent generations (Squeak Carnwath, Deborah Oropallo, Alan Rath) are represented. But the works are generally not prime examples, and they are far outnumbered by inconsequential works by marginal artists.

di Rosa's idiosyncratic approach to collecting also characterizes the installation style in the house, where objects are crammed together covering virtually every nook and cranny of available space. Touring the rooms is a fun-filled experience—a relentless bombardment of visual stimuli with distinctions between artwork and household items continually blurred. Though a similar mode of disarray used to prevail in the Main and Gatehouse Galleries, it has been supplanted by a more staid, chronological orientation that facilities viewing individual works and calls attention to the creative impulses represented by the collection.

The collection here may not do justice to Bay Area art, but it does offer a personal perspective in a delightful setting.

Artesa Winery

architect: **DOMINGO TRIAY**, 1997
1345 Henry Rd, 94559
707-224-1668 f: 224-1672
www.artesawinery.com
info@artesawinery.com
daily, 10–5
car: Hwy 121/12 east; turn left onto Old Sonoma Rd (a short distance after the di Rosa Preserve); take the first left onto Dealy Ln and left again when it forks into Henry Rd.

Built into a hill and deriving its form from nature, the architecture of Artesa calls to mind the giant earthworks created by artists in the 1970s. The aim here was to integrate the man-made structure with the environment so the natural setting would remain intact. Indeed, the building is barely visible from the road except as a low-lying, double-tiered berm covered with native grasses. Only the precisely sloped sides and flat tops (reminiscent of Mayan temples) belie nature—until you get to the entrance, where steep staircases climb up to a broad plaza, formally landscaped with fountains, pools, and sculptures. The entry portal tunnels into the hillside and then opens onto a spread of interior spaces. Although the design incorporates an atrium courtyard and expansive terraces with panoramic views stretching far

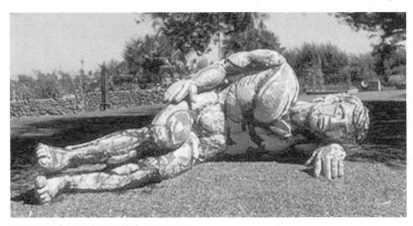

Viola Frey, *Reclining Nude #2*, 1987; di Rosa Preserve

back to the San Francisco Bay, the style—a mild-mannered, staid version of Minimalism—is unremarkable, particularly in terms of the variously sleek and tacky materials.

Oxbow School Studios

architect: **STANLEY SAITOWITZ**, 2000
530 3rd St, 94559
car: Hwy 29; exit at Downtown Napa/Lake Berryessa; go straight onto Napa Vallejo Hwy, which becomes Soscol Av; turn right at 3rd St; Oxbox is on the left, between Bailey and DeWoody Sts.

This studio complex is the campus centerpiece at Oxbow, a private art school offering a one-semester program for high-school juniors and seniors. Comprising four units arranged in a row with courtyards and passageways in between, the complex turns its back to the street in favor of a northward orientation facing the river. The imprint of Stanley Saitowitz is evident in the rudimentary cubic forms—designed to be light-filled and spacious, equipped with roll-up doors (25-

The Art Guys, *Grape Suits*, 2001; Copia

feet wide) for flexible, functional efficiency and indoor/outdoor seamlessness, and constructed from industrial materials (concrete, steel, glass) with cedar siding as an offset.

Copia

architects: **JAMES STEWART POLSHEK**; **PETER WALKER** (landscape), 2001
500 1st St, 94559
707-259-1600 f: 257-8601
www.copia.org
info@copia.org
Mon, Wed–Sun, 10–5
admission: $5/4
car: Hwy 29; exit at Downtown Napa/Lake Berryessa; go straight onto Napa Vallejo Hwy, which becomes Soscol Av; turn right at 1st St and go two blocks.

Devoted to the study, celebration, support, and production of food, wine, and the arts, Copia is an epicurean Disneyland for the ever-growing population of haute-cuisine afficionados, gourmet cooks, gardening sophisticates, and highbrow tourists. The brainchild of Robert Mondavi and his wife, the center (named after the goddess of abundance) presents an ambitious program of exhibitions, concerts, films, lectures, seminars, classes, cooking demonstrations, and tastings. It also houses a café, restaurant, and gift shop.

Although a rather upscale institution, Copia is located in a fringe, economically downtrodden area of Napa, a blue-collar city in a county renowned for its affluence. Conceived as a linchpin of the community's revitalization, it also serves as a prime signifier of and marketing tool for the lifestyle and culture that have become synonymous with northern California.

Even more than the huge building, the edible gardens, stretching across the front and extending way back on the other side of 1st St, announce Copia's character and presence. Arranged in a grid pattern, the three-and-a-half-acre spread has been entic-

ingly described as "an expansive outdoor playground where you can eat, smell and taste seasonal plantings, learn gardening and cooking techniques, or enjoy a stroll and picnic." There are vegetables (including 20 different kinds of carrots), fruits (among which are 30 wine grapes), herbs, botanicals, flowers, a lavender collection (with no fewer than 40 varieties), orchards, and a seed-saving garden. There is also an outdoor cooking pavilion.

An alley of poplars flanked by shallow water terraces leads through the garden up to the building's main entrance, which is further demarcated by a break in the fieldstone wall that accentuates the ground floor of the structure. The rugged material is reminiscent of old Italian farmhouses, though configuring the wall as a false front punctuated with cut-out voids is a postmodern conceit. Indeed, the facade evinces James Polshek's trademark propensity for planar surfaces diversified by materials, arranged in a contrapuntal order, and accentuated by contour delineation. Here, corrugated aluminum and polished concrete offset the stone, while canopies and the undulating roofline differentiate segments and exaggerate the building's horizontality.

In contrast to the front, the rear facade of Copia is a curved, glass curtain wall shaded by a colonnaded overhang. It overlooks and opens onto a concert amphitheater and landscaped terrain extending down to the river. The architecture of the back is more aligned with the interior, which centers around an exceedingly open, vast, light-filled atrium.

A grand staircase leads up to various galleries on the second floor. These include the "core" space, where long-term exhibitions (e.g., *Forks in the Road*) look at the role of food and wine in American life from scientific, historical, and popular-culture perspectives. Adjacent galleries present changing art exhibitions with the same thematic focus. Spanning the gamut from the glitzy to the esoteric, and diversely laced with whimsy or serious scholarship, the shows include a varied, uneven mix of objects. Sample exhibitions: *Canstruction*, *Counter Culture—The American Diner*, *Design & the Tools of he Table (1500–2005)*, *Out of Earth—Adventurous Winery Architecture*.

A few works of art are also installed in the lobbies and scattered around the grounds. Among the most notable are **MARIO MERZ**'s *The Horizon of Light Passes Through the Vertical Day* (1995)—a long, narrow glass-topped table scattered with wine, honey, and neon elements—and **DENNIS OPPENHEIM**'s *Candelabra*, a huge assemblage of trash cans, pots, woks, and candles alluding to the life cycle of food from kitchen to dining table to garbage.

Hess Collection Art Gallery

Hess Collection Winery
4411 Redwood Rd, 94558
707-255-1144 f: 253-1682
www.hesscollection.com
info@hesscollection.com
daily, 10–4
car: Hwy 29, exit at Redwood Rd west; continue 4½ miles, then veer left at the fork with Mt. Veeder Rd; the winery is another ½ mile down the road.

Located on the mountainous slopes of the western rim of Napa Valley, the Hess Collection Art Gallery is housed in a three-story, ivy-cove½red building from 1903, adjacent to the winery's vintner facilities. This was one of the first serious art venues in the region (opened in 1989), and it still presents a strong, albeit uneven and arbitrary selection of contemporary European and American art. Since this is the only place to see certain international figures, not otherwise represented in Bay Area art institutions, the collection has added value.

The display is mainly on the top two floors in airy, nicely renovated spaces bathed in natural light. (The rear spaces of the entry level contain some works on paper.) All the

Magdalena Abakanowicz, *Crowd*; Hess Collection Art Gallery

objects come from the private collection of Donald Hess, a Swiss entrepreneur and founder of the winery, who began amassing his art holdings in 1960s. Among the more than 100 works are representative examples by Magdalena Abakanowicz, Francis Bacon, Georg Baselitz, Franz Gertsch, Gilbert & George, Lynn Hershman, Morris Louis, Robert Motherwell, Marcus Raetz, Arnulf Rainer, Alan Rath, Robert Rauschenberg, Gerhard Richter, Frank Stella, and Clyfford Still. Since the collection tends to include several objects by each artist, you get a chance to see early and late works, works in different media, or variations on a single theme. Should you be unfamiliar with the compelling sculptures by the esteemed Polish artist Abakanowicz, her *Crowd*—a haunting ensemble of 18 life-size headless figures made in resin and burlap—is a knockout. Alan Rath's *Quintet*, a witty grouping of electronically controlled robotic arms that move on the wall, is also noteworthy.

Yountville
Napa Valley Museum

architects: **FERNAU & HARTMAN**, 1998
55 Presidents Circle, 94599
707-944-0500 f: 945-0500
www.napavalleymuseum.org
Mon, Wed–Sun, 10–5
admission: $4.50/3.50/2.50
car: Hwy 29, exit at Yountville Veterans Home; turn west and follow tree-lined California Dr to the first stop sign; turn right onto Presidents Circle; the museum is just ahead on the right.

This may not look like a museum, but its appearance is perfectly attuned to the farm culture of the Napa Valley. Although the museum's mission—to interpret the arts, culture, history, and sciences of the region—overlaps with Copia (see above), in style and concept, both the building itself and the nature of its exhibits are dissimilar. Here, a humble, down-to-earth sensibility prevails in contrast to Copia's chic opulence.

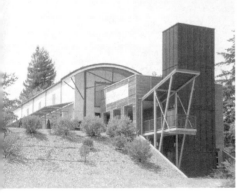

Fernau & Hartman, Napa Valley Museum

Designed by the Berkeley-based firm of Laura Fernau and Richard Hartman, the architecture is a prime example of their acclaimed mode of merging vernacular forms (light-frame barns, water towers, tool-storage structures, mining-camp platforms) with modern means and materials. The current building (phase one of a large project that will add other buildings with extensive outdoor galleries and agricultural displays) centers on a modestly sized exhibit hall set on the edge of a hilltop. The simple, shed-like form is supplemented by bright-yellow awnings—a long, horizontal overhang bisecting the facade on one side, and sunscreens set vertically alongside tall windows on the other. On the inside, the asymmetrical corrugated-aluminum roof, whose stunning curve is exaggerated by red steel trusses, sweeps across a basically simple and open, light-filled space. The ambience is barnlike, but the aesthetic is industrial-contemporary.

Adding verve to the main structure is the admixture of disparately shaped forms at the south end: a raw wood cubic building housing restrooms and an elevator; a rusted steel tower; and a roofed observation deck.

Dominus Winery

architects: **HERZOG & DE MEURON**, 1998
2570 Napa Nook Rd, 95499
707-944-8954
Located on the west side of Hwy 29, bordering the Madison St exit (just north of the Napa Valley Museum).

You can only get a fleeting glimpse of this architectural gem while driving past on the highway, since it is not open to the public. But do keep your eyes peeled so you can at least register its existence. What you will see, set back from the road in the midst of vineyards, is a very long, linear building with a covered passageway in the center.

What you unfortunately cannot see is the ingenious, functionally creative mode of construction. It reveals the virtuosity of

Herzog & de Meuron in revolutionizing the classic stone-wall architecture of European wineries, while also evincing a concern for light, energy efficiency, and the local setting. As they explain: "In front of the facades, we placed gabions, a device used in river engineering, that is, wire containers filled with stones. Added to the walls, they form an inert mass that insulates the rooms against heat by day and cold at night. We chose a local basalt that ranges from dark green to black and blends in beautifully with the landscape. The gabions are filled more or less densely as needed so that parts of the walls are very impenetrable while others allow the passage of light: natural light comes into the rooms during the day and artificial light seeps through the stones at night. You could describe our use of the gabions as a kind of stone wickerwork with varying degrees of transparency, more like skin than like traditional masonry."

Although this structure is inaccessible to the general public, a visit to the de Young Museum in Golden Gate Park enables direct contact with the extraordinary architecture of Herzog & de Meuron.

Rutherford

Rubicon Estate Winery

1991 St. Helena Hwy, 94573
800-782-4266 f: 707-963-9084
www.rubiconestate.com
daily, 10–5
Located on the west side of Hwy 29, just south of the intersection with Rutherford Crossroad.

Film director Francis Ford Coppola bought a parcel of the Inglenook Estate in 1975, and then in 1995 he purchased additional acreage that included the winery's chateau. Renovation of the structure ensued, and when it opened to the public in 1997, it featured a museum. (Formerly known as Niebaum-Coppola, the winery changed its

name to Rubicon Estate in 2006.) Besides displays of historical documents and artifacts related to the winery, the museum contains a nostalgia-ridden collection of memorabilia from Coppola's films—including Corleone's desk and chair from *The Godfather*, costumes from *Bram Stoker's Dracula*, the torture chamber from *Apocalypse Now*, movie stills, and Oscar statues.

Should you be a film buff with a particular interest in Coppola's work, a visit here is a nice way to spice up your Napa experience. Be advised, however, that Coppola acquired (2006) the historic Chateau Souverain property in Geyserville (tentatively renamed Coppola Winery, 400 Souverain Rd, 707-433-8282) and he plans to move the film-related collection to that location once its renovation is completed.

Calistoga

Clos Pegase

architect: **MICHAEL GRAVES**, 1987
1060 Dunaweal Ln, 94515
707-942-4981 f: 942-4993
www.clospegase.com
info@clospegase.com
daily, 10:30–5

car: Hwy 29; exit at Dunaweal Ln; turn east (Twomey Vineyard is on the corner) and continue for less than ¼ mile; Clos Pegase is on the left.

The design for this winery resulted from an architectural competition cosponsored by SFMOMA (1985). The winner, Michael Graves, a leading figure of the postmodern movement, was selected from a field of 96 entrants. His "temple to wine and art" has a decidedly classical look, though the stripped-down appearance and gargantuan scale of the columns, doorways, towers, arch above the open-air portico (west facade), and pediment and colonnade at the service entrance (south facade) are bold distortions. Similarly, his use of color—muted rose, orange, and beige with blue linear accents—makes familiar architectural forms stand out loud and clear. On the one hand, decorative details are eliminated; on the other, abstract representation transforms drab surfaces and simple shapes into an eye-catching syntax.

The public entrance on the west facade leads backs to a charming inner courtyard with formal gardens, a small vineyard, some sculptures, and picnic tables. The front and back structures house reception spaces, including a theater, while the building on the right contains the winery's storage and processing facilities.

Before heading inside, be sure to walk all around the surrounding grounds, which serve as a sculpture park. The selection encompasses prime works of early Minimalism as well as representative objects from the last decades of the 20th century by leading American and European artists. Set near the southwest corner of the winery is

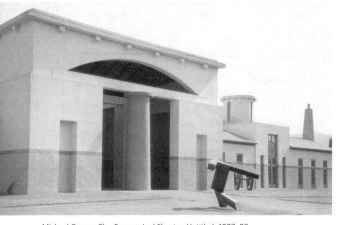

Michael Graves, Clos Pegase; Joel Shapiro, Untitled, 1987–88

The Extravagant—one of **JEAN DUBUFFET**'s classic whimsical, animated figures in red, white, blue, and black. Across the road is *Barrier* (1962), a reductive object by **ROBERT MORRIS** that uses a repeated # shape. *Whale's Cry* (1988), a work in rusted and stainless steel by **MARK DI SUVERO,** featuring a mix of odd parts that swing around a center pole, is up ahead on the hillside. Be sure not to miss **RICHARD SERRA**'s *Twins* (1972), situated in the middle of a quadrangle of poplars, off to the side and behind the di Suvero. Though not one of his premier works, it gives evidence of his inimitable use of steel plates to create a tension-laden space.

Tony Smith, *Marriage*, 1961; Clos Pegase

If you double back to the Dubuffet and walk across the road, you will encounter **RICHARD DEACON**'s *Smile* (1992), an upright ribbon-like form of dimpled stainless steel that reveals the artist's indomitable focus on the fabrication process and the inherent structural properties of materials. Walk to the rear of the lot and you will come upon two reductive geometric sculptures that are classic exemplars of the 1960s: **ROBERT MORRIS**'s *3 L-Beams* (1965–67)—a work that presents the same right-angled form in three different orientations—and **TONY SMITH**'s *Marriage* (1961)—an unfolding architectonic image that plays with scale, shape, and structure. As you exit the parking area, you will see the marble *Memory of Dreams* (1972) by **AGUSTIN CÁRDENAS**—a little-known French-Cuban artist who derived inspiration from Surrealism and Henry Moore—and *Two Lines Up Oblique* (1977), a stainless-steel kinetic work by **GEORGE RICKEY** that asserts a balance between order and randomness.

Walk alongside the west facade of the winery and you will pass by **WILLIAM TUCKER**'s *Leda* (1990)—a blob-like mass of bronze giving evidence of compression, expansion, weight, and a sense of gravity; *Wheels II* (1963–88), another minimalist work by **ROBERT MORRIS** that repeats a single image to convey perceptual differ-

ence depending upon viewpoint; and **JOEL SHAPIRO**'s Untitled (1987–88)—one of his signature abstract-figurative objects with a suggestively human form (torso and appendages) but no personalizing characteristics.

When you reach the north end of the building, the periphery road is flanked by **MARK DI SUVERO**'s *Applebone* (1986), a red painted structure comprising I-beams and a suspended component of cut steel scraps; **ELYN ZIMMERMAN**'s *Palisades Project* (1981), a wall of one polished and seven natural slabs of granite set in a reflecting pool; and **ANTHONY CARO**'s *Sunshine* (1964), an open, "tabletop" arrangement of brightly painted steel elements that plays void against solid, zigzag against linearity.

If you now turn to the south and enter a garden-like vineyard that is part of the

Anthony Caro, *Sunshine*, 1964, Clos Pegase

Tony Cragg, *Bodicea*, 1989, Clos Pegase

winery's inner courtyard, you will come upon the witty, absurd *Thumb* (1963), a seven-foot-high bronze by the French artist **CÉSAR**. Within the courtyard itself, you will find **TONY CRAGG**'s *Bodicea* (1989), a bronze that may look like a bunch of grapes but derives its image from the Celtic goddess of fertility, who was represented in antiquity by a cluster of breasts; **MIMMO PALADINO**'s Untitled (1990), a tall, haunting image that reasserts the emotive power of myth, mystery, and magic in both figurative and abstract forms; **SANDRO CHIA**'s *Bacchus as Poet-Painter* (1988), a hyper-expressionistic representation of the god of wine in an action-oriented pose; and **ANTHONY CARO**'s *Veduggio Dream* (1972–73), a composite of cut sheets of rusted steel.

Clos Pegase also showcases art throughout its interior spaces. Paintings, drawings, and some sculptures don the walls and floors of the visitors center (a small gallery to the left of the entry door), tasting bar, wine reserve room, cask room, and caves. The collection favors expressionist and surrealist work, mainly by European artists from the mid-20th century. (It also includes wine-related art and artifacts from other eras.) In contrast to the garden sculptures, here the quality is very uneven, the selection draws mainly from fringe artists, and there is a disturbing mix of

original objects with reproductions. Notable among the array are paintings by Karel Appel, Francis Bacon, Oscar Dominquez, Matta, and Jean Paul Riopelle, and sculptures by Tony Smith and Jean Dubuffet.

On your way out of the building, under the covered passage of the main portico, you will see **HENRY MOORE**'s *Mother Earth* (1957)—a small bronze whose primordial, emergent form evokes the belief that this mythic figure, one of the first beings, was spontaneously born of nothing and is like Earth itself, a source of life.

Santa Rosa
Sonoma County Museum

425 7th St, 95401
707-579-1500 f: 579-4849
www.sonomacountymuseum.org
questions@sonomacountymuseum.com
Wed–Sun, 11–5
admission: $5/2
car: Hwy 101; exit at Downtown Santa Rosa, which takes you onto Morgan St; turn right onto 6th St, left onto A St, and left onto 7th St.

Founded in 1985 and housed in a classic Beaux-Arts building, the Sonoma County Museum presents exhibitions on history and art in vintage spaces centered around a two-story atrium and balcony. A focus on topics related to the natural world and the land has shaped much of the art program, including exhibitions featuring earthworks and environmental projects. The museum's Project Space presents an ongoing series of shows by young regional artists.

The main drawing card for visitors interested in the broad contemporary art scene is the museum's collection of drawings and sculptures by Christo and Jeanne-Claude. A small room on the second floor is dedicated to rotating displays of work from this archive. The collection is rooted in Christo's *Running*

Christo, *Running Fence, Sonoma & Marin Counties,* 1972–76; Sonoma County Museum

Fence, the 25-mile-long fabric wall he created in 1976 across the landscape of Marin and Sonoma Counties.

Sample exhibitions: *Stephen Galloway Photographs, Robert Hudson—The Sonoma County Years, Hybrid Fields, Ned Kahn in Santa Rosa, James Turrell—Light & Land.*

Ned Kahn

Digitized Field, 2004
516 3rd St, 95401
car: Hwy 101; exit at Downtown Santa Rosa, turn right, follow 3rd St to B St.
Located on the west face of the AT&T (SBC) building at B St.

Ned Kahn, an artist acclaimed for his public artworks inspired by natural phenomena, has here suspended a fluttering, glittering, 62-foot-high wall over the facade of a high-rise office building. The undulating surface, composed of thousands of small aluminum leaves, continuously changes color in response to prevailing wind and light conditions.

Charles M. Schulz Museum

architect: **C. DAVID ROBINSON**, 2002
One Snoopy Pl, 95403
707-579-4452 f: 579-4436
www.schulzmuseum.org
inquiries@schulzmuseum.org
Mon, Wed–Fri, 12–5:30; Sat–Sun, 10–5:30
admission: $8/5
car: Hwy 101; exit at Steele Ln and go west; get in the extreme right lane and continue on West Steele Ln when the road splits after Cleveland Av; continue for two blocks and turn right at Hardies Ln; the museum is on the northwest corner.
Located in a residential area at the northern end of Santa Rosa.

Should you be a fan of the *Peanuts* comic strip or the down-home humor of its creator Charles M. Schulz, this is a place you will not want to miss. Alternatively, you might want to visit just to see a well-designed modest-sized museum.

In keeping with the playful whimsy of the cartoon, the building's exterior has

white stone walls with black slate panels and highlights of red, yellow, and blue. A slanted copper roof, which will oxidize to blue-green, a curved entrance wall, and cut-out window shapes further enliven the front facade. Inside, an airy two-story lobby leads to exhibition galleries, an auditorium, and a store on the ground floor, and a re-creation of Schulz's studio, a research library and archive, a classroom, and additional galleries upstairs. Displays feature a broad selection of original comic strips, preparatory sketches, and memorabilia in a classy but comfortable setting enhanced by wood paneling. Though the rooms are scaled for small artwork, large wall expanses in the lobby, painted and tiled with grand murals, provide a nice counterpoint. Glass curtain walls also open onto a delightful back courtyard containing a handful of sculptures, the most prominent being Lucy's baseball cap in iridescent purple. If you missed the labyrinth in the shape of Snoopy's head on your way in (it occupies the area alongside the entrance path in front), be sure to check it out upon leaving the museum.

Healdsburg

This charming community with a well-pre-served town square, lies at the northern end of the Alexander Valley. It is an ideal end point for meanderings through the Napa and Sonoma wine country. If you really want to enjoy the rustic character of picturesque California villages, just travel a short distance west from Healdsburg along the Russian River to Guerneville and Jenner. The redwood forests and riverbank coves are natural delights, and the old-time flavor of the shops asserts a resistance to outsider invasion without being too touristy. For pure pleasure, arrange to stay at one of the area's bed & breakfast inns, where a restful, scenic environment combines with gourmet breakfasts and down-home friendliness. Inns of choice include the Sonoma Orchid Inn

(12850 River Rd, Guerneville, 95446) and the Village Inn (20822 River Blvd, Monte Rio, 95462).

Hotel Healdsburg

architect: **DAVID BAKER**, 2001
25 Matheson St, 95448
707-431-2800 f: 431-0414
www.hotelhealdsburg.com
car: Hwy 101; exit at Central Healdsburg onto Healdsburg Av; continue ahead to Matheson St; the hotel is on the left, facing the city's historic plaza.
Located 67 miles north of San Francisco.

With its spare, modern appearance, the architecture of this new luxury hotel signifies the shift in Healdsburg's town center from a rural community square to an upscale, visi-tor-oriented destination. In fact, the building is pretty mild by contemporary architectural standards. As in most designs by David Baker, it rises above the norm by taking simple geometric forms and orchestrating them into a rhythmic ensemble. Instead of a single boxlike form, the hotel is composed of three structures separated by pedestrian alleys and landscaped terraces on the ground level and connected by glass bridges on the upper levels. In addition, protruding balconies, inset bays, and latticed steel cornices on the rooftop serve as contrapuntal accents that enliven and refine the starkness of the gray stucco walls and cubic shapes.

Further refreshing details are visible when you walk down the pathways to the courtyard in the center of the complex. Among these are the twig fencing, wisteria-covered per-golas, screened sitting area, and array of chic chairs. Although this area is contained within the hotel, it is open and directly accessible to the surrounding streets. Similarly, storefronts that frame the ground floor and border the plaza freely interface with the outside com-munity.

Geyserville

Oliver Ranch

River Rd, 95441
510-412-9090 f: 412-9095
sholiver@earthlink.net
Apr 15–May, Sept 15–Oct: Sat–Sun, by reservation to organized groups associated with cultural institutions
admission: $50/person donation to an arts organization of your group's choice
Located in Alexander Valley, just beyond the juncture of Hwys 101 and 128.

Yes, it is off the beaten track and has restricted access with a hefty visitor's fee, but if you can arrange a visit, it will be one of those memorable experiences that renews your enthusiasm for contemporary art. Formerly a sheep ranch, the 90-acre spread of rolling, oak-dotted hills has been transformed into a land-art wonderland by Steven and Nancy Oliver. Since 1985, they have been commissioning artists to create site-specific works on the property. Unlike public art, which typically entails bureaucratic madness and excruciating constraints of time, materials, budget, and design, here artists work at their own pace and have the freedom to explore new ideas. Their work is facilitated by the expertise and resources of Steven Oliver, a trained engineer who owns a large construction company. Commissions are still being implemented, at the rate of about one per year.

Currently, the roster of projects (listed in the order in which you'll encounter them on a walk through the property) includes:

BRUCE NAUMAN, Untitled, 1998–99. This may at first seem like a normal, albeit very long, narrow, and oddly isolated staircase, but it is actually a classic work by Nauman, aimed at causing disorientation and imbued with a sadistic underpinning. As is evident once you begin to descend or ascend, you easily lose your balance since the steps are not evenly sized: all the treads are equal

Bruce Nauman, Untitled, 1998–99; Oliver Ranch

but the risers vary in height. The sculpture is also a stunning image—a streak of white cascading 1/4 mile down the slope of a hill, crossing a road in the process.

ANDY GOLDSWORTHY, Untitled, 1991. As is his habit, the artist chose to work with ephemeral materials found in the natural environment. He set up six projects, which last from two minutes to two months, and register changes occurring as a result of weather conditions, displacement, growth, or life/death cycles. Though the elements and situations no longer exist, a record of them endures in Goldsworthy's photographs.

JIM MELCHERT, Untitled, 1988–89. This project comprises the colorful tiles with decorative patterns that line the swimming pool.

JUDITH SHEA, Shepherd's Muse, 1985–88. This, the first project commissioned by the Olivers for the ranch, comprises an empty bronze overcoat, broken classical columns tumbling down a rocky knoll, and an enormous white concrete head resting on its side in a grassy clearing at the bottom of the hill. The work exemplifies Shea's use of

Martin Puryear, Untitled, 1994–95; Oliver Ranch

hollow clothing objects, body fragments, and ancient relics as vessels into which personal feelings and ideas can be projected.

DENNIS LEON, Untitled, 1992–93. Aiming to assert a seamless merger between art and nature, Leon produced an ensemble of trompe-l'oeil boulders in cast bronze that are barely discernible from the surrounding rocky landscape. Even weather marks appear in the patina, though on close inspection you can see impressions of the bolts used in casting.

ELLEN DRISCOLL, Untitled, 1989–90. Conjuring an allegory of music and the Arcadian tradition of open fields, Driscoll scattered four tubular objects near the shores of a lake on the ranch's property. Some are shaped like flutes, and all appear worn and fragmented like ancient artifacts.

BILL FONTANA, *Earth Tones*, 1992. As you walk along the hillside paths, you will hear the sounds of crashing waves, a roaring waterfall, trains going over a railroad bridge, thunder, and other disorienting reverberations that clearly are out of place in this pastoral landscape. These are part of Fontana's acoustic project based on the translocation and dislocation of sound.

KRISTIN JONES and **ANDREW GINZEL**,

Pananemone, 1990–91. In keeping with their fascination with time and place, the artists have created a group of wind instruments that reveal shifting patterns of light, shadow, and movement in direct response to nature. Included are copper-leafed spheres, tree-slung wind sensors, spinning discs, and aluminum poles.

MARTIN PURYEAR, Untitled, 1994–95. For the sculptural segment of this work, the artist constructed one of his signature shapes—a bulging, curvaceous mass with a decidedly phallic form. Its provocative, inexplicable nature is heightened by the 18-foot wall alongside, which contains a crosshatched wooden door that opens onto a cave-like room inside the bulge. But the portal has been sealed off, denying all entry. The work gives strong evidence of Puryear's skill in creating abstract forms with illusory qualities. The stonework, which integrates different tones and shapes, and the definition of the circular window, door, and arches in the wall, also show his virtuosity in craftsmanship. By using stones from upstate New York, Colorado, and California for the masonry and including a nonindigenous olive tree, transplanted from Southern California, in the ensemble, he decontextualizes the work from

the immediate environment only to intensify its evocative character.

ROGER BERRY, *Darwin*, 1988–89. This long, double-banded arch of Cor-ten steel, set on a slant above a gently depressed curvature in the terrain, has the idiosyncratic aura of a rainbow. In fact, the shadow it casts tracks the path of the sun from winter equinox to summer solstice.

RICHARD SERRA, *Snake Eyes and Boxcars*, 1990–93. In contrast to his renowned steel-plate sculptures, which foreground issues of stability and scale, this work is composed of twelve solid blocks of Cor-ten steel and deals with density and weight. The blocks of different heights, some weighing as much as 22 tons, are set in pairs across a grand sweep of hill and meadow. Though seemingly strewn about like dice, Serra has precisely calculated their positions using a mathematical formulation based on ground elevations. Despite its austere, minimalist character, the sculpture, like most all of Serra's art, has a gripping potency.

TERRY ALLEN, *Humanature*, 1991–92. Positioning two bronze figures—a headless male leaning back against a tree with his pants down around his ankles, and a high-heeled, short-skirted woman bending over with her head buried in a rock—at a distance from each other in a wooded setting inflected by a chorus of crickets, Allen has sown the seeds of a bawdy, albeit realistically expressive narrative about human nature.

URSULA VON RYDINGSVARD, *Iggy's Pride*, 1990–91. Using cedar beams, stacked and glued together, carved, and covered with a graphite overlay, the artist created a series of nine jagged ridges that extend out from the hillside. Recalling forms in nature well worn by the vicissitudes of time, they also represent the nine members of her family who were forced to live in Polish refugee camps in Germany during World War II.

MIROSLAW BALKA, *43 x 30 x 2, 43 x 30 x 2, 1554 x 688 x 10*, 1995–96. Personal history forms the basis of this and most all of Balka's art. Here the minimalist platform of white sand and white cement recreates the footprint of the house in Poland where the artist was born and which he now uses as his studio. The six rectangular indentations with the semblance of tombstones commemorate family members, and the water streaming into them suggests the flow of life and memories coming and going.

ANN HAMILTON, Untitled, 2002–07. Consonant with her creation of enrapturing settings in which actions take place, in this work, Hamilton has developed a spellbinding performance-oriented structure: a seven-story cylindrical tower with a double-spiral staircase, inspired by St. Patrick's Well in Orvieto, Italy. The idea is to have the audience sit on one staircase and the performance take place on the other.

ROBERT STACKHOUSE, *Russian River Bones*, 1989. Boat forms are a seminal element in Stackhouse's art, and here he develops the imagery as a long expanse of white concrete set atop stilts. Though the supports are all the same height, the platform undulates, its surface directly correlating with the curvatures in the terrain below.

Although it is not a sculpture, the Visiting Artists House designed by **JIM JENNINGS** (2002), with an integral artwork by **DAVID RABINOWITCH,** is one of the most extraor-

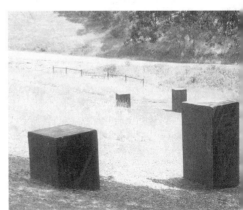

Richard Serra, *Snake Eyes and Boxcars*, 1990–93; Oliver Ranch

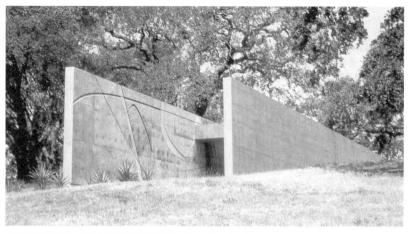

David Rabinowitch and Jim Jennings, Visiting Artists House; Oliver Ranch

dinary creations at the Oliver Ranch and one of the most imaginative, trailblazing dwellings of the current era. It calls to mind the groundbreaking architecture of Mies van der Rohe's Barcelona Pavilion (1929) and Philip Johnson's Glass House (1949), while also embracing the concepts and aesthetics of Richard Serra's steel-plate sculptures.

Rather than being based on a grid plan sitting atop the ground, the residence is situated between two long concrete walls that slice through a hill. Actually, the residence contains two suites, one mirroring the other and each with a living room, bedroom, kitchenette, and bath. A patio separates the units, and each has its own terrace at the far ends, where the walls open out to the landscape. The conjunction of outdoor and indoor space is further asserted by the glass curtain walls that bound the units in front and back, and the narrow skylights that run along the side walls. Refinements, like the slight convergence of the side walls and decline in the floor, also aim to enhance the interface by framing perspectival views of the lake in the distance. Indeed, the interior has

a magical continuity with the surrounding terrain. Even the entrance—a pair of narrow, converging stairs that descend to a gap in one of the side walls and place you in the patio—evinces this.

The same pristine clarity that is notable in the structure also prevails in the interior layout. A cubic form (housing the bath and kitchenette) is set in the center, unattached to the side walls and sheathed in aluminum. It is the only enclosed element in an otherwise free-flowing space. Without question, the openness plays a critical role in countering the spare, reductive character of the design. The wood-slat ceiling and maple floors similarly offset the coolness of the industrial materials, but it is the Rabinowitch drawings—*Carved Systems Involution (for Catrina Neiman)* (1992–2002)—that energize and shape the space in a unique way. Incised into the side walls, their sweeping, looping, wavy lines extend down the full length of the residence's structure, adding an rhythmic dynamic to the geometric rigor of the architecture and further connecting the interior to the landscape beyond.

Index

Page numbers in **bold** refer to illustrations.

INDEX

Photo credits

Page 27, 28, courtesy of San Francisco Museum of Modern Art; p. 30 (bottom), courtesy of the artist, 303 Gallery, and Yerba Buena Center for the Arts; p. 34, Naina Ayya, courtesy of SF Arts Commission; p. 38, courtesy of Crown Point Press; p. 40 (top), courtesy of Lisa Dent Gallery; p. 40 (bottom), courtesy of Cartoon Art Museum; p. 42 (bottom), courtesy of SF Camerawork; p. 43, courtesy of Patricia Sweetow Gallery; p. 44, courtesy of Museum of the African Diaspora; p. 45, courtesy of Studio Daniel Libeskind, WRNS Studio, and Contemporary Jewish Museum; p. 46, courtesy of Museum of Craft & Folk Art; p. 47 (bottom), courtesy of Modernism Inc.; p. 48, courtesy of Gallery Paule Anglim; p. 49, John White, courtesy of 871 Fine Arts; p. 50, courtesy of Stephen Wirtz Gallery; p. 51, courtesy of Fraenkel Gallery; p. 51, courtesy of Jack Fischer Gallery; p. 53, courtesy of Haines Gallery; p. 54, courtesy of Robert Koch Gallery; p. 55, courtesy of Gregory Lind Gallery; p. 56, courtesy of Rena Bransten Gallery; p. 57 (top), courtesy of Heather Marx Gallery; p. 57 (bottom), courtesy of the artist, John Berggruen Gallery; p. 60, courtesy of Alessi; p. 69 (bottom), courtesy of Hosfelt Gallery; p. 70 (top), courtesy of Braunstein /Quay Gallery; p. 74, Camille Washington, courtesy of the artist, and New Langton Arts; p. 77, courtesy of Linc Real Art; p.79 (bottom), courtesy of Bucheon Gallery; p. 99, courtesy of Gallery 16; p. 111, courtesy of the artist; p. 119, courtesy of Triple Base; p. 121, courtesy of Ratio 3; p. 125 (top), courtesy of Jack Hanley Gallery; p. 125 (bottom), April Banks/ Kimara Dixon, courtesy of Intersection for the Arts; p. 147, courtesy of the artist, San Francisco Art Institute; p. 152 (top), Ken Friedman, courtesy of The Fillmore; p. 153, courtesy of Anthony Meier Fine Arts; p. 154, courtesy of the artist; p. 155, courtesy of Atys; p. 156, Lily Rodriguez, courtesy of Exploratorium; p. 161, courtesy of Legion of Honor; p. 168, courtesy of California Academy of Sciences; p. 171, Lewis Watts, courtesy of San Francisco Arts Commission; p. 172, Craig Mole, courtesy of San Francisco Arts Commission; p. 173, Richard Barnes, courtesy of San Francisco Arts Commission; p. 174, Perretti & Park, courtesy of San Francisco Arts Commission; p. 181, 183, 184, 186, 188, 217, courtesy of Thomas Beischer; p. 189, courtesy of Montalvo Arts Center; p. 193, courtesy of San Jose Museum of Art; p. 195, courtesy of San Jose Institute of Contemporary Art; p. 197, courtesy of San Jose Arts Commission; p. 198, courtesy of San Jose City Hall; p. 199, Joe Fletcher, courtesy of Berkeley Art Museum; p. 200, Jack Fulton, courtesy of Berkeley Art Museum; p. 202, courtesy of University of California, Berkeley; p. 204, courtesy of Modernism, Inc.; p. 205, courtesy of City of Berkeley; p. 206 (bottom), courtesy of Kala Gallery; p. 208, courtesy of Paulson Press; p. 212, courtesy of 21 Grand; p. 213, courtesy of Oakland Art Gallery; p. 215, courtesy of the artist, Susan Vielmetter, Los Angeles, and Mills College Art Museum; p. 217, courtesy of Oakland International Airport; p. 218, courtesy of Sleep Train Pavilion; p. 227, courtesy of di Rosa Preserve; p. 230, courtesy of Hess Collection Art Gallery; p. 235, Tom Golden Collection, courtesy of Sonoma County Museum; all others, courtesy of the author.